音の本を読もう

——音と芸術をめぐるブックガイド

編著＝金子智太郎

ナカニシヤ出版

はじめに──この本の成り立ち

　「音」という語にまとめられる論点は幅広すぎる。話声、音楽、信号音、騒音、聴覚、聴衆、音響メディアといった論点をこの一語でまとめてよいのだろうか。この語を使うときはいつもそうしたためらいを感じる。しかし、話声と音楽と信号音のあいだや、騒音と聴衆と音響技術のあいだなどにある物事について考えようとするとき、この語はやはり役に立つ。さまざまなものや領域がこの語によって結びつく。私は音について考えながら、思いもよらなかった出来事や人々とも出会うことができた。

　この本は 2010 年以降に出版された音と芸術をめぐる著作の書評を集め、学術や批評の場でこのテーマが近年どのように語られてきたのかをまとめている。音というだけでは広すぎるので芸術という枠をつけて、編者の私を含めて 22 名の著者による 40 本の書評を集めた。この本の出発点となったのは、2011 年から 2015 年まで音楽言論誌『アルテス』に掲載された私の書評連載である。この連載には 1990 年代にかたちをとりはじめ、2000 年代以降に世界的な動向となった学術領域「サウンド・スタディーズ」や芸術ジャンル「サウンド・アート」の動向を、英語圏の著作を通じて見ていくという趣旨があった。本書はこれをある程度受け継いでいる。

　しかし、そうでない面も多くある。この本は連載が終わったときすぐに企画されたのではなく、紆余曲折を経て生まれたからだ。だから、音と芸術をめぐる本という枠組みなしで書かれた書評も含まれている。芸術との関わりが中心にない書評もある。2010 年以前に出版された本の復刊の書評もある。ここからは制作の大まかな経緯を記しておくが、この本を初めて読むときはここで、目次や気になった書評に移ってよいかもしれない。本書の枠組みや構成に関心が向いたら続きを読んでほしい。

　私は『アルテス』創刊号から最終号まで隔号で、英語で書かれた本を 1 冊ずつ、計 16 冊評した。そのうちの 2 冊、デイヴィッド・グラブス『レコードは風景をだいなしにする──ジョン・ケージと録音物たち』（若尾裕、柳沢英輔訳、フィルムアート社、2015 年）とデヴィッド・ノヴァック『ジャパノイズ──サーキュレーション終端の音楽』（若尾裕、落晃子訳、水声社、2020 年）は書評執筆後に翻訳が出版された。さらにこの文章を書いているあいだに、アンドリュー・シャルトマン『「スーパー

マリオブラザーズ」の音楽革命——近藤浩治の音楽的冒険の技法と背景』（樋口武志訳、DU BOOKS、2023年）の出版も発表された。本書には先の2冊を除いて14冊の書評を収録した。最新のポピュラー音楽研究と歴史あるインディペンデントな音楽実践の魅力が結びついた『アルテス』という雑誌で、自分以外の誰が関心をもつのかわからない連載を続けさせていただいたことには感謝しかない。先に書いたとおり、この連載はサウンド・スタディーズとサウンド・アートを軸としていたが、個々の書評にはっきりそう書いてはいなかった。その理由の一つは、2010年代に入って両分野がさまざまな場面で再検討を迫られており、説明なしにこれらの言葉を使いたくなかったからである。連載第1回の冒頭には「音を使った美術作品をサウンド・アートと呼ぶ——現在こうした説明はいかにも苦しい」と書いた。サウンド・スタディーズの動向についてはこの後に説明する座談会で詳しく扱った。サウンド・アートについては本書「結びに代えて」であらためて考えよう。取りたてて何事もなく終わった連載を『アルテス』編集部のご厚意により、私は2016年に自分のウェブサイトに全文掲載した。

2017年、国際日本文化研究センターで細川周平が代表者となり、共同研究「音と聴覚の文化史」が始まった。「「音楽」の枠を超えて、音に関わる複合的な文化的営みを明らかにしようとする」[1] この研究会は、当時の日本のサウンド・スタディーズ的研究をまとめようとする試みだったと言っていいだろう。2016年に顔合わせをし、翌年から3年間、30名を超える共同研究員、オブザーバーやゲストが年に3〜4回集まり、それぞれの研究を紹介していった。この研究会の成果をまとめたアンソロジー『音と耳から考える——歴史・身体・テクノロジー』（細川周平編著、アルテスパブリッシング、2021年）には44名の執筆者が参加した。序文で細川は、英語圏の「音研究 sound studies」を「音をめぐる研究を柱に、既存の領域にリンクを張るような企て」と表現した。この研究会にとっての「既存の領域」とは——執筆者プロフィールの「専門」に「音楽」が含まれるのは約半数、「メディア」は約10名、「映像」や「社会」などが含まれるのはそれぞれ3〜4名である。この割合は、音楽学者である細川が組織した研究会だからという解釈もできるが、2010年代後半に「音に関わる複合的な文化的営み」に関心をもつ研究者や作家を広く集めた結果の実態と見てもよいだろう。

1) 国際日本文化研究センター、共同研究「音と聴覚の文化史」2017–2020年〈https://www.nichibun.ac.jp/archive/research/coop/2017/3.html（最終確認日：2023年9月21日）〉

　同時代の動きは学術だけではなかった。2018 年に批評誌『エクリヲ』のウェブサイトで「音楽批評のアルシーヴ海外編」という洋書の書評シリーズが始まった。編者の佐久間義貴から依頼され、私もサロメ・フォーゲリン『音の政治的可能性——聴取の断片』（Bloomsbury Publishing, 2018）の書評[2]を寄稿した。私が『アルテス』の連載を出版したいと考えだしたのは、このシリーズの存在が大きい。ここから 5 本の書評を本書に掲載させていただいた。ただし、このシリーズは題名からも明らかなようにサウンド・スタディーズやサウンド・アートを軸としていない。このこともこの本が枠組みにあまりこだわらない理由の一つである。

　「音と聴覚の文化史」研究会が終わりを迎えた 2020 年に私は本書を企画し、各執筆者に依頼をした。研究会を通じて育まれたつながりを持続させたいという試みがいくつかあり、これもその一つである。初出となる書評の多くは新型コロナウィルス感染症が拡大したこの年か翌年に書かれた。執筆者には、2010 年以降に出版された音と芸術の関わりをめぐる本について書いてほしいと依頼した。選書はおおよそ執筆者に任せたが、出版社編集部からの勧めもあり、和書から多く選んでもらった。2021 年 3 月には秋吉康晴、阿部万里江、葛西周、山内文登とともに、ビデオ通話アプリケーション Zoom を通じて座談会を行い、「音の本とサウンド・スタディーズ——音による思考、音をめぐる思考」と題してまとめた。そして、ここから編集にとても長い時間がかかってしまったことは、編者である私に責任がある。

　この本の章立てはすべての原稿が揃ってから決めた。『音と耳から考える』をはじめ、多くのサウンド・スタディーズ系アンソロジーを参考にした。まず重視したのは、既存の領域のリンクである。音と芸術というテーマを一つの領域と見立て、区分して各章にするのではなく、各章を異なる領域が出会い、比較される場にしようと試みた。サウンド・スタディーズならこの主題がなければという発想はなく、音楽学、社会学、メディア論、映像論といった既存の領域に対応する章もない。結果として耳慣れない章題ばかりになったことは許していただきたい。区分のための章立てではないため、一つの章が潜在的に、別の章に入れた本を含んでよいと考えている。この書評はなぜこの章に含まれるのかといった割り当ては、すべて編者である私の独断であり、それぞれの評者が意図したものではない。

2）金子智太郎「「サウンド」の政治——サロメ・フォーゲリン『音の政治的可能性——聴取の断片』評」2018 年〈http://ecrito.fever.jp/20181227220219（最終確認日：2023 年 9 月 21 日）〉

　前後編に分けた座談会「音の本とサウンド・スタディーズ──音による思考と音をめぐる思考」は、本の紹介という体をとりながら、私自身はこれまで中途半端な接しかたをしてきたサウンド・スタディーズを話題の中心に据えた。そのきっかけの一つは、海外で研究する阿部と山内が「音と聴覚の文化史」研究会と『音と耳から考える』において、それぞれの仕方で近年のサウンド・スタディーズの動向をふりかえり、その反省をふまえて自身の方法論を展開したことだった[3]。私もこれまで散発的に言及してきた動向そのものについて、この機会にあらためて検討したくなった。そこで座談会を企画し、この分野を長年フォローしているだけでなく、諸領域のリンクを意識させるユニークな研究を続けている、秋吉と葛西にも参加してもらった。「音による思考と音をめぐる思考」という座談会の副題は、私の言葉づかいの稚拙さのせいで、意味することがわかりにくいかもしれない。音という視点から何かを見つめようとする思考と、音のありかたや広がりと向きあう思考が、いかにずれながら結びつくのか。そもそも両者は異なるのか。さまざまな議論が交わされた座談会で、司会を務めた私にはこうした問題意識が印象に残ったのである。もちろん、この座談会は難解な問いに頭を悩ませるだけでなく、面白い本を無数に紹介しあう楽しい時間でもあった。書評ではあつかえなかった過去の本から未刊行の本まで、学術論文から漫画、図鑑、本の映像化まで、少なくとも 80 冊以上の書名が並んでいる。

　本書には音と芸術をめぐる 2010 年代の思考の記録という面がある。だが、時事性のある本はほとんど含まれない。SNS にもスマートフォンにも、東日本大震災にも新型コロナウィルスにも、ほとんどふれられていない。もともと私の連載のころから選書は計画的ではなかったので、2010 年代を代表する 40 冊と言うつもりはない。書評が書かれた時期も 10 年の開きがあり、私の書評は改訂もした。そのような事情があるとはいえ、いずれにしても 22 名の評者がこの時代に共有したいと望んだ本が選ばれているのはたしかである。

　この本の制作にあたり、ナカニシヤ出版の米谷龍幸氏と井上優子氏をはじめとする制作スタッフのみなさんにはたいへんお世話になった。書名を提案してくれたの

3）阿部万里江「ちんどん屋の「響き」から考える──日本と英語圏の音研究／サウンド・スタディーズ」『音と耳から考える──歴史・身体・テクノロジー』細川周平編著、アルテスパブリッシング、2021 年、38–49 頁。山内文登「方法としての音──フィールド・スタジオ録音の「共創的近代」論序説」同上、173 頁。

も米谷氏である。「音の本を読もう」というフレーズは、かつて東京都文京区にあった書店「あゆみ BOOKS 小石川店」の旧 Twitter（現 X）アカウントで、有地和毅氏（現ひらく ブックディレクター）が 2015 年ごろから使いはじめたハッシュタグに由来する。このタグによって音に関心をもつ人が、冒頭で述べたような、思わぬ本との出会いを経験したのではないか。有地氏のご厚意により、この言葉を使わせていただいた。書評シリーズ「音楽批評のアルシーヴ海外編」の編集を務める佐久間氏には、この本の内容について定期的に相談し、書評に加えて座談会の書き起こしや文献リストの作成を担当していただいた。中村将武氏にはマーティン・デヴィッド・スミス氏による書評を翻訳してもらった。加納大輔氏には表紙デザインを担当していただいた。ここに記して感謝したい。

<div align="right">

2023 年 9 月

編者

</div>

【付　記】
本書刊行にあたり出版費用の一部について JSPS 科研費 20K00213 の支援を受けた。

目　　次

第4章　音響修辞学
音によって物語る ————————————————————————— *81*

第5章　電気になった声の世界
ボーカロイドのオラリティとは ————————————————— *103*

第6章　螺旋状の視聴覚論
「視聴覚連祷」以後 ——————————————————————— *121*

座談会　音の本とサウンド・スタディーズ

【凡　例】

各書評冒頭の文献情報については、以下の書式に従って記載した。

●日本語文献
作者名
書名
出版社、発表年

●外国語文献
作者名
書名（評者が翻訳）
Author Name, Book Name, Publisher, Year

●翻訳された外国語文献（書評の内容は原著にもとづく）
作者名
書名（翻訳版）
Author Name, Book Name, Publisher, Year
（訳者名、出版社、発表年）

●翻訳された外国語文献（書評の内容は翻訳書にもとづく）
作者名
書名（翻訳版）
訳者名、出版社、発表年

また作品名の括弧表記については、以下のように統一した。
『　』（二重鍵括弧）……書籍、映画、アルバム等のタイトル
《　》（二重山括弧）……視覚美術作品、音響芸術作品、楽曲等のタイトル

書評では外国語文献の書名、論文名を日本語訳し、文献一覧に原題と翻訳を
併記した。出版社や掲載誌は外国語で示した。他方、座談会で言及された外
国語文献は訳さずにカタカナで表記し、註と文献一覧は原題のみを掲載した。
「結びに代えて」でも註のみに登場する外国語文献は原題のみとした。

座談会

音の本とサウンド・スタディーズ

音による思考と音をめぐる思考【前編】

秋吉康晴、阿部万里江、葛西周、山内文登　　司会 金子智太郎

　この座談会は 2021 年 3 月 15 日にビデオ通話アプリケーション Zoom を使って行われた。脚註には関連する本や論文、ウェブサイトなどを掲載する。

■ 方法論を問う

　金子　この座談会では音の文化に関する国内外の本を、概略でいいので、お互いにたくさん紹介していきたいと思います。それから、音や聴覚の文化について考える研究領域であるサウンド・スタディーズを、話の枠組みとして設定しておきます。ただ、サウンド・スタディーズとは何かという問いが前面に出るよりも、それぞれの研究や関心に基づいて話してもらいたいです。

　その前にこの座談会に期待したいことを少し話させてください。集まっていただいたみなさんとは、国際日本文化研究センターで 2017 年から 3 年間開催された共同研究会「音と聴覚の文化史」でご一緒しました。そのまとめは『音と耳から考える』[1] というタイトルで現在、書籍化が進められています（［編註］2021 年 10 月に出版）。この研究会は発表者がとても多く、さまざまな領域でどんな音が研究されているのか、たくさんの知識が得られました。この研究会を通してさらに知りたいと思ったのが、それぞれの研究で音をいかに考えようとしているのか、音に対するアプローチの仕方、音文化研究の方法論です。だからここでは、みなさんと本をたくさんあげながら、音や聴覚についてこんなアプローチがある、こういう考え方があるという話をして、さまざまな方法を比較したり、関係づけたりしたいと思っています。

　そこでまず、この座談会の前提知識になりそうな議論を一つ紹介させてください。サウンド・スタディーズの古典的研究と言っていい、ジョナサン・スターンの『聞

1)　細川周平編著『音と耳から考える──歴史・身体・テクノロジー』（以下『音と耳から考える』）アルテスパブリッシング、2021 年。

こえくる過去』[2] は、録音を考えるためのアプローチをそのための言葉と一緒にいくつも提案しました——「聴取の技法」とか「保存の精神」とか。なかでも「視聴覚連祷（れんとう）」はよく参照されます。聴覚と視覚を対比する文化論ではこれまで、視覚は空間的で知的、聴覚は時間的で感情的などの固定観念がくり返し語られてきました。こういった観念はキリスト教を背景とすることが多いので、スターンはこの対比を「視聴覚連祷」と名づけて、この連祷を議論の出発点にしないようにと、むしろこの発想が広がった経緯を研究しようと主張したんですよね。スターンのこの用語は聴覚をめぐる研究から出発して、知性と感情の違いとか、諸感覚の比較にどんな意味があるのかとか、音を超えてさまざまな問いを考えさせます。音に関心をもつ多くの研究者がこういった問題を共有して、研究に取り入れてきました。

　みなさんがよくご存じのことを長々と話してしまい恐縮ですが、おそらくこの座談会を読む読者のための予備知識として必要だろうと思い、最初にもってきました。これからみなさんに紹介していただく本が音をどのようにあつかうのか、論じるのかについて、簡潔に話していただけるとうれしいです。

　この座談会は前編と後編に分かれます。前編ではまず、読書経験を通じて自分の研究を紹介していただき、またお互いに質問していただきます。後編は順に興味深い音の本を紹介していきましょう。この構成はあくまで話を進めるための口実なので、脱線は大歓迎です。それでは、お名前の五十音順に自己紹介をしていただけますか。

■技術のなかの思想

　秋吉　僕は先ほど話に出てきた「音と聴覚の文化史」研究会では、トーマス・エジソンが蓄音機を発明した過程で、音をどう捉えていたのかというテーマで発表をしました。また『音と耳から考える』では、電話の発明史を題材に身体の拡張物としてのテクノロジーというメディア論的な技術観を再考する文章[3]を寄稿しました。当初は音楽の研究をしたいと思っていたはずなんですが、いつの間にか音楽からしだいに離れて今は音のテクノロジーのことばかり研究しています。

　最初のきっかけは細川周平さんの『レコードの美学』[4]だったと思います。僕は大学時代に芸術学を専攻していたんですが、写真や映画を研究している院生が多

2) ジョナサン・スターン『聞こえくる過去——音響再生産の文化的起源』中川克志、谷口文和、金子智太郎訳、インスクリプト、2015 年。
3) 秋吉康晴「電話は耳の代わりになるか？——身体の代替性をめぐる音響技術史」『音と耳から考える』342–353 頁。
4) 細川周平『レコードの美学』勁草書房、1990 年。

かったんです。学部時代、そうした人たちの話を聞いているうちに、映像のテクノロジーに関する議論と同じようなことを音楽の分野でもできないかと考えはじめました。それで読んだのが『レコードの美学』です。この本で細川さんはベンヤミンやアドルノといったフランクフルト学派の議論や、ドゥルーズやデリダをはじめとするフランス現代思想の議論を縦横無尽に参照しながら、録音の聴取体験を哲学的に論じているんですね。前衛音楽とポピュラー音楽を問わず、音楽の作品例もたくさん引かれているのですが、僕がいちばん興味をそそられたのは第一章「レコードの考古学」でした。この章ではエジソンによる蓄音機の発明にはじまり、デジタル録音技術にいたるまでの歴史が紹介されているんですが、よくある技術史の本のように単にテクノロジーの進歩をたどっているわけではないんです。テクノロジーの発明の背景にどういった感覚や身体の観念が隠されていたのか、そうした観念は音や音楽の感性にどのように作用したのか——テクノロジーの歴史を題材に、そういった美学的な議論がなされているんです。こんなふうにテクノロジーを論じられるのかと当時の僕は非常に驚いたのですが、そのときの驚きが今でも僕の研究の根っこにあるような気がしています。

　金子　いつごろのことでしょうか。

　秋吉　2002 年ぐらいです。当時は『レコードの美学』の出版からすでに 10 年が経過していたわけですが、ああいった射程をもった音の本は日本ではまだ少なかったと思うんですよ。それで探しているうちマクルーハンの『メディア論』[5] やキットラーの『グラモフォン・フィルム・タイプライター』[6] のようなメディア論の古典を読んだり、ちょうどアドルノの『音楽・メディア論集』[7] も翻訳されたばかりだったので、ベンヤミンの複製芸術論と比較しながら読むようになりました。そして、それらを読んでいるうちに、音響技術史をもっと掘り下げてみたいと思いはじめました。そういう関心がしだいに強まり、博士論文は録音技術の発明史と受容から声の観念史を再構築するというテーマで書きました。ちょうどその頃、先に説明していただいたスターンの『聞こえくる過去』をはじめとして、英語圏のサウンド・スタディーズがしだいに盛り上がりを見せていたのが大きかったと思います。

5) マーシャル・マクルーハン『メディア論——人間の拡張の諸相』栗原裕、河本仲聖訳、みすず書房、1987 年。
6) フリードリヒ・キットラー『グラモフォン・フィルム・タイプライター』石光泰夫、石光輝子訳、筑摩書房、1999 年。
7) テオドール・W・アドルノ『アドルノ 音楽・メディア論集』渡辺裕編、村田公一、舩木篤也、吉田寛訳、平凡社、2002 年。

こういった本から影響を受けてきたせいか、レコードの中身にどんな音楽が入っているかよりも、レコードやスピーカーから音が鳴ること自体、あるいはそれらを通して音を聴くという体験自体の歴史や哲学的な意味に関心があります。

　金子　そこから始まって、いま一番関心があることは何ですか。

　秋吉　いま関心があるのは、ヴォルフガング・フォン・ケンペレンという18世紀の著述家・発明家の仕事[8]です。彼は実に多才な人物で、さまざまな発明を行ったんですが、その一つに「話す機械」という機械式の発話シミュレータがあります。音声合成の元祖と言われたりもするんですが、現代とは違って当時はテクノロジーが哲学的な思索の道具でもありました。ケンペレンの「話す機械」も啓蒙時代の機械論哲学や言語起源論からの影響を受けていて、音声をシミュレートすることよりも、言語の本質を考えることに目的が置かれていました。

　金子　その議論は現在の音声合成とも関わっているんでしょうか。

　秋吉　仕組み自体は現在の音声合成につながっていますが、根底にある関心はだいぶ違うと思います。いまはテクノロジーをどうやって使うか、何に役立つかというのが関心の的じゃないですか。対して、ケンペレンの生きた18世紀はテクノロジーの開発や観察を通して人間とは何かという哲学的な問いにアプローチする文脈があったんです。そこを掘り下げていけば、もしかしたら現在のテクノロジーの見方を少し変えられるかもしれないと思っています。

　金子　現在のテクノロジーを通じてものを考えることもできるんじゃないか、と。

　秋吉　そういう可能性がありますね。ただの便利な道具として利用するだけじゃなくて。

　金子　なるほど。秋吉さん、ありがとうございます。次に阿部さん、お願いします。

■響きと空間

　阿部　私は大学も大学院もエスノミュージコロジー専攻でした。最初は音楽に興味があって入っていったんです。博士論文の対象をちんどん屋にして、フィールドワークを始めて2年目くらいに考えたことなんですが、彼ら、自分たちの生業についてめちゃくちゃ語る方々なんですよ。ちんどん屋さんは路上のエスノグラファーだと私は思うんです。大阪の「ちんどん通信社」[9]の人たちは、自分たちは音楽を

8) トム・スタンデージ『謎のチェス指し人形「ターク」』服部桂訳、NTT出版、2011年。
9) ちんどん通信社ウェブサイト〈https://tozaiya.co.jp/（最終確認日：2023年4月14日）〉

演奏しているんじゃなくて、音を出していると言っていた。良い音を出して、良い仕事をするというところに重きを置いている。そこから、彼らのいう良い音とは何か、あえて音楽ではなく音とこだわって呼んでいるということは何なんだろう、と考えたくなりました。

特に最初に興味があったのは空間論、人文地理学でした。ルフェーヴルの『空間の生産』[10] は、音についての本ではないけれど、そこらじゅうに音とか響き方についての言及があります。それと、スティーヴン・フェルドの「アクーステモロジー（音響認識論）」[11] の共通するところをくっつけて、ちんどん屋さんが常に心がけている社会性と空間性と音の関係性を同時に考えられないかと。三つ目の要素はスチュアート・ホールの「アーティキュレイション」[12]。これも音に関するテクストではないんですけど。これらを合わせることで、ちんどん屋さんのこだわっている、見えていない、すぐそこにいるわけでもなくて、自分たちからは見えていない、でも聴いているであろう聴衆の心に訴えるような音の響きをどうやって出せるかという、その作業を理論化しながら音や響きについて考えることにこだわりはじめました。そのときはサウンド・スタディーズのことをそこまで意識していなかったんです。

　金子　そのときというのはいつごろですか。

　阿部　2004 年くらい。そこから音とのおつきあいが始まりました。

　金子　ルフェーヴルの『空間の生産』は少し意外でした。

　阿部　彼は『リズムアナリシス』[13] という本もあって、音を気にしている人だと思ったんです。あの本は音のメタファーをちょっとかっこつけて使っているぐらいですけど。でも『空間の生産』の方は、空間に関する議論の中のいろんなところに音が散りばめられている。それらを掬い取りながら空間と社会性と、情動的なつながりの接合点を、音を通して考えていくことができたらいいなと思いました。なので、自分の研究で大事な古典文献と言ったら、フェルドの「アクーステモロジー」とルフェーヴルとホールかなと思います。

　金子　フェルドは『鳥になった少年』[14] ですか。

　阿部　その本は私が大学の卒論を書いていたときに出会ったんですけど、そのと

10)　アンリ・ルフェーヴル『空間の生産』斎藤日出治訳、青木書店、2000 年。

11)　註 14 ～ 16 を参照。

12)　『現代思想 臨時増刊号 総特集＝スチュアート・ホール 増補新版』青土社、2014 年 4 月。

13)　Henri Lefebvre, *Rhythmanalysis: Space, Time and Everyday Life*, Continuum, 2004.

14)　スティーブン・フェルド『鳥になった少年――カルリ社会における音・神話・象徴』
　　　山口修、山田陽一、卜田隆嗣、藤田隆則訳、平凡社、1988 年。

きフェルドは「アクーステモロジー」というかたちで理論化していなかった。その後に「ウォーターフォールズ・オブ・ソング」[15]と「ア・レインフォレスト・アクーステモロジー」[16]という音響認識論を整理した論文があって、それが私にとってはキーでした。

　金子　そうして音についての研究が始まって、『音と耳から考える』では阿部さんは、サウンド・スタディーズというものが現在までどのように進んできたのかを見渡すような文章[17]を書かれていました。あらためて、いま音にまつわる関心がどうアップデートされているのかを教えてください。

　阿部　博論を書いたのが2010年、今から10年以上前で、当時サウンド・スタディーズということ自体をあまり意識しないで書き上げました。その後にサウンド・スタディーズが勢いを増すのと並行しながら、本に書き直して出版したのが2018年[18]。出版後のここ数年間に人文学では「脱植民地化」や「グローバル・サウスからの再配置（remapping）」についての議論が新しいかたちで再び盛んになっています。こう言うと読者のみなさんは戸惑われるかもしれませんが、特に音は脱植民地化に関してとても貢献ができるという、期待を負っているテーマだと思うんです。良くも悪くも。この座談会でその話ができるといいなと思っています。

　金子　それは自己紹介の後にぜひ話しましょう。

　阿部　それとサウンド・スタディーズという用語のメリット、デメリットについて、みなさんの考えを聞きたいです。英語圏の北米とヨーロッパを中心にまとまったものを輸入物としてサウンド・スタディーズと呼んでいると私は考えているので、そこから出てくる偏りをどうやって突っこんで、ずらしていけるか、というチャンスはいろいろあるんじゃないかなと思います。

　金子　これもみなさん考えがあると思います。次は葛西さん、お願いします。

15) Steven Feld, "Waterfalls of Song: An Acoustemology of Place Resounding in Bosavi, Papua New Guinea," in *Senses of Place*, Steven Feld, & Keith H. Basso eds., N. M. School of American Research Press, 1996, pp. 91–135.

16) Steven Feld, "A Rainforest Acoustemology," in *Revista Colombiana de Antropologia*, vol. 49, no. 1, 2013, pp. 217–239.

17) 阿部万里江「ちんどん屋の「響き」から考える——日本と英語圏の音研究／サウンド・スタディーズ」『音と耳から考える』36–63頁。

18) Abe Marié, *Resonaces of Chindon-ya; Sounding Space and Sociality in Contemporary Japan*, Wesleyan University Press, 2018.

■聴取が混在する場

　葛西　私のバックグラウンドは阿部さんと割と近いと思います。学部から博士までずっと音楽学専攻で、特に日本音楽史を専門としてきました。研究対象も音全般というよりは音楽と呼ばれてきたものをあつかってきているので、サウンド・スタディーズの中心的な問題関心とはややずれているように見えるかもしれません。でも、鳴り響きを音と音楽に二分して、音楽をあつかうなら音楽学、従来の音楽の範疇から溢れるものをあつかうならサウンド・スタディーズということではないんじゃないかと考えています。

　私自身は音楽ジャンルを問わず、音として音楽を同じ土俵に乗せてとらえ直して、ある場での聞こえ方、聞かれ方というのを追究しようと試みてきたようなところがあります。その点で運命的だったのは、高校のときに渡辺裕さんの『聴衆の誕生』[19]を読んだことですね。いまだに高校生のころ読んだものに振り回されている感じはするんですけど。

　金子　高校ですか。早いなあ。

　葛西　『聴衆の誕生』を読んだとき、それまで鳴り響く音楽のほうにばかり関心があったので、いまの音楽の聴き方が普遍的ではないということとか、音楽がどういうふうに聴かれるかが時代によって変わっていくということが、とにかく刺激的だったんです。それで、時間的・空間的に遠く離れたところの聞こえというものに意識が向くようになって。19世紀フランスで共同体のシンボルになった教会の鐘の音の機能を論じたアラン・コルバンの『音の風景』[20]や、同じ鐘でも京都の梵鐘に着目して、平安時代の文学や資料から当時の音環境を読み取ろうとした中川真さんの『平安京 音の宇宙』[21]とか、過去のサウンドスケープをあつかった本を読んでいきました。専門が音楽史だったので、歴史的な資料を読み解いて、そのとき音が鳴り響いていた空間とそこでの聞こえを想像することに関心をもつようになったんです。

　大学院修士課程の頃、音や音楽、聴覚文化に関心のある若手研究者が大学や分野を超えて集まる研究会に参加するようになったことにも、大いに触発されましたね。2000年代半ばはサウンド・スタディーズの黎明期という感じで、『文化を聞く──

19）渡辺裕『聴衆の誕生──ポスト・モダン時代の音楽文化』春秋社、1989年（中央公論新社、2012年）。
20）アラン・コルバン『音の風景』小倉孝誠訳、藤原書店、1997年。
21）中川真『平安京 音の宇宙』平凡社、1992年（『平安京 音の宇宙──サウンドスケープへの旅』平凡社、2004年）。

音、聴取とモダニティに関する小論』[22]とか『聴覚文化——現代音楽論集』[23]とか英語圏での出版が活発で、研究会でも『聴覚文化読本』[24]を輪読しました。この時期の読書や議論を通じて、音、音楽、ノイズ、無音など鳴り響きや聞こえに関わるあらゆる事象を並列して語り、音や聴覚を通じて世界を認識し直す、という機運の高まりを実感するうちに、同じ時代・地域であっても個々の聴き手によって聴き方にギャップが生じるような場に改めて興味をもち始めました。

今は温泉地での音楽体験を研究対象としています。温泉地は、いろんなジャンルのパフォーマンスが提供されて、そこに熱心に聴きにきている人と何となく居合わせている人が混在しているような場でもあります。場と音楽をめぐるこれまでの研究は、音楽ジャンルとの結びつきが強すぎているんじゃないかという問題意識もあったので、ジャンルが混ざってさまざまな聴き方や聴こえが発生するような場所ということで、今温泉に関心がある感じです。聴取態度についてジャンル横断的に考えるうえでも、サウンド・スタディーズという領域は有効に思えます。

金子　場の話にはいろいろなかたちでみなさんの研究が関わると思います。『聴衆の誕生』と同じく 90 年前後の聴取論には庄野進さんの『聴取の詩学』[25]もありますね。それでは最後になりましたが、山内さんお願いします。

■録音による／をめぐる知の生産

山内　音にいかに関心をもつようになったかと、サウンド・スタディーズと現在言われているものにいかに関心をもつようになったか、たぶんこの二つのフェーズはみなさん微妙にずれていると思うんです。自分なりにサウンド・スタディーズとの出会いの前と後みたいな感じで、後付け的な自己紹介をしたいと思います。

そういうふうに思い返すと、音への関心というのはまず音のメディアに対する関心が先にありました。特にレコードですね。僕の場合、バックグラウンドとしてはポピュラー音楽研究というのがまずあったと思います。それと、僕は韓国に長らく留学していた時期があるので、韓国朝鮮研究。この二つが結びついて、後に植民

22) Veit Erlmann ed., *Hearing Cultures: Essays on Sound, Listening and Modernity*, Berg, 2004.

23) Christoph Cox & Daniel Warner eds., *Audio Culture: Readings in Modern Music*, Continuum, 2004（Bloomsbury Academic, 2017）.

24) Michael Bull & Les Back eds., *The Auditory Culture Reader,* Berg, 2003（Bloomsbury Academic, 2016, Routledge, 2020）.

25) 庄野進『聴取の詩学——J・ケージからそしてJ・ケージへ』勁草書房、1991 年。

地期のレコード、特に SP レコードをめぐるいろんな問題を考えるようになりました。学術領域で言うと人類学と歴史学が交差する歴史人類学あたりに自分の研究の軸足の一つを置いています。そのうえで、歴史資料として古いレコードをあつかうという関心がまずあって、韓国の「音盤学（ディスコロジー）」という学術分野との出会いがありました。専門のジャーナルが出ていて、研究者も多くいます。

　金子　音盤学は山内さんの書評[26]に出てきましたね。SP 盤を調査するときに使われる言葉で、まずディスコグラフィをつくるところから始まって、それから社会学的、人類学的方向に展開しているという。その過程を山内さんはずっと見てきたということですか。

　山内　そうですね。参与観察というか、レコードを資料とみなす人たちがいて、それを通じてある種の歴史を書いていくという行為があり、そういう知識をつくりだしていくネットワークみたいなものが緩やかにあるわけです。そのなかに僕自身が身を置きながら、そうした人々を直接研究の対象として記述するのではなくて、そこに流通していく知識を学び、自分も現地語で参与し、対話を重ねていきました。ちんどん屋がエスノグラファーでもあると阿部さんもおっしゃっていましたけど、僕の場合は知識生産の主体であるところのそういった人たちと一緒に歴史を考えていくという、こうした点に自分なりの歴史人類学的なアプローチがあるかと思います。

　金子　現地で音盤学を追求した人たちも、音盤を通じていろいろと学ぼうとした。もともと知識がたくさんあったわけではなく、彼らが知識を学んでいく過程に山内さんは参与していたと。

　山内　そうですね。一口に「音盤学」といっても関心のもち方は多様です。テクノロジーに関心がある人もいれば、特定の音楽ジャンルに関心がある人もいたり。あと、どういった場所や立場で聴くのかといった問題関心もあります。このあたりは後でみなさんとお話できると思うんですけど。

　そのころに個人的に関心をもっていた、影響を受けた本をあげるとすると、ウォルター・オングの『声の文化と文字の文化』[27]。歴史・文化研究をするうえで、文字の世界と声の世界を対照させながら、特に声の世界の独自性というか、特徴を考えていくというのはすごく魅力的だったんです、当時の自分にとっては。

26)　山内文登「裵淵亨『韓国蓄音機レコード文化史』」☞本書 174-177 頁。
27)　ウォルター・J・オング『声の文化と文字の文化』桜井直文、林正寛、糟谷啓介訳、藤原書店、1991 年。

　もう一つあげると、ジャック・アタリの『ノイズ——音楽／貨幣／雑音』[28]と訳されている本。そこに提示された音と音楽、カオスとコスモス、この弁証法による壮大な歴史観は刺激的でした。また音、ノイズの予言性という着眼点もですね。音楽は政治や経済に先立ってコスモスを体現していて、それを破壊していくようなカオスも同時に生起してきて。そういうふうに音と音楽の対立を通じて、どうやって歴史を考えていくかという。ただし、思い返してみると、自分の理解の枠組みには、どこか音と文字というオング的な対比がかぶさっていました。アタリも、特に「演奏のレゾー」や出版を論じるところなどで、かなり音の記録について書いていますので、そういう読み方がどうも自分のなかに混在してたのかなと思います。

　最後に簡単に、自分なりにサウンド・スタディーズというべき領域との出会いを話すと、僕にとってガツンときたのはやっぱりスターンの『聞こえくる過去』。冒頭でも話の出た「視聴覚連禱」の問題があって、やはり自分もそういったパラダイムのなかで文字と音、目と耳とを対比しがちな部分があった。自分にとって音の資料がすごく大事だと思いたかった部分もある。それに対して、いやいや実は耳にせよ、音にせよ、共に近代のいろんな問題を背負っているから、単純に二元論的に考えることはできないよね、という。この本を通じて、たぶん現在サウンド・スタディーズの流れの一つにある、近代のとらえ直しという問題意識と強く接点をもつようになったんじゃないかなと思います。

　金子　近代性のとらえ直しという大きな問題のなかで、山内さんが関心を寄せている論点はどのあたりですか。

　山内　さっき阿部さんもおっしゃっていた植民地主義の問題がまずあります。サウンド・スタディーズの「リマッピング」とも関わってくる話なので、後でまた話題に上がると思うんですけど。暫定的に言えば、自分自身がやってきた韓国・朝鮮、台湾、そして帝国日本に関わる「植民地近代」といった枠組みを一方で意識しながら、東アジアにおける音や耳の問題を二項対立ではないかたちでとらえ直したいですね。西洋でスターンが批判した「視聴覚連禱」と重なる部分もあるし、そうではない部分もある。まだ抽象的かもしれませんが、テーマとしてはそのあたりに一つ関心をもっています。

　金子　ありがとうございます。それでは、次のフェーズに入ろうと思います。い

28）ジャック・アタリ『音楽／貨幣／雑音』金塚貞文訳、みすず書房、1985 年（『ノイズ——音楽／貨幣／雑音』みすず書房、1995 年、2012 年）。原題は *Bruits: Essai sur l'économie politique de la musique*（『ノイズ——音楽の政治経済学に関する試論』）。

まこうして話してもらったことを元に、互いが互いに質問していきましょう。共通点を探ったり、話をさらに深めたり、いろんな展開があると思うんです。全員にでも個人にでも、論点も広くても狭くてもいいので、とにかく互いに聞きたいことを聞きあうということで。秋吉さんからお願いしていいですか。秋吉さん以降は順番ではなく聞きたい人からにして、最初だけお願いします。

■視覚論

　秋吉　みなさんに質問してみたいのは、ビジュアル・スタディーズをどれくらい意識されているのかということです。スターンは「視聴覚連禱」で感覚をめぐる本質主義を批判していますが、そうした批判はすでに視覚についての議論ではじまっていたと思うんですよね。とくにジョナサン・クレーリーの『観察者の系譜』と『知覚の宙吊り』[29]の影響は日本でも大きかったと思います。クレーリーは『観察者の系譜』で近代は視覚中心主義の時代だったという通念を問い直していて、近代科学によって視覚への信頼がしだいに崩れていく過程と、視覚への信頼を立て直すために新しい映像技術が次々と発案されていく過程を関連づけています。僕は周りに映像研究者が多かったこともあって、スターンと同じくらい、そうした研究からも影響を受けました。「視聴覚連禱」からの脱却をはかるなら、ビジュアル・スタディーズとの協働も必要なのではと思うのですが、みなさんのご意見をうかがってみたいです。

　金子　クレーリーはよく読みました。音の研究がそれぞれのフィールドでどうやって視覚の問題につながっていくかということですね。みなさんは自分の研究のなかで、視覚の問題はどういうあつかいになっているのかな。

　秋吉　サウンド・スタディーズに対して、僕は音を過度に特権化している傾向があるのではないかと感じています。もっと映像や視覚の研究に寄っていってもよいのではないかと。

　金子　それは同感です。音楽学の延長として音を考える場合と、メディア研究の延長として音のことを考える場合、あえてざっくりそう分けるなら、後者は当然、映像や視覚の問題が出てきます。これらの問題のあつかい方は、音楽から音に関心をもった人とずれが出てくるのでしょうか。阿部さんいかがですか。

29）ジョナサン・クレーリー『観察者の系譜――視覚空間の変容とモダニティ』遠藤知巳訳、十月社、1997年。『知覚の宙吊り――注意、スペクタクル、近代文化』岡田温司、大木美智子、石谷治寛、橋本梓訳、平凡社、2005年。

12

　阿部　自分の研究をふり返ってみると、ちんどん屋のフィールドワークでハッと させられた発想があって、それは自分たちには見えていない聴衆を想像しながら演 奏するというものでした。フィールドワークを終えて博士論文を書いているときに、 スティーヴン・フェルドが大学院に客員として来ていたので、その話をしてみたん です。そのときに彼が言っていたのが、こういう視覚と聴覚の関連性についての研 究は、音楽学にはまだ深く掘り下げたものはないが、フィルム・スタディーズの人 たちがずいぶん前から面白いことを言っているよ、と。そのときに私が読んだのが ウォルター・マーチ[30]とミシェル・シオン[31]でした。ちんどん屋の音が聞こえて くる体験を分析する際、見えてないものから聞こえてくる音、しかもその音源は常 に動いていて、その音源には必ず身体があるという認識がある。そういった見えな い音源や、音の身体性や、音がきっかけになって社会性が生まれるということをど うやって論じるか考えていたときに、映画のサウンドデザインの実践者でもある彼 らの映画音響論は刺激になりました。

　金子　音研究では見えないものも重要な論点になってきますね。葛西さん、いか がでしょうか。

　葛西　シオンは映画における声だけの存在を俎上に載せたわけですが、見えてい る映像と聞こえている音の関係性から、観客の聞こえがどのように構成されている か浮かび上がらせた点が新鮮でした。私自身は大学院で博覧会という、実践も議論 も視覚偏重の傾向を持つ対象をあつかうようになりまして。

　金子　博覧会は視覚偏重なんですか。

　葛西　「見世物」や「スペクタクル」という言葉にも顕著なように、祝祭は視覚 と結びつけて語られがちなんです。他方で、博覧会の音の話をするときに、それが 「見られるもの」でもあることが忘れられてしまうのが引っかかって。それで、楽器 が演奏されず、音を出されることのないまま展示される事例なんかを積極的にあつ かっていたところはあります。

　金子　博覧会というテーマはそういう事例がたくさん集まるんですか。

　葛西　展示にせよ興行にせよ、「見られるもの」として視覚優位に設計されがちで、 音も音楽も鳴り響いているはずなのに周縁化されやすいですからね。博覧会はとに かく網羅的にアーカイヴされるのですが、目録とか報告書とか写真帖とか、視覚的

30）ウォルター・マーチ『映画の瞬き——映像編集という仕事』吉田俊太郎訳、フィルム アート社、2008 年（新装版 フィルムアート社、2018 年）。
31）ミシェル・シオン『映画にとって音とはなにか』川竹英克、ジョジアーヌ・ピノン訳、 勁草書房、1993 年。

な資料が非常に多いんです。聴覚に関する展示や公演でも、ほとんど視覚的にしか記録が残されていない。現場では聴覚的なプレゼンテーションもたくさんあったけれど、その音を伝えてくれる資料は限定的です。時期にもよりますが、特に国内の博覧会ではそうですね。

　金子　視覚的なものに囲まれたなかで、音がどんな役割を果たすのかという関心が、研究のなかにいつもあったと。

　葛西　そうですね。音に関わる事物でも、視覚的な面だけで価値づけられる場所があるということとか。

　金子　見えないものという論点と並んで、音を見るという論点も大きいですね。メディア研究者だったら、レコードの溝のように音を図形に変える装置とか、いくらでも実例や研究は出てきます。

　葛西　音の視覚化は、映像の創作でも研究でも大きな論点だと思います。栗原詩子さんの『物語らないアニメーション』[32] は、作曲技法や演奏語法を映像に「翻訳」しようとするノーマン・マクラレンのアプローチを分析しています。

　金子　作家をあげるときりがなさそうですね。この話はだいぶ長くなったので、山内さん、視覚論についてでも、新たな話題でもどちらでも構いませんが。

■フォノグラフィの二つの定義

　山内　視覚と聴覚については、みなさんそれぞれ違う感性の構成があると思うんです。僕自身はすごく音に敏感な部分がたぶんあって。海外での生活が長いので、韓国に行ったり、アメリカに行ったり、いまは台湾にいて、自分にとっての音のカオスのなかで、生き抜くためにいかに自分なりの秩序をそのつど構築していくのかという課題とでもいうんですかね。言葉だけじゃなくて、交通音とかいろんなサウンドスケープも含めて、音を通じて世界と対峙し、理解しようと努めてきました。ときどき、自分のなかにスッと入ってくる音があって、サバイバルするために感覚をシャットダウンというか、防御用の壁を築いていないといけないような状況もあるんですが、それでもなお飛びこんでくる音というか。攻撃的なときもあれば、ある種の感動を呼び起こすときもあって。主体・客体という言葉を使えば、音のほうが主体で、自分のなかにスーッと入ってきてしまって、どうにも止められない反響を呼び起こす。そういった経験が自分としては割合的に多くて。なので、おそらく

32）栗原詩子『物語らないアニメーション──ノーマン・マクラレンの不思議な世界』春風社、2016 年。

音とか耳というものを他の感覚よりも重視して考える傾向があるのかなと。

金子　音が主体という話はわかる気がします。

山内　ただ、僕は研究対象としてフォノグラフィに関心をもっています。フォノグラフィというのは表音文字、より広く音を記すこと、書くことです。文字と録音は断絶もしているし、フォノグラフィという概念でつながっている部分もある。僕がハーバード大学で訪問研究者をやっていたときに、ちょうど「ヒアリング・モダニティ」という不定期のセミナーが一年間行われていました。スターンとファイト・アールマン [33] が初回に出ていて、直接話す機会があって、特にスターンとは日をあらためてこのあたりの話をする機会がありました。そのとき、彼は録音を文字とかから考えていくのではなく、この関係を極力切りたい、そうではない文化的起源のほうに音の再生技術を結びつけたいと言っていました。一方、僕は研究のテーマ上、東アジアの文脈では漢字の問題とか表音文字の問題とかが重要だと思っていると話しました。意見の違いというか、そういったことがありましたね。音を視覚化していくという営みは、文字はその一つに過ぎないし、楽譜もそうで、いろんなかたちがあるんです。

金子　なるほど。フォノグラフィという言葉を狭い意味では音を文字であらわすこと、広い意味では音を目で見えるようにするきわめて広い実践を指すために使うんですね。

山内　そうです。フォノグラフィにはいろんなとらえ方があると思うんです。金子さんも、フィールド・レコーディングをフォノグラフィとしてとらえるという、そういった書評を書かれていますよね [34]。その場合のフォノグラフィはフォトグラフィとも関係していて、そこにある音を忠実に記録するのではなく、録音の場であるとか、録音している主体を含めたさまざまな音を、ある種の作品として、総体として提示していくようなアプローチがある。フォノグラフィという概念はスタジオにも使われていて、スタジオ録音の場合では、エヴァン・アイゼンバーグの『レコーディング・エンジェル』[35] などに書かれていますけど、入念に加工されていることが強調される。原音に忠実なのではなく、録音された作品としていかにつくり

33) Veit Erlmann, *Reason and Resonance: A History of Modern Aurality*, Zone Books, 2014.

34) 金子智太郎「スティーヴ・ロデン『…私の痕跡をかき消す風を聴く──ヴァナキュラー・フォノグラフの音楽 1880–1955』」☞本書 170–173 頁。

35) Evan Eisenberg, *The Recording Angel: Music, Records and Culture from Aristotle to Zappa*, Yale University Press, 2005.

あげていくか、アートとしてフォノグラフィを考える。ただ、僕の最近の研究のなかでは、昔から使われている表音文字としてのフォノグラフィを意識しています。

　金子　違いがありますね。僕やアイゼンバーグは基本的に音の話ですが、山内さんのフォノグラフィは聴覚から視覚への変換が重要です。

　山内　フォノグラフィにはいくつもの思想や実践の系譜があるような気がします。

　金子　そう思います。スターンとの意見の違いは面白いです。さっき山内さんが大事だったと言っていたオングは、スターンにとっては批判の対象ですよね。スターンはいわゆる視覚中心主義をあらためて相対化したいと考えていた。視覚が優位にあるような文化では、音が反動として神秘的な価値をもつとされることがある。それに対してスターンはいわば、音はそんな特別なものではないと論じました。

　とはいえ、視覚中心主義批判や視覚中心の近代に対する批判という姿勢は、音をあつかう研究には根強くあります。こうした姿勢が研究を後押しする場面はいくつもあったと思うんです。阿部さんが先に話してくれたような、脱植民地化の議論がそうですよね。音を通じた近代主義批判。音の脱植民地化と言ってもいいのかな。この話は前から聞きたかったので、イレギュラーな進行になりますが、僕からの質問として、阿部さんにこの論点についてどう考えるか聞きたいです。

■ 音による脱植民地化

　阿部　私はたぶん中途半端な立ち位置からこのテーマに関心をもっています。私は北米で学術的な訓練を受け、そこにどっぷり浸かって北米中心の言説のなかから出てきました。特に文化人類学、民族史的な研究にルーツを置いているのですが、そこで特に近年高まってきているのが、知識生産の形態とその流通の仕方自体に対する批判です。それで、関係存在論とか、文化人類学とつながったところから、音を通してその批判が上手くできるのではないかという流れに興味をもっています。一方で、ある意味植民地的知識を産出する場である北米の立ち位置からすると、音自体の脱植民地化という概念については、あまり語れる資格がないかもしれないですけど。

　山内さんがおっしゃっていた、異文化のなかでの音を使った秩序の見つけ方というのは、私が理解するフェルドの音響認識論と似ているところがあります。秩序というよりは、音と差異の関係性ですね。フェルドは空間的なことと存在論的なことを混ぜています。自分の空間的な居場所と、世界への関係の仕方、自分の存在の仕方というのを、音は上手く導きだしてくれる。そういう知識と知識以前の感じ方（アフェクト、情動）や、存在の仕方とか、世界のとらえ方を突き詰めていくと、音

というのは西洋中心の、近代の知識のあり方を相対化し、別の存在論や認識論を考えるために生産的なメディアになると考える流れに私は興味をもっています。これは、私がいままで受けてきた北米・欧米中心の教育を反省しながら、日本を研究する日本人としてどういったことができるかなという自問から生まれた興味でもあって。自分のちんどん屋の研究のなかで、空間と音と社会性の関係性を論じるときに「響き（hibiki）」とあえて日本語を使ったのも、文化的に特異な聞き方を使って論じていくことの大切さを意識しはじめて、たどり着いたのが響きという日本語だったからです。音自体の脱植民地化というよりは西洋主義の知識の形態を、音を通して存在論の方から批判していく。

　金子　自分のルーツや研究の成り行きから、阿部さんは音を使って批判をするという議論に関心があり、それは音のなかでの植民地化や脱植民地化とは問題意識が異なってくるというわけですね。

　阿部　そうです。アナ・マリア・オチョア[36]とかジム・サイクス[37]とかの本は人間と非人間とか、人間と環境とか、自然と文化とか、音と音楽とか、そういう当たり前に使われるカテゴリー自体が相対的に生まれていく経過を歴史的に、または民族誌的に見せていく。私は、音がこうした議論にとても適している題材なんだととらえているんです。

　金子　なるほど。研究のなかで音を使っていこうとするスタンスと、音の中身を見ていこうとするスタンスとで、ずれや重なりあいがあるところが、サウンド・スタディーズのとても面白いところかもしれないですね。

　阿部　もう一つ付け加えると、研究で得られた知識を、音を使って発表できるかという問題もあります。音について論じるとき、研究者は文字で書いていますよね。音を使った表現が学術的にどう関わってくるのか、可能性はあるのかということも興味があります。

　金子　音を通じて知識を表現する。たんなる口頭発表とか、音楽による表現とは別の話ですね。

　阿部　はい。自己表現ではなく音を通して知識をつくりだしていくのであれば、音を使って知識の伝達はできるのかなと。フェルドも書いていますけど「音による人類学の試み（ドゥーイング・アンソロポロジー・イン・サウンド）」[38]にも関心

36）阿部万里江「アナ・マリア・オチョア・ゴティエ『聴覚性──19世紀コロンビアにおける聴取と知識』」☞本書 64–67 頁。

37）Jim Sykes, *The Musical Gift: Sonic Generosity in Post-War Sri Lanka*, Oxford University Press, 2018.

があります。

　金子　試みはすでにあると。語りにはなってしまいますが、「オーラル・ヒスト
リー」とも関わるような話かなと思いました。

■耳をめぐる術語

　金子　葛西さん、続きの話でも別の話でも構いませんが、いかがでしょうか。

　葛西　話が戻ってしまうかもしれないんですが、視覚偏重な言語や概念が多いが
ゆえに思考の不自由さを感じて悩むことがよくあるので、みなさんの考えを聞いて
みたかったんです。たとえば、「ゲイズ（注視する）」のようなことを聴覚に関して
言いたいのに、それにピタッと合致する表現がどうもない。ただ「注視する」と言
いたいのではなく、社会的に体系化されたものの見方、フーコー的な「眼差し」[39]
とか、ヒエラルキーに裏づけされた目つきといったニュアンスを求めているときに、
「眼差し」は使い勝手がよいのに、音について同じようなことを言おうとすると、言
葉が見当たらない。そもそも聴覚について語るときは、誰もが同じように聞いてい
るという前提に陥った言葉づかいになりやすい。私の関心は個人や集団による聞き
方の違いとか、社会的に構築された聞き方、聞き逃し方みたいなところにあるので、
上手く表現できないときがあるんですよね。

　さっきの山内さんのお話で思い出したんですけど、「耳にはまぶたがない」みたい
な表現はいろんなところで出てきますよね。パスカール・キニャールなんかが言っ
ていたと思うんですけど[40]。聴覚は受動的という考えが前提になって生まれる表
現です。作曲家の團伊玖磨さんは、音の暴力という点から BGM について語ってい
て、『エレベーター・ミュージック・イン・ジャパン』[41] にも載っているエピソー
ドですが、トイレでベートーヴェンは悪趣味だ、みたいな批判をしているんです。
これはわからなくはないんですよね。私は戦時下の音楽をつうじたプロパガンダの
調査もしてきたので、そういうふうに暴力的に耳に入ってきて、聞き手を操作して

38) Steve Feld, & Donald Brenneis, "Doing Anthropology in Sound," in *American Ethnologist,* vol. 31, no. 4, 2004, pp. 461–474.

39) ミシェル・フーコー『臨床医学の誕生』神谷美恵子訳、みすず書房、1969 年（みすず書房、2020 年）。『監獄の誕生——監視と処罰』田村俶訳、新潮社、1977 年（新潮社、2020 年）。

40) パスカール・キニャール『音楽への憎しみ』高橋啓訳、青土社、1997 年。

41) 田中雄二『エレベーター・ミュージック・イン・ジャパン——日本の BGM の歴史』DU BOOKS、2018 年。

くる音があることは実感しています。ただ、そういう状況の説明をするにも、「まぶたがない」という視覚にまつわる言葉になってしまう。たとえば「ゲイズ」について最近海外の研究者と議論したときにも「オーラル・ゲイズ（aural gaze、耳の眼差し）」なんて言った人がいて。

金子 苦しいですね。

葛西 「オーラル・ゲイズ」とか「クリティカル・リスニング（批判的聴取）」とか、そういう表現になってしまうんですよね[42]。

金子 たしかに聴覚を語るボキャブラリーの偏りは興味深いテーマです。ここにも視覚と聴覚の違いがあるとしたら、それはどう生まれたのか。もちろん、聴覚ならではの表現もたくさんあります。「小耳にはさむ」とか。ただ、学術的に深堀りされているわけではあまりなさそうです。われわれが研究者として、新しく言葉や概念をつくり、意見を提出していける問題だと思うんですけど。

秋吉 少し話題がずれるんですが、いいでしょうか。ボキャブラリーについては僕もよく悩みますが、ひょっとしたら哲学とか文学に手がかりが見つかるかもしれません。最近、ヘルダーの『言語起源論』[43]を読んでいたんですが、聴覚論も入っているんですね。聴覚は適度に能動的で適度に受動的だから、視覚と触覚の中間の感覚だという話があって。つまり、聴覚は視覚的な能動性と触覚的な受動性を併せもっているというんです。それを読んでて、聴覚を他の感覚から切り分けて考えるんじゃなくて、あくまで諸感覚の間で考えるというやり方もあるんだとあらためて発見がありました。ヘルダーは響きについても書いているので、阿部さんにもぜひ読んでいただきたいです。心を弦で、認識を共鳴でたとえているんです。

阿部 それは知らなかった。

秋吉 ヘルダーにとって心とは共鳴弦であり、音によって触発されることで初めて理性が働きはじめるというんですね。これは視覚中心主義的な自我のモデルとはまったく異なるもので、面白い表現です。ただし問題もあって、ヘルダーのモデルでは音が聞こえない人は理性がないということになってしまうんです。

金子 聞こえないというトピックもとても重要なので、この話は後にとっておきましょう。

42) 2022年2月には「白人の聴き方」を批判的に論じた本が『ソニック・ゲイズ——ジャズ、白人性、人種化された聴取』というタイトルで刊行。T. Storm Heter, *The Sonic Gaze: Jazz, Whiteness, and Racialized Listening*, Rowman & Littlefield, 2022.

43) ヨハン・ゴットフリート・ヘルダー『言語起源論』宮谷尚美訳、講談社、2017年。

　阿部　ちょっとふざけた意見になるかもしれないですが、日本語のオノマトペっ
てすごく訳しにくいんですけど、感覚的な、音だけが生む文化のなかでは共有され
る意味をもっていて面白い可能性があると思います。私は日本語のオノマトペのボ
キャブラリーの豊かさと面白さに興味があるので、遊び心をもってそれを研究のな
かでも使ってみたいですね。谷川俊太郎のような文になるかもしれないんですけど。
そんなクリエイティブな方向もあるかもしれないですね、どんな文章になるかはわ
かりませんが。

　金子　オノマトペの面白さを活かすんですね。僕からも提案していいでしょうか。
秋吉さんが感覚どうしの関係の話をしてくれましたが、たしかに聴覚について研究
しているとよく、異なる感覚の協働に目を向けるようになると思うんです。視覚中
心主義のかわりに聴覚中心主義を唱えるのではなく。だから、異なる感覚のボキャ
ブラリーをあえて聴覚に使う表現に注目してみたいです。チラッと聞くとか、どこ
かで見たような。

　葛西　私は心のなかでは「耳差し」といつも呼んでいます。

　金子　すでに思いついていたのか。そこから、眼差しと耳差しはどう違うのかと
考えるわけですね。山内さん、いかがでしょうか。

■耳と口のサイクル

　山内　いま出てきた話ともつながると思うので、音の脱植民地化の話に戻っても
いいですか。といっても、音というより耳の脱植民地化の問題です。いかに聞くの
か、という部分に関しての脱植民地化というのは、よりイメージが湧きやすいとい
う気がします。人間中心主義が入り込みやすい発想かもしれませんが。この座談会
の後編で本の紹介をするときに取りあげようと思っていた話題で、どこまで話した
らよいか難しいんですけど。

　少し先走ると僕はジェニファー・ストーバーの『ソニック・カラー・ライン』[44]
という本を紹介したいなと思っていました。著者のストーバーがカフェで本を書
いていると、そばにいる人からときどき、あなたは何を書いているのと聞かれる
そうなんです。ストーバーは「人種と音、耳などについて書いているんです」と言
う。そうすると、人種は肌の色という視覚と結びついているんだから理解できない
という反応をする人もいるけれど、面白いことをやっているね、それはわかるよと

44) Jennifer Lynn Stoever, *The Sonic Color Line: Race and the Cultural Politics of
　　Listening,* New York University Press, 2016.

言う人もいて、そういう人はたいてい白人男性で、その場で黒人のしゃべり方とか、ジェスチャーをこっそり真似するんだそうです。ストーバーはそれを白人の耳、「ザ・リスニング・イヤー（聞く耳）」という言葉で呼びます。「ザ」をつけて、支配的な聞き方という意味で。この耳をもつ人は、そうそう、これは黒人のしゃべり方だ、わかるわかる、となって、白人だけの愉快なひとときを楽しもうとする。ストーバーはそういうことを批判的に考えているので、「まさに私は、あなたがなぜそういう耳をもっていて、なぜそういう音を黒人的なものだと考えるのかということについて、本を書いているんだ」と心のなかで思いながら、それを相手に言ってしまうと喧嘩になるかもしれないので、注意しながら本の執筆に戻る。

　なぜ私はそういう耳をもっているのか。耳を反省することは、彼女にとってはある種の耳の脱植民地化につながる行為です。今挙げたような音を聞いたときにも笑わなくなる、面白いと感じなくなる耳をもつことが脱植民地化というか。そして、音のなかに白人たちが想像する黒人の音がもしあるとすれば、それをそうじゃないものにすることが音の脱植民地化かもしれない。彼女としてはそういったことを考えていて。

　金子　ストーバーが経験したやりとりというのは、聴覚と発声が一体になっているわけですよね。聞いて話して聞いて話してという。そのサイクルのなかで耳がつくられていく。耳のボキャブラリーは発声のボキャブラリーと結びついていることが重要なのかな。眼の場合は自分がどう見られるかということと関わってくるんでしょうか。聞くことと話すこと、もしくは発声する、とにかく音を出すことなどのサイクルは、サウンド・スタディーズのなかでずっと考え続けられていくんでしょうね。

　阿部　「ボイス・スタディーズ」[45]という研究分野も出てきたのでややこしい話ですよね。サウンド・スタディーズとどう違うふうに位置づけて立ちあげるのか。

　それは置いておいて、山内さんがおっしゃったことに付け足させてください。東洋と西洋はよく対比されがちですけれど、ギャヴィン・スタインゴとサイクス[46]は「グローバル・サウス」と「グローバル・ノース」としてとらえ直して、サウンド・スタディーズの再配置をしようという議論をしていて、刺激的です。そこで、山内さんに、音の研究における台湾、韓国、朝鮮から見えてくる脱植民地化の意義

45) Nina Sun Eidsheim, & Katherine Meizel eds., *The Oxford Handbook of Voice Studies*, Oxford University Press, 2019.

46) 後編の註 12・13 を参照。

や、山内さんご自身の考え方をお伺いしたいです。

　山内　すごく大きいテーマなので簡単にはお話できないんですが、後編に紹介したい本に、『キーワーズ・イン・サウンド』[47]というのがあって、僕のゼミでもよく使います。この本で取りあげられるキーワードに関してみんなで討論するときに、まずは英語で読んである程度理解してから、中国語でいろいろ考えるということをやっていくんです。それに関してお話ししたいことがあるので、そのときにお応えするかたちでいいですか。

　金子　はい。その話は後編ということで。他に付け足したいことがある方は。

　葛西　レコードのようなテクノロジーに関しても、耳の脱植民地化についての議論がありますよね。山内さんの研究とも重なる話だと思うんですけど。マイケル・デニングが『ノイズ・アップライジング』[48]で論じていたような、1920年代後半以降に植民地の港湾都市で、その土地固有のいわゆるヴァナキュラーな音楽がどんどんレコード化されていった現状が、世界のサウンドスケープの転換であって、耳の脱植民地化とも呼べるんじゃないかという話です。港湾都市、海域について語るというアプローチも、さっき阿部さんが話されたような、従来の地理的区分から展開していく動きだと思います。ただ、英語圏の植民地主義の理論はアジアの事例にそのままでは援用しにくいところがありますね。『ノイズ・アップライジング』で語られたのと同じようなことは日本でも起こっていますけど、日本では西洋を模倣して、ヴァナキュラー音楽がレコード化されたわけで、擬似西洋的なところがあるので、私はむしろ耳の帝国化ととらえています。

■音を使って、または、音のなかで

　金子　長くなったので、このあたりの話を後編に持ち越しましょう。前編の最後に一つだけ確認しておきたいのですが。これまでの話のなかで、音を使うということを考えるときと、音のなかを見ていくとき、二通りの話があったと思います。阿部さんは自分のアプローチを前者と考えていて、僕や秋吉さんはどちらかというと後者に関心があるのではないかな。最後にこのことも問題提起としてふれておこうと思いました。後者の考え方は、音のなかにある種の植民地があるのではないかと

47）後編の註1を参照。

48）Michael Denning, *Noise Uprising: The Audiopolitics of a World Musical Revolution*, Verso Books, 2015.

49）パディ・ラッド『ろう文化の歴史と展望——ろうコミュニティの脱植民地化』森壮也監訳、長尾絵衣子、古谷和仁、増田恵里子、柳沢圭子訳、明石書店、2007年。

いうものです。あえて植民地と言いましたが、中心と周縁とか、特権などが音についても検討されますよね。声の中心性とか。

秋吉 後者の論点に関して言えば、ろう文化の研究では脱植民地化ということがよく論じられているんです[49]。聞こえない人たちに対して、手話ではなく音声言語で話しなさいという教育をしていた時代があった。現在、口話主義（オーラリズム）と呼ばれる教育方針で、19世紀に欧米諸国で優勢になった考え方です。つまり手話を禁止して、聴覚障害者を聴者の社会に同化しようとしていたわけですが、他方では植民地で言語教育による同化政策も進んでいたわけですよね。そう考えると、植民地化は必ずしも地理的な他者にだけ関わる問題ではないと思うんです。こう話しなさい、こう聞きなさい、そういうふうに身体性を制度的に一元化していくことも広い意味での植民地化だとは言えないでしょうか。そういう意味では、スターンが書いているような聴覚の近代化もある種の植民地化の歴史として読むことができそうです。スターンは近代的な聴取の主体がさまざまな科学・制度・テクノロジーの複合体において構成されていくプロセスをたどっていますが、「主体」を意味する「サブジェクト」には「従属する」という意味もありますよね。

金子 サウンド・スタディーズが自戒を込めて考えないといけないところですね。ろう文化に関しては、さっき話した、話すことと聞くことのサイクルがスタンダードになっていることが重要です。聞こえないことというテーマも先送りにしていました。ろう文化については現在もいろいろな研究が出ているので、それも後編で。

第1章

アーティキュレイション

なぜこの音があるのか、聴く私はいかに成立するのか

　作曲家、近藤譲が 1979 年に発表した『線の音楽』は、音の分節を意味する「アーティキュレイション」という題をもつ考察から始まる。音は「常に相対的に他の音から区別されて、ひとつの音として認識される」（14頁）。「「聴こえる音」の構造化の第一歩が「音の分節化」である」（24頁）。2014 年に復刻された本書は音文化を支える音の分節化について、この時代の動向のなかで再考するよう促している。サロメ・フォーゲリン『ノイズと沈黙を聴く——サウンド・アートの哲学に向けて』は、芸術的、理論的テーマとして音そのものに焦点を合わせようとする近年の動向の成果の一つだろう。彼女の議論には、分節化された音をその外部にある意味と結びつけることに対する不信があり、また音の只中にある自己をめぐる観察がある。フォーゲリンの姿勢に共感しそうな電子音楽家、理論家のフランソワ・ボネが近藤の 40 年前の作曲論を読んだら、どのように受けとめるだろうか。

　ゲイリー・トムリンソンの『音楽の百万年——人類の現代性の創発』は音のアーティキュレイションの問題を考古学的資料にもとづいて考察し、旧石器時代人の集団行動にその由来を求める。バーニー・クラウスの『野生のオーケストラが聴こえる』は非人間が発する音に分節と調和を見いだそうとする。音のアーティキュレイションは当然、音楽や人間を超えて広がる営みだが、音楽学の探求はこの広がりにも向かっている。座談会で紹介されたノーリー・ニューマーク『ボイストラックス——メディアと芸術における声への同調』は「轍（トラック）」（☞本書 207 頁）という概念を用いて機械や大地など、非生物の音を論じようとする。この概念は近藤の「線」といかに関わるのか。

01

近藤譲
『線の音楽』

アルテスパブリッシング、2014年

**現代音楽の作曲家が聴取行為の復権と共に
新たな創作の可能性を模索した記録**

　普段、録音されたものであれば特に苦労せず実に多種
多様な音楽に触れることができる私たちは、現代音楽が
その都度さまざまな事件を巻き起こしながら生まれて
きたことを忘れてしまいがちである。イーゴリ・スト
ラヴィンスキー《春の祭典》（1913年）初演時のスキャ
ンダル。エリック・サティ（1866-1925年）の作品にお
ける突飛なアイデアの数々。1960年代より後には、音
楽作品を書くということそのものがどれほどの困難に晒されたか、作曲家の苦労を
多くの人は知らないでいる。同時に、当時の作品を聴くことの困難さも、私たちは
あまり気に留めていない。

　当時の現代音楽の創作をめぐる困難さは、音楽の形式、図式、時間をめぐるものだ。
1960年、作曲家ジェルジ・リゲティは「フォルム（Wandlungen der musikalischen
Form)」という楽式論（楽曲の形式つまり楽式について論じたもの）を発表し、そ
のなかで、トータルセリー、不確定性、偶然性といった当時の主要な方法論を見渡
したうえで、「シンタックス〔文法〕上のより大きな相違に対し、音楽の諸タイプの
比較的に僅かな相違しか存在しない」（「フォルム」足立美比古・加藤就之訳『エピ
ステーメー』第2巻8号、1976年、160頁）と看破した。そして当時の多種多様な
楽式に対し、「全体内部の一個のフォルム構成項の位置はその全体における他の構成
項の機能に対していかなる拘束力をも持たない。〔…〕フォルム全体は大抵それ自身
では無方向で発展的な形を持たないのであり、そのフォルム全体の内部では機能と
位置の個別モメントは原則的には交換可能なもの」（158頁）と批判的に指摘した。

　作曲家それぞれの文法が異なっているわりに、それほど違った作品が生み出されるわ
けではなく、個々の作品においても展開上の拘束力が弱い。こうした創作状況にあると

したうえで、展開やつながりといった横の線を、いかに必然性のあるものとして構築できるかが喫緊の課題であると、リゲティは考えていた。そして創作をめぐる困難さから、楽式論をつくりあげたのである。

　さて、日本では作曲家・近藤譲がリゲティと似た労作を残している。それが同書『線の音楽』（初版は朝日出版社、1979 年）だ。同書は 2014 年に、LP『線の音楽』（1974 年）の復刻版 CD の発売と同時期に復刊された。同書は「線の音楽」のコンセプトの説明に終始するものではないが、内容的には地続きである。この「線の音楽」というコンセプトについて、復刻版 CD のライナーノーツには次のようなことが書かれている。

　　この「線の音楽」は、一音単位に分節＝連接（articulate）された音の列として、区分され得ない純粋持続と、継起する数音を単位とした伝統的なアーティキュレイションによる時間構造の双方から離れた、際限のないパルスとしての持続を獲得する。この持続は、その強引な続在と、分節＝連接単位の極度な細かさによって、人の表現的な、或は情感的な音楽への参加を阻止し、音とその時間的展開を聞くことに馴らされた耳を音の外に、メタ音に向けさせる手助けとなるだろう。（5 頁）

　実際に『線の音楽』の一曲目《CLICK CRACK》（1973 年）を聴くと、不規則なタイミングで音が変わる、微かに倍音を伴ったピアノの単音が、間断なく連なっている。リゲティの表現を借りれば「フォルム全体は大抵それ自身では無方向で発展的な形を持たない」ものに聞こえる。だが、「フォルム全体の内部では機能と位置の個別モメントは原則的には交換可能」であるかどうか。「線の音楽」のフォルムを図式的に区切ることはできないように思う。そもそも、「音とその時間的展開を聞くことに馴らされた耳を音の外に、メタ音に向けさせる」ことに重点が置かれるのであって、新たな時間的展開が目指されるのではない。つまり、フォルム内の個別モメントが拘束力をもつかどうかを聴くのではなく、拘束力を求める聴取を、まさに聴いている最中で相対化しつつ、「線の音楽」を聴くのである。こうして、「線の音楽」はリゲティの楽式論より議論としては一つ先へ進んでいる。

　最初の章「アーティキュレイション」で、近藤は音楽の成立条件をラディカルに考察するところから出発する。まず「聞こえない音楽」という思考実験から入り、音の分節化、分節化された音の連接というこの二つの契機を、音楽を成立させるものとして導き出す。ちなみに、近藤がライナーノーツに書いていた「区分され得な

い純粋持続」とは、ジョン・ケージ《4分33秒》とラ・モンテ・ヤング《夢の家》のことだとこの章の記述から推測される。前者は「一つの無音」の音楽で、後者は「一つの音」の音楽である。

鍵を握るのは連接というアイデアだが、これは難解だ。連接とは「分節された音を扱うための方法としての関係付け」だが、「分節された音が含んでいる関係」によるものではない、という（27頁）。リゲティの表現を交えれば、「他の構成項の機能に対していかなる拘束力をも持たない」個別モメントを、それでも交換可能ではなく拘束力のあるかたちでつなげる、といったところだろうか。どういった連接が可能かという問いを立てて、それから考察のために連接という概念を用いているため、理論上に循環的な空白地点ができてしまうのを回避できないでいるように見える。

連接と同時に「グルーピング」という概念も導入されている。これは同書では、ある音と他のある音を、リズム、和音、旋律といった何かしらの関係としてまとめ上げる聴覚のはたらきのことを指している。この概念はG・W・クーパーとL・B・メイヤーの『音楽のリズム構造』（徳丸吉彦、北川純子共訳、音楽之友社、2001年）から採用され、近藤はリズム構造以外についてもグルーピング概念でとらえようとしている。その結果グルーピングの意味が文脈に依存し、連接の循環を解消する手立てとはなっていないように思える。

しかし重要なのは、ライナーノーツにあるように「音とその時間的展開を聞くことに馴らされた耳を音の外に、メタ音に向けさせる」ことだ。近藤は、聴き手自身のグルーピングに委ねるかたちで、複数の連接の可能性をもたせた作品を書く、という結論を出した。

> 「連接」様態の大部分は単に潜在的に「連接」可能な状態の中から個々の聴き手によって聴き出されることで初めて確定する。私はグルーピングを聴き出すことが可能であるように、しかし特定のグルーピングの安定した確立を妨げるように音を決定したのであって、「連接」様態のすべてを確定したわけではない。ここには私が作った持続があるが、その持続をどのように辿るかは、聴き手自身に委ねられる。（102頁）

それは、メタ音の存在など気にしない聴取者を炙り出すことにもつながる。次の章「散奏」の冒頭にあるように、「線の音楽」は伝統的な聴取に依った聴取経験を引き寄せることになった。「散奏」では五楽器のための〈視覚リズム法〉の分析がなされる。

音の分節化、分節化された音の連接というこの二つの契機の必要性は、作曲家

の操作の必要性を裏付けるものだ。分節化や連接が不要となれば、それはそのまま、作曲家が不要という結論となり、自らの考察に従うならば近藤は作曲家をやめなくてはいけなくなるだろう。近藤の作曲家としてのアイデンティティは、美術家・評論家であるジョセフ・ラヴとの対話を書き起こした章「ジョセフ・ラヴ──芸術の前提についての３日間」が説明しているように思える。

　近藤は、音の分節化の放棄は方法論として棄却し、聴取の解釈行為に新たな分節の可能性を託したが、作品概念そのものは保持し、インターメディア的な方向性は導出しなかった。ここには高度な緊張関係があるように思える。そしてこの方向性は、ジョン・ケージの仕事からくみ取ったものでもある。『日本の作曲家たち──戦後から真の戦後的な未来へ（下）』（音楽之友社、1979 年）で、秋山邦晴は近藤を次のように評している。「かれはケージに日常的な騒音やガラクタ音楽の思想を見るよりは、音楽が日常生活の形而上学をかたちづくることを理想とするような実践者として見るのである。そしてそれは、そのままかれの音楽の方向性でもあるにちがいない」（161 頁）。

　不確定性の音楽に比べれば「線の音楽」は聞きやすく反動的にすら思えるかもしれない。実際秋山は、《ブリーズ》を激賞しつつも「一種の老成ぶり」（159 頁）に戸惑っていた。そして《Air No.1》に対しては「音楽の基本原理へのある種の楽天性」（164 頁）と批判していた。この点は、今日でも未だに各人に判断が委ねられているだろう。同書は「線の音楽」を耳で判断するための、また一つとない重要なヒント集となっている。

　『線の音楽』は、今日の現代音楽を聴取する際のヒント集でもある。日本の現代音楽において、いまだ「音楽的時間」というアイデアは一般的だ。また同書は、聴く側からの創作とアカデミックなエクリチュールとの間の絶えざる相克に、今日いかなる課題を汲み取るべきかという視座を与える。音楽的時間のコンセプトを作品のうちにもっている作曲家は、具体的には、金子仁美、鈴木治行、稲森安太己などが挙げられるだろう。この本の、最後の「音楽的時間」の章さえ読めば、読者は現代音楽の一つの潮流に対する判断基準を得たのも同然だ。ただ、現在の「音楽的時間」を反省する作風が、近藤が「イディオレクト」と断じたものに依っているのか、それともなにか独自の領域をきちんと保持しているのか。その辺りは読者一人ひとりが判断せねばならない。

<div style="text-align: right">（西村紗知）</div>

02

サロメ・フォーゲリン
『ノイズと沈黙を聴く──サウンド・アートの哲学に向けて』

Salomé Voegelin, *Listening to Noise and Silence: Towards a Philosophy of Sound Art,*
　Continuum, 2010

聴く「私」はいかに成立するのか

　音を使った美術作品をサウンド・アートと呼ぶ──現在こうした説明はいかにも苦しい。サロメ・フォーゲリン『ノイズと沈黙を聴く──サウンド・アートの哲学に向けて』は、アルヴィン・ルシエやビル・フォンタナのインスタレーションとメルツバウや灰野敬二のパフォーマンスを同列に論じている。同書はサウンド・アートを定義しようとするのでも、概観しようとするのでもないが、フォーゲリンの議論からはこのジャンルの現状の一面が見えてくる。

　2000年代半ばより英語圏で「音」と「アート」を題名にもつ単著が相次いで出版された。こうした流れの先駆となったのは99年のダグラス・カーン『ノイズ、ウォーター、ミート──芸術における音の歴史』(MIT Press) だろうが、06年のブランドン・ラベル、邦訳も刊行されたアラン・リクト、トーマス・ベイ・ウィリアム・ベイリー、セス・キム゠コーエン、そしてフォーゲリンと続いている。カーン以外の著者はアーティストでもあり、これらの著作が初の単著のようだ。ラベル、キム゠コーエン、フォーゲリンの著作は出版社コンティニュアムの音楽部門の「サウンド・スタディーズ」というカテゴリーから刊行された。こうした一連の著作を吟味し、立場の異同を明らかにしていくには、そう長くはないサウンド・アートの歴史をたどり直す必要がある。

　サウンド・アート史の出発点をどこにおくかは複数の候補がある。ルイジ・ルッソロが騒音楽器を、マルセル・デュシャンが音の出るオブジェを制作したのは1910年代。サウンド・インスタレーションと呼ばれる作品があらわれたのは60年代。サウンド・アートという用語が現在に近い意味で普及しだしたのは80年代だった。80年代の代表的な展示、たとえば「眼と耳のために」展 (1980年)、「サウンディングス」展 (1981年)、「サウンド／アート」展 (1983年) などのカタログを見ていく

と、音を発するオブジェや彫刻が目につく。これらの作品は聴覚表現と視覚表現の結びつきに重きをおいた。

　音と造形だけでなく、サウンド・アートは当時より音とその外部の「何か」の結びつきを探求していく傾向があった。たとえば、場所、メディア、身体、記憶……。これはケージの「音をありのままにする」という主張に対する批判として理解できる。93年の『ミュージック・トゥデイ』（セゾングループの西洋環境開発文化事業室から発売されていた音楽雑誌、94年に廃刊）サウンド・アート特集では、カーンや藤枝守、デヴィッド・ダンらが揃って、ありのままの音を鑑賞するというケージの主張はルッソロから続く「すべての音を音楽化する」プログラムの最終地点であり、これからはむしろ音をさまざまな文脈と結びつけることに意義があると訴えた。

　2000年代初頭に相次いだサウンド・アート展では、この傾向に変化が起きた。「サウンド・アート——音というメディア」展（NTT インターコミュニケーション・センター、2000年）、「ソニック・ブーム——音の芸術」展（ヘイワード・ギャラリー、2000年）、「ボリューム——音のベッド」展（P.S.1、2000年）、「ビットストリームス」展（ホイットニー美術館、2001年）、「ソニック・プロセス——音の新しい地理学」展（ポンピドゥー・センター、2002-03年）などには、一般的にミュージシャンとして知られる作家が多数参加し、いわば「再び音自体へ」という傾向が見られる。これらの展覧会には会場に設置されたヘッドフォンだけで鑑賞する作品もあり、物議を醸した。

　クリストフ・コックスの批評「形式への回帰——サウンド・アートのネオモダニズム」（*Artforum International*, vol.42, no.3, Nov. 2003）はこの変化を簡潔に図式化した。彼はジョン・オズワルドやクリスチャン・マークレー、ジョン・ゾーンらを、引用やパスティシュを駆使するポストモダニストと呼び、池田亮司、カーステン・ニコライ、フランシスコ・ロペスらを、音や聴覚自体を探求するネオ＝モダニストと呼んだ。コックスは後者が、音をありのままにしようとしたケージや、純粋な視覚を強調した美術批評家クレメント・グリーンバーグら、モダニストの関心を引き継いでいると論じた。

　コックスの状況認識、特にモダニストとの関係については疑問の余地があろう（たとえば、グリーンバーグとケージを並べること）。サウンド・アートにおける90年代から2000年代にかけての変化を説明することは現在も続く課題である。たとえば、制作環境のデジタル化という潮流に対する反省として、音や聴覚の再考がうながされたということはありそうだ。この時期にはアラン・コルバンやエミリー・トンプソンら、歴史・社会学者によるサウンドスケープをめぐる著作が相次いで出

版されたことも注目したい。ここでは音とその外部の関係がきわめて多層的かつ一時的であることがあらためて強調された。

　前置が長くなったが、フォーゲリンがフォンタナと灰野を同列に論じるのは、こうしたサウンド・アートの動向をふまえていると言えそうだ。音や聴覚自体への関心の復活とミュージシャンの参加が、サウンド・アートという用語の使われ方、特に音楽との区別に影響を与えた。フォーゲリンが「サウンド・アートの哲学」として、エド・オズボーンやジャネット・カーディフとジョージ・ビュレス・ミラーに交えて、メルツバウやベルナール・パルメジャーニ、シャルルマーニュ・パレスティンらを取りあげるのはこうした状況と呼応する。ただし、ここまでの歴史的整理は、状況を説明するために経緯をできるだけ単純化したものであることは断っておきたい。フォーゲリンはカーンらのケージ批判、音の音楽化に対する批判を共有する。しかし、彼女は音の外部を考慮するのではなく、いわば音の内部にさらにもぐりこんで音楽化を乗り越えようとする。

　彼女が『ノイズと沈黙を聴く』の下地としたのは「私はサウンド・アーティストではありません──コンセプトとしての音の探求と視覚的定義の恐怖」（2006年）というプレゼンテーションだった。サウンド・アートという用語に対するアーティストからの批判は少なくない。ニューハウスの論考「サウンド・アート？」（『ボリューム──音のベッド』P.S.1, 2000）はこの用語が「音楽の定義には手をふれずに」使われることに不満をあらわした。フォーゲリンの主張はさらに過敏である。彼女がこの用語を拒否するのは、音をいかなるものとも、スコアやアレンジ、作曲者や演奏者、音源、視覚表現、あらゆるかたちの記録とも結びつけたくないという理由からだ。彼女によれば、これらは全て本質的に視覚的で、これらと結びつくと音はどこか損なわれてしまう。ほとんど神経症的な視覚の拒絶がタイトルの「恐怖」にこめられた。

　『ノイズと沈黙を聴く』でもフォーゲリンは序論から明言する──音とその外部の関係はあくまで一時的で、客観性をもたない。彼女はミュジーク・コンクレートの創始者ピエール・シェフェールのようにすべての外部から切り離された音自体を考察すべきだと主張するわけではない。「聴くことは文脈に依存するが、その文脈はつかの間のもの」（30頁）というのが彼女の立場だ。音や聴覚を通じてリスナーが外界と偶発的、一時的な関係をもつことで、このはかない関係を維持したまま、次第に主観性や時空間の認識が生まれてくるのではないか。「壊れやすく、弱々しく、聞くことや聞こえるものに対する疑惑に満ちた」「音響的主観性」（92頁）、つまり聴く「私」はいかに成立するのか。

　こうした探求には哲学的感性論に多くの先駆者がいる。フォーゲリンはベルクソン、ハイデガー、アドルノ、メルロ＝ポンティ、クリステヴァらの哲学的理論を議論の骨子として取りいれた。しかし、率直に言えば、彼女がこうした先駆者の思考を正確に理解しているかは疑わしい。同書が批評よりも理論の構築を目指しているだけに残念なところだ。

　フォーゲリンが自らの聴覚経験の記述を積みかさね、彼女の音響的主観性のあり方を浮かびあがらせていく文章は読み応えがある。記述される経験はあくまで偶発的、つかの間の、主観的なものとされ、記述はレトリックに満ちている。メルツバウのライブでの経験はこう表現される。「もう誰も私の声を聞くことはできないし、私も外界の音が聞こえない。これが私の世界だ。ノイズに満ちた生活世界が身体にぴったり張りついている。リズムを受けいれ、ひたすら走る。疲労し、眠気すら感じながら音を甘受している」（68 頁）。こうした主観的かつ入念な経験の描写には、音楽批評が培ってきたレトリックが生きている。フォーゲリンはこれまであげた他にも、アントナン・アルトー、グレゴリー・ホワイトヘッド、スティーニ・アーン、ロバート・カーゲンベンらの新旧の作品を脈絡なく参照する。解釈するのではなく、作品を聴くときの経験に主観性、「私」があらわれるプロセスを記述するためだ。

　彼女によれば、音響的主観性が生成するきっかけはノイズと沈黙である。ノイズとは、聴覚から強制的に客観性（音のさまざまな文脈）を剥ぎとる暴力的な音を指す。ノイズはリスナーを聴覚に閉じこめるとともに、外部と通じようとする欲求を育む。他方、沈黙は「聴く自己」を聴くようリスナーにうながす、聴覚にとっての鏡のようなものとフォーゲリンは考える。

　2000 年代初頭のようにミュージシャンが展覧会に参加して注目されることはもうなくなった。むしろ、初めから展示もすればミュージシャンと共演もするアーティストがあらわれている。マークレーのような作家はサウンド・アートという用語が要らなくなるほど成功した。こうした状況のなかで、同書は音をあつかう作家が作品の文脈を重視する視覚表現のシーンに呑まれることに警戒を発する。サウンド・アートは音楽でも美術でもないとフォーゲリンは言いたいのだ。こんな主張があらわれた一方、キム＝コーエンの『耳のまばたき——蝸牛殻のないソニック・アートに向けて』（Continuum, 2009）は、デュシャンの「網膜美術」批判を聴覚に適用して現代美術の文脈を全面的に取り入れようとする。今後のサウンド・アート批評ではキム＝コーエン的な議論がますます求められるだろう。それでも、フォーゲリンの過敏とも取れる警告を記憶に留めておきたい。　　　　　　　（金子智太郎）

03

フランソワ・ボネ
『言葉と音──音響の群島』

François J. Bonnet, *The Order of Sounds: A Sonorous Archipelago*, Robin Mackay trans., Urbanomic, 2016

音の不可思議さと錯綜を果敢に受け止める書

　フランソワ・ボネは、カッセル・イェガー名義でエディション・メゴ、シェルター・プレスなど名門レーベルから作品をリリースし、ジム・オルーク、ステファン・マシュー、オーレン・アンバーチ、ジュゼッペ・イエラシらとコラボレーションを行う制作者だが、1981年生まれながらピエール・シェフェールが設立し、かつてヤニス・クセナキスやリュック・フェラーリやベルナール・パルメジャーニらも在籍したGRM（フランス音楽研究グループ）の所長であり、フランス現代思想色の濃い聴覚文化論の理論家としての顔ももつ。GRMはシェフェールの提唱した、騒音などの「具体音」を取り入れた実験音楽、ミュジック・コンクレートの美学的探究と音楽的知覚への探究がそもそもの出発点であり、ボネはこのバックグラウンドに自覚的である。『言葉と音──音響の群島』（仏語原題 *Les Mots et les sons : un archipel sonore* はフーコーの『言葉と物』（渡辺一民、佐々木明訳、新潮社、2020年）を彷彿とさせる）では、この流れに身をおきつつミュジック・コンクレートにおける音概念を批判的に継承し、音を受け止めることに関する哲学的な分類が試行される。

　まず読者は、女性が目を閉じて貝殻に耳を当てる姿が印象的な表紙に目を引き寄せられることだろう。冒頭のページを開くと、「貝殻に耳を近づけることは、海全体の音を聞くことだ」との詩的な文章が始まる。なぜ我々は、貝殻を通して海の音が聞こえると感じるのか。音は、海の特定し得ない場所から発せられ、本来一瞬にして消えてしまう性質のものだ。なのに、延々と海から反響してきた音であるかのように感じてしまう。それは何故なのか。それにしても、貝殻からの微かな音に、海「全体」を聞く、というのはどういうことだろうか──。こうして音、より正確には海の音のイメージに近い Sonorous（本稿では便宜的に音響と訳す）の不思議さの探

究が始まる。神話や歴史上における聴覚文化の豊富な逸話を例証しつつ思考を深めていく。ベンヤミン、ドゥルーズ、ナンシー、アドルノ、バルト、シモンドンらの思索を経由し、幾度も音と聴覚の関係性を問い直す。

　ボネの言う音響とは、必ずしもその全てを聞くことのできる音＝可聴音ではない。「オブジェクト」として最初から聞き手に認識されているわけでもない。ある種のきっかけを与える存在には違いないが、常にはっきりと認識できるわけでもない。しかし聞き手に対して完全に受動的な実体であるわけでもない。ボネは音響を注意深く可聴音と分けつつ（たとえば感知できない高周波や低周波は物理学的な特性のなかで理解可能だ）、古代ギリシャのプネウマやアリストテレス、エリアーデの「騒音の魔術」、ラウディヴの「死者の声の実験」などで、古来から人間を魅了してきた音響の曖昧さを論じる。やがて外堀を埋めるような作業から、今度はシェーファーのサウンド・オブジェクト概念に見られる還元的な聴取を批判的に検証していく。還元的な聴取のスタンスとは、音を音のオブジェクトとして、その真の起源や、それがもつかもしれない意味を抽象化して、音それ自体に向かうことが目標とされる。たとえば、ピタゴラスの弟子たちが、カーテンに隠れた師の声だけを聴くことに由来し、聴覚のみで音を聴取するという、アクースマティック・アートの概念からもうかがえるが、発生源がわからない状態でサウンド・オブジェクトを聞くという行為では、従来の聴取の因果関係から解放された音自体をオブジェクトとしてとらえ、純粋な（少なくともシェーファーはそう考えた）条件のなかで非常に簡単に記述分析ができることが意図されている。

　しかし、ボネは還元的な聴取によってその因果関係から解放されたとしても、実はそこには別の形式的な決定があって「言語の力」をこの作業に導入したにすぎず、識別可能な音のみを対象とする限り、聴取する側に形態学的な基準の枠組みが確立されていることを指摘する。つまりオブジェクトは事前の決定を通して読み取られているに過ぎない。これではボネにとっては音響と聴取のダイナミズムを存分にとらえているとは言い難い。彼はユリシーズにとっての「セイレーンの歌」やロートレアモンの「マルドロールの歌」などを参照し、「欲望－聴（Desiring-Listening）」という概念から考察しながら、音を何らかの意味づけ以前の、あるいは知識以前としてのものに遡行して音響と可聴音を、考察していく。やがて還元的な聴取は文化的、社会的に非常に限定されていることから、「還元された聴取は存在しない」と結論づけるのだ。

　では、いかにして新たな聴覚概念は可能となるのだろうか。まず、同書の大きな参照源としてドゥルーズの影響が挙げられるだろうが、ここでも還元主義的な聴取批判のあとで、音における現象学的なアプローチに対し出来事論的アプローチを対置させる。現象学では、音は聴衆の意図によって対象とされた瞬間から現れる。しかしこれはボネの論じてきた音響概念を完全に掬い上げているわけではないだろう。他方で、ロベルト・カザーティとジェローム・ドゥキッチによって提唱された出来事的アプローチ（『音の哲学』Editions J. Chambon, 1994）は、聞き手とは無関係に音は音自体のために存在し、森の中の木が倒れた場合、その音は誰に聞かれなくとも存在すると考える。体験した観点から感覚的諸相において音を語る現象学的アプローチに対して、物理主義が接近する出来事論的アプローチは音を局所的な振動の出来事としてとらえ、発信源である共鳴体が動かなければ、音は動かないものとする。

　ここで興味深いのは、ドゥルージアンであれば出来事論的アプローチに傾斜するだろうが、現象と出来事の止揚不可能な多重性をそのまま引き受けながら、これらの視点は和解できるものではないとし、音の本質的に異質で分断された性質を考慮に入れて、論を形成していくところにある。出来事論的アプローチでは「共鳴体の中の音響的事象」である共鳴や残響を局所的な音の集合として決定することは不可能であり、そもそも直観に反してしまう。さらには、空気の入っていない瓶の中の音叉を例に挙げ、人間の聴覚に適合する周波数で振動するはずなのだが、空気のあるなしで音叉が共鳴に左右される不自然さを指摘する。

　ボネは『言葉と音』において、これらの矛盾を包摂しながら、スキゾロジー（Schizology）、つまり「精神分裂学」的アプローチを、ドゥルーズからの積極的な参照を否定したあとで掲げる。曰く、振動、出来事、潜在的な可聴性、そして聴取者の出会いの場に音を位置づけ直す試みである。ここでは、音は知覚される空間と知覚されない空間の間で変化するものとして開かれており、最終的にボネはピーター・シュミットやブライアン・イーノ、ジョン・ケージらを取りあげながら、失語症的な聴取の可能性を掲げている。もはや何も喋らず、何も音を発音せず、沈黙に従属する「きく」であり、非武装化された「きく」へと向かうのだった（同書の文脈上、Listening の対訳を「聞く」や「聴く」も包含する「きく」とし、従来論じられてきた「聴取」にとどまらない聴覚の多様性を意味する用語として用いた）。

　ところで『言葉と音』の副題は、「音響の群島」である。群島という言葉からはさまざまな情景が思い起こされることだろう。それは明らかに単一の島でなければ、

人間が一瞬で把握できる単純さも備えていないだろう。より無数の諸島、浅瀬があるだろうし、島の丘陵や森林、岬などがあるに違いない。一度接近すると、遠方からとらえていた認識論的枠組みが覆され、目の前に広がる光景は新しい意味をもちはじめる。同書はミュジーク・コンクレートにおけるシェーファーのサウンド・オブジェクトから遠く離れ、音と聴取の複雑な関係性モデルを構築したことで、一歩踏みこんだ内容と評価できるだろう。また、カッセル・イェガー名義の作品を鑑賞しながら、理論と実践を多層的に読み込む余地があることも、特筆すべき点だと言える。　　　　　　　　　　　　　　　　　　　　　　　　　　　　　　　　（大西穣）

04

ゲイリー・トムリンソン
『音楽の百万年——人類の現代性の創発』

Gary Tomlinson, *A Million Years of Music: The Emergence of Human Modernity*, Zone Books, 2015

旧石器時代のミュージッキング

　メディア理論家スティーブン・ジョンソンは『創発——蟻・脳・都市・ソフトウェアの自己組織化ネットワーク』（山形浩生訳、ソフトバンクパブリッシング、2004年）で、「創発（エマージェンス）」という現象を「低次のルールから高次の洗練へと向かう動き」と表現した。たとえば、コンピューター科学者ロドニー・ブルックスが1990年ごろに制作した昆虫型ロボット「ゲンギス」は、この創発のメカニズムを取りいれていた。ゲンギスが画期的だったのは、情報が集約される中央制御装置を排して、無数のごく簡素な制御装置を体中に分散させたことだった。そして、それぞれの制御装置が情報をやりとりすることで、中央で制御するよりもずっと洗練された動きが可能になったのだ。単純なやりとりから複雑なふるまいが生まれるこうした現象を、ジョンソンは先の著作の副題にあるようなさまざまな領域にみとめていった。ちなみにブルックスらが設立した iRobot 社は現在ロボット掃除機「ルンバ」の開発で知られている。

　音楽学者ゲイリー・トムリンソンによる『音楽の百万年——人類の現代性の創発』は、この創発という概念によって旧石器時代の音楽を論じていく。ジョンソンが紹介したとおり、この概念はすでに多くの学問に取りいれられている。「身体化された認知」をめぐる研究などはその一つだろう（フランシスコ・ヴァレラ、エヴァン・トンプソン、エレノア・ロッシュ『身体化された心——仏教思想からのエナクティブ・アプローチ』田中靖夫訳、工作舎、2001年）。考古学や人類学でも同様の発想にもとづく理論が展開されており、トムリンソンはそれらを参照しながら先史時代の音楽のあり方を描きだそうとする。同書は新事実の発見から新たな理解を導くというより、これまで根拠もなく語られてきた推論を再検討して、事実を別の解釈によってとらえ直そうとするものだ。

　再検討されるのはたとえばこんな推論である。旧石器時代後期、人類は比較的安全な住居や洗練された道具を獲得していた。そうして生まれた余裕によって、過去を記録し、未来を予測することもできるようになった。生存に直接関わるわけではない道具、精巧な装飾品や楽器もつくられるようになった。それらは何か精神的なものと関わっていた。トムリンソンによれば、このような推論はほとんど根拠のないフィクションにすぎない。これに対して、彼は創発という発想にもとづくもう一つのフィクションを提示していく。

　トムリンソンが同書の出発点にしたのは、およそ100万年前の前期旧石器時代、アシュール文化である。フランスのサン・タシュール遺跡を標準遺跡とし、アフリカ、西ヨーロッパ、西アジア、インドに広く分布するこの文化にはキャンプも携帯品もなかったようだが、水滴型の両刃石器がつくられていた。そして、この石器の左右対称性を抽象的思考の証と考える考古学者がいた。一方、この想定には何の根拠もないと指摘して、対称性は作業工程や素材の性質に由来する副産物にすぎないと主張した学者もいた。この論争に対して、考古学者クライヴ・ギャンブルは後者を支持しながら、抽象的思考を必要としない簡潔なやりとりの連鎖から対称性が偶発的に生まれたのではないかと論じた（『ヨーロッパの旧石器社会』田村隆訳、同成社、2001年）。作業全体を制御する思考を想定するのではなく、道具製作にまつわる集団のやりとりに対称性の由来を求めようとすることは、まさに創発の発想である。

　トムリンソンがこの対称性の創発を同書の出発点にもってきた理由は、これに続いていく旧石器時代の音楽の展開――声の活用、離散的音高の設定、楽器の製作など――が、基本的に同じようなかたちで生じていったと解釈するからである。ブルックスの昆虫型ロボットは、動作をあらかじめ指示する中央制御装置ではなく、相互にやりとりする無数の制御装置によって生物のように動きまわる。両刃石器も同じように、集団のなかでの模倣やゴールのないフィードバックといった簡潔なやりとりを通じて、トップダウンではなくボトムアップによって生まれたと考えられる。ギャンブルはこうしたやりとりを、人類学者ティム・インゴルドがつくった「タスクスケープ」という概念を参照して説明した（インゴルド「ランドスケープの時間性」*World Archaeology*, vol.25, no.2, 1993）。タスクスケープはかたちに残らないが、動的で、時間と関わっている。トムリンソンはこのタスクスケープに、音楽学者クリストファー・スモールが提唱した「ミュージッキング」、行為としての音楽を組みこもうとする（スモール『ミュージッキング――音楽は〈行為〉である』野澤豊一、西島千尋訳、水声社、2011年）。

創発の発想はすでに多くの学問に導入され、それぞれの領域で固有の議論と結びついている。トムリンソンがこのタスクスケープという概念をいかに理解したのか、さらに見ておこう。彼はこの概念の先駆として、人類学者アンドレ・ルロワ＝グーランが早くも 60 年代半ばに『身ぶりと言葉』（荒木亨訳、筑摩書房、2012 年）で論じた、「動作の連鎖」をあげている。そして、これらは「社会的行動と物質的条件が出会うマトリクス」（63 頁）なのだと説明する。

　生物の進化においては、生物が環境に適応するだけでなく、環境を改変してニッチをつくりだすことで、生物と環境が循環するように相互作用するという議論がある。トムリンソンはさらに、文化をもつ生物の進化においては、この循環のなかにもう一つの循環、「エピサイクル」（大きな円の円周を中心とする小さな円）が生まれると語る。このもう一つの循環とは、集団における相互のやりとり、「動作の連鎖」である。文化をもつ生物は、このやりとりを通じて環境に適応し、ニッチをつくりだす。そのため、トムリンソンは音楽の展開を環境への適応だけから説明する議論も、環境から切り離してしまう議論も受けいれない。音楽は生存に直接関わるものではないが、余裕から生じたものでもないと彼が考えるのは、こうした理由がある。

　トムリンソンによる具体的事実をめぐる解釈をもう一つあげよう。およそ 4 万から 3 万年前に繁栄したフランス、ピレネー地方のオーリニャック遺跡を標準遺跡とするオーリニャック文化の遺跡からは、たくさんの装飾品や絵画、彫刻が見つかっている。有名なラスコーの洞窟壁画やホーレ・フェルスのヴィーナスもこの文化に属する。南ドイツの洞窟からは管楽器のような穴の開いたパイプが複数出土した。これらの出土品はまさに先に説明したような、人類の精神の発達をあらわすものとして解釈されがちだった。パイプは宗教的なものや、情緒的なものを表現するための道具と考えられた。これは人類の精神の一つの到達点であり、ここからより複雑な音楽の展開がはじまる出発点でもあるという評価もあった。音楽学者はよく、このパイプからどんな音が出るのかに関心をいだいた。

　トムリンソンの解釈はこれらとまったく異なる。まず、彼はこのパイプよりも先に、タスクスケープにおける重要な展開があったと推測する。パイプはこの展開の結果であるとともに、展開を手助けする手段でもあったのだろう。この重要な展開とは、音の高低を離散的にとらえることである。トムリンソンは、パイプの穴がどの音に固定されたのかよりも、穴が固定されたこと自体が重要だと考える。音の連続的な流れを分離して、固定したことが、後に洗練された音高のシステムにつながっていくからだ。トムリンソンによれば、世界を離散的にとらえようとする姿勢

は同時代のタスクスケープ全般にあらわれていた。さまざまな出土品がこのことを物語っているという。

　『音楽の百万年——人類の現代性の創発』は、先史時代の文化をあつかう著作にありがちな、起源をめぐる問いを慎重に避けている。また進化における革命的な出来事も同書には出てこない。起源や革命という発想は、単純なやりとりの蓄積から偶発的に秩序が生まれるという創発の発想とは相容れないからだ。

　トムリンソンの解釈は推論だけでなく、出土品の詳細な観察によっても補強されている。新発見にもとづく議論ではないが、彼の解釈をきっかけに新たな事実がこれから明らかになるかもしれない。とはいえ、それと同じくらい意義があるのは、創発というロボット工学にも応用される現代の概念によって旧石器時代の音楽を考察するという、彼の理論構成である。タスクスケープ、エピサイクルといった、創発と結びつく概念についての説明も充実している。音楽の成り立ちを知るためだけでなく、創発という視点から音楽を考えるためにも重要な著作と言えそうだ。

<div style="text-align: right">（金子智太郎）</div>

05

バーニー・クラウス

『野生のオーケストラが聴こえる──
サウンドスケープ生態学と音楽の起源』

伊達淳訳、みすず書房、2013 年

自然の音に魅了された音楽家

　1938 年生まれの著者バーニー・クラウスはスタジオ・ギタリストとしてキャリアをスタートした。1960 年代半ばにポール・ビーヴァーとともに「ビーヴァー＆クラウス」を結成し、5 枚のアルバムをリリースする。1968 年に生態環境をテーマにしたアルバム『イン・ア・ワイルド・サンクチュアリ』の制作をきっかけに自然の音に魅了されたクラウスは、40 歳の時に音楽業界を去り、大学院に進学、博士号を取得する。その後、世界各地の生態系のサウンドスケープを録音し、音響生態学の第一人者として知られるようになる。このようにミュージシャンとしてキャリアを重ね、ある時に自然音の美しさに気づき、フィールド・レコーディングにのめり込んでいった人物は少なくない。同書でも言及されている英 BBC の録音技師でサウンド・アーティストのクリス・ワトソンもその一人である。「自然の音を求めて音楽業界を後にしたと思われるかもしれないが、そうではなく、音楽業界にいたからこそ自然の音を発見できたのである」（18 頁）とクラウスは述べる。音楽家として培われた耳があったからこそ、自然の音の美しさに気づくことができたということだろう。

　同書の最も特筆すべき点は、文章と対応したクラウス自身の極めて高品質な録音を特設のウェブサイトから聴くことができる点にある。たとえば、録音中、野生のジャガーの接近に気づかず突然その唸り声を聴いて、「一瞬のうちに体が緊張し、油断していたわたしの体内でアドレナリンがどっと分泌した……ジャガーの声、息遣い、胃をごろごろと鳴らす音の力強さに圧倒されたまま座っていた」（12 頁）という時の録音を聴くと、そのゾッとするほどの緊張感が伝わってくる。高品質な録音は、その時、その場の生々しさを読者に伝えるのである。

　同書の内容について簡単に紹介していく。第1章では、クラウスが自然の音に魅了されるきっかけとなったサンフランシスコ近郊の森での啓示的な録音体験が紹介される。「ミューアウッズの森に入ってレコーダーのスイッチを入れた瞬間、辺りの雰囲気が作用したのか、音に対するわたしの感覚は一変した」（15頁）、「初めての空間に取り込まれて自分もこの経験の一部になってしまったように感じていた」（15-16頁）など、私自身を含め、フィールド・レコーディングを行う者であれば誰しも経験するであろう身体感覚の変容の記述に共感を覚える。また生物の声を個別にとらえて分析する従来の学術的な録音形式を「現実の景観について不完全な形で捉えることになり、自然に対する感覚が歪んでしまう」（37頁）と批判し、「生体音響として変化し続ける全体のなかでそれぞれの声がどうやって適切な位置に収まっているのか」（34頁）をとらえようとする筆者のスタンスが示される。

　第2章では、ジオフォニー（川のせせらぎ、波、雨、風、大地の動き、雷など非生物が発する自然の音）に焦点が当てられる。ジオフォニーは地上で最初に登場した音であり、「動物の声、さらには人類の音にまつわる文化の重要な側面が進化してきた背景にあったもの」（42頁）と述べる。たとえば、「小川は、地形や植生、一日の時間帯、季節、降雨量、流量などによって、さまざまな声を持っている」（49頁）。またネズパース族の古老の案内で峡谷を吹き抜ける風が一面の葦を通る際に生じるパイプオルガンのような複雑に調和する倍音を聴いた体験、神からのメッセージを伝える聖なる声として滝の音を聴いていたワイアム族の話などが紹介される。

　第3章と第4章は、この本の主題であるバイオフォニー（人間以外の生物が発する音）に関する章である。まず択伐前後のリンカーン・メドウのサウンドスケープを分析し、生物種の多様性が大幅に減少したことを示す。視覚的には断片的にしかとらえられない変化を録音（とその分析）は暴きだす。そして「写真は何千もの言葉に匹敵するかもしれないが、自然のサウンドスケープは何千枚もの写真に匹敵する」（78頁）と主張する。またボルネオの森で録音した音響分析図を示し、歴史があって健全な生息環境では個々の生物が発する音は特定の周波数帯域で棲み分けているという音響版「ニッチ仮説」を提唱する。それぞれの種が発する音は生殖、食糧の確保、集団防衛などさまざまな目的があり、他の音にマスクされることなく聞き取られなければならない。つまり、生物の声は個々の生態環境のなかでオーケストラにおける各楽器のように他の音と調和するかたちで共存していると主張する。

　第5章と第6章では、バイオフォニーと人間の音楽の関係性について、霊長類研究、中央アフリカのバヤカ族の音楽と森の音との関係性、創世神話、宗教儀式、自

然の音からインスピレーションを受けた作曲家などを事例に探っていく。著者の広範な知識と関心の広さがうかがえる章であり、バイオフォニーを手掛かりに人間の音楽表現の根源に迫っていく。

第7章と第8章では、アンソロフォニー（人間が発する音）とバイオフォニーの関係性に焦点が当てられる。アンソロフォニーには、電気機械の音、生理的な音、管理下にある音、偶発的な音の4種類があり、現代では電気機械の音、すなわち自動車や飛行機などの交通騒音（ノイズ）の増大が問題となる。ノイズとは「聴覚を刺激する廃棄物」、「粗悪音」であり、「ノイズはほとんどの場合――少なくとも自然界の観点から言うと――「アンソロフォニー」が原因である」（174頁）。そしてそれらのノイズがいかに人間の心理、生理およびバイオフォニー全体に悪影響を及ぼしているか、さまざまな研究を事例に挙げて説明する。

第9章では、これまでの総括と展望が示される。すなわち、商業伐採などの人為的な影響により、多くの野生生物の生息環境が消失し、その密度と多様性が減少していること、その結果、生態系のサウンドスケープはクラウスが録音を始めた60年代と比べて劇的に変化していることなどである。クラウスは、自然音を録音することについて、「それでもこの冒険が与えてくれる純粋な喜びや驚きは、必要とするエネルギーや数々の危険を間違いなく上回る」（253頁）と述べる。そして、技術の進化により、ますます多くの人が自然の音を録音する楽しみを共有するようになった現状を一つの希望としてみる。

生態系を丸ごと録音し、分析するクラウスの手法が、『野生のオーケストラが聴こえる』でも度々登場するサウンドスケープの概念を提唱したマリー゠シェーファーの影響を受けていることは想像に難くない。そして、健全な生息環境においてそれぞれの生物種は周波数帯域ごとに棲み分けているという「音のニッチ仮説」は、世界各地の生態系の音を長年録音し、分析してきたクラウスだからこそ発見できたものであろう。生態系の音環境について、生態的、文化的な側面から考察するだけでなく、音響面の変化を視覚的に示して論を展開している点は、今後のサウンドスケープ研究にも影響を与えるだろう。

一方、生粋のナチュラリストであるクラウスの筆致からは、「手つかずの自然（音）」という幻想を追い求め、それを礼賛する態度が強く感じられる。クラウスが、交通騒音など人間が出す「ノイズ」に汚染されていないサウンドスケープを求めて人里離れた場所を旅するとき、皮肉にも彼自身がその忌み嫌う「ノイズ」の発信源となっている（飛行機や電車、車で移動するわけだから）という矛盾にどこまで自覚的なのだろうか。人工的な音ができる限り聞こえない自然豊かな環境で音を録音

することはもちろん素晴らしい体験だ。一方、現代の生活がもはや「ノイズ」と切り離せないものであるならば、そうした雑多な「ノイズ」や人工物と「自然」との混淆から生み出される響きのなかに美しさを見出すような感性、志向性があっても良いのではないか。それはフィールド・レコーディングというものが、そのプロセスを通して、音の聴き方を含めた自らの身体と環境との関わり方を不断に変えうるような再帰的な実践だと考えるからである。

　いずれにしても、『野生のオーケストラが聴こえる』は生態系のサウンドスケープを包括的に論じたほかに類のない書籍であり、自然の音、文化の音、自然環境とそれらの関係性に興味をもつ人にとって必読の書と言えよう。　　　　　　　（柳沢英輔）

第2章

口と手と諸感覚

身体の豊かな技法

　ジョナサン・スターンは「身体の技法」をめぐるマルセル・モースの議論を元にして、近代における「聴取の技法」の最初期の事例——ラエンネックによる聴診器の開発——を論じた。彼によれば、近代における聴取の技法は諸感覚を分離して扱うようになっていった19世紀の諸科学の動向と結びついていた。また、装置を通じて音を聞きとるという聴取の技法は、以降に形成された音響技術の核にもなった。本章にまとめたのは音と関わる身体、主に口と手の技法を扱う本だが、分離されて孤立した感覚の技法とは異なる、細分化された技法の網の目とか、一つの感覚の障害から生まれる技法といった、豊かな技法をめぐる議論が集まった。

　前半の二冊は主に口に関わる。細馬宏通の『ミッキーはなぜ口笛を吹くのか』は映画『蒸気船ウィリー』（1928年）に、映像技術と音響技術をつなぐ蝶番としての口の働きを見てとる。声について探究していったブランドン・ラベルは、げっぷ、窒息、せき、吐瀉、泣く、叫ぶ、歌う……といった項目が並ぶ「口の用語辞典」をつくった。これら多様な口の技法はそれぞれが社会と異なる関わりかたをもつのだ。

　本章後半の二冊は感覚の障害を別の角度から見つめる。工作趣味が一因となって視力を失った音楽家、ムーンドッグは20世紀半ばのニューヨークの路上で、自作の楽器を演奏した。ロバート・スコット『ムーンドッグ——6番街のバイキング』は彼の経歴を、彼がそのなかで音を吸いこみ吐きだした、大都市のサウンドスケープとともに描こうとする。キャロル・パッデンとトム・ハンフリーズによる「ろう文化」ガイドブック、『新版「ろう文化」案内』は「ろう」を聴力の欠如ではなく、文化としてとらえようとする。ろう者による抵抗運動という側面もあるという「ろう文化」には、読唇や手話だけでなく聴取や音楽も含まれている。「ろう」をめぐる本については座談会後編（☞本書213-215頁）でも取り上げた。

06

細馬宏通

『ミッキーはなぜ口笛を吹くのか──アニメーションの表現史』

新潮社、2013 年

音が息吹くアニメーション

　アニメーションに音、あるいは音楽をどのように組み合わせるか。この問いに明確な理由をもって答えられる人は、アニメーション作家にも少ないのではないか。無音のアニメーションはあり得ても映像のないアニメーションは存在しないように、アニメーション制作における創造性はまず視覚表現とともに始動する。

　1906 年、世界初の短編アニメーションといわれる『愉快な百面相』がアメリカで公開されたときも、やはりそれは絵先行だった。ただしサイレント・フィルムで作られていても、鑑賞される劇場空間では楽団の即興演奏や弁士の声と合わせて上映された。このときアニメーションと音は協働的なセッションを取りもちはじめたといえるが、両者はどのように結びついていったのだろう。

　『ミッキーはなぜ口笛を吹くのか』は人間行動学を専門としてきた著者が、アニメーション黎明期の表現に行動観察の視点を適用し、その魅力を紐解く論考集である。アメリカン・アニメーション史を知る手引き書ともなり、第 1 章では最初期のアニメーション作家であるジェームズ・スチュアート・ブラックトンやウィンザー・マッケイらの活動、彼らが手がけていたチョーク・トークについて詳述している。第 6 章ではそうした演目の公開場所だったヴォードヴィル劇場の様子と、サイレント・フィルムからトーキーへの移行期に奮闘した技術者たちの取り組みを通して、やがてフィルムと一体化するサウンド・システムの開発過程を綴る。

　そして第 7 章では同書のタイトルとなった「ミッキーはなぜ口笛を吹くのか」の解として、ディズニー初のサウンド・アニメーション『蒸気船ウィリー』（1928 年）が試行した音の工夫が明かされる。著者が一貫して注目する映像と音の同期、とりわけキャラクターの口の動きと音が合うリップ・シンクは、なぜアニメーションに

とって重要なのだろう。その理由を『蒸気船ウィリー』の魅力とともに記した本章を見ていこう。

　世界最初期の音声映画『ジャズ・シンガー』（1927年）に感銘を受けたウォルト・ディズニーは、すぐにサウンド・アニメーション『蒸気船ウィリー』を製作、公開する。内容はやや先んじて公開された実写映画『キートンの蒸気船』（1928年）をふまえたもので、ウクレレや噛み煙草といった小道具に加えて、音楽の喪失と再生、父子関係といったテーマを引用したことが窺える。

　ミッキーが全身でリズムを取りながら口笛を吹く姿が印象的だが、本作には「口」にまつわる表現が複数見られると細馬は指摘する。その一つは、口笛を吹くための原動力となる空気を吸う仕草、呼吸についてだ。ミッキーが口笛を吹くとき、すぼめた口脇の頬袋がメロディに合わせて膨らんだり狭まったりする。そして口笛の音が途切れる数フレームの間に、ミッキーは大きく口を開け、またすぼめる。呼吸を感じさせる瞬間的な息継ぎの作画により、口の動きと音のタイミングが連動することで、口笛の音色は映像空間のキャラクターが生じさせたのだという印象がもたらされる。

　つぎに、リップ・シンクが示しづらい開け放した口である。ミッキーをたびたびからかうオウムが笑うとき、その笑い声とともに、開いた嘴の周りに6つほどの短線が放射状に浮かんで点滅する。静止画の漫画が用いる記号的な形喩をサウンド・フィルムがあつかうのは過剰な表現にも思えるが、この短線は開いたままの口元や、物と物が当たった瞬間の単音とともに現れる。ギロを弾くように洗濯板をなぞるといった持続的な音の表現には使われず、絵と音が合うタイミングを示すための補助的な表現として用いられている。

　そして作品終盤に見られる、ガチョウの大きな口である。ミッキーに抱えられ、首元を握られたガチョウは、彼の手の動きに合わせて嘴を開けたり閉めたりする。嘴が開くタイミングで鳴き声が当てられ、幾度かの開閉ののちガチョウはカメラ、つまりは観客に向かって画面を覆いつくしてしまうほど大きく口を広げる。ミッキーの手とガチョウの口とその鳴き声との連動が、3D映像さながらの奥行き表現を伴って観客にアピールされている。

　動的なパースペクティブの表現は『蒸気船ウィリー』の監督の一人であり、ディズニーの主要アニメーターだったアブ・アイワークスが得意とするところで、彼は『蒸気船ウィリー』よりも先に完成した『プレイン・クレイジー』（1929年）でも卓越した作画技術を披露している。しかしサイレントだった『プレイン・クレイ

ジー』は配給に苦戦し、『蒸気船ウィリー』の成功のあとで音を加えてようやく公開された。『蒸気船ウィリー』が得た支持は、口という記号によって示されたキャラクターの世界に音があることの感動が当時の観客に歓迎された証だろう。口と音の同期は描かれた絵であるアニメーションキャラクターが生命を獲得する方法であり、アニメーターによる描画表現は音と組み合わさることでキャラクターの存在感を示す表現へと変貌していった。

細馬はまたサウンド・オン・フィルムの開発者ド・フォレストがヴォードヴィリアンの口を撮影していたことや、音声フィルムが「トーキー（語る映画）」と名付けられたことを挙げて、製作者たちがいかに口を意識していたかを説く。音声フィルムの勃興期において、口は観客が作品世界をより強固に感じるための神聖な器官となり、ミッキーの口笛は観客の世界とアニメーション空間とをつなぐ洞穴から吹き届けられたのだった。

ところで、音声映画と謳われた『ジャズ・シンガー』が、実際にはまだ多くの中間字幕を用いていたように、『蒸気船ウィリー』の製作時期にあたる1920年代はサウンド・オン・フィルム開発の過渡期にあった。このときフィルムは映像における二つの音の指向性、すなわち劇伴と作中音のどちらかを得意とする仕組みを伴い、異なる技術者たちの元でそれぞれに発達していった。劇伴は、シーンの印象を観客に伝えるための音楽で、劇中のキャラクターは聴くことがない音である。作中音は、キャラクターが発するセリフやその動作に由来する音など、キャラクターにも聞こえる作品世界の音だ。

シネフォンを採用した『蒸気船ウィリー』は、最初期の音声フィルム作品でありながら、この劇伴と作中音、どちらもの要素をもっている。メロディラインを備える演奏をキャラクターが行う動的なアクションとしてシーンに取り込むことで、劇伴と作中音を同時に表現している。たとえば作品中盤、楽譜とウクレレを食べてしまったヤギはミッキーたちに体を改造され、弦楽器のハーディ・ガーディとなって曲を奏でる。このときヤギから聴こえるメロディは、伴奏としても、キャラクターも耳にする作中音としても機能する。ミッキーによる口笛も同様で、ディズニーは音楽劇の構造を活かして劇伴と作中音を束ね、キャラクターと観客が同じ音楽を共有する体験を提供することで、両者が生きる空間を重ね合わせていった。

『ミッキーはなぜ口笛を吹くのか』は、ウォルト・ディズニーと並んで黎明期に活躍し、音への多彩なアプローチで知られるフライシャー兄弟についても紙幅を割いている。彼らは実写で撮影した映像を写し取ってアニメーションにするロトスコー

プの発明家で、音声フィルムが発明される以前からボールが跳ねるモーションで楽曲を表現するなど、音への関心を実践的に表現してきた。『ベティ・ブープ』シリーズでは、音楽を可視化するようなダンスが特徴的なキャブ・キャロウェイやルイ・アームストロングの動きをすくい取り、彼らと優れたアニメーションを生み出している。『トムとジェリー』シリーズで活躍した音楽家、スコット・ブラッドリーもまた、既存の楽曲を変調させる音のメタモルフォーゼや、音節を細分化してキャラクターの状況と連動させるといった方法で劇伴演出の可能性を広げたという。

　彼らによる、スコアを聴くだけでストーリーラインがイメージできるほど映像と呼応する音楽は、姿なきキャラクターの身に起こる出来事を擬人化した音の様子として伝えてくるようだ。キャラクターの動作が音を生じさせたり、劇伴がキャラクターのふるまいに連動したりする同期表現は、音にもまた生命感の躍動を与える。音はその由来となるキャラクターの存在に紐づけられて息吹く。そのときアニメーションと音は、それぞれが自律的に場面を表し、互いが共生的に成り立つ豊かさをもち得るだろう。

　アニメーションの誕生からおよそ一世紀が過ぎた現在、アニメーションと音の関係性はどのように更新されているだろうか。日本では写し絵の舞台や政岡憲三によるアニメーション・オペラ、草月アートセンターが主導した「アニメーション３人の会」に先駆的な実践が見られる。アニメーションと音の根源的な関わりをめぐる同書は、国内におけるアニメーションと音の邂逅を記録した『秋山邦晴の日本映画音楽史を形作る人々／アニメーション映画の系譜──マエストロたちはどのように映画の音をつくってきたのか？』（秋山邦晴／高崎俊夫・朝倉史明編、DU BOOKS、2021 年）とともに、視覚的な運動と音の交わりを模索する人々が自分自身の方法を見つける助けになるにちがいない。　　　　　　　　　　　　　　　　（松房子）

07

ブランドン・ラベル
『口の用語辞典──声と口唇幻想の詩学と政治学』

Brandon LaBelle, *Lexicon of the Mouth: Poetics and Politics of Voice and the Oral Imaginary,*
Bloomsbury Publishing, 2014

口の技法

　オーストリアの作曲家ゲオルク・ヌスバウマーによる
《ビッグ・レッド・アリアス》（2004 年）は、声によら
ない口のパフォーマンスだ。まず歌手たちが赤いガムを
ゆっくり噛む。指揮者がその背後を歩き、肝臓、腎臓な
どと内蔵の名前をささやいていく。歌手たちは口のなか
でガムを内臓のかたちにし、最後に吐きだす。ブランド
ン・ラベルの『口の用語辞典──声と口唇幻想の詩学と
政治学』には吐かれたガムの写真が載っている。白黒画
像だが、生々しく濡れたガムの細部はたしかに内蔵のひだや血管のように見えなく
もない。ラベルはこのパフォーマンスを噛むという所作の陰画と評する。食物を吸
収するための咀嚼によって小さな彫刻が作りだされた。ヌスバウマーは口の日常的
な所作を組み合わせ、発声とは別のかたちの、口による創造活動を示してみせた。

　ラベルの同書は、噛む、吐くといった口のさまざまな所作を並べあげ、それぞれ
と結びつく文化や想像力、作品を論じていく。声について調べていくうちに、口を
無視できなくなったと彼は書いている。同書の魅力を伝えるには、目次に並んだ用
語をあげていくのが一番よいかもしれない。げっぷ、窒息、せき、吐瀉、泣く、叫
ぶ、歌う、たわごと、うなる、ため息、あくび、キス、舐める、吸う、笑う、舌足
らず、どもる、誓う、口笛……。

　同書はサウンド・アートの作家・理論家として知られるラベルの 5 冊目の著作に
なる。2006 年に出版された彼の『バックグラウンド・ノイズ──サウンド・アート
の展望』（Continuum）は、アラン・リクト『サウンド・アート──音楽の向こう側、
耳と目の間』（木幡和枝監修、荏開津広、西原尚訳、フィルムアート社、2010 年）と
並んでサウンド・アートの概説書として注目を集めた。ラベルによれば『バックグ

ラウンド・ノイズ』と、これに続く『聴覚のテリトリー——音の文化と日常生活』（Continuum, 2010）、そして『口の用語辞典』は、音をめぐる実践を論じた三部作だという。そこで、まず彼のサウンド・アート批評の基本的なスタンスを過去の文章から見ていき、そのうえで同書の特色について考えてみよう。

　ラベルの発想の方向性は初期のころからかなり一貫している。彼はかつて実験音楽家が主張したような音そのものへと向かう姿勢を批判し、音をその外部と結びつけ、多様なものが交流する場としてとらえようとする。『偶然の振れ幅——その出来事の地平』（展覧会カタログ、川崎市市民ミュージアム、2001 年）に収録された論考「フィールドレコーディング、或いは拡張された場において見出された音」（ケイト・ストロネル、佐藤実、牧浦典子訳）では、美術家ヨーゼフ・ボイスの「社会彫刻」やシチュアシオニストの「転用」といった概念を参照しながら彼はこう書いている。「音そのものは、常にそれを越えてすぐのところにあるコンテクストと重なる「場」における身体の力や衝突に決定されるため、それは決して存在しないのだ」（79 頁）。「音それ自身もまた条件付けられ、社会化され政治化された出来事として起こる」（87 頁）。

　『バックグラウンド・ノイズ』の序論「聴覚をめぐる諸関係」はこのように始まる。「音は本来的に、また無視しえないほどに関係的である」。「音から関係をめぐるレッスンを導きだしながら、芸術の媒体としての音がいかに発展してきたのかを歴史的に追いかけること、これが私のねらいだった」（ix 頁）。同書は実験音楽史をテーマごとに描き直すような構成をとっており、そのなかでは美術理論家ニコラ・ブリオーの「関係性の美学」（立石弘道、谷口光子「ニコラ・ブリオー『関係性の美学』」『藝文攷』2016 年、80-93 頁）も言及される。『バックグラウンド・ノイズ』で示された関係性というテーマを、特に現実の具体的な場所や時間と関連づけて展開させたのが『聴覚のテリトリー』ということになるだろう。『口の用語辞典』でもこうした姿勢は変わらない。ブリオーではなくエドゥアール・グリッサンの「関係の詩学」（『〈関係〉の詩学』管啓次郎訳、インスクリプト、2000 年）をあげて、ラベルは次のように述べている。「口は身体を主体として、諸関係のネットワークのなかにある主体として成り立たせ、維持する役割を果たす」（2 頁）。

　それでは、ラベルはなぜ声ではなく口に焦点を合わせたのか。同書に先立って彼は「生のオラリティー——音響詩と生きた身体」（ノーリー・ニューマーク他編『声——デジタル芸術とメディアにおける声の美学』（The MIT Press, 2010））という論考で声について考察した。彼はここで、音響詩人の声が電子機器を通過することで、

起源としての身体に回収されることなく、広範な関係性に開かれていったと論じている。声というきわめて関係的な現象と比べると、口はより個人に属しているように見える。もちろん、彼の関心はまず声にあったし、『口の用語辞典』でも声は議論の中心にある。だが、ヌスバウマーの《ビッグ・レッド・アリアス》のように、ラベルが取りあげる作品は声と直接には関わらないものも少なくない。いずれも美術作品だが、身体に歯型をつけていくヴィト・アコンチ《トレードマークス》(1970年)、笑っているとも泣き叫んでいるともつかない女性が無音で映しだされるサム・テイラー＝ジョンソン《ヒステリー》(1997年)、男女が嘔吐をくり返すマーティン・クリード《作品番号610（病んだ映画）》(2006年) などがそうだ。噛む、笑う、泣く、吐くといった所作をめぐるこれらの作品を論じながら、ラベルは口という器官がいかに社会と交わっているか、つまり口がいかに関係的かを訴えていく。「声がどのように働くのか、声がどのように響き、ふるまい、あらわにしたり隠したり、現れたり消えたりするのかを、口は力学的に強く条件づけている」(4頁)。このように述べた後に彼はすぐ、声が口だけでなく喉や胸、全身と関わるとも指摘する。声か口かという二択に答えは無さそうだが、ラベルは音や意味を条件づける身体や物質に重きを置こうとしたようだ。

　ラベルが口の関係性を考えるためにまず参照するのは、イギリスの言語学者、ジョン・レーヴァーの論文「声質と指標的情報」(1968年) や、社会言語学の先駆者、ウィリアム・ラボフによる1960年代の研究『ニューヨーク市における英語の社会的階層化』(2nd edition, Cambridge University Press, 2006) である。彼らは、言語の習得が何よりも口を中心とする身体部位のコンフィギュレーションの問題であり、身体とからみ合う社会的慣習の問題であることを証明した。また、ラベルはドナルド・メルツァーとルネ・スピッツの精神分析理論から、口とは身体の外部と内部が相互作用するための軸であるという主張を援用する。メルツァーはこのことを説明するために、口を舞台に見立てる「口の劇場」という概念を提案した（『メタ心理学の拡人の研究』(Clunie Press for the Roland Harris Trust, 1986)）。他にもラベルは食事の所作と社会的地位の関係をめぐるジョン・バージャーの論考「食うものと食われるもの」(『なぜ動物を見るのか』(Penguin Books, 2009)）などを引きながら、口がいかに優れて関係的な器官であるかを語っていく。

　個人と社会、主体と客体を結びつける蝶番としての口を論じるために、ラベル自身が採用したのは「マウジング」という用語である。口という器官は固有の機能をもつというより、さまざまな口の所作、すなわち「マウジング」に開かれている。ただし、この所作は物理的制約だけでなく社会的慣習の制約も受けているため、通

常は一定の範囲内に収まる。だからこそ、口は多様なものの交流の場としての役割を果たすこともできる。ラベルのこうした議論は、彼が言及こそしていないものの、マルセル・モースによる「身体の技法」の研究を思わせる。思うに、同書の主題は多岐にわたる口の技法なのだ。この用語辞典が口の部位や形状ではなく動きに注目するのは、こうした理由からだろう。噛む、吐く、うなる、吸うなど、個々の枠組みをもつ一定の口の所作をラベルは「マウジングのモダリティ」と呼んでいる。

　作家であり理論家でもある書き手にはよくあることだろうが、ラベルの議論の進め方は、最初に一つの問いを示し、それを調査と推論を重ねながら論証するというものではないことが多い。実践から得られた認識をもとに、多くの理論や作品によってそれを補強しつつ、事象から事象へと次々に移っていく。こうしたスタイルは用語辞典というこの本の構成とよく合っていると感じる。ラベルの基本的な姿勢さえ押さえれば、あとは節題や索引を手がかりに、気になったところから読むことができる。口の所作をめぐる芸術について知りたいとき、考えたいときに、この辞典に詰まった思考や作品が役に立つはずだ。　　　　　　　　（金子智太郎）

08

ロバート・スコット
『ムーンドッグ──6番街のバイキング』

Robert Scotto, *Moondog: The Viking of 6th Avenue*, Process Media, 2013

視覚障害とサウンドスケープ

　通名「ムーンドッグ」ことルイス・ハーディンは1940年代からおよそ30年間にわたりニューヨークの街角に立ち、自作の楽器を演奏し続けた。パーカッションを中心とする彼のスタイルはクラシック、ジャズだけでなく、北米先住民、ヒスパニック、日本などの音楽の影響が入り混じる、とてもオリジナルなものだ。彼の音楽は後にミニマル・ミュージックの先駆者となる若き作曲家たちに大きな影響を与えた。実際、ムーンドッグは60年代にスティーヴ・ライヒ、フィリップ・グラス、ジョン・ギブソンと4人で共演した録音を残しており（出版社のサイトからダウンロードできる）、グラスの家に1年近く間借りしたこともあった。グラスは同書の序文で当時のエピソードを語っている。「彼は黒人やユダヤ人が好きでないと言っていた。私もユダヤ人かと聞かれ、そうだと答えた。そのとき彼は、なぜこんなことが起こるのか、なぜ最良の友人たちはみなユダヤ人か黒人なのかと思い悩んでいた。ひどく悲しそうで、ままならない境遇に困惑していた」。そのコスチュームから「6番街のバイキング」と呼ばれたムーンドッグの複雑な人間性がかいま見えるエピソードだ。

　ニューヨーク市立大学バルーク校で英文学を教えるロバート・スコットによる『ムーンドッグ──6番街のバイキング』が出版されたのは2007年だが、同タイトルの伝記ドキュメンタリー映画の公開が予定されているためか、2013年になってペーパーバック改訂版が発売された。ムーンドッグは前述のとおり現代音楽史に関わる作曲家であり、また人間性、活動などすべてが特異な人物であるにもかかわらず、まとまった研究は同書が初めてのようだ。英文学者であるスコットの関心は主にムーンドッグの生涯にあるようで、この本には幼少時の家庭環境に始まる実に詳細な記述が詰まっている。反面、その音楽性や思想に関心をもって手にとると、残

念に思うかもしれない。それでも、事実の蓄積からムーンドッグを軸とするさまざ
まな同時代の文化の交差が浮かびあがるところがこの本の魅力だ。

　たとえば、幼いハーディンはいわゆる「ティンカー」、つまり器用に物をつくり
だす子どもだったという。1916年生まれの彼は『ポピュラー・メカニクス』や『ポ
ピュラー・サイエンス』といった雑誌を片手に、地下室や納屋の屋根裏で木を削り、
楽器づくりに没頭した。こうした経験が、特異な楽器の制作で知られる作曲家ハ
リー・パーチとも比較される、彼の創作楽器のルーツになった。このエピソードか
らはアメリカ実験音楽と発明の結びつきの強さがあらためて見てとれる。ハーディ
ン少年の器用さと技術に対する好奇心は、不幸なかたちで彼の一生を左右すること
にもなった。少年は16才のとき、線路わきで見慣れない部品を拾い、持ち帰って分
解しようとした。その正体は先日の洪水で工事現場から流れてきた雷管だった。爆
発事故で失われた視力は二度と回復しなかった。

　時がたち50年代、日々ニューヨークの街角にたたずむムーンドッグは当時のア
ンダーグラウンド・スターの一人だったという。彼は反ベトナム戦争集会でも演奏
し、ときに抗議のマイクをにぎった。彼の元へ「巡礼」し、彼を援助した有名人のリ
ストはそうそうたるものだ。デューク・エリントン、ベニー・グッドマン、チャー
リー・パーカーら黒人ジャズメン。政治家パーシー・サットン、カシアス・クレイ
（モハメド・アリ）、マーロン・ブランド。ジョン・ケージもその一人だった。アメ
リカ中西部で育ち、人種差別気質もあったムーンドッグの音楽は、皮肉にも黒人と
ユダヤ人に受けいれられ、ジャズとミニマル・ミュージックの接点の一つになった。

　もちろん、彼の音楽を評価したのは黒人とユダヤ人だけではなかった。ニュー
ヨーク交響楽団指揮者のアルトゥール・ロジンスキはもっとも早くからの理解者の
一人だった。ムーンドッグが通名をめぐってラジオDJのアラン・フリードを訴え
たときは、かの指揮者アルトゥーロ・トスカニーニの援助があった。自主制作では
なく、レコード会社からの最初のリリースとなった『ムーンドッグ オン・ザ・スト
リーツ・オブ・ニューヨーク』（Mars, 1953）をプロデュースしたトニー・シュヴァ
ルツも、そうした援助者だった。通名をめぐる法廷にトスカニーニを連れてきたの
は彼である。

　私が同書を手にとった大きな理由に、このシュヴァルツとムーンドッグの交流に
ついて知りたかったということがある。50年代初頭、ニューヨークの郵便番号19
番地域で聞こえる多種多様な音を収集したレコード『ニューヨーク19』（Folkways,
1954）を制作していたシュヴァルツは、このプロジェクトの一環としてムーンドッ

グの作品を発表した。後にコマーシャル・プロデューサーとなったシュヴァルツは
ムーンドッグの音楽をたびたび使用し、使用料を支払って彼を援助したという。私
は、このようなビジネス・パートナーとしての交流の背景に、両者が共有する独特
な感性があったのではないかと思う。そして、ムーンドッグの音楽を理解しようと
するとき、この感性はこれまで注目されてきた彼の音楽性とは別の観点をもたらす
だろうと考えている。

　このことを説明するために、本題からは外れるがシュヴァルツの経歴を簡単に紹
介したい（詳細は金子智太郎「サウンド・パターンを聴く――トニー・シュヴァル
ツのドキュメンタリー録音」（『美学』2015 年）を参照）。1923 年にニューヨークに
生まれたシュヴァルツは、40 年代後半よりテープ・レコーダーを屋外に持ちだし
て都市の音を録音する活動を始める。広告デザイナーだった彼はいわば趣味として、
また習慣として録音を始めたようだ。当時、マンハッタンは戦後の建設ラッシュで
急速に姿を変えつつあり、ムーンドッグのようなストリート・ミュージシャンも日
に日に増加していた。シュヴァルツが日々の仕事の合間に続けた録音は膨大な量に
なり、彼はその一部をラジオで放送するようになる。また、録音をいくつかのテー
マ別に編集したものを、アメリカのルーツ音楽や世界の民族音楽をあつかうフォー
クウェイズ・レコーズから発表した。さらに、シュヴァルツは 50 年代末から録音
の経験を活かしてラジオやテレビのコマーシャルを手がけるようになる。1964 年
の大統領選挙でリンドン・ジョンソン応援コマーシャルとして放映された、通称
「デイジー」（「ひなぎくと少女」）が彼の仕事のなかでも特に知られている。シュ
ヴァルツはその後も都市の録音を継続しながら、マーシャル・マクルーハンと交流
を結んでメディア理論の著作を執筆し、また禁煙、エイズ予防、反核などの市民運
動にも積極的に参加した。

　このような経歴をもつシュヴァルツとムーンドッグの興味深い共通点の一つは、
視覚障害の経験だ。偶然にも同じ 16 才のとき、シュヴァルツは一時的な心因性の
視覚障害をわずらい、6 ヶ月間視力を完全に失っていた。彼はこのときの経験が音
響世界や録音に対する関心をより深めたと語っている。ふたりのもう一つの共通点
は、サウンドスケープに対する感性だ。シュヴァルツは「サウンドスケープ」とい
う用語がつくられるずっと前から、ストリート・ミュージシャンが奏でる音楽だけ
でなく、マンハッタンの子どもや大人の会話、機械の騒音、生活や自然の物音など
を記録して、レコードにしていた。

　スコットの記述によると、あるときムーンドッグはクイーン・エリザベス号の霧
笛と同じキーでフルートを吹いていたという。CBS 社屋の建設中には、周囲の騒音

がうるさくて「目が見えない」（115頁）と不満をもらしたとも書かれている。シュヴァルツはムーンドッグが霧笛に合わせて演奏するのを録音し、アメリカン・エアラインズのラジオ・コマーシャル「都市のサウンド」シリーズに使用した。シュヴァルツの著作『電子メディア戦略──社会を動かすメディアパワー』（梶山晧訳、産業能率大学出版部、1983年）にもその経緯が書かれている。彼がプロデュースした『ムーンドッグ オン・ザ・ストリーツ・オブ・ニューヨーク』からも、霧笛や路上の騒音が聴こえてくる。

　私が気になるのは、視覚障害とサウンドスケープの関係がムーンドッグとシュヴァルツの作品にどのような影響をもたらしたのかということだ。視覚障害心理学においては、視覚障害と聴力の関係には未解決の問題が多いという。実験によると、音高、リズム、音色といういわゆる音楽的感覚の判断には視覚障害者と健常者の間に有意な差は見られない。一方、音の強さの判断は視覚障害者が優秀だった。原因は、視覚障害者が自分と物体の距離を知るために音の響きの変化を利用しているからではないか、と推測されている。こうした心理学的アプローチもムーンドッグのスタイルの形成を理解するために参考になるかもしれない。『ムーンドッグ──6番街のバイキング』には彼の視覚障害にまつわるエピソードも豊富に収集されている。戦後のニューヨークで視覚障害者がどのような生活を送っていたのかという、聴覚文化論的視点からこの本を読みとくこともできるだろう。　　　　（金子智太郎）

09

キャロル・パッデン、トム・ハンフリーズ
『新版「ろう文化」案内』
森壮也、森亜美訳、明石書店、2016 年

ろう者の耳から、音の文化を省みる

　『新版「ろう文化」案内』は 2003 年に晶文社から出版された翻訳書の改訂版であり、原書（*Deaf in America: Voices from a Culture*）は 1988 年にアメリカで出版された。初版から数えればやや古いが、アメリカ手話（American Sign Language = ASL）を学ぶ際の必読文献として長らく読まれてきた名著である。アメリカ手話は 19 世紀に誕生した比較的新しい視覚言語であるが、現在では少数言語の一種として認定されており、本場アメリカでは外国語の選択科目になっている大学もあるという。同書で紹介される「ろう文化（Deaf culture）」は、そうしたアメリカ手話を母語とする言語的マイノリティの文化を意味する。著者の言語学者パッデンとハンフリーズもその一員であり、自身の体験談や他の当事者へのインタビューを交えつつ、「ろう文化」の歴史や実態を入門的に紹介している。決して最新の研究書ではないが、福祉や教育ではなく文化の観点から手話者の生活を考えるとき、同書は文字どおり最良の案内となるだろう。

　内容の紹介に入る前に、同書の背景となる「ろう」の意味の学術的な文脈をすこし詳しく紹介しておきたい。英語で「ろう」や「聴覚障害」を意味する deafness は、他人の言葉に耳を貸さない不寛容さも派生的に意味し、社会性の欠落を蔑視するニュアンスを含む。このような偏った「ろう」のとらえ方は、過去の社会制度にも表れている。それを象徴するのが、19 世紀後半にアメリカのろう教育を変えた「口話主義（oralism）」の台頭である。その支持者らはダーウィニズムを曲解しつつ、音声言語を生物進化の最先端に位置づけ、手話を「原始的」な動物の身振りと同一視した。同時に、彼らはろう者の発話訓練を徹底化することで、聴者の社会に同化しようとしたのである（ダグラス・C・ベイントン『禁じられた言語──アメリカ

文化と反手話運動』（University of Chicago Press, 1996））。こうした口話主義の立場は、マジョリティとしての聴者の身体能力や慣習を規範化するものであり、現在では「聴能主義（audism）」という言葉で批判される（ハーラン・レイン『手話の歴史——ろう者が手話を生み、奪われ、取り戻すまで（下）』前田浩監修、斉藤渡訳、築地書館、2018 年）。とはいえ、その優位性は 1880 年の国際ろうあ教育会議（ミラノ会議）で確立され、以後、ろう教育思想の中心に長らく居座った。

　「ろう文化」という概念は、こうした歴史への批判と反省なしには理解することができない。著者たちは「ろう」の文化的な側面を強調するために、大文字からはじまる Deaf を意図的に用いている。それは健聴者に対する「聞こえない（deaf）」人々という消極的なラベリングの歴史を上書きしつつ、ろう者ならではのコミュニケーション様式や聴覚性に注意を向けるためである。この意味で「ろう文化」について学ぶことは、単にマイノリティへの理解を深めるにとどまらず、聴者がふだん自明視しているかもしれない音や聴覚の観念を見つめ直す機会にもなるはずだ。それが『新版「ろう文化」案内』を「音の本」としてここに紹介する意図である。

　音の経験がいかに多様であるかを知るのに、同書は格好の材料となるだろう。「聞こえる人（聴者）」と「聞こえない人（ろう者）」という区分自体が決して自明のものではないという事実が、何度も確認されるからである。同書の骨子となるのは、聴力ではなく文化の観点から、その境界をとらえ直そうとする姿勢である。ここでいう「文化」の概念は、人類学者クリフォード・ギアーツの古典からとられている。ギアーツは人間を「未完の動物」と定義し、身体的な特性というより、象徴的な意味の体系（＝文化）によって行動を支配された生き物だと考えた（『文化の解釈学〈1〉〈2〉』吉田禎吾、柳川啓一、中牧弘允、板橋作美訳、岩波書店、1987 年）。パッデンとハンフリーズはそうした理解を聴者とろう者の区分にも適用しつつ、それらのカテゴリーが文化の所産にほかならないことを例証していく。

　最初に取りあげられるのは、聴者とろう者の自己認識がいかに形成されるかという問題である。著者たちによれば、それは聴力によっておのずと規定されるわけではない。たとえば、ろう者に囲まれて育つ場合、ろう児の多くは音が聞こえないという事実に気づくのが遅れるという。また反対に、たとえ聴者であっても、ろうの家庭で育つ場合には、ある時期まで音が聞こえることを意識せず成長することもある。こうした複数の事例からは、聞こえる、聞こえないという基本的な認識でさえ決して自然の所産ではなく、身近な他者との交流や衝突によって「発見」されるものであることが明らかにされる。

　また、聴者の社会では、ろう者は聴力損失の度合いでひと括りにされてしまう場合が多いが、当事者の認識は必ずしもそうではないという。発話と読唇を学んで生活を送る人々もいれば、手話を主に用いる人々もいるように、彼らの帰属意識は「聞こえない」という属性だけでは説明がつかない。この点に関して、パッデンとハンフリーズはアメリカ手話（ASL）の文化的な重要性をくりかえし強調する。彼らが「ろう文化」と呼ぶものにとって、アメリカ手話は決して英語の代替手段ではなく、ろう者が口話主義による弾圧をかいくぐって継承し、みずから発展させてきた固有の言語とみなされている。そうした意識は 1960 年代の公民権運動のなかで強まり、みずからを「聴覚障害者（the deaf）」ではなく、手話者という意味での「ろう者（the Deaf）」として定義するろう者運動へとつながった。その意味で「ろう文化」はろう者自身による抵抗運動として意識的に形成された側面ももっている。この自意識の表れとして、アメリカろう者劇団がやはり同時期に、英語劇の翻訳上演から、手話の歴史や特性を意識したオリジナル劇の創作に移行したことも紹介されている。

　「音の本」として読むうえでとくに興味深いのは、ろう者が音と無縁な存在ではないということがさまざまな事例によって示されている点である。著者らが批判するのは、ろう者は「音という障壁」によって豊穣な意味の世界から疎外されているという、よくあるイメージの欺瞞である。ろう者は無音の中にいるわけではなく、むしろ音と深く関わりながら生きているからである。その一例として、ろう児が興じる音の遊戯があげられる。聴者の子どもと同じく、幼いろう児は音を出す遊びをしながら、各々の聴力に応じて音量と反響の特性を学ぶ。さらに、その過程で、彼らが立てる騒音や生活音が聴者にとってもつ意味を少しずつ理解する。聴者のリアクションを鏡として、ろう者は聞こえない音を身体化していく――たとえば放屁の音で恥をかかないですむような方法を学ぶ――のだという。こうした例とは別に、ろう者にとっての音楽も紹介される。たとえば英語の流行歌を手話に翻訳してリズミカルに演じる手話歌は、遅くとも 1940 年代には存在していた。また、より近年（1988 年当時）の事例として、クレイトン・ヴァリやエラ・レンツのように、日常的な事物の運動を音楽的なリズムやハーモニーとして表現する手話詩人の活躍もあげられる。いわく、ろう者の世界は無音であるどころか、実は騒々しいほどに多種多様な音と音楽に満ちあふれているのだという。

　パッデンとハンフリーズは、聴者にとって未知の世界であったと言える「ろう文化」を内側から紹介した。1988 年の出版後、原著は「ろう文化」の地位向上に

貢献しただけでなく、聴者が大勢を占めるアカデミズムを再考するきっかけを与えた。その表れとして、近年ではろう者の歴史を通して、諸学に潜む健常者優位主義（ableism）を省みる動きが盛んになっている。たとえば、メディア研究者のジョナサン・スターンは近代的な音響技術の起源には「ろう」があったと指摘し、電話の発明の影に不完全な聴覚を補完ないし代替するという理念があったことを読み取っている（『聞こえくる過去──音響再生産の文化的起源』中川克志、金子智太郎、谷口文和訳、インスクリプト、2015 年）。なお近年のスターンは自身が発声障害になったのを機に、障害論も書いている。事故や病気、生活習慣や老化によって、視力や聴力などの機能は遅かれ早かれ衰える。スターンは機能障害を生のいわば必須条件とみなし、経験の貧困ではなくむしろ多様性として積極的にとらえなおそうとする（『衰退した能力──障害の政治現象学』(Duke University Press, 2021)）。また、人類学者のミシェル・フリードナーとステファン・ヘルムライクはろう者が音を知覚するさまざまなやり方に取材し、障害者研究を通じてサウンド・スタディーズを拡張する可能性を論じている（「サウンド・スタディーズとデフ・スタディーズの出会い」*Senses & Society* 7, issue.1, 2012, 72–86）。「ろう文化」の豊かさに触れることは、聞こえる／聞こえないという素朴な二元論がいかに音の理解を狭めてしまうのかに気づかせてくれる。まずは『新版「ろう文化」案内』を導きとし、より深く「ろう文化」の歴史を知りたい読者には、原書の続編にあたる『「ろう文化」の内側から──アメリカろう者の社会史』（森壮也、森亜美訳、明石書店、2009 年）もおすすめしたい。　　　　　　　　　　　　　　　　　　　　　　（秋吉康晴）

第3章
フォノグラフィ
音をいかに表現するか

　「フォノグラフィ」は音を書きとること、描くこと、記録することなどを意味する。「フォノグラフ」は一般的に蓄音機を意味するが、2000年代より世界各都市に結成された「フォノグラファーズ・ユニオン」はフィールドレコーディング作家のグループである。さらに「フォノグラフィ」には録音だけではなく、例えば、波形、擬音語、漫画の吹きだしなど多岐にわたる、音を音以外のかたちで記録したり表現したりする実践全般をあらわす使いかたがある。広い文化にまたがるフォノグラフィという実践をめぐる歴史研究として、「音を書く（inscription）」行為を通じてコロンビアの植民地化を再考するアナ・マリア・オチョア・ゴティエ『聴覚性——19世紀コロンビアにおける聴取と知識』は、近年の重要な到達点と言えるだろう。

　現代の実践をめぐる研究には、ロンドンのCRiSAP（Creative Research into Sound Arts Practice）共同ディレクター、キャシー・レーンとアンガス・カーライルがフィールドレコーディング作家にインタビューをした、『イン・ザ・フィールド——フィールド・レコーディングの芸術』がある。ジョナサン・スターンは彼が編集を務めた『サウンド・スタディーズ・リーダー』において、サウンド・スタディーズという学術領域の役割を「人間の世界のなかで音が何をするのか、音の世界のなかで人間が何をするのかを再記述する」（2頁）と説明した。言いかえれば、この学術領域はフォノグラフィとヒューマノグラフィの結合である。彼にとっては「再」記述という点が特に重要であろう。そして、その再記述は人間だけでなく非人間、非生物へと広がるのかもしれない。浜田淳編『音盤時代の音楽の本の本』はミュージシャンの楽曲と人間性を同一視してきた音楽批評に逆らい、両者の関係を再記述しようとするさまざまな試みの集成として読むことができる。

10

アナ・マリア・オチョア・ゴティエ
『聴覚性――19世紀コロンビアにおける聴取と知識』

Ana María Ochoa Gautier, *Aurality: Listening and Knowledge in Nineteenth-Century Colombia*, Duke University Press, 2014

声と耳の関係性から考えるポストコロニアル的政治学

　コロンビアのメデリン市出身、現在テュレーン大学で教鞭を執るアナ・マリア・オチョア・ゴティエによる『聴覚性――19世紀コロンビアにおける聴取と知識』は、2015年の民族音楽学会で単著に与えられる最高賞であるアラン・メリアム賞を受賞しており、おそらくこの10年に出版された音に関する英語の学術文献のなかでももっとも頻繁に参照された一冊だ。母語であるスペイン語での出版が多かったオチョアが英語で書いたこの本は、分析対象となる歴史的資料、理論的分析、ラテンアメリカからの視点などさまざまな点で革新的な研究である。エスノミュージコロジー、音楽学、サウンド・スタディーズ、人類学、そしてラテンアメリカ、カリビア学に影響を与え、各分野で重要な転換点の役割を果たしている。

　「音」とは何か、その意味はどうつくられ知覚されるのか、「耳」とは何か、「聴覚」はどう定義されるべきかといった議題をかかえるサウンド・スタディーズ。20数年という比較的短い歴史のなかで、そのアプローチに西洋至上主義、男性優位のジェンダー視点、健常者優先主義が潜在的に含まれてきたことへの反省をうながす声が近年高まっている。その現状を反映する意味もこめて、19世紀コロンビアの植民地化の過程における音と声をテーマに、サウンド・スタディーズにおける知識の脱植民地化の重要性を訴える同書を選んでみた。また、音に関する英語圏の文献リストをつくる際、白人男性著者が多数を占めがちななか、意識的に女性著者、さらに英語を第二外国語とするコロンビア出身の有色人女性が執筆した本を取りあげる重要性も指摘したい。

　まず概要を掴んでみよう。オチョアは歴史的資料を元に19世紀のコロンビアに

おける人間と非人間の交差点で音を出す存在物を考察することで、聴覚／聴取がいかに言語、音楽、声、そして音という概念の成立に関与したのか、それらの概念が「生命の政治学」を形成したかを考察する。先住民、アフリカとカリブからの黒人奴隷、ヨーロッパ系植民、そして混血の子孫が混在するコロンビアは、スペインによる植民地から独立する過程において、多数の認識の枠組みが入り組む複雑な環境だった。同書は独立国家としての枠組みがつくられる過程で知覚、特に「音声性（vocality）」と「聴覚性（aurality）」がいかに人種の差異を規定し、さらに「人間性」、すなわち市民権を規定するのに重要な役割を果たしたのかを分析する。この研究を通して、ラテンアメリカとカリブ海諸島は「生命の政治」と「表現の政治」のなかで音楽と語学、知識と感覚が密接し、ほどき難く絡み合った歴史的土壌として描かれる。

　同書の画期的な点をいくつか挙げてみる。まず注目したいのは、民族誌的な研究を軸とするエスノミュージコロジーという分野で録音技術以前の音文化を考察するにあたり、「音を書く（inscription）」行為を研究対象とするところである。オチョアはこれを「普及と伝達のためのテクノロジーによって、聴取を記録する行為」と定義する。分析対象を音楽とも音とも「聞く行為」ともせず、声と耳の関係性が記述される過程に焦点を当て、そこから植民地性と近代性という枠組みの成り立ちを分析する点は斬新だ。同書のタイトルの「聴覚性」は単に耳による聴取を指すのではない。筆記されるもののうちに耳と口の関係が浸透している様、またそこからはみだす音に注意を向けるというコンセプトであり、書かれたものの反対語として規定されがちな「口頭性（orality）」という概念を覆すものだ。言いかえれば、口頭と記述の二項化の狭間からほころび出る、声と耳の関係性の政治学ととらえるのが的確だろう。

　たとえば、第1章は19世紀初頭の旅行記より、カリブ海側とボゴタを含めた内地をつなぐマグダレナ川の唯一の交通手段だったカヌーの舵取り、ボガの声についての記述を取りあげる。先住民とアフリカ系の血筋の混ざったクレオールとヨーロッパ系のエリートたちの聞いたボガの声は、興味深いと同時に居心地の悪い不安を生むものとして記録された。旅行者は、舟を漕ぐボガが発するかけ声を「遠吠え」と表現し、「文化」よりも「自然」に近い動物的なものと見なした一方で、ボガらの声が周囲の環境、動物、耳にしたカトリック賛美歌や西洋のメロディーの模倣にもとづくのではと憶測した。こうした旅行者の記述は既存する声、言語、歌、自然界の音といったカテゴリーの限界を示すと同時に、複数の人種的、文化的差異間の関係性、また自然界との関係性を音がいかに包括するのかを示していく。

　二つ目の画期的な点は研究方法である。旅行記、小説、手紙、詩、文法入門書、正字法書、先住民族の言語の記録などさまざまな分野にまたがる膨大な量の資料を綿密に、また木目に逆らうようにクリエイティブに分析しながら音声の痕跡を読みとくオチョアの方法は圧巻だ。緻密かつ学際的、創造的な資料の分析が必要とされたのは、単に録音技術が発明される以前の音を対象としたからではない。あえてさまざまな媒体に記録されていく声と音、記述されていく過程に生まれる聴取の歪みや政治性を対象としたからである。これらの資料のアーカイブは、それぞれの声の記述に携わった言語学者、科学者、歴史学者、歌の収集者、小説家、文法学者などさまざまな書き手の経歴に照らし合わされながら分析される。第2章では、あえてアフロカリビアン系の話調の音感を強調した詩を書いた、コロンビアのアフリカ系作家カンデラリオ・オベソが記した音を分析する。オベソの独創的なアフリカ系音感の記述は、ボゴタを拠点としたヨーロッパ系の教養人たちが作り出した正字法の慣習がいかに独断的、作為的であるかを照らし出す。アフリカ系、またクレオール的視点（聴点？）からの抵抗的な「音の書き」方だ。

　そして三つ目に言及すべきは、英語圏の読者でも苦労する難解な文章に詰め込まれた理論的枠組みである。序章にしか出ないが、ある意味本全体にわたる枠組みとして提示されるのが「音響的アセンブラージ（acoustic assemblage）」だ。これは聞く者と、他者の聞き方を理論化する者のあいだ、また聞く行為とそれを理論化する行為のあいだに生まれる関係性が織りなすダイナミズムを指す。何度読んでもすぐには消化しにくいコンセプトだが、ヴィヴェイロス・デ・カストロを筆頭とする人類学の存在論を反映した概念である。他者を自分の知識の枠にはめて理解する比較法ではなく、音が媒介する複数の関係性を通して相互的に生まれるものとして自他の差異をとらえ直す、いわば音響関係性存在論だ。植民地的遭遇は既存の差異の衝突ではない。差異とは遭遇するもの全てが必然的に相互変化する過程の産物である。音や声はその感覚的折衝の過程そのものだ——これがこの本を貫く理論的アプローチである。

　この理論的枠組みは人間社会内の差異だけではなく、人間といわゆる「自然」との関連性にも適応される。先述のボガの例でも示したように、他者を「動物的」な声と聞き書きとめる行為は、後に先住民言語を明晰さの欠けた「野蛮」な音として聞きとるキリスト教的保守派と、人間的表現の音として評価した世俗的ヒューマニズム派のあいだのイデオロギー論争の場となる（第3章）。さらには政府に属した文法学者らが「正しい」発声、発音を記号化し、「書かれたもの」から組織的に（話される）言語を統一、統制することで、人種的他者を人間以下のものとして抑圧、排

除する国家形成へとつながる（第4章）。多様な人口が複雑に混在した19世紀のコロンビアが独立する過程で、誰が「人間」カテゴリーに入るのかという問題は、誰が公民権をもつのか、その境界をどう定義するのか、という国家創立の根底に直結する。この過程をオチョアは声の「動物政治学（zoopolitics）」と呼び、いかに発音、発声、声色が人間を定義する源になり、公民権に含まれるもの、除外されるものの境界線差異を生むかを論じ、「音響的アセンブラージ」の政治性を説く。

　ここで明確にしておきたいのだが、同書は植民地における西洋化を歴史的に分析するだけではない。ラテンアメリカ植民地での声の政治学が、19世紀ヨーロッパの人権概念や音楽学や言語学の形成に欠かせない要素だったことを示す、感覚からとらえたグローバルヒストリーを描く試みでもある。海を隔てた植民地が独立国家として変遷する過程に記述された音の知識流通がヨーロッパの科学知識の基礎を作った様を、丁寧なアーカイブ調査で裏付けることで西洋近代性と植民地性の多様な相互関係を照し出す分析は、この本の重要な貢献の一つだ。

　以上、紹介してきたように『聴覚性』はたいへん重要な著作だが、あえて同書の揚げ足をとるならば、声という概念がコミュニケーションという領域に限られてしまう点を指摘できるだろう。スティーヴン・フェルドの音響認識学の系統に直結しており、副題に「知識」とあることからもわかるとおり、音と認識、知識が同質的にとらえられるのは必然的だ。一方、同書で定義された「音」にはいくつかの例外を除き、クィアスタディーズなどが音声の重要な側面としてとらえる、身体性や時間性を考察する余地が少ないのも事実だ。読者はオチョアの創造的な理論的取り組みからヒントを得て、さらに認識・知識・伝達の域を超える音声の他の可能性をも考察するプロジェクトを想像してみるとよいかもしれない。

　アーカイブの「書かれた音」から声と耳の関係性を読み解く（聴き解く？）革新的な一冊である。人間中心主義を批判的にとらえ、言語学、哲学にも及ぶ学際的なアプローチをとる同書は、ラテンアメリカ、カリブ海の文化と歴史に興味がある人はもちろん、研究対象、分析方法、理論ともに脱植民地的研究の新しい可能性を探る模範的な本として、幅広い読者に刺激を与えるはずだ。　　　　　　（阿部万里江）

11

キャシー・レーン、アンガス・カーライル
『イン・ザ・フィールド──フィールド・レコーディングの芸術』

Cathy Lane & Angus Carlyle, *In the Field: The Art of Field Recording*, Uniformbooks, 2013

フィールド・レコーディングから聴こえる自己

　環境の音を録音する実践、フィールド・レコーディングに取り組む作家たちは、マイクとスピーカーを通じて何を聴き取ろうとしているのか。同書はキャシー・レーンとアンガス・カーライルによる、18名のフィールド・レコーディストへのインタビュー集である。インタビュアーの二人は、ロンドン芸術大学のリサーチセンターとして設立され、ロンドン・カレッジ・オブ・コミュニケーションに拠点を置く CRiSAP（Creative Research into Sound Arts Practice）の共同ディレクターを務める。2013 年 2 月には同書と同名のシンポジウムも開催され、フィールド・レコーディングという実践をめぐって議論が交わされた。大英博物館に残された貴重な過去の音源も公開されたという。

　インタビュアーであるレーンとカーライルの関心の中心は、フィールド・レコーディングとは何かという問いかけではなく、環境の音を録音する活動にこめられた多様な欲望にあるのではないかと思う。序文で著者たちはあらかじめいくつかの問いを立てている。順にあげると、「なぜフィールド・レコーディングを始めたのか」、「録音に自分がどう現れていると思うか」、「録音に何を探しているか」と続く。ここからも著者たちの興味が作家の動機や欲望にあることが伝わってくる。この興味はときに作家の価値観や、録音の評価基準をめぐる問いかけへと向かう。

　作家たちの答えにはいくつかの大きな傾向があり、それらが対立するように見えるときもある。たとえば、録音のドキュメンタリー性を重視するかという問いに対する答えがそうだ。ピーター・キューサックやイアン・ロウズらは音源の調査に時間を費やし、そうすることで音楽から距離を取ろうとする。映画学校出身のブッダディティヤ・チャトパディヤイも音源とその場所の関係を重視する。その一方で、笹島裕樹は自分の作品のドキュメンタリー性を否定し、耳に聴こえる音と録音の違

いに関心を寄せる。フランシスコ・ロペスは録音を通じた音の変形にこそ重きをおく。クリスティナ・クービッシュもまた、脳が音と音源を結びつけたがることを認めながらも、音によって実在しない場所のポートレイトを創ろうとする。こうした姿勢の違いはそれぞれの作品にはっきりと現れているようにもみえる。

　しかし、この対比は見かけほど単純ではない。笹島は録音するとき、環境を「あるがままの」状態に保とうとする。非現実的な音を志向するロペスやクービッシュも「場」や「場所」の創造という言葉をくり返し使っている。一方、キューサックは自分がフィールド・レコーディングの「純粋主義者」（ここで言う「純粋」とは録音が無加工であることを指す）ではないと語る。チャトパディヤイは録音をまったく私的な活動としながらも、聴き手とコミュニケーションを取るために映画的物語が必要だと考える。フィールド・レコーディングはドキュメンタリー、音楽、物語の間で揺れ動いている。

　フィールド・レコーディングに取り組むきっかけについての問いは、作家たちが置かれていた状況を教えてくれる。アニア・ロックウッド、アンドレア・ポリ、ヤナ・ウィンデレンらは口を揃えたように「システマティックな」作曲手法に対する抵抗感が録音に向かう理由になったと語る。逆に、シンガーだったマニュエラ・バリーレは即興演奏の「アナーキーな」表現に限界を感じて録音を始めたという。一方、ダヴィデ・ティドーニは8才の頃から子ども用テープ・レコーダーで遊んでいたと語る。グルーンレコードを運営するラッセ゠マーク・リークは録音機材の作動自体に興味をひかれたと答えている。

　同書に登場するなかで比較的ベテランのフィールド・レコーディストたちは、いずれも60年代末から70年代に録音を始めていた。携帯型テープ・レコーダーが手に入りやすくなった時代であり、リュック・フェラーリが漁港の環境音によって構成されたミュジーク・コンクレート作品《ほとんど何もない》（1967-70年）を発表し、サウンドスケープ理論が生まれたのもこの頃だ。パプアニューギニアのカルリ族の音文化をめぐる研究（『鳥になった少年──カルリ社会における音・神話・象徴』山口修、山田陽一、卜田隆嗣、藤田隆則訳、平凡社、1988年）で知られるスティーヴン・フェルドは、モーグ・シンセサイザーの共同開発者ハーブ・ドイチに録音を習ったという。ジェズ・ライリー・フレンチはニュー・ウェーヴの影響を語る。「私は幸運にも、ニュー・ウェーヴからすべてが音楽であることを学んだ」（164頁）。

　70年代には日本でも「生録ブーム」が起きていた（詳細は金子智太郎「一九七〇

年代の日本における生録文化——録音の技法と楽しみ」（『カリスタ』2017年）を参照）。「カセットデンスケ」のような携帯型レコーダーを持って野外で録音する活動が普及し、各地で生録音会が開かれた。ソニーが「全日本生録コンテスト」を主催し、専門雑誌やラジオ番組もあった。当時の文章を読むと、この頃からすでに環境の音を録音する実践がさまざまな欲望を抱えこんでいたことがわかる。たとえば、先行する個人旅行ブームやSLブームが生録の流行に与えた影響は大きい。それに対して、オーディオ・マニアは生録を音による初めての創作体験としてとらえていた。ラジオ・ドラマはそうした創作の一つの型になった。また当時の入門書では、録音がオリエンテーリングや室内ゲームの道具としてレクリエーションと結びつけられた。「全日本生録コンテスト」の審査委員長を務めたのは、映画評論家として知られる荻昌弘であり、彼は生録を自主制作映画と重ね合わせて、テクノロジーによる芸術のもっとも大衆的な手法と考えていた。（金子智太郎「市民による音づくり——映画評論家、荻昌弘のオーディオ評論」（『音と耳から考える——歴史・身体・テクノロジー』アルテスパブリッシング、2021年）参照）。

　同時代の野外録音実践の記録である『イン・ザ・フィールド』のなかで私が特に面白いと思ったのは、録音に自己がどう現れるかという問いだ。たとえば、笹島は録音から自分の痕跡を消そうとする。録音中にその場を離れることも留まることもあるが、留まるときは「狩り」のように録音機材を動かしたりはしないという。ただし、彼は録音場所や録音機材の選択に自己が現れているとも付け加える。フェリシティ・フォードも似た趣旨の答えを返している。写真が銃を撃つように撮影できるのに対して、録音はじっと静かに集中する必要がある。彼女にとって、フィールド・レコーディングと静止した身体の内部感覚は切り離せない。録音機材を作動させたまま長く放置することもあるロペスの場合は、その間まったく別の場所で休んでいることもあれば、少し離れた場所で静かに音を聴いていることもあるという。ウィンダレンは録音の間に自分がその音を聴いているということを、聴き手に意識させないようにしたいと語る。

　反対に、バリーレは自分の知覚を聴き手に伝えることがフィールド・レコーディングの長所であると考える。こうした発想を共有する作家たちは一様に、録音に残る自分の息の音と足音の話をする。ポリは南極大陸の大地を歩く彼女の足音を自分の録音のフェイバリットにあげている。氷河が自分の身体に反応する不思議さに惹かれるのだという。キューサックやチャトパディヤイも録音に二つの音を意図的に入れるようになったと語る。キューサックによれば、足音は相対的位置の基準とな

り、録音にパースペクティブをもたらすのだ。

　フェルドも彼の多くの録音に自分の息の音が残っており、身体の存在が感じられると語る。彼は 1970 年代半ばよりパプアニューギニアでフィールドワークを実践し、大学時代にはドイチやクセナキスに電子音楽を学んだこともあった。アンガス・カーライルによるインタビューのなかで、人類学と芸術実践の結びつきを強調しながら、フェルドは次のように語っている。

　　自分の録音をどう使っているかというと、聴取の歴史をめぐるデータを収集して、聞く主体についての理論を組み立てる手段として使います。聴取の歴史をくり返し問い直すために使います。芸術の制作が聴取の歴史のアーカイヴをつくることにつながるように使います。（211 頁）

　さらに、彼は録音を使って、社会的なものと音響的なものの相互接続、相互依存について考えているという。

　　録音のプロセスや対象はいつも、変化していく社会的関係性の記録です。だから、私はレコーダーを、音による媒介を通じたモノ、他者、自己の社会的、物質的な共存関係をより深める装置と考えているんです。（209 頁）

　長年のフィールドワークで培われた知見を濃縮したかのようなフェルドの言葉は、同書のハイライトの一つだろう。ただし、私は録音のドキュメンタリー性と同じように、録音に現れる自己についての一見相反する答えは、実際は複雑に絡み合っているのではないかと思う。沈黙して自己の痕跡を隠すことも、モノや他者との共存関係の一つのあり方だろうからだ。　　　　　　　　　　　　　（金子智太郎）

12

ジョナサン・スターン編
『サウンド・スタディーズ・リーダー』

Jonathan Sterne ed., *The Sound Studies Reader*, Routledge, 2012

サウンド・スタディーズの自意識

　90年代より、音や聴覚をめぐる学際的なアンソロジーが多数出版されてきた。サウンド・アートの論考を収めたものも少なくない。ジム・ドゥロブニク編『聴覚文化』（YYZ Books, 2004）はクリスチャン・マークレーらの作品を紹介し、キャロリン・バーザル、アンソニー・エンズ編『ソニック・メディテーションズ──身体、音、テクノロジー』（Cambridge Scholars Publishing, 2008）ではジャネット・カーディフとジョージ・ビュレス・ミュラーらが、トレヴァー・ピンチ、カリン・ビスタヴェルド編『オックスフォード・ハンドブック・オブ・サウンド・スタディーズ』（Oxford University Press, 2012）ではマックス・ニューハウスやデヴィッド・ダンの水中作品が論じられている。

　反対に、サウンド・アートをめぐるテキストのアンソロジーに、音文化に関する論考が収録される場合もある。たとえば、一冊ごとに一つのテーマにまつわる文章を集めた「ドキュメンツ・オブ・コンテンポラリー・アート」シリーズで「音」の特集が組まれている（WhiteChapel Gallery, 2011）。キャレブ・ケリーの編集による同書の目次には美術家、音楽家に混ざって、ミシェル・セール、W・J・T・ミッチェル、エミリー・トンプソンらの名前が見られる。

　音響テクノロジーをめぐる刺激的な著作を残してきたジョナサン・スターンの編集による同書『サウンド・スタディーズ・リーダー』も、「ソニック・アーツ」に一章を割いたアンソロジーである。他には聴取と「ろう」、空間、テクノロジー、集団、声といったテーマごとに章が設けられ、ジャック・アタリ、フリードリヒ・キットラー、ジャック・デリダらの著作といった古典から、細川周平『ウォークマンの修辞学』（朝日出版社、1981年）の一節や、近年の研究まで、既刊の論考が収められ

ている。「ソニック・アーツ――美学、経験、解釈」と題された章は、音楽論とともにダグラス・カーン、ブランドン・ラベルのサウンド・アート論が並んでいる。同書はいわゆる「リーダー」なので、アンソロジーとしての特徴は乏しいように見える。しかし、先行するアンソロジーが多くあるだけに、スターンが「サウンド・スタディーズ」と呼ぶ動向を概観する視点がある。最新研究の紹介ではなく、サウンド・スタディーズがどうあるべきか、スターンの考えるサウンド・スタディーズの自意識がこの『リーダー』から見えてくる。それが明確に語られた彼の序論を読みながら、サウンド・スタディーズとサウンド・アートの関係をあらためて考えたい。

　カナダのマギル大学で教えるスターンの主著は2006年に出版された『聞こえくる過去――音響再生産の文化的起源』（中川克志、金子智太郎、谷口文和訳、インスクリプト、2015年）だ。19世紀に加速した諸科学の展開を通じて、現在も音響テクノロジーを支える文化的基盤が形成されていくプロセスを多角的に論じている。テクノロジーと感性の関係をめぐる研究として、ジョナサン・クレーリーの『観察者の系譜――視覚空間の変容とモダニティ』（遠藤知巳訳、以文社、2005年）と比較できるだろう。スターンの『MP3――フォーマットの意味』（Duke University Press, 2012）はモチーフこそ現代的ながら、音響テクノロジーと音響心理学の長い結びつきをたどる内容で、前著の延長上の議論と言える。そして、彼が編んだ本アンソロジーからは音響テクノロジーだけでなく音の世界の全域にわたる好奇心がうかがえる。

　スターンはこのように定義する。「「サウンド・スタディーズ」とは音を分析的な出発点もしくは到着点とする人文科学の学際的な沃土の名称である」（2頁）（阿部万理江による訳を参照した）。彼の姿勢はこの次の文章によりはっきりあらわれているように思える。サウンド・スタディーズは「音にまつわる実践と、それを記述する言説や制度の両方を分析することで、人間の世界のなかで音が何をするのか、音の世界のなかで人間が何をするのかを再記述する」（2頁）。ここでは音と人間が等しく重要であるとされ、また「再記述」という言葉に彼の主張がこめられている。これは学際的な学問で、音響学、社会学、歴史学、人類学、音楽学など多くの分野を参照するが、決して包括的ではない。むしろ、スターンはサウンド・スタディーズが自分の「知が部分的でしかないと常に意識している」（4頁）と言う。音とはこういうものだ、耳はこう働く、こういった知は領域・時代ごとに変化していく。そこで、サウンド・スタディーズは各領域・時代の知がどう形成されたのかを説明しようと試みる。自分がもつ知をくり返し反省するという意味で、サウンド・スタ

ディーズは「再帰的に（reflexively）」進むとされ、こうした反省のない議論に対してスターンはいつも批判的だ。

　彼が過去の議論に向ける批判は手厳しい。たとえば、次のように指摘する。テクノロジーでもサウンドスケープでも、音の世界の歴史を語るとき、人は過去が現在よりも有機的で信頼できるものであったとみなす傾向がある。サウンド・スタディーズは同時代の音の世界の急激な変化を受けて流行しだしたと考えられがちだが、実際にはたえず音は変化してきたし、学際的研究も行われてきた。たとえば、1920 年代にはフロイト（『文化への不満』1930 年）やハイデガー（『存在と時間』1927 年）らが音響テクノロジーに言及した（『サウンド・スタディーズ・リーダー』2 頁）。スターンが特に槍玉に挙げるのは、マクルーハン、オング、アタリらが説いた聴覚と視覚の比較だ。「聴覚は球状で、視覚は線状だ」、「音は私たちのところにやって来るが、視覚はその対象に向かう」、「聴覚は情動に関わり、知覚は知性に関わる」、「聴覚は主として時間的な感覚で、視覚は主として空間的な感覚である」（9 頁）（『聞こえくる過去』28 頁も参照）といった対比は、なぜそう感じられるのかを探求すべき問題であり、議論の前提にすべきではないとスターンは強調する。

　彼にとって、音や聴覚についての知自体がサウンド・スタディーズにとっての問題そのものなのだ。だからこそ、この領域には人間をめぐる再記述が欠かせない。知がどう獲得されるかという方法の問題があり、またさまざまな領域の知の争いがある。それぞれが歴史をもち、権力と結びついている。スターンは同書が強い「北米バイアス」をもっていることも認める。このような知の問題に対して、実践において全面的に向き合っている作家として、スターンがアメリカの音楽家ポーリン・オリヴェロスを挙げているのは興味深い。彼女が唱える「ディープ・リスニング」という実践は、音の世界を調査する方法であり、それを変えていこうとする姿勢を育むものでもある。また同時に、彼女の実践は前衛的音楽全般にいまもある父権的態度に対する批判にもなっているとスターンは指摘する。

　こうしたスターンの議論を見ていくと、サウンド・スタディーズの自意識とかつてカーンや藤枝守らが論じたサウンド・アートの自意識（『ミュージック・トゥデイ』19 号、1993 年）には共通点が少なくないと感じる。サウンド・アートが音や聴覚の様態を形成するものや、音を通じて人が行うことに関心を向けるなら、それはいわばサウンド・スタディーズの実践版だ。だとすれば、スターンが序論後半に記したサウンド・スタディーズの現状分析は、サウンド・アートの現状を考察する手がかりにもなりそうだ。

　彼はこれまでのサウンド・スタディーズが大きく二つの立場に分かれると考える。耳で感じられた音を強調する立場と、物質の振動としての音を強調する立場だ。「聴覚文化」という用語は前者の姿勢を反映している。この立場は視覚文化論の方法を参照しながら、いわゆる「視覚のヘゲモニー」の撹乱を試みる。スターン自身もかつてはある程度、この人間中心的な立場だったという。『聞こえくる過去』にはこうある。「音である振動と音ではない振動との境界線は、振動そのものの性質もしくは振動を伝達する空気の性質に由来するのではない。そうではなく、音と音ではないものとの境界線は、聴覚能力がもつとされる可能性——人であれリスであれ——にもとづいている」（前出『聞こえくる過去』24 頁）。

　しかし、スターンはもう一つの立場にも目を向けるようになったようだ。フランシス・ダイソン『鳴り響くニュー・メディア——芸術、文化における没入と身体化』（University of California Press, 2009）やスティーヴ・グッドマン『音の戦争——サウンド、情動、そして恐怖のエコロジー』（MIT Press, 2010： ☞本書 156-159 頁）などは、感じられた音ではなく振動を議論の核として、その物質性を重視するとともに、「ろう」の問題にもアプローチしようとする。「ろう」はスターンにとっても重要なモチーフで、聴取と並んで『サウンド・スタディーズ・リーダー』第一章のテーマになっている。彼によれば、音の世界に関する現代の知を統合する分野である音響心理学では、健常な聴取とろうの境界がたえず問題になってきた。

　サウンド・スタディーズは「人間の世界のなかで音が何をするのか、音の世界のなかで人間が何をするのかを再記述する」という言葉は、こうしたスターンの再帰的な思考から生まれたのだろう。この研究領域の名称に音と聴覚のどちらがふさわしいのかという問いは、たいした意味がないのかもしれない。音をめぐる議論から聴覚論に対して、また後者から前者に対して、批判がくり返し投げかけられることに比べれば。　　　　　　　　　　　　　　　　　　　　　　　（金子智太郎）

13

浜田淳編
『音盤時代の音楽の本の本』

株式会社カンゼン、2012 年

オルタナティヴな音楽批評の可能性

　近年商業出版されたポピュラー・ミュージックに関する音楽書を眺めてみると、話題になりやすい書籍にはいくつか傾向があるように見える。一つは歴史系で、あるジャンルなりシーンなりの成立過程についてわかりやすく解説したものだ。もう一つはディスク・ガイド系で、やはりあるジャンルやシーンについて、アルバムを整理することで一つのパースペクティヴを提示するもの。どちらも初心者向けにあるジャンルやシーンを紹介する入門書という意味では共通したニーズに応えていると言える。そしてもう一つは著名なミュージシャンをテーマにした評伝や論集。ミュージシャン自身による自伝をここに含めてもよいかもしれない。もちろんこれだけではなく、他にもシーンの現状分析や音楽ビジネスの未来予想、あるいはニッチなジャンルに特化した専門書などが話題になることもあるものの、いずれにしても、音楽の歴史を紐解き、アルバムを並べて見取り図を把握し、あるいは特定のミュージシャンについて深掘りすることに注目が集まることからは、読者が単に読み物として音楽書を楽しむだけではなく、自らのリスニング体験をより豊かなものにしたいという欲望を抱いていることがうかがえる。

　ではそのように自らのリスニング体験を豊かなものへと導く良質な音楽書と出会うためにはどうすればよいのか。音楽について書かれた本は無数にあるが、音楽書それ自体をテーマにした本となるとあまり見当たらない。そもそも優れた音楽書とはどのようなものなのか。約 200 冊もの書籍を取りあげた同書は、そうした悩みを抱える読者にとって有用な手引きとなる、音楽の本に関するブックガイドだ。批評家やライター、ミュージシャンなど総勢 20 名が参加しており、さまざまな角度から主に広義のポピュラー・ミュージックにまつわる音楽書をリストアップしていく内

容になっている。

　冒頭には「音の聞き方が変わった本」と題して、10名の執筆者がそれぞれ数冊の書籍または文献を挙げながら自身の読書経験について筆を執っている。取りあげられる書籍は必ずしも字義通りの音楽書だけでなく、たとえば作曲家／ギタリストの杉本拓が「音楽を哲学の問題として考えることのはじまり」として自身の音楽活動に引き付けながらルートヴィヒ・ウィトゲンシュタインの代表的な哲学書『論理哲学論考』（藤本隆志・坂井秀寿訳、法政大学出版局、1968年）を挙げていたり、サウンド・アーティスト／キュレーターの恩田晃がやはり自身のアーティスト活動を振り返りながらピーター・ビアードのコラージュ日記『ダイアリー・幻の日記』（リブロポート、1993年）やスタン・ブラッケージが映像作家について記した『フィルム・アット・ウィッツ・エンド』（Documentext / McPherson & Co, 1991）を挙げていたりする。読書で音の聴き方が変わることに対して懐疑的な書き手が複数いることも興味深い。たとえば作曲家／ピアニストの高橋悠治は「音の聞き方は生来の環境や文化によって、意識しないでも身についた習性で、本を読んだくらいで変わるはずがない」と喝破し、「音と人間のかかわりについて指摘した最近の例」として2冊の書籍を挙げている。音楽評論家の高橋健太郎は「最初に結論を書いてしまうと、そんな本はない」と断言しつつ、「数ある音楽書籍のなかで、ぼくがもっとも心揺さぶられた一冊」を挙げるほか、小説等で描写される「実在するサウンドから解き放たれた」架空の音楽に関する「忘れ得ぬ強烈な記述」を紹介する。いずれにせよ、より豊かなリスニング体験を求める読者にとっては、どれも手に取ってみる価値がある書籍には違いない。

　また、同書には「ザ・グレーテスト・ヒッツ・オブ・音楽本」と題して101冊の推薦図書が短評付きで掲載されている。面白いのは雑誌のオールタイム・ベストのように選者の合議や機械的な集計でリストを作成しているのではなく、9人の担当者がそれぞれ自薦した書籍がそのまま掲載されているという点だ。偏っていると言えば偏っているのかもしれないが、合議や機械的な集計だとしばしば当たり障りのないありふれた作品が並んでしまうことを考えると、選者それぞれの感性やモノの見方が反映された唯一無二のリストに仕上がっているとは言える。その甲斐あってか選ばれた書籍はミュージシャンによるエッセイから批評家の論集、あるいは小説、アカデミックな研究書など、国内／海外を問わずバラエティ豊かだ。だがそれだけに今の時代から見て目立ってしまうのはジェンダー・バランスで、全101冊のうち女性による著作は10冊以下、すなわち1割にも達していない（ちなみに同書も執筆

者20名のうち女性は1名のみ）。このことの是非はここでは一旦措くとしても、とかく音楽批評の世界は男性中心主義的になりがちで、刊行から約10年が経過した現在の視点から振り返ったときに、そうした音楽批評をめぐる状況をあらためて突きつけられる。

推薦図書の間には適宜インタビューが掲載されており、書き手として活躍する5名（三田格、湯浅学、野田努、岸野雄一、佐々木敦）の人物の読書遍歴を探ることで読むべき（かもしれない）音楽書をあぶり出していく。音楽と言葉の関わりについて個々別々のスタンスや批評観がうかがえるのも面白いが、インタビュイーが5名とも1950年代後半〜60年代前半生まれで世代がおおよそ同じであるため、70〜80年代に青春時代を過ごした読者ならではの音楽書との出会いが語られているのは今読み返すと興味深い。ゼロ年代〜テン年代が青春だった書き手に同じ質問を投げかけたら、おそらく全く別の答えが返ってくることだろう。たとえば雑誌ではなくウェブメディアのテキストが多数入ってくるのではないだろうか。

ところで優れた音楽書とはどのようなものなのだろうか。『音盤時代の音楽の本の本』の「はじめに」では、「目を見開かされ、背筋を伸ばされ、そして世界の見え方が変わり、明日の自分をも変えてしまうような、思わず無為に流れゆくときを止めて、沈思せざるをえない文章」という言い方がなされている。だがすでに述べたように、音楽書を読むことが音の聴き方の変更に直接的に寄与するかどうかについては懐疑的な見方もある。むしろ優れた音楽書に関する評価で同書に通底しているのは、単に音の聴き方を変える本というよりも、「ロキノン的なもの」のオルタナティヴとしての音楽批評であるように思う。

音楽雑誌『rockin'on』または『ROCKIN'ON JAPAN』に象徴される音楽批評のあり方を指した「ロキノン的なもの」とは、同書編集部の言を借りれば「ある種ルーチン化しやすい、つまり仕事がさくさくと終わるための方法論」であり、「すぐに意味の部分、曲名や歌詞やミュージシャンの発言を引用して、その作品の話者と、署名としてのアーティストの存在とをいっしょくたにして論じる例」であり、すなわちビジネスとして量産可能なテキストの謂いである。それに対して作品（の話者）をミュージシャンの物語から切り分け、それと真っ向から対峙し、その都度その都度、自らの経験と思考をもとに判断／記述していくテキストがオルタナティヴな音楽批評であり、優れた音楽書の要件になると言えるだろう。近年はとかく日々の回転が早いウェブメディアが音楽に関するテキストの大勢を占めるようになっていて、毎日のように衆目を集めるトピックを生産しては消費し、生産しては消費しという

運動を効率よく繰り返していくために、まさに「ロキノン的なもの」がなし崩し的に蔓延しており、言ってしまえば、専門性をもたない表層的なテキストが量産され続けているという現状もある。もちろん全てのウェブメディアがそうだとは言わないが、全体的な傾向としてそうした状況にあって、「ロキノン的なもの」の成れの果てのようなテキストではなく、あくまでもオルタナティヴな音楽批評を打ち出そうとする同書の編集方針は、むしろ今のような時代であるからこそ価値があると言うこともできる。容易に消費可能なテキストはちょっとした時間潰しには役に立つかもしれないが、何かの体験に変容を迫ることはほとんどない。そして読書経験によって直接的に音の聴き方が変わることはないにしても、陰に陽に思考と判断が要求されるオルタナティヴな音楽批評は、リスニング体験をより豊かなものへと導くきっかけにはなるはずだ。

　類書として、同様に「ロキノン的なもの」に対するオルタナティヴを掲げた書籍に、メタ音楽批評特集を組んだムック『エクリヲ vol.7』（エクリヲ編集部、2017年）を挙げることができる。『音盤時代の音楽の本の本』が広義のポピュラー・ミュージックが中心であることを踏まえるなら、クラシック／現代音楽を中心にアカデミックな方面から文献をまとめた椎名亮輔編『音楽を考える人のための基本文献34』（アルテスパブリッシング、2017年）は相互補完的なガイドとなる。日本の音楽批評の歴史を俯瞰するのであれば、優れた一冊として栗原裕一郎と大谷能生の共著『ニッポンの音楽批評150年100冊』（立東舎、2021年）も類書に加えられる。また、『音盤時代の音楽の本の本』は2012年に刊行されているため、テン年代以降の書籍に絞ったブックガイドである『音の本を読もう』の前史として読むこともできるだろう。　　　　　　　　　　　　　　　　　　　　　　　　（細田成嗣）

第4章
音響修辞学
音によって物語る

　音によって物語る表現をめぐる本のためにこの章題がある。漠然と
したカテゴリーだが、古典的な弁論術から、効果音やバックグラウンド
ミュージックによる演出、サンプリングや音声合成技術を駆使した現代の
音による語りまでを、貫いて考えるために音響修辞学という言葉を使える
かもしれない。渡辺裕『感性文化論──〈終わり〉と〈はじまり〉の戦後
昭和史』は日本のラジオやレコード、映画をめぐる感性に、1960年代後半
を転換点とする変化を見てとる。彼によれば、戦前から続く架空の聴覚的
現実をつくろうとする感性がこの時代を境に、ある対象を包みこむ実際の
現実を意識する感性へと変わった。名高いゲームサウンドトラックを分
析したアンドリュー・シャルトマン『「スーパーマリオブラザーズ」の音
楽革命──近藤浩治の音楽的冒険の技法と背景』は小品だが、効果音を含
むゲームの音と、ゲームがプレイされる実際の環境を関係づける議論が興
味深い。ヴィデオゲーム音響修辞学はこれからも厚みを増しそうだが、い
ずれは長門洋平『映画音響論』（☞本書 126-129 頁）などが参照されるの
だろう。

　音の引用の巨匠二人、ピピロッティ・リストとマシュー・ハーバートの
修辞学は、どちらも記録をめぐる制約が大きな意味をもつ。リストのヴィ
デオ・アートが映像と音声の不平等や、鑑賞者の没入の限界など、再生の
制約に目を向けようとするのに対して、ハーバートの音楽にとっては原音
と記録の違い、すべての音を記録することの不可能性といった、録音の制
約が重要になる。ジェームズ・ブラクストン・ピーターソンによる『ヒッ
プホップ・アンダーグラウンドとアフリカ系アメリカ文化──表層の下
へ』は、アメリカ黒人文化の「黒の修辞学」の展開を、インディー・ヒッ
プホップの語り口や音づくりに見ようとする。ここでは、真意や出典を容
易に明らかにしない「暗号（サイファー）」が、その修辞学の鍵の一つと
される。

14

渡辺裕
『感性文化論──〈終わり〉と〈はじまり〉の戦後昭和史』

春秋社、2017 年

聴覚から「感性」へ

　同書のタイトルに「音」の字は入っていない。現に、全4章からなる『感性文化論』の最終章は音や聴覚についての議論ではなく、高速道路の話である。音楽文化をめぐるラディカルな論考でわれわれを刺激しつづけてきた渡辺裕は、なにゆえ 2010 年代に「「首都高」の萌えポイント」について語ることになったのか。この点に関しては「あとがき」の記述が示唆的なので、まずは同書の後ろの方からページを開いてみよう。

　かつては自身の専門分野を音楽学と認識してきた渡辺は、近年「聴覚文化論」の語を使うようになったと述べる。これは、「音楽」という枠に窮屈さを覚えるようになったためと説明されているが、同時に、オーディトリー・カルチャー・スタディーズ／サウンド・スタディーズという英語がかなり一般化されてきたという学界の趨勢にも言及されている。

> 英語で「聴覚文化（auditory culture）」という概念が使われるようになったのは明らかに、ひとつの領域として確立した「視覚文化（visual culture）」研究の「音バージョン」を意識してのことであろうが、そこには同時に、これまで文化に関わる議論のパラダイムが「視覚帝国主義」的に作られてきていたことを反省し、それに対抗する形で、ともすると置き去りにされがちな「聴覚」を中心にして文化の歴史や現状を捉え直そうとする目論見が込められていた。（316 頁）

　聴覚文化論なる概念に関する一つの基礎的認識をコンパクトに示す記述になっているが、しかし渡辺はこの言葉のなかにも安住しない。なぜならば、聴覚中心にものごとを考えることは、今度は「聴覚帝国主義」的な弊害を招く可能性につなが

るという意味で何も問題は変わらないし、そもそも「感覚というものは常に「マルチモーダル」である」（317頁）のだから、ある一つの感覚のみを特権的にあつかうことに意味はないからだ。したがって、「感性」と称しているのである。同書は、聴覚・視覚を含む人々の感性が1968年前後を境にどのような変質をこうむったか、それはなぜかという問題をあつかう。同時に、過去との比較において現在のわれわれの感性のあり方が逆照射されてくるという、きわめてアクチュアリティの高い一冊ともなっている。

　同書前半の第Ⅰ部は、「「ラジオ的」現実」（78頁）および記録映像の「「作りもの」性」（113頁）の議論であるという意味で、1960年代以前の日本における「作りもの」的リアリティについての考察となっている。中継や記録は客観的であるべきだとする現在の一般的な考え方に反し、かつてはそういったメディアの内部に含まれる「演出」にも、積極的にリアリティを見出すような感性が存在したという議論がこのパートの骨子である。とりわけ第1章に関しては、「実感放送」（68頁）、「架空実況中継」（84頁）といったかたちで、戦前日本のラジオがある種の「聴覚的現実」をつくりだし、事実とフィクションという二項対立的図式を解体していくような力をもっていたという指摘が重要である。こういった架空実況中継的感性は戦後へも引き継がれ、テレビが力をもつようになる1960年頃から下火となるが、東京オリンピックの1964年にはかろうじてその命脈が保たれていた。オリンピックのアナウンスに残存していた「ラジオアナウンスのたたずまい」（99頁）こそは、そのような前時代的感性の残滓であり、以後顕著になる「視覚優位」の文化状況において捨て去られていくことになる音表現の可能性を鮮やかに示すものであった。

　その東京オリンピックのアナウンスを含む音声記録に、さらに高次の「作りもの」性を嗅ぎ取るところから第2章ははじまる。有名な記録映画、市川崑『東京オリンピック』（1965年）冒頭の開会式入場行進シーンで流れている音楽およびアナウンスがなんと、当日の中継映像のものと異なっているのである。映画用に後づけしたBGMおよびナレーションという意味ではなく、その時の実況中継の体裁で行進用音楽および中継音声としてのアナウンスが再録されてしまっている。現在の感覚ではあまりに露骨な「やらせ」演出ということになるが、その「あまりに露骨」である点に渡辺は、当時と現在の感性の根本的な構造的差異を見出す。100メートル走のレース（映像はスローモーション）を40秒かけて実況してしまうこの映画の「演出」は、当時話題になった「記録か芸術か」論争を超えて、「作りもの」性がその両者に通底し前提されている事実を示す。渡辺によると、「やらせ」や「作りもの」性

を忌避するリアリティの感覚は、画像と音声が同時に収録されるビデオテープ＝テレビ・ドキュメンタリー的感性の一般化によって強化されてきたものだが、まさに放送なるものがラジオからテレビへ移行しつつあった時期の映画『東京オリンピック』は、その意味でも、人々の感覚が根本的に書き換えられていくプロセスを真正面から描くものとなっている。

　同書後半の第Ⅱ部における最大のキーワードは「「環境的」感性」（178 頁）である。再度『東京オリンピック』を引き合いに出すならば、たとえば同作冒頭におかれた、オリンピックに向けた東京の大改造のためにビルを解体するシークエンスをどう評価するかという問題がある。われわれの目には当然、意図的にオリンピックの祝祭性に「水をさす」、市川のシニカルな批評性のあらわれに見える（＝それまでの人々の生活を破壊したうえにオリンピックは成立する）。しかしながら、古い建造物や街並みに価値を見出すというメンタリティ自体がじつは自明なものではなく、多様な文化的コンテクストのなかで歴史的に形づくられてきたものなのだと渡辺は述べる。

　　　この一九七〇年前後の時代以前には、そのような思考モードは、ごく一部の特
　　　殊な人々の間以外には存在せず、古びて使いにくくなった建物を壊すことに
　　　疑問をもち、保存を主張するような酔狂な人はほとんどいなかったのである。
　　　（160 頁）

「対象」それ自体に対する合目的的な認識よりも、その対象を含む環境＝場所にこそ意識を向けること。あるいは環境に向けるまなざしの角度を変えることで、何度でもその環境を再発見していくこと。これらの論点は、「「広場」の思想」（196 頁）なる概念を介して 60 年代末のフォークゲリラと結びつく（第3章）。一般に「抵抗と挫折のストーリー」として政治的に解釈されてきたフォークゲリラという運動にあって、その要となったのは新宿西口地下広場という環境＝場所だった。そして、「「サウンドスケープ」の思想を先取りしたかのよう」（209 頁）な音の出る雑誌＝『朝日ソノラマ』が出したいくつものソノシートは、フォークゲリラという「広場の音」の世界全体をイメージとして記録・提示することで、当の運動と相補的に同時代的感性の「環境」化を明示する。しばしばフォークの脱政治化という流れの象徴と見なされる吉田拓郎に関しても、その最初期の録音に環境音的意匠が含まれている点に注意しつつ渡辺は、挫折から「シラケ」へ、といった政治的読解ではなく、

メディアにおける環境的感性の問題としてフォークソングを読み直している。

　1970 年前後以降の、こういったメンタリティの変化ないし環境的感性の前面化は、第 4 章の首都高景観問題へと連続していく。美しい景観の破壊という現象の代名詞とも見なされる、高速道路建設により変容した日本橋の景観は、実は 60 年代前半の建設当初はプラスイメージをもって受け止められていた。それが、東京再発見の機運とともに批判にさらされていくようになるのが 1980 年代以降、とりわけ小泉政権下で 2006 年に発表された「日本橋川に空を取り戻す会」の提言でピークを迎える。しかしその一方で、都市を「裏側」から眺めて愛でる、ある種のサブカルチャー的審美眼が首都高やその景観を「萌え」の対象とすることで、新たな価値も付与されることになった。順に、「『惑星ソラリス』（近未来）型礼賛」、「『三丁目の夕日』（懐古）型批判」、「『ブレードランナー』（サイバーパンク）型偏愛」とでも呼べそうなこれらの立場に関して、後二者の根がいずれも 1970 年前後の日本近代建築再発見の動向に象徴される新しい感性の誕生にあるとする指摘は説得的である。とりわけ「『ブレードランナー』型」に関しては、藤森照信や赤瀬川原平らの「路上観察学」的視点にその直接的なルーツを探れるわけだが、そのこと以上に重要なのは、表面的な二項対立を超えたところで複雑に作用する、より大きな同時代的感性のダイナミズムである。

　渡辺の近作を前後に置いてみると、『感性文化論』のスタンスが一層明らかになるようだ。音楽からははみ出しつつも音の問題の周囲を旋回する『サウンドとメディアの文化資源学──境界線上の音楽』（春秋社、2013 年）から、ほぼ音の話が出てこないコンテンツツーリズム論『まちあるき文化考──交叉する〈都市〉と〈物語〉』（春秋社、2019 年）へ。とはいえ、これはある程度同時並行的に進められてきた仕事のまとめられた順序を示すものに過ぎないという側面も強いのだろうし、音への視点（聴取点か）が捨て去られようとしているなどとも到底思えない。過去と向き合うことによる現在の読み直しと、硬直した二項対立的思考からの脱却という主題は、その行間に音を響かせながら常に連続しているように見える。　　（長門洋平）

15

アンドリュー・シャルトマン

『「スーパーマリオブラザーズ」の音楽革命——近藤浩治の音楽的冒険の技法と背景』

Andrew Schartmann, *Koji Kondo's Super Mario Bros. Soundtrack*, Bloomsbury Academic, 2015
（樋口武志訳、DU BOOKS、2023 年）

家庭にやってきたゲーム・サウンドトラック

　150 ページほどの小型本で音楽アルバム 1 枚を論じるブルームスベリー・パブリッシングの「33 1/3」シリーズに、任天堂の近藤浩治が作曲した「スーパーマリオブラザーズ」（任天堂、1985 年）のサウンドトラックが取りあげられた。シリーズは 100 冊を超え、マニアックな名盤も多く取りあげられているが、ゲーム・ソフトをアルバムに見立てたのは同書が初めてだという。とはいえ、ヴィデオ・ゲームのサウンドトラック研究はすでに英語圏で著作や論文がいくつも出版されているし、日本でも岩崎祐之助がファミコンからスマートフォンまでをたどる『ゲーム音楽史——スーパーマリオとドラクエを始点とするゲーム・ミュージックの歴史』（リットー・ミュージック、2014 年）を書いている。そんななかで、短くまとまった同書はゲーム・サウンドトラック研究の入門書として読めそうだ。「スーパーマリオ」なら実物なしで音を思い浮かべられる人は多いだろう。

　音楽書のシリーズだからか、シャルトマンはまずヴィデオ・ゲームの歴史や 8 ビット音源などの文脈を丁寧に説明し、必要があれば五線譜を使って近藤の作曲法を解説していく。シャルトマンはブラームスやベートーヴェンに関する論文を発表している音楽学者であり、同書に先立って著作『マエストロ・マリオ——任天堂はいかにヴィデオ・ゲーム音楽を芸術にしたのか』（Thought Catalogue, 2013）を発表している。

　近藤の独創性を音楽ファンに伝えるために、シャルトマンはゲーム・サウンドトラックの歴史における「スーパーマリオ」の位置を際立たせようとした。これが結果的に、彼の議論にゲーム・サウンドトラック研究を超えた意義——技術がいかに

家庭に入っていくのかという問題に対する寄与──をもたらしている。このことは同書の論旨を紹介してからあらためて説明しよう。

　シャルトマンは同書第1章を意外にも、1983年に起きたいわゆる「アタリ・ショック」、北米家庭用ゲーム市場の崩壊を説明することからはじめる。この事件を最初にもってきた理由はおそらく、アーケードから家庭へとゲーム市場が移りかわっていくときの紆余曲折を印象的に描き、そのなかで革新的な家庭用ヴィデオ・ゲームとして「スーパーマリオ」が登場したことを強調したかったからだろう。シャルトマンは近藤の作曲法の特徴をアーケード・ゲームのサウンドトラックと比較しながら説明していく。彼によれば、アーケード・ゲームの音の主な役割はゲーマーの関心を集めることと、プレイの背景を埋めることだった。これはアーケードという環境のなかでは理由のあることだ。一方、シャルトマンは近藤が「スーパーマリオ」サウンドトラックに次の二つの機能をもたせようとしたと指摘する。一つはゲーム世界の明確なイメージを作りあげること、もう一つはゲーマーの身体的・情緒的経験をより深めることである。

　第一の機能のために、近藤はゲーム内の二つの世界のBGMにはっきりした区別をつけていった。二つの世界とは、地上・水中の開かれた世界と地下・城内の閉ざされた世界である。シャルトマンは近藤がいかにさまざまな方法でこの区別をつくりだしたかを具体的に語っていく。調性、リズム、沈黙などのあらゆる音楽的要素がこの区別のために工夫されているという。

　第二の機能はややわかりづらいので、シャルトマンはまず「スペースインベーダー」（タイトー、1978年）の加速するBGMを例にとる。音によってゲーマーに緊張感をもたらすこの演出は、「スーパーマリオ」にも取り入れられた。シャルトマンは近藤がこうした演出を画期的に洗練させたと考える。その代表例の一つが、ゲーマーに自発的に「動きたい」と思わせる地上BGMだ。任天堂ホームページに掲載された近藤自身による解説を参照し、また五線譜を示しながら、シャルトマンは地上BGMがいかにゲーマーとキャラクターを身体的・情緒的に結びつけるのかを語る。

　シャルトマンによる「スペースインベーダー」と「スーパーマリオ」の比較やアーケードと家庭の対比をめぐる議論は、ゲーム・サウンドトラックが家庭にもちこまれたときにどんな革新が起きたのかを教えてくれると言えそうだ。近藤浩治による「スーパーマリオ」サウンドトラックの場合は、世界や物語がより明確に表現されるようになり、ゲーマーとキャラクターの結びつきがさまざまなかたちで演出されるようになった。シャルトマンがどこまで意識しているのかはわからないが、家

庭にもちこまれるというこの状況は、技術の歴史にとってごく一般的な論点である。例えば、カリン・ベイスターフェルトとアナリース・ヤコブスは論文「音の追憶を保存する——多様な場面にわたるテープ・レコーダーの家庭化」（カリン・ベイスターフェルト、ホセ・ファン・ダイク編『音の追憶——オーディオ技術、記憶、文化実践』Amsterdam University Press, 2009）で、テープ・レコーダーの普及について論じるために科学技術研究における「家庭化（domestication）理論」を参照している（なお、domestication は「家畜化」とも訳される。動物の家畜化や人類の自己家畜化については日本語でも多くの著作がある）。技術の家庭化をめぐる議論として読むことで、シャルトマンの議論はゲーム・サウンドトラック研究にとどまらず、さまざまな技術とゲームを比較する際にも参考にできるのではないか。例えば、コンピュータのパーソナル化をめぐる古典的な著作にシェリー・タークル『インティメイト・マシン——コンピュータに心はあるか』（西和彦訳、講談社、1984年）がある。同書は「テレビゲーム」にも章を割いている。

　技術の家庭化という観点から読んでいくと、「スーパーマリオ」の効果音に関するシャルトマンの考察がひときわ面白くなる。というのも、彼はこの効果音の意外なところにいわばアーケード文化のなごりを見つけているからだ。

　「スーパーマリオ」は効果音もやはり洗練されていて、世界観やゲーマーとキャラクターの結びつきを確立する重要な要素になっている。シャルトマンはこのことを、効果音をいくつかの「ファミリー」に分類しながら説明していく。まず、ブロックの破壊音のような、現実を模倣する効果音のファミリーがある。次に、動作に付けられた非現実的な効果音のファミリーがあり、ジャンプの音などがこれにあたる。この音は、細馬宏通が『ミッキーはなぜ口笛を吹くのか——アニメーションの表現史』（新潮社、2013 年：☞本書 46-49 頁）で論じていた、ミッキーマウスの動作にともなう効果音、いわゆる「ミッキー・マウジング」と同じもので、動作を強調することでキャラクターに生命を与える機能をもつ。シャルトマンによれば、ゲームの効果音はカートゥーンから多くのことを学んでいる。

　ミッキー・マウジングに現実感がともなうのは、キャラクターの動作と効果音の動きがゲーマーの日常の経験を通じて結びつくからである。シャルトマンはこのことをジョージ・レイコフとマーク・ジョンソンの「身体化された認知」理論から解説する（レイコフ、ジョンソン『レトリックと人生』（渡部昇一、楠瀬淳三、下谷和幸訳、大修館書店、1986 年）参照）。ジャンプの音が上昇音であることが説得力をもつのは、ゲーマーの現実の経験のなかで高い位置と高い音が一般的に結びつい

ているからだ。豆の木が伸びる音が上昇音で、クッパが溶岩に落ちる音が下降音なのも同じ理由からである。「スーパーマリオ」のミッキー・マウジングはこうしたルールに厳格なために、統一感があり、一つの世界の表現に貢献している。

　ところが、このルールに従わない非現実的な効果音がある。旗を降ろすときの音がそうだ。旗は下降するのに、音は上昇する。シャルトマンはこの例外的な食い違いをアーケード文化のなごりと解釈する。旗を降ろす動作によって得点が上昇するから、音は動作ではなく得点に対応している。この得点という要素は、世界や物語の一部というよりも、アーケード文化のなかでゲーマーが自己顕示するためのものである。「スーパーマリオ」のゲーマーは実際、物語の進行とは無関係に得点を追求することもできる。したがって、旗を降ろす効果音は「スーパーマリオ」が文化と市場が動いていく流れのなかにあることを示しているのだ。

　シャルトマンによる効果音の分類は先に紹介したものよりさらに細かい。彼はミッキー・マウジングの分類や、現実の模倣にもミッキー・マウジングにも入らない効果音も考察している。この最後のファミリーに含まれるファイアボールを投げる音、これもシャルトマンはアーケードのなごりと考える。クッパの炎とは違い、ファイアボールの音は現実の何にも似ていない。投げる動作とも関係がない。この音はむしろ「スペースインベーダー」に代表されるアーケード・ゲームの伝統に属している。シャルトマンによると、任天堂のゲームからはこのアーケードで生まれた発射音がよく聞こえるのだという。　　　　　　　　　　　（金子智太郎）

16

『ピピロッティ・リスト──Your Eye Is My Island ─あなたの眼はわたしの島─』

展覧会カタログ、京都国立近代美術館、2021 年

ミュージック・ヴィデオからヴィデオ・アートへ、 ヴィジュアル・ブックという翻訳のあり方

　ピピロッティ・リストが《エバー・イズ・オーバーオール》を発表したのは 1997 年だったが、19 年後にビヨンセは、このアイディアを盗用することでリストに最上級の賛辞を贈ることになる。2016 年のミュージック・ヴィデオ《ホールド・アップ》において、彼女は野球のバットで自動車のガラスを破壊している。リストに感想を尋ねたところ、「うーん、クールなオマージュかな」と言ってケラケラと笑った。「私がオノ・ヨーコやアートの世界に行き着いたのは、ポップ・ミュージックが窓を開いてくれたから。お返しをもらえて嬉しいです。バットじゃなくて花だったらもっと良かったけれど。意味が変わっちゃうから。いや、でもすごく光栄でした」(33 頁)。

　リストにとってその「窓」とはブラウン管 TV だったことは想像に難くない。というのも、テレビが放映するミュージック・ヴィデオは音楽を映像でプロモーションするという新しさを高らかに宣言する一方で、映像が音楽なしには決して成立しないという他律性があったからだ。それゆえに、他律から生じる逆説的な自由さを彼女は引き継いでいる。彼女の実質的なデビュー作である《わたしはそんなに欲しがりの女の子じゃない》(1986 年)では、ビートルズの「ハピネス・イズ・ア・ウォームガン」(1968 年)の歌詞の主語が「彼女(She)」から「私(I)」へすり替えられ、また男性の身体を舐め回すように触れる手を追う《ピッケルポルノ／ニキビみたいなポルノ》(1992 年)では、撮る主体としての「私」を獲得する。男性のものを女性である「私」のものへすり替えるのは、女性性の奪還というよりも、互いが互いの領域を侵犯し、一つに溶け合いたいからだ。

　映像にとって音楽とは遅れてやってきたものである。映画の歴史を顧みると、映像と音を同期して再生できるようになったのは、1920 年代に誕生したトーキー映画以降のことで、それまでは生演奏、弁士の語りなどの手法によって映像の隣で音はライブで流されていた。いっぽうで、音楽は自らを翻訳するメディアとして映像を機能させようとした。別の現実をたしからしく現出させようとすることで発展してきた映画とは異なり、動かないものが動いて見えるような「見立て」を生んだゾートロープなどの原初の映像装置のもつトリックに注目することで、時間とともに流れて消えゆく音や音楽の視覚化への挑戦が可能となった。

　たとえば、ナムジュン・パイクは《グローバル・グルーヴ》（1973 年）で世界中のグルーヴを一つのテレビの中に詰め込み、別々の場所に散らばった人々が同時に作品を鑑賞できるようにすることで、テレビを小さな地球に見立てた。作曲家であるジョン・ケージに私淑した彼がヴィデオという表現を獲得したのは、テレ・コミュニケーションをアートの中に組み込んで、私たちは一つの市民であると主張するためだとも、音楽がもつ時間性を視覚化させるためだとも言える。彼にとっての窓は世界を見るための窓で、こちらもあちらも同質の情報を手に入れることを期待する大きな窓だった。しかし、パイクと同様に音楽が出発点にあったリストは窓をそのようにはとらえていない。彼女の窓はこちらとあちらを明確に分けながらも、お互いがお互いを気にしてチラチラ覗き合うすりガラスの窓なのだ。

　彼女はヴィデオがもつマテリアリティを手放すことができなかったアーティストでもある。ヴィデオを撮り、映されるまでに必要なハードウェアを重視した作品を制作し、それは鑑賞者が没入したくてもどうしてもできない境界線のように機能してきた。彼女の作品は誰にとっても開かれ、閉めることもでき、なんだったら割ることだってできるが、容易に忍び込むことはかなわない窓のような構えで私たちを迎える。《わたしの海をすすって》（1996 年）は、部屋のコーナーを中心として二つの壁面に投影された映像インスタレーションである。水の中をたゆたう男女、海の青さと透明さを背景に沈んでいくさまざまな色鮮やかなもの。その背景で流れるのは共同制作者であるアンダース・グッギスベルグとカヴァーしたクリス・アイザック「ウィキッド・ゲーム」（1989 年）であり、途中から遠くから聞こえてくるリストの叫びながら歌う声とユニゾンしてゆく。私たちは彼女の映像を観て、絶対に水がこちら側へ流れてこないと安心しているが、あちら側の遠くからは叫ぶ女の歌声も聞こえる。本作品において音楽は奥行きを生み出すことで、こちらとあちらを隔

てる壁を打ち壊して一つにしようとする効果を担っている。音楽の上に映像が乗っかって一つに融合したミュージック・ヴィデオのように、彼女の作品も既存のものや価値観に上書きをすることで、そのもの全体を獲得し、一つに溶け合う過程をテーマにしている。それは作品が実際に立ち上がる技術的な面においても、彼女の作品のコンセプトにおいても同様であり、その不可分な関係性を結ぶことで彼女はヴィデオ・アートの新しい可能性を開拓したのである。

　日本の美術館では13年ぶりとなるピピロッティ・リストの個展開催に合わせてつくられた同書は、ヴィデオをカタログという動かないものへ翻訳するときに何が必要かを示してくれる。同書は彼女の作品イメージをコラージュ的に張り巡らせるコンセプト・グラフィックのパートと、論考や作品情報などのテキストが所収されたパートの二部構成となっており、別々に製本されたものがゴムのバインダーでまとめられている。言葉とヴィジュアル、伝える情報の質をまずは一旦切り離してしまうカタログデザインは、展覧会カタログにおいてよくある手法だ。ヴィデオ・アートを動画以外の方法で再生することが十全たる再現とはなりえないとしたら、ヴィデオ・アーティストであるリストの作品や展覧会の記録を別のメディウムが担う時に、彼女の作品と彼女自身のどのような側面が注視されるべきなのだろうか。
　《溶岩の坩堝でわれを忘れて》（1994年）は、10cm四方に満たないほどの小さなモニターを床に埋め込むかたちで展示される作品である。カーペットの裂け目から覗く溶岩の中の女の主張はともすれば見つけられないし、忘れられてしまうし、踏まれてしまう。しかしながら、同書のなかで同作のイメージはズームアップして掲載され、鑑賞する人々とその作品の縮尺は正確ではないものに編集・加工している。リストは作品が機能するためにそれぞれの展示会場にふさわしい映像サイズを選択するが、同書における作品サイズの縮尺の変更やコラージュは、作品をより明瞭に見せるとともに、映像という多動なものにたしかに宿る作品のマテリアリティを静止画としてあらわす翻訳を行う。過剰なまでに画像に画像を重ねるヴィジュアルブックは、彼女の映像イメージの再現でありながら、作品や展覧会を通じた彼女の態度も表現する。その態度がどのように育まれてきたのかは、テキストブックによって知ることができる。
　同書では、リストの展歴や主要参考文献などの他に、本展を企画した京都国立近代美術館主任学芸員、牧口千夏による「「ピピロッティ・リスト——Your Eye Is My Island」展について」、カルヴィン・トムキンズ「ピピロッティ・リストの色鮮やかな世界」、マッシミリアーノ・ジオーニによる「水面下の愛」の三つの論考が掲

載されている。牧口は本展と同書の構成を紹介しながらも、リストにとって美術館がどのような場所であるかを企画者の立場から語る。ジオーニは、彼女の作品を複数点取りあげ、西洋美術史の文脈の突端に彼女を位置づけ、彼女の作品が美術館や西洋美術史にとって重要であることを補強する。その一方で、彼らの言説は未だに鑑賞することが視覚を中心としたものであることを示してもいる。しかし、ヴィデオ・ワークスの背後にあるものとしてしか彼女の音楽は評価することはできないのか、と言われたらそうではない。トムキンズはリストの世界を形成した彼女のキャリアをまとめることで、音楽がどのように彼女の世界に影響を与えたかを度々指摘する。レ・レーン・プロシェーヌというガールズバンドでの活動を並行させていたことや、「アートの世界では珍しく、動画と音楽に有機的な統一性を与え」（32頁）たという評価がなされていることを紹介することで、彼女の人物像に私たちが想像する「アーティスト」という肩書き以上の奥行きを生む。

　リストがアートに踏み込みジャンプする過程で重要だったポップ・ミュージック、ことさら、バンドミュージックは、四方八方に霧散する「わたしたち」の関心ごとをたゆたいながらも一つに絡めてゆく。同書のブックデザインに施される製本テープや、リングノート製本など巧妙にチープとエレガンスのバランスを見極めるDIY的な細やかさは、彼女のハイアートとポップ・ミュージックの間をたゆたう態度へのリスペクトだ。トムキンズがリストに贈った賞賛のことば「複数の要素——浮かれた気分、サスペンス、タイミング、コミカルな暴力、アナーキーさ、そして愛くるしい音楽——が途轍もない完璧さで溶け合っている」（18頁）は同書においてもあてはまる。

<div align="right">（檜山真有）</div>

17

マシュー・ハーバート
『音楽——音による小説』

Matthew Herbert, *The Music: A Novel Through Sound*, Unbound, 2018

**奇想を通して紡がれるサンプリング
ミュージックのポテンシャルと限界**

　マシュー・ハーバートは90年代からドクター・ロキットやハーバートなどの名義で活動をつづけるエレクトロニック・ミュージック界の奇才である。アルバムごとに使うサンプルのソースに特定のテーマを設けたコンセプチュアルな作風や、オーケストラやビッグバンドを従えたいささか奇抜なライブパフォーマンスは、彼をある種のマッドサイエンティストのように見せる。しかし、その活動は単に奇抜であったり他の実践から異質であるばかりではなく、サンプリングという手法に対する高度な批評たりえている。

　そんなハーバートが発表した「アルバム」が、この小説『音楽——音による小説』だ。奇抜な、いわばノヴェルティ的な作品ではないかという予感は半分当たっていて、想像通りというか、物語によって読者をよろこばせるような類のものでは決してない。ただひたすらに、奇想に満ちたサウンドが言葉を通して記述され、前書きによれば全部でおおよそ1時間に及ぶとされる「アルバム」を形作っている。とはいえ、小説と呼ぶにも、あるいは音楽と呼ぶにも似つかわしそうもないこの長大な「文字によるアルバム」——副題は「音による小説」と名乗ってはいるのだが——は、単なるアーティスティックな気まぐれの産物などではない。サンプリングという手法、ひいてはそれによって形作られる音楽に対するステイトメントのごとく読むことも充分に可能だ。

　2000年にハーバートが発表したマニフェスト「P.C.C.O.M.（= PERSONAL CONTRACT FOR THE COMPOSITION OF MUSIC）」は、サンプリングを含む現代的な楽曲制作に、いささか不条理なまでの厳しい制約を課すものだった。サ

ンプルであれプリセット音源であれ、自分がつくりだしたもの以外のあらゆるサウンドの使用を堅く禁じる等々、マゾヒスティックとすら言える「縛りプレイ」が以降の彼の活動の中核に据えられることになる。加えて、その制約は2005年の「P.C.C.O.M. Turbo Extreme」ではより過激になる。ここで付け加えられた条項のなかでも彼の活動との関係でもっともわかりやすいものは一番目の項目だろう。

　　一、トラックの主題が決定されたあとは、そのトピックに直接関係のあるサウンドのみ使用されうる。たとえば、もしそのトラックがコーヒーに関するものならば、次のようなサウンドが含まれうる。コーヒー農場主とその縁者によってつくられたサウンド。カップやスプーン。ミルク。コロンビア、等々。（拙訳）

　この条項はすぐさま、それに先駆けて「P.C.C.O.M」のころに発表された人体から採取したサウンドをフィーチャーした『Bodily Functions』（2001年）であるとか、あるいはその後のよりコンセプチュアルな一人の人間、一つのクラブ、一頭の豚をモチーフにした一連の「ONE」シリーズ（『ONE ONE』『ONE CLUB』（ともに2010年）、『ONE PIG』（2011年））を想起させる。こうした「縛り」をもってしてなお、これらの彼の作品がすこぶるポップに響くことは驚異的である。
　しかし、彼の作品のそつないエレガントさは逆説的に次のようなことを明るみに出す。それは、サンプリングに限らずレコードなりCDなりにサウンドを詰め込んでいく、という過程こそが最大の制約なのではないか、ということだ。私が個人的によく引き合いに出す表現として、「ミックス（ダウン）は社会性」という細野晴臣の金言がある。いわずもがな、録音物として市場に流通させるためには特定の規格に適合するようにチャンネルを整理し、長さを切り詰め（あるいは引き伸ばし）、それ相応の音質なり音量、あるいはダイナミックレンジへと収める必要がある。製品として完パケすることと、作り手自身がスタジオのなかで完成を意識することには埋められない溝がある――あるいは頭のなかで鳴っている音楽と、完成したそれとの間にも同じような溝があるかもしれない。

　実際、2015年に行われたインタビューでハーバートは本作執筆の動機を次のように語っている。

　　僕がこの世界のサウンドをどうとらえているのかを要約したようなものというか。ただ最近になって、そんなサウンドを、リアルな実生活の中で、自分の

生きているうちに音を用いて表現するのは不可能だと気づいたんだ。そうであれば、想像しているサウンドを言葉を駆使して表現するのが唯一の選択肢だと思ったのさ。

『LIFE IN A DAY 地球上のある一日の物語』（2011 年）という映画の音楽に僕は携わったんだけど、そこでみんなの〈お気に入りの音〉というのを使いたくて一般募集することにした。それで集まったものを、試しに一斉再生してみたんだ。実際に音を出してみようか（屈んで PC を取り出し、iTunes を操作しだす）。これから鳴らすのは、465 人分の〈お気に入りの音〉を同時に鳴らしたものだ。それは僕にとって、世界が僕らを滅ぼそうとしている音に聴こえるんだよ。

これでたったの 465 人分だからね。地球上には何億人も住んでいるわけで、彼らをみんな集めて、同じことをやってみたらどうなるんだろう。その音は想像することはできても、楽器やコンピューターでは表現しきれるはずもない。だから言葉で書くしかなかったんだ。（小熊俊哉「ハーバートが音楽を語る――ジャズとクラシック、『Bodily Functions』と『The Shakes』、想像のサウンドを記した自著」Mikiki、2015 年）

『音楽』の冒頭に収められた「前奏曲（prelude）」は、太平洋のどこかに口を開けた海溝の奥深くに設置されたマイクと聴音機、そしてスピーカーから発される音の描写から始まる。それは理屈でいえば不可能ではないにせよ、実現することはほとんど不可能な未知のサウンドの世界を想起させる。そして、このシステムで鳴らされるのは世界中から採取される眠る人びとの様子であり、実は地球外のなにものかがただ一つ目覚めたまま、これらに耳を傾けていることが示される。ここまで手のこんだ SF 的なギミックが登場するのは「前奏曲」と終章の「ディミヌエンド（Diminuendo）」くらいだが、世界中のあらゆる場所で並行して生じては消えてゆくサウンドをあたかも地球外の超越的な場所から聴取するかのような描写は同書に一貫している。サンプリングという手法、あるいはそもそも録音技術一般がもたらす聴取の経験は、同時には存在しえないものが媒体の上で共存してしまうことによってもたらされる不可解さを伴う。その戯画として卓抜した導入と言えよう。
　とりわけ、さまざまな来歴をもち、地理的にもスケール的にも隔たった多種多様なサウンドの列挙は重要な意味をもつ。それは、互いに無関係なものの遭遇というシュルレアリスト的な奇想と同時に、世界におけるサウンドの遍在を強く示唆する

からだ。これだけ執拗な記述によるマキシマリズムをもってしても同書はあらゆる可能なサウンドを包摂するには至っていないように思える。となれば、ハーバートが常に制作にあたってなんらかのモチーフを設定し、「P.C.C.O.M.」のような制約を自らに課すことも理解できる。あまりにも過剰にサウンドがあふれているなかでなにを選び取るかに意義をもたせることは、制作の別のプロセス——作曲、加工、アレンジ等々——にリソースを割くことにもなる実利的な側面もある。

　そして、主題を設定することはすなわちサウンドに文脈を担わせること、少なくともそう明示することにつながる。『音楽』では、あらゆるサウンドが固有名詞やアイデンティティ・ポリティクス、あるいは社会問題を示唆する文脈と結び付けられ、サウンドのマキシマリズムとともに意味のマキシマリズムも志向されている。今日のポップ・ミュージックに何気なくサンプリングされる具体音もまた実際にはこうした意味の過剰に晒されうるし、ハーバートはまさにそうしたサンプリングミュージックの文脈形成能力を社会批評や政治的プロテストにも接続してきた。しかし同時に、同書にみられる文脈への志向は、サウンドのみ提示されただけでは感取できないものでもある。それはあたかも、サンプリングによってその音の来歴を作品に組み込もうとしても、サンプリングという行為は不可避的にその来歴を切断してしまうというアンビバレンスが描かれているようでもある。サウンドが背後に従える文脈の雄弁さと、サウンドそのものの物言わぬ空虚さの両面が逆説的に浮かび上がる。

　破壊的なまでの騒音を感じさせる第11章「モデラート（moderato）」のクライマックスはその点で興味深い。ここでは、それまでもっぱら不定冠詞のついた「とある○○（a/an xx）」たちの放つサウンドの集積であったものが、いつしか「すべての○○（all/every xx）」によるサウンドの列挙に変わる。内容も徐々に平和や理想的な世界へと漸近し、さらにはダンスフロアや各々の場所で人びとが音楽を分かち合い享受する瞬間へとフォーカスしていく。このクライマックスはちょっとクドいほど感動的に思えた。ハーバートの頭のなかで鳴っているサウンド、そのサウンドが彼のなかに描き出すヴィジョンの描写として、あまりにもしっくりくる。

　演奏され、録音物のなかにつめこまれたサウンドは、この世界に満ちるサウンドの総体へとイマジネーションを跳躍させるにはあまりに寡黙である。思いを馳せることによってのみ到達しうるサウンドへの傾聴がありうる、という例示として、同書は稀有な体験をもたらしてくれる。相応の辛抱強さがなければ通読するのも難しいが……。

<div align="right">（imdkm）</div>

18

ジェームズ・ブラクストン・ピーターソン
『ヒップホップ・アンダーグラウンドと
アフリカ系アメリカ文化──表層の下へ』

James Braxton Peterson, *The Hip-Hop Underground and African American Culture: Beneath the Surface*, Palgrave Macmillan, 2014

来るべき「アフロ・マニエリスム」に向けての試論

　同書を掻い摘んでいえばヒップホップをめぐる「地下」のテーマ批評で、この主題を選び取ったこと自体、G・R・ホッケが「精神史的洞窟学^{スペレオロギー}」と綽名したマニエリスム──硬直した古典・合理主義に対する暗号的・韜晦的・反抗的身ぶりをもった綺想──へこの音楽ジャンルを導くものだといえる。他に類書のない画期的な一冊なのだが、当の著者がこの本の真のポテンシャルに気づいていないので、以下書評の体裁をとりつつマニエリスムという切り口を設けて、同書のもつ隠された次元にも触れていきたい。

　19世紀アメリカ、白人主人から南部黒人奴隷たちを北部自由州やカナダに逃がした秘密組織に「地下鉄道」があった。「鉄道」というもののそれは隠語であり、実際に逃げる手段は徒歩や馬車だった。その際に奴隷制度反対論者たちは、逃がし屋を「車掌」と呼んだり、黒人の隠れ家を「駅」と読んだり、暗号を駆使して追手の目をかいくぐった。こうした「黒の修辞学」（ヘンリー・ルイス・ゲイツ・Jr.）こそが黒人文化の本質であるとし、ピーターソンは地下鉄道からアンダーグラウンド・ヒップホップまでを貫通する巨大な根^{ルーツ}を掘り起こそうとする。

　同書に導入されたこの「地下鉄道」のメタファーが、ヒップホップの世界ではコンシャス・ラップの代名詞程度に貶められていた「アンダーグラウンド」のもつ意味合いを賦活する。たとえばピーターソンの師匠にあたるマーシリエナ・モーガンの『ザ・リアル・ヒップホップ』（Duke University Press, 2009）では、L. A. ベイエリアに限定的な地下活動としての「プロジェクト・ブロウド」をあつかうのみであるが、ピーターソンにとってのアンダーグラウンド概念は地下鉄道のように全国津々浦々に張り巡らされた「リゾーム」状のものであり、こうした地理的な限定は

意味をなさない。あるいは「地下鉄道」とはその「移動性」を特徴とし、黒人主体の絶えず変容するアイデンティティのメタファーともなるのである。そのあたりのピーターソンの認識は、アレックス・ヘイリー原作の『ルーツ』（黒人奴隷時代の話に始まる大河小説）のTVヴァージョン（1977年、リメイク2016年）が米国で驚異の視聴率を叩きだしたことに触れ、(根っこだけに) 黒人の地下空間が地理的に一挙拡大されたと見なすマクルーハン風の綺想に現れているだろう。

　こうした革新性を随所に示しつつも、ピーターソンの「アンダーグラウンド」理解は基本的に師匠モーガンに忠実で、逃走（flight）、闘争（fight）、自由（freedom）という奴隷制以来の黒人解放運動の古典的なまでの三大スローガンに結びついている。黒人文化の「地下」概念を発掘（ディギング）するために、さまざまな文学テクストからヒップホップの楽曲まで、引用され分析される。リロイ・ジョーンズの『ダッチマン──奴隷』（邦高忠二訳、晶文社、1969年）という黒人男性と白人娼婦の「地下鉄」を舞台にした罵り合いから殺人に至る戯曲や、「地下」で発掘される巻物にヒップホップの奥義が記されていたという魅力的な書き出しで始まるサウル・ウィリアムズ『デッド・エムシー・スクロールズ』（MTV Books, 2006）など非常に気の利いた素材が選び抜かれている。

　さまざまな「地下」を舞台にしたテクスト群からヒップホップにおける黒人アイデンティティー及びそのアンダーグラウンド概念を考えていくといった手法を取ることからもわかるように、ピーターソンが追いかけているものは音楽／文学といった領域感覚を越えた地下の「黒い精神史」である。それゆえピーターソンは、デ・ラ・ソウルらを代表とするネイティブ・タンというヒップホップ集団の名前の響きに、リチャード・ライトの『アメリカの息子（A Native Son）』（橋本福夫訳、早川書房、1972年）、およびそれに対するコメントであるジェームズ・ボールドウィン『アメリカの息子のノート』（佐藤秀樹訳、せりか書房、1968年）などの引喩（アリュージョン）を読み込む。こうした高度に韜晦的な引喩を駆使するインディー・ヒップホップの暗号的想像力こそが、オーバーグラウンド・ラップのマッチョ一辺倒の視覚的優位を転覆させるものだとピーターソンは説く。

　暗号的想像力という点で行けば、グレイヴ・ディガズの「ザ・ナイト・ジ・アース・クライド」（1997年）の謎めいたミュージック・ヴィデオをファイヴ・パーセンターズの教義に照らし合わせて解説するなど、同書ではナズなどの有名ラッパーも加入するこの謎の「地下」組織にも筆が及んでいる。ファイヴ・パーセンターズはネイション・オブ・イスラムの分派で、グループはその信仰の基礎を、ブラック・ムスリムの伝統、古代エジプトのシンボリズム、フリーメイソンの神秘主

義、グノーシス主義の精神性に置いている。彼らは「ゴッド・ホップ」の力を借りて、人々を改宗させ、関連のある問題を批評し、新たな構成員を勧誘する。「シュプリーム・アルファベット」や、リリックを代数学のように組み合わせる「シュプリーム・マスマティクス」といった、ほとんど数秘術めいた暗号学を駆使するこの秘密結社こそが、ヒップホップ文化をアフロ・マニエリスムに位置づける骨子だと言える。

また『ヒップホップ・アンダーグラウンドとアフリカ系アメリカ文化』はラップ一辺倒であるようでいて、『メイキング・ビーツ』（Wesleyan University Press, 2004）の著者であるジョゼフ・シュロスが推薦文を寄せていることからもわかるように、「地下」のテーマでビートメイカーにも筆が及んでいる。ギャングスタの DJ プレミアによる、その入り組んだ引用の織物と化したトラックを指してピーターソンは「秘密の、ヘルメス的世界」などと形容している。たしかにその易々と出典を開示しないアンダーグラウンドかつ秘教的な姿勢はマニエリスムの典型的な韜晦の身振りである。ましてや、この「チョップ」なる技法を開発した DJ プレミアという人物は、大学でコンピュータ・サイエンスを学んでいた理工系であり、そのようなダイダロス的人物が「ギャングスタ」なるディオニュソス的名前のユニットに所属しているパラドックスがあるのだが、こうした分裂にこそ豊かなマニエリスムは宿るのである。

最後にアフロ・マニエリスムの問題系をすこし離れ——同書が文学・言語学の知見にあまりに依っていて、鳴っている音楽そのものへの関心が低いことへの解毒剤として——同書の「聴取」を問題にした分析箇所を強調して終えることにしよう。5 章「アンダーグラウンドの暗号」～6 章「死者のための涙」の流れがその意味では同書の白眉だろう。ラルフ・エリソンによる黒人文学のカノン『見えない人間』（上下巻、松本昇訳、白水社、2020 年）における、ルイ・アームストロングの音楽を蓄音機五台がかりで同時に鳴らしてそのヴァイブスをからだ全体で感じたいという文章記述について、ピーターソンはレコード再生にはない、蓄音機再生ならではの幽かな音の揺らぎがグルーヴを生むことを予測し、この地下室に生きる「見えない人間」に複数のターンテーブルを駆使するヒップホップ DJ の役割を読み取る。

6 章はその議論を引き継いで、この『見えない人間』を作品中に引喩したモス・デフ（ラッパー）～ジェフ・ウォール（写真家）の系譜へと話をつなげていく。とりわけジェフ・ウォールの《「見えない人間」以後》（1999-2001 年）という写真作品に漂う「暗示された音楽」——すなわちエリソンの小説で描写された、孤独な地下

室で鳴り響く、ルイ・アームストロングを蓄音機五台で同時再生したDJプレイ――
――を聴取する内省的かつ地下的な作業に取り組むことが、オーバーグラウンドの黒
人マッチョ・ヒップホップの視覚的イメージの氾濫への対抗策になりうると、ピー
ターソンは語る。どういうことか？　文化史家フレッド・モーテンが言う所の「音
の本質」や「音の物質性」なるものを一枚の写真から抽出し、黒人文化のコンテクス
トをおさえたうえで、抑圧されてきた黒人たちの泣き声／叫び声にまで思いを馳せ、
写真を聴覚的に「体験する」ことである。つまり白人女性に口笛を吹いただけで惨
殺された黒人少年エメット・ティルのビフォーアフターの写真（識別不可能なまで
に顔をズタズタにされた死体は母親の意志で公開された）をただ「見る」のではな
く、隙間に入り込み、その口笛を「聞く」こと、そして「体験」することが、聴取
を立体的なものにする。音楽史をただなぞっているだけ、ましてや平面的な聴取で
事足れりとする表層批評の立場では、決して聞こえてこない「音」があるというこ
とだ。

　ワイリー・サイファーが名著『文学とテクノロジー――疎外されたヴィジョン』
（野島秀勝訳、白水社、2012年）で説いた、西洋視覚中心主義がもたらした「疎外
されたヴィジョン」に対する、「アフロ・メセクシス」とでも名づけるべきブラッ
ク・カルチャーからの回答がこれだ。文学・音楽・写真のクロス・レファレンスを
通じたコンテクスチュアルかつインターテクスチュアルな立体的＝精神史的聴取が
あって初めて、その場に鳴っている音だけを聴取することがもたらす世界からの疎
外から逃れることができるだろう。　　　　　　　　　　　　　　　　（後藤護）

第 5 章
電気になった声の世界
ボーカロイドのオラリティとは

　初音ミクが 2007 年に登場し、ボーカロイドという音楽ジャンルが生まれたことは、声とテクノロジーの関わりをめぐる 2010 年代の議論を活気づけた。柴那典が『初音ミクはなぜ世界を変えたのか？』のなかで指摘するとおり、この動向はアニメやネットの文化だけから語ることはできないだろう。それならば、この音楽ジャンルと結びつく文脈を、柴が参照した第二次世界大戦後の文化や社会すら超えて、限りなく追いかけたらどうなるのか。増野亜子『声の世界を旅する』とケリム・ヤサール『電気になった声──電話、蓄音機、ラジオがいかに近代日本をかたちづくったのか 1868–1945』は、まったく別の方向に進んだ、そうした壮大な試みとして読める。本書『音の本を読もう』では扱えなかったが、フランス現代文学が描いた声をめぐるアンソロジー『声と文学──拡張する身体の誘惑』（平凡社、2017 年）も、初音ミクに言及しながら、広大な声の文化を探求する。ボカロ以外の電子の歌声に関心があるなら、国際的なダンスミュージックシーンの内実を語るジェイス・クレイトン（DJ／Rupture）『アップルート──21 世紀の音楽とデジタル文化をめぐる旅』が、モロッコの女性歌手によるオートチューンの活用と地域の文化の結びつきを論じている。
　日本における電子音響技術の衝撃をめぐって多くを教えてくれる『電気になった声』は、戦前の日本における音声技術の受容の背景に、伝統芸能などに見られる「土着の口承性（オラリティ）」があると考える。口承性は声による表現のありかたであり、文字による表現（リテラシー）とよく対比される。ヤサールによれば、日本の学者は 17 世紀から中国との対比において、自分たちの文化は話し言葉が豊かだと見なしてきたという。では、西洋の音響技術がこの対比に割って入ってから、日本の口承性はどうなったのか。柴はボカロが J ポップにもたらした影響についても考察したが、このような議論は電子音響技術全般にどれだけ広げられるのだろうか。

19

柴那典
『初音ミクはなぜ世界を変えたのか？』

太田出版、2014 年

ある日突然「電子の歌姫」が誕生して、
未曾有の現象を巻き起こしたわけではない。

　歌声合成ソフトウェア・ボーカロイド（以下、ボカロ）の「初音ミク」が「世界を変えた」という挑発的なタイトルの同書は、綿密なインタビュー取材をもとにしてそのプロセスを描き出す。「この本は学術的な論考をまとめたものではなく、僕自身が体験した一つのドキュメントになっています」（293 頁）と音楽ジャーナリストである著者の柴那典が書くように、この本はソフトウェアが指揮を執る時代の音楽文化を取り上げた学術書というわけではない。しかし、当時のキーパーソンを適切に選定したインタビューや、音楽ジャーナリストならではの同時代に向けられた幅広い視野から、ボカロ音楽のブームをめぐる「音」と「声」に関する学術的な論点を見出すことは難しくない。また、当時の音楽産業をめぐる状況が著者の体験をもとに活き活きと記述されている点で、同書自体を学術的に取り扱うべき資料として見ることもできるだろう。

　一方で、ある種のオタク向けキャラクターでもある初音ミクを主題とする同書を、「音の本」ではないと感じる読者もいるかもしれない。しかし、著者が注意深く指摘するように、初音ミクとボカロをめぐる現象は、単にアニメやオタクやネットの文化だけには還元することのできない複雑さをもって生じたものである。言い換えると、2010 年代の音を考えるためには、楽器とソフトウェアの関係性、ネット文化と社会的制度、そこでのユーザーの振る舞い等について考える必要があるということでもある。同書はその複雑さについて数多くのインタビューを通して教えてくれる。

　こうして同書の目的は、初音ミク・ボカロを生みだしたインターネットと音楽の密な関係性を 20 世紀のポピュラー音楽史に接続し、ボカロを音や音楽に関する議論の対象として再配置すること、として設定される。何度も繰り返される、初音ミ

クは「ある日突然生まれてきたのではない」という記述からは、初音ミクを一過性
のブームとして消費することへの批判と、電子音声技術の系譜自体への着目を見て
取ることができる。同書は初音ミクが発売された 2007 年を区切りとする 2 部構成
になっており、初音ミク以前の展開を記述する第 1 部は、音と声の電子的技術の
歴史研究としても読むことができる。そこにおいて一見まったく別なものに思えて
しまうインターネットの文脈と音楽の文脈とを接続すべく動員されるのが、ポピュ
ラー音楽史において 60 年代と 80 年代の二度にわたって生じた「サマー・オブ・ラ
ブ」ムーブメントである。サマー・オブ・ラブは一過性のカウンターカルチャーで
はあったが、著者によればその本質は新しい音の技術が普及したことによる「遊び
場」の生成であり、後の音楽ジャンルにも時代を越えて影響を与えてきた。ボカロ
技術に対しても同様の見方ができること、さらにはコンピューターとインターネッ
トの技術と密着してきた電子楽器の系譜としてもとらえることができる、というの
が著者の立場である。この点については後述しよう。第 2 部からの描写は執筆当時
の記録としての性格が強くなる。特定の作家や作品に目を向けた記述は少しばかり
主観的なニュアンスが色濃く、鮮やかな文体は音楽雑誌記事的かもしれないが、そ
の生々しさは当時のドキュメントとして高い価値がある。

　さて、ソフトウェアでもありキャラクターでもある初音ミクを中心に置きながら
編年的に綴られる同書には、歌声合成技術の開発史から世界初のボーカロイドオペ
ラの記録まで幅広いトピックが登場する。ここからは筆者の関心に沿って論点を整
理し、現代の音の成り立ちを考えることにつながるものを三つだけ紹介しよう。
　一つ目は、電子的に合成された音を制御するソフトウェアの系譜という論点であ
る。インタビューを通じてヤマハによる歌声合成技術 VOCALOID エンジンの開
発史を辿るなかで、著者は初音ミクの登場以前になされてきた試行錯誤の蓄積を強
調する。デジタルシンセサイザーとサンプラーによる 80 年代以降の宅録の普及や、
MIDI 規格と DTM（Desktop Music）文化の広がりは、2000 年頃には「打ち込み」
による大抵の楽器演奏のシミュレーションを可能にした。その事実がさまざまな音
楽性を生みだしてきたのは周知の通りである。だからこそ、その歴史において「取
り残されていた」歌声が、ソフトウェア制御によって次にシミュレートすべき対象
とされたのだ。さらに、著者の見立てである初音ミクとサマー・オブ・ラブの接続
関係もこの系譜に見出される。60 年代北米西海岸におけるサマー・オブ・ラブの
爆発は、同地域でヒッピー文化とコンピューター文化の精神的基盤として作用し、
音楽のための技術と情報のための技術はサマー・オブ・ラブを共通の起点として世

界に向けて広がった。その系譜には遡ってモーグ・シンセサイザーや、ひいては電子楽器としてのボカロ・初音ミクを位置づけることができるはずだ。これこそが著者の主張のコアであり、電子的な技術を用いた楽器開発としてのボカロの文脈化を行う同書は、インタビューに依拠して記述されるという点でも、田中雄二『電子音楽 in JAPAN』（アスペクト、2001 年）の続編として読むことができるだろう。

　他方で、ボカロは単なる新しい DTM ソフトウェアというわけでもない。もう一つの論点は、キャラクターとしての初音ミクの流行現象を支えたネット文化の成立過程である。この論点はユーザーの振る舞いや著作権管理をめぐる制度設計に着目する文化史として描かれる。2007 年の初音ミク発売が突然世界を変えたわけではなく、その前からオンラインの「遊び場」がボカロ受容の培地として成立していた複雑さがあり、著者はこれを企業や作家へのインタビューから解き明かしていく。「ニコニコ動画」というプラットフォーム上での MAD 動画や「THE IDOLM@STER」動画の流行は、二次元バーチャルアイドルを「プロデュースする」様式を生みだし、「ボカロ P」による制作のあり方を規定した。また同時期に拡大したプロシューマー型の音楽文化である「同人音楽」も、ボカロ P による初音ミク作品の生産・消費地となった。こうして初音ミクを媒介とした N 次創作の連鎖が流行現象になると、「遊び場」は次第に「市場」へと再編成されていく。そこで問題になったのが、ソフトウェアとインターネットの組み合わせが引き起こす無秩序なコンテンツの循環に未対応だった当時の著作権管理制度である。たとえばネット文化に特有のアンチ JASRAC の姿勢は、ボカロ曲がカラオケ配信される際の著作権使用料の分配制度を機能不全にしていた。しかし、ボカロ楽曲を循環させたいと願うユーザーや各産業や JASRAC は協調して解決を模索し、結果として N 次創作をも取り入れた循環の仕組みを成立させた。つまり、ボカロの音が現実社会で実際に循環するためには、ネット文化や著作権管理制度の水準での変容も必要だったのだ。初音ミクの声が循環するための社会的な仕組みの生成プロセスを、同書は記録しているのである。

　最後に、ボカロがポピュラー音楽の音楽性に作用したという論点にも触れておこう。還元主義的な作家論や作品論に向かう危うさがないとはいえないが、同時代のボカロ作家やボカロ曲に幅広く目を向けながら音楽性の傾向を取り出す所作は、音楽ジャーナリストの面目躍如である。同書で「高密度ポップ」と名指されるボカロ曲の傾向（テンポが速く、譜割りが細かく、沢山の言葉が詰め込まれ、スピード感と情報量が過多な音）がそれだ。高密度ポップが生みだされた理由を著者は二つ挙げる。一つは、ボカロ曲が共有されてきたニコニコ動画のアーキテクチャによるも

のであり、コメントの「弾幕」に慣れた多動な視聴者の注意を惹き続けるためのギミックとして生みだされたこと。もう一つは、ボカロの DTM ソフトウェアとしての特徴／限界によるものであり、「息継ぎなし」の発声が可能なことや、そもそも歌唱力に関する情報量の少ない合成音声を有効活用するために楽曲自体の情報量を増やすしかなかったことだという。著者による楽曲の「密度」に関する指摘は、続く『ヒットの崩壊』（講談社、2016 年）でも繰り返され、2010 年代以降のアイドルソングにおける「過圧縮ポップ」の批評を展開している。ボカロ P 出身の作家によるヒットが目立つ昨今の J ポップの現実を踏まえても、ボカロの声を現在進行形のポピュラー音楽史に位置づけようとする観点は有効であろう。

　『初音ミクはなぜ世界を変えたのか？』という挑発的なタイトルではあるが、ここまで見てきた通り、著者はけっして初音ミクがポピュラー音楽史の世界を変える断絶をもたらしたとは書いていない。むしろ初音ミクは、コンピューターとソフトウェアが制御する電子音、オタク文化とも親密なネット文化におけるユーザーの振る舞い、そしてロックやテクノやヒップホップを抱えてきたポピュラー音楽、それぞれの歴史が切り結ぶ結節点として描写されている。繰り返される「ある日突然生まれてきたのではない」という記述が注意を向けさせるのは、変わってきた（いく）世界のなかで初音ミク・ボカロをどのように位置づけて理解するべきか、という著者の問題意識であり、同時にメディア技術史的な関心でもある。問いを解くために行われた著者による丁寧で幅広いインタビュー取材の成果からは、単なる新しい電子楽器でもなく、単なるオタク文化における表象でもなく、単なる音楽産業の歌姫でもない、多面的な初音ミクの姿が立ち現れる。つまり、歴史的な観点を踏まえたうえでソフトウェアの特徴やデータ通信の慣習やプラットフォームのアーキテクチャの作用にまで目を向けることなしには、現代の音／声の成立プロセスを把握することは困難だということでもある。同書によって示された論点を受け取り、学術的な立場から考察を加えるべきことは多くあるだろう。また 2010 年代のインターネットと音楽の関係性を記録した良質なドキュメントという点でも、同書には広く読まれる価値がある。

<div style="text-align: right">（日高良祐）</div>

20

増野亜子

『声の世界を旅する』

音楽之友社、2014 年

声でひもとく音楽のフィールド

　2000 年代後半から 2010 年代前半にかけて、音楽や歌についての論考の多くが、議論のなかで「ボーカロイドをどのように位置づけるか」という問いに向き合うこととなった。それは、ヒトの声が身体を経由せずに発せられることの目新しさそれ自体に原因をもつというよりは、それが当たり前になっていく過程に立ち会った研究者たちが需要にこたえた結果であるだろう。ボーカロイドを用いた音楽が現れた当時のムーブメントと、それが日本語で音楽をつくる・聴く者たちの耳に普及していくプロセスは、人間の「声」が身体と不可分であるということを自明視できなくしていった。それは、音楽やことばのみならず、口と耳を介したあらゆるコミュニケーションに携わる研究者たちにも、人が「うた」にもたせる意味を見つめ直させた時期であったのだ。「声」を切り口に、世界各地の音楽を通文化的につないだ同書もまた、そうした議論の一つである。泣き歌から子守歌、トーキングドラムやビート・ボクシング、歌垣など、多種多様な「声の文化」を旅して、最後に 2014 年当時のボーカロイドにおける身体の使い方を問い返すところに戻ってくる。そこでボーカロイドと対比されるのは、第十一章で詳述される、インドネシアの歌芝居・アルジャである。アルジャは著者の専門領域であり、声を通して物語中の人物に「なる」、声が非常に重要な意味をもつ芸能として取りあげられている。

　先に結論部を案内したが、同書は民族音楽学のたしかで豊かな知見に裏打ちされた、「声の文化」を横断する概説書である。民族音楽学全体を概観する入門書としては、同書の著者である増野亜子が編集し、徳丸吉彦が監修した『民族音楽学 12 の視点』（音楽之友社、2016 年）が、近年の研究成果をバランスよく配置しており、活用しやすいだろう。対して同書は、「声」に焦点を定め、それを切り口として個々の

事例を論じながら、それらをばらばらに切り離さず章ごとの検討内容に落とし込むという手法を取っている。民族音楽学に限らず、参与観察を伴うフィールドワークを主要な研究手法とし、調査で得られたデータにもとづいて論考をつむいでいく文化人類学や民俗学とその隣接領域では、研究成果は地域を限定したフィールドでの調査データにもとづいて報告されることがほとんどである。筆者があとがきで自ら明かしているように、同書のような、通文化的、かつ専門を横断して書かれながらも専門家の検証にたえる事例を網羅して、なおかつ読みやすさを保った本を作るのはかなり勇気のいる仕事である。しかし、サブスクリプションや動画投稿サイトの発展によってアクセスできる音楽が膨大になった現在、「何をどのように聴くか」は、真摯に音楽に向き合う個人にとって重大な問題であり、それを定める指針としての入門書の需要はこれまでよりも高まっているのではないだろうか。同書をその一冊たらしめているのは、執筆時点で世界最新の先行研究群と、一般読者でも入手しやすい音源・映像資料へのリンク集、そしてそれらを伝わりやすく表現する著者の力量であるだろう。

　『声の世界を旅する』は、「旅のはじめに」ではじまり、全11章と4本のコラム、そして最後に「旅の終わりに」が収録されている。第一章「思い通りにならない声をめぐって」は、身体から飛び出るくしゃみやあくびの「声」に着目することから出発し、自分のコントロールを超えた感情の表出として、フィンランド東部やパプアニューギニアの泣き歌につながる。第二章「ともに歌うということ」では、各地の合唱に焦点があてられる。台湾、グルジア、アルバニア、アフリカ中央部の事例を挙げ、それぞれの合唱のポリフォニー性を検討するとともに、その外郭を支える社会のジェンダー規範が合唱をどのように規定しているかが解説される。さらにトマス・トゥリノが提唱した「参加型パフォーマンスとプレゼンテーション型パフォーマンス」（同書の刊行後に出版された邦訳『ミュージック・アズ・ソーシャルライフ──歌い踊ることをめぐる政治』（野澤豊一、西島千尋訳、水声社、2015年）では「参与型パフォーマンス／上演型パフォーマンス」と訳されている）の枠組みを用いて、校歌・国歌が共同体をつくるさまに及ぶ。第三章「協調する身体」は、作業をする際の掛け声からじゃんけん、遊び歌など、日本の生活で身近な「声を合わせる」事例から、ニュージーランドの先住民マオリのハカや、一部が「ソーラン節」として知られるにしん漁の〈沖揚げ音頭〉、アメリカの囚人たちによる労働歌など、他人と共同で何かをするための歌の事例が示される。ソーラン節については、小中学校の運動会やよさこいソーランなどを通して馴染みがある読者も多いと思われる

が、実際に労働の場で歌われていた録音を NHK ウェブサイトの「みちしる」アーカイブスなどを利用して聴くことができる。

　ついで第四章「一人で静かに歌う歌」は、同じ仕事歌でも各地の子守歌にみられる音の響きや歌詞の分析を通し、自らに語りかける声という観点から、西アフリカの粉挽き歌につないでいく。第五章「のばして、揺らして、響かせる声」も一人で歌う歌なのだが、日本の石焼き芋売りの呼び声を例にとり、歌い手によって自在に伸縮するフリーリズム、日本でいうところのコブシ、専門用語でいうメリスマ歌唱法を用いた声の出し方に踏み込む。イランのアーヴァーズ、日本の声明、ロマの歌唱、モンゴルのオルティン・ドー、そしてオペラ・アリアを俎上に上げながら、歌い手によって揺らされる声を分析する。第六章「声とことばの魔術的な力」では、口にすることでその内容が現実味を帯びるというまじないや語呂合わせを導入に、痛み止めの呪文や、ムスリムの人びとが神の名を秘匿することなどを通して声がもつ力について論じる。第七章「ことばをもたない歌の力」は反対に、いわゆる歌詞をもたず、声のみで音を表現する創作した言語の響き（ジベリッシュ）や母音のみでうたうヴォカリーズ、そしてスキャットやビート・ボクシングなどの意味を伴わない声の表現について、第八章「楽器を歌う声、ことばを話す楽器」では楽器を習得する際の口三味線や唱歌、そしてアフリカに多く見られるトーキングドラムについて、それぞれ事例を挙げながら解説がつなげられていく。

　第九章「会話する歌、喧嘩する歌」では、歌をボールのようにやり取りするゲーム性、格闘性を軸に、歌を通して他者と意味のやり取りをする中国の白族の歌掛けやイヌイットの喉遊びなど、対人コミュニケーションとしての音が論じられる。対して第十章「ドリトル先生の声」では、家畜を呼ぶためのヨーデルや喉歌など、声を用いたヒトと動物とのコミュニケーションが論じられる。そして第十一章「声を演じる」は、バナナのたたき売りの声からはじまり、職業や役割として、そして役としての声を検証しながら、著者自身が行ったフィールドワークのデータを使いながら説明される、インドネシアの歌芝居アルジャにおける声の解題である。演じる場において、声は、それを出す身体だけのものではなく役柄の声として人格をもつ。そして人格をもった声についての考察が、冒頭で述べたボーカロイドのあり方に接続されて旅を終えるのである。

　『声の世界を旅する』では、本文の前に、それぞれの章がどのようにつながるかを示した関係図が記されている。第一章の導入は「身体と声」であり、その大きな枠組みが全体につながる。また、それぞれの章が、「みんなで歌う」（第二章・第三

章）「一人で歌う」（第四章・第五章）、「ヒトとヒト（第九章）」「ヒトと動物（第十章）」といった、対になる内容が隣り合う構成になっているほか、「声の持つ多様な力」、「歌うという行為の社会的側面」、「コミュニケーションとしての声と歌」、「響きの力」、「ことばを離れた音としての声（第七章・第八章）」といったトピックの有機的な連関が章を越えたまとまりを作り出している（8頁）。また、章の合間に4本のコラムが挿入されている。コラムは、筆者自身が旅を通して出会った声のエピソードが、短いエスノグラフィ（民族誌）の筆致で描かれる。いずれも、本格的なフィールドワークの記録というよりは旅の記録という体裁を取り、読み手であるわれわれが短期間の旅行で出会うかもしれない音と声を、民族音楽学者はこのように聴くのだ、というイメージを描きやすくなっている。一冊を通し、調査地で撮影された写真や各種の記譜法にもとづいた楽譜のほか、筆者本人の筆によるイラストも理解を深める一助になるだろう。

　そのなかで、第十一章末からコラム「声の動きは身体の動き」にかけてあつかわれるインドネシア・バリ島の歌芝居アルジャの事例では、著者自身が長年携わってきたフィールドワークの記録と分析を平易なことばで読むことができる。コラムには、著者の師匠が来日して実施したワークショップについての記述もある。フィールドでの師が自らの研究拠点でパフォーマンスや講演を行う瞬間に立ち会うことは、多くの駆け出しフィールドワーカーが大きな目標にする未来である。それを踏まえてこの部分を読むと、フィールドワークで築いた観察眼や、自らも演じ手としての経験をもつからこその着眼点、そして師匠への尊敬や憧れを含んだ筆致に気づくことができるだろう。

　また、コラム「器楽のざわざわ、歌の静寂」は、著者がアイルランドのパブで出会った伝統歌唱について語られている。にぎやかさを体現したような酒場にあって、楽器のセッションはざわめきのなかで奏でられ続けるのに、歌が披露されると一気に静まり返るシーンが印象的に描かれる。楽器との対比によって歌の特殊性が浮き彫りにされるのだが、このコラムをはじめ、徹底的に声だけを考察することによって、ヒトの声もまた、音を出す多種多様な楽器や音具の一つでしかない、ということにも気づかされるかもしれない。　　　　　　　　　　　　　　（辻本香子）

21

ケリム・ヤサール

『電気になった声──電話、蓄音機、ラジオがいかに
近代日本をかたちづくったのか　1868–1945』

Kerim Yasar, *Electrified Voices: How the Telephone, Phonograph, and Radio Shaped Modern Japan, 1868–1945*, Columbia University Press, 2018

音響技術と近代日本の成立の結びつきをめぐる考察

　日本語は英語に次いで電話線で送信された二番目の言語になった。アレクサンダー・グラハム・ベルが招いた二人の若い日本人学生、伊沢修二と金子堅太郎が新たな機械を通して挨拶を交わしたときのことである。19世紀後半に起こった技術革新は音の記録と伝達を可能にした。人類は音を捕捉し、再生産し、再生し、そしてアーカイブすることが可能になったのである。このとき生まれた新しいメディアは、私たちと音の関係に根本的な変化をもたらし、社会、経済、政治における音のあり方を永久に変えてしまった。しかし、国家のアイデンティティを形作り、ナショナリズムに火をつける活字メディアの働きに関しては研究が蓄積されてきたのに対して、音のこうした働きについてはごく最近になってやっと注意が向けはじめられたばかりである。人間と音の環境の関わりは明らかに歴史的、文化的に条件付けられている。グローバルな技術転換の網の目に絡め取られているとはいえ、音はしばしば特定の文化に特有の役割と意味をもっている。印刷が活字を通じて「想像の共同体」を作り出す力をもっていたのと同様に、音を記録、送信、再生する技術もまた、「近代日本」の創造に貢献した。ケリム・ヤサールが同書に記したように、音の記録と送信は近代の文化と技術における逃れられない革新であった。声が日本文化において歴史を通じて重要な役割と価値をもっていたことを示すことで、同書は、国家の空間の形成に関する技術の役割について、音の重要性を敷衍する独自の議論を展開する。比較的最近まで、歴史家は音に関してほとんど無視し、近代の経験の視覚的側面に焦点を合わせてきた。

　『電気になった声』は、音が共同体の社会的・慣習的活動にとって中心的な存在であるという前提から出発し、およそ百年間のあいだに音と近代日本の国家的空間の

つながりがいかにして生じたのかを説明する。この時代に電話や蓄音機、ラジオといった新しい「近代的な」技術が普及し、「出版資本主義」によってそれ以前に生じつつあった国家についての想像力に音を組み入れるプロセスに取りかかった。同書があつかう新しい技術は、1868年の明治維新が加速させた国家主導のイデオロギーの均質化を更に徹底させた。ヤサールは電話、蓄音機、そしてラジオがどのように日本人の音、そのなかでも特に声に対する関わりと理解を根本的に変えたのかを論じる。聴覚に対して視覚を優位におくことは、社会的・文化的活動に読む能力が欠かせないものになったこと、そして書くことと見ることが世界を理解するために必要不可欠であるという偏見が埋め込まれたことを意味する。また、この優位は、エリート的な視覚文化が文字をもたない「未開」の文化よりも優れていると考えてしまう傾向と階級意識の区別を支え、そうした傾向や区別を文字通り刻みこむのに役立った。同書は近代日本において「想像の共同体」としての国家がつくられるプロセスに音を置き戻すことで、近代性をめぐるこれまでより豊かな理解に向けた重要な一歩を踏み出している。

　ヤサールは、電話の到来を取りあげる第1章で、日本における声の役割について説得力のある主張を行い、日本文化にとって声と口述の優位性が重要であったこと、またそれが現代でも変わらないことを明らかにする。1600年代から、学者たちは日本を話し言葉の豊かな文化とみなし、「文字の豊かな」国である中国と対比してきた。この「土着の口承性」は、浪花節、弁士、歌舞伎や落語といった日本の芸能に明らかである。そして、ヤサールはこうした口頭の語りに対する衝動が戦前期を通じて重要性を保っていたことを指摘する（28頁）。それまでの想像を超えて声を遠くへ伝えることができる電話は、1900年に「呼び出し電話」が導入されるとすぐに流行した。このシステムは、電話線をもっていない人でも、電話交換局に行けば話したい人の近くにある電話交換局まで連絡することができた。電話局から相手に7日間有効の「呼び出し通話券」が送られ、通話券にはしばしば電話の予約時間が記された。統計によれば、サービスが始まった年に6000件を超える電話がかけられ、10年後には50万件、1930年代半ばには200万件へと増加している。これは電話の声がもつ不思議な力と楽しさによるもので、交換手が忙しいときには電話をかけるのに一時間かかることも珍しくなかったが、それも問題とはされなかった。伊沢と金子のベル研究所での体験から2、30年の間に、電話は日本の近代的な暮らしに欠かせないものになっていた。

　電話、蓄音機、ラジオ、これらの機器が「文明開化」の意味に関する議論と結び

114

つくことは避けられないことだった。しかしどこにおいても近代の経験の中心には
あいまいさがあった。セス・ヤコボウィッツが最近示したように、日本において電
信は恐ろしく、素晴らしく、しかし止められないものとしての近代を象徴するもの
であった（『明治日本における書く技術——近代日本の文学と視覚文化のメディア
史』(Harvard University Asia Center, 2015)）。ヴィクトリア朝イングランドでは、
チャールズ・ディケンズ、トーマス・カーライル、チャールズ・バベッジ、ジョー
ジ・エリオットなどが近代的な技術によってもたらされた音響の変容がもつあい
まいな本性について興味をもち、それについて記述している（ジョン・ピッカー
『ヴィクトリア朝のサウンドスケープ』(Oxford University Press, 2003)）。カーラ
イルはロンドンの騒音——喧騒から逃れるために屋根裏に取り付けた換気扇の音を
含めて——に対して怒りを覚えた。それに対してヤサールは、日本の例として夏目
漱石が平穏と静けさを求めて定期的に引っ越したことを挙げる。漱石は電話を連絡
のために多く用いたが、客人がいる間はずっとそれが鳴らないようにしたり、仕事
の間はそもそも受話器を外していた。電話は騒音を発し、「一時的な近代性による
独裁の一部をなす」ことで、いつも仕事から気をそらせ、時間を浪費させ、集中
を妨げるものだった（47頁）。作家の永井荷風もまた、「隣室のラヂオと炎暑との為
に読書執筆ともになすこと能わず」と、技術のもたらす苛立たしい騒音から逃れる
術を探し求めた（148頁）。

　第4章と第5章は、荷風の天敵を全国に広めたラジオ網の形成に関して魅力的な
示唆を与えてくれる。ヤサールはラジオのスポーツ実況とその聴覚的経験の発達に
ついて詳細に論じていく。「家に帰った」聴衆に向けたオリンピックのラジオ放送
は、コメンテーター、聴衆とアスリートがより大きなものの一部である感覚を与え
た。第5章であつかわれるラジオドラマは人々が同じ番組を同じ時間に聴取する点
で、媒介された音を大衆に対して届けた。だが、この大衆への音の伝達は、たとえ
出版・放送機関の管理によって取り締まられていたとしても、ラジオという技術が
聴衆自身のコンテンツを作る機会をもたらしたためでもあった。

　蓄音機に関する章は西洋音楽と西洋的な音楽の聴き方が日本の音楽に与えた影響
に関する議論によって展開される。蓄音機が日本で初めて公的に展示された1879
年から、複製のもつ魅力は視覚と聴覚の区別をもたらした。加えて、その黎明期に
は聴覚メディアが自然な、生きた存在であるという感覚が存在した。録音機器が重
要な日用品となるにつれて、著作権と所有権に関する問題がこの新しい技術を取り
巻く議論の中心を占めるようになっていった。重要なこととして、ヤサールによれ
ば、日本におけるこれらの議論は、世界の他の場所で起こったものとほとんど異な

らないのにもかかわらず、日本音楽の本性と芸術形式の影響を受けていた。大正時代にポピュラー音楽の録音文化が発展したことで、音響技術のもつ過去から現在にわたる文化的記憶を形成する力は、聴衆にとって想像上の共同体を作りあげた。最終章では戦前期における音と映画に関してこれまで幅広く行われてきた議論の検証を行っている。

　全体として、『電気になった声』は音響技術と「近代日本」の成立の結びつきをめぐる、刺激的でよくまとまった概略書である。ゆっくりと成長しているこの領域の調査と教育に大きな貢献を果たすと同時に、同書は東アジア研究や日本研究にとどまらず、近代史のさまざまな授業に役立つ。しかし、もし国土空間に関して検討したものだとするのであれば、同書は日本のさまざまな場所については限られた記述しかしていないという点には注意が必要である。また近代的な生活様式が広がるにつれて、共同体、政治、社会の新しい分裂が白日のもとにさらされていった。ロンドンではバベッジとカーライル（そしてチャールズ・ディケンズまでも）が、下層階級や路上にたむろする移民の騒音について懸念をもっていた。彼らの騒音に対する苛立ちは、それを作る人、作り出す空間、作り出す理由に多くを負っていた。第2章と第3章において、私たちは新しい技術によって生じた両義性についていくつかの有益な考察を見つけることができる。しかし、交換手が主に若い女性であった電話に関する章を脇におけば、階級、人種やジェンダーと新しい技術に関する議論は限定的である。同様に、ヤサールは結論部分で植民地計画の音響的側面に関して多くの研究が行われてきたことを述べてはいるものの、同書は日本の帝国主義的拡張に関しても大きく取りあげているわけではない。同書が優れて行っているのは、西洋を超えた範囲における音楽文化と音響技術に関して、今後どのような研究がなされるべきかを明らかにすることである。同書はこの課題の学際性を示すすばらしいモデルであり、新しく生じつつある領域における議論、調査、そして教育を刺激する、画期的な研究書である。（マーティン・デヴィッド・スミス／訳：中村将武）

22

ジェイス・クレイトン
『アップルート——21世紀の音楽とデジタル文化をめぐる旅』

Jace Clayton, *Uproot: Travels in 21st-Century Music and Digital Culture*, FSG Originals, 2016

「ワールド・ミュージック 2.0」、及びその前線としてのダンスフロアをフィールドワークする

　西洋音楽の文脈から外れた周縁あるいは辺境の音楽文化を広く包括する「ワールド・ミュージック」という概念は、欧米中心の音楽市場の要請によって80年代に一般化したものである。もちろん世界各地のローカルな音楽文化が西洋の主流の音楽に影響を与えるという現象は、歴史をさかのぼれば19世紀末から顕在化したものではあった。たとえば1889年のパリ万国博覧会がドビュッシーやラヴェルといった作曲家と東洋音楽との出会いを準備したことは象徴的な逸話だ。そこからおよそ一世紀を経て、アメリカでのレコードの発明と普及に端を発しグローバルな規模に至ったポップ・ミュージックの市場が、万博のように文化混交の場として機能するようになり、20世紀末には欧米のリスナーにとっての文化的他者そのものが「ワールド・ミュージック」の名のもとに商品化されるようになった。

　こうした「ワールド・ミュージック」の概念やその実態は、民族音楽学から音楽社会学、カルチュラル・スタディーズといった多様なディシプリンにおいて吟味されてきた。およそ30年にもわたるその蓄積は、「ワールド・ミュージック」という言葉の周辺で起こる現象をナイーヴに言祝ぐことも、逆に単純に批判することも避け、よりダイナミックで繊細な文化の生成プロセスとして理解することを促す（輪島裕介「音楽のグローバライゼーションと「ローカル」なエージェンシー——「ワールド・ミュージック」研究の動向と展望」『美学芸術学研究』20号、2002年）。とはいえ、ここ数年ひんぱんに耳にするようになった「文化的盗用（cultural appropriation）」行為に対する厳しい批判の声は、異文化間の情報のレベルでの交流とフィジカルなレベルでの断絶・対立がともに加速し引き裂かれ続けているインターネット以降の世界において、依然として「ワールド・ミュージック」がプロブ

レマティックな概念＝現象であることを告げてもいる。

　DJ/rupture のステージネームで活動し、欧米のアンダーグラウンドなダンスミュージック・シーンを中心に高い評価を受けているジェイス・クレイトンが著した『アップルート──21 世紀の音楽とデジタル文化をめぐる旅』は、世界中を渡り歩く DJ の視点からローカルな音楽の姿をいきいきと描き出す旅行記であり、欧米の先進国主導で進むテクノロジーの発展と文化の浸透に対して世界中の人びとがどのように応答しているかを批判的な視座から考察する優れた批評書でもある。

　同書で取りあげられるのは、欧米の音楽がヘゲモニーを握るポップ・ミュージックの市場においては可視化されづらい文化圏だ。それはたとえばモロッコであり、ジャマイカであり、エジプトであり、メキシコなどである。興味深いのは、どの場所にも YouTube や Facebook といったソーシャル・メディアの影がちらつき、MP3 のような圧縮音源が飛び交い、コンピュータと Pro Tools をはじめとする DAW（デジタル・オーディオ・ワークステーション）による従来のレコーディングスタジオよりも安価な制作設備が揃っている──つまり、人と人とのコミュニケーションやコンテンツの制作・流通にいたるまで、テクノロジーによってある程度標準化されている、ということだ。

　もちろん、こうした標準化において主導権を握るのは欧米の先端的なテック企業であるため、しばしばその土地ごとの伝統や慣習とはズレをもつ。それゆえ、そもそもテクノロジーを受け入れることができなかったり、あるいはあまりの浸透力に伝統をかき消されかけたり、またあるいは思わぬ誤用によって新たな可能性が開けたりする。そうした多様な（テクノロジーと文化の）衝突と融和のケーススタディが、この本には詰まっている。

　たとえばそうした文脈でもっとも耳目を集めやすいと思われる同書のトピックは、第二章の中核をなすオートチューン論、とりわけモロッコのアマジグの人々（いわゆるベルベル人）のコミュニティにおけるオートチューンの受容だろう。欧米のポップ・ミュージックを席巻したこのテクノロジーが北アフリカの少数民族のコミュニティに普及しているという事実だけで、興味深い現象だ。

　オートチューンは主にヴォーカルの音程を補正するソフトウェアで、1996 年の登場以来、ポップ・ミュージックに革命的なインパクトを与えた、この分野では最も有名なブランドの一つである。のみならず、特殊な用い方をするとヴォコーダーに似た「ロボ声」を作り出せるため、2000 年代以降には「補正」の範疇を超えたエフェクターのように常用されてもいる。

　このオートチューンが、アマジグの女性歌手の歌声に必ずといっていいほどかけられている（＝「ロボ声」として使われている）ことをクレイトンは見出す。しかも、その普及は2000年代初頭のこと。欧米のポップ・ミュージックで爆発的に流行するのとほぼ同時か、ともすればもう少し遡るかもしれない。加えて、現地のエンジニアは、オートチューンに丁寧にも搭載されたアラブ的な旋法（モード）に適合させる機能を用いるのではなく、ソフトウェアをほぼ初期状態のセッティングのまま、エフェクトのかかり具合を最大にするだけなのだという。

　現地をフィールドワークし、ミュージシャンやエンジニアと交流しなければ見出しえないこうした事実から、クレイトンはポップミュージックにおけるオートチューンの濫用や、それが現代の音楽文化に及ぼす影響への社会学的、人類学的な思索を開始する。それはまた、新しいテクノロジーによってあらためてあらわになる、共同体のなかに根付く「伝統」なるものの核心を照らし出す。たとえば、実はオートチューンがイスラム文化で重視される巧みなメリスマ（歌詞の一音節に複数の音符を用いる歌い方）を強調するのに最適であること、また、女性の歌声に求められるアマジグのジェンダー観ときらびやかな「ロボ声」に意外な親和性が見られること、等々。

　既存のローカルな文化がグローバル化（この場合はテクノロジーのかたちをとる）に飲み込まれながらも、その波を人びとが思いもしないかたちで乗りこなすことによって文化そのもののアイデンティティが問い直され、また想定外の用法によってテクノロジーそのものがよってたつ文脈も相対化される。クレイトンが世界を遍歴するなかで体感し、言語化してみせるこうしたダイナミズムは、「ワールド・ミュージック」のありようを考察するうえで貴重な視座を提供してくれる。

　最初に「ワールド・ミュージック」が話題を呼んだ80年代と現在のあいだでは、音楽産業をめぐる状況は大きく変化している。制作の現場においてはデジタル録音の普及、DAWの一般化が挙げられるし（中村公輔『名盤レコーディングから読み解くロックのウラ教科書』リットーミュージック、2018年）、流通と消費に目を向けてみても、アナログレコードからCDへの移行、音声圧縮フォーマットの普及、iPodの登場とダウンロード配信の一般化、そしてストリーミングプラットフォームの登場と、産業構造を変えるレベルの革新がいくつも起こった（スティーヴン・ウィット『誰が音楽をタダにした？──巨大産業をぶっ潰した男たち』関美和訳、早川書房、2018年）。

　クレイトンは、『アップルート』のなかで、こうした変化のうち、インターネットを介した音楽コンテンツの流通サイクルの劇的な加速や、DAWの低価格化に伴う

制作環境の民主化を経た 2000 年代以降の「ワールド・ミュージック」を、「ワール
ド・ミュージック 2.0」と名づける。いささか時代がかった命名だが、2000 年代に
世界各地のローカルなサウンド——ダブステップ、バイレ・ファンキ、クドゥーロ
等々——が欧米の市場へ次々紹介され続けたことを思い起こせば、実際それらが 80
年代に続く第二の「ワールドミュージック」の潮流であることは疑いえない。また、
情報テクノロジーを中心とした変化であるのだから、「2.0」の名はたしかにふさわ
しいものだ。

　「ワールド・ミュージック 2.0」は 2000 年代に特有の現象ではない。現在も、ダン
スホール・レゲエやアフロビーツ（フェラ・クティに端を発するアフロビートではな
く、ハウスやヒップホップ、そしてダンスホールなどのサウンドに影響を受けたダンス
ミュージック）、南アフリカから登場したゴム、そしてラテン・トラップやレゲトンと
いったラテン・ポップの隆盛など、ローカルに発展したサウンドがグローバルなポッ
プスのフィールドに進出する例は後を絶たない。

　ここでダンス・ミュージックが特権的なジャンルとなることには一定の必然性が
あり、そこに同書のアドバンテージがある。制作プロセスのほとんどすべてがデジ
タル化されているダンスミュージックは、DAW をはじめとするテクノロジーの発
展と民主化の恩恵をもっとも受けやすいし、またサンプリングやリミックスといっ
た技法はインターネットによる情報流通との高い親和性を示す。また、DJ やプロ
デューサーは絶え間なく未知の音楽を探求（＝ディグ）してはダンスフロアを通じ
て拡散し、世界的なトレンドをつくりだす、現代のポップミュージックにとって最
も重要な（しばしば問題含みな）プレイヤーでもある。クレイトンのテクノロジー
への理解とダンス・ミュージックへの鋭いアンテナ、そしてなにより DJ としての
現場での経験が、アクチュアルな問題提起と思索を根拠づけているのだ。

　ときにダナ・ハラウェイやレフ・マノヴィッチといった論客の名を示しながら展
開する文章の筆致は、クレイトンの旺盛な批評精神と、音楽への真摯な姿勢を感じ
させてやまない。また、折々にさしはさまれるさりげない情景の描写がもつ得も言
われぬ情緒は、同書をレヴィ゠ストロースの『悲しき熱帯』にも連なる人類学的紀
行文学の系譜に位置づけたくなるほどである。同書があつかうトピックや理論的な
示唆はこの文章で示したものだけにとどまらない。グローバル化が進行するなかで
再編が続くポップ・ミュージックシーンに対して、一人の DJ がここまで雄弁な記
録を残したことは喜ばしい。　　　　　　　　　　　　　　　　　　　（imdkm）

第6章
螺旋状の視聴覚論
「視聴覚連禱」以後

　　平倉圭は『かたちは思考する──芸術制作の分析』でロバート・スミッ
ソンの映画を分析するさい、振動数の近い波が干渉して生まれる合成波を
意味する「うなり」という語を用いて、視聴覚のさまざまな運動パターン
が「ずれを孕みつつ重なる」ありかたを表現しようとした。平倉は映像を
物語の一元論にも、視聴覚の二元論にも還元せず、諸要素の螺旋状の絡み
合いとしてとらえる。ジョナサン・スターンの「視聴覚連禱」以降、視聴
覚の結びつきを問う議論にはこうした螺旋状の運動がしばしば見られる。
視聴覚それぞれの本質を追求したり、両者を統合する原理を探したりする
のではなく、両者が立場を何度も入れかえるとか、両者の関係に言語や別
の感覚といった第三、第四の要素が加わるところに目を向けるのだ。
　　長門洋平『映画音響論──溝口健二映画を聴く』は視覚と聴覚の二元論
を離れて、映像、音楽、声、（効果）音を等価にとらえ、その関わりを考え
るためのさまざまなアプローチを提示する。ホリー・ロジャースは『ギャ
ラリーを鳴り響かせる──ヴィデオとアート-ミュージックの誕生』にお
いて「ヴィデオ・アート-ミュージック」という用語を提唱し、美術と
音楽というヴィデオ・アートの二つの系譜の絡み合いを描きだす。ジャ
ネット・クレイナック『反復されたナウマン』は、サウンド・アーティス
トによって先駆者として参照される美術家、ブルース・ナウマンの作品を
考察するために、美術批評と音響技術史のあいだに緻密な言説のネット
ワークをつくる。大友良英が『音楽と美術のあいだ』において語った「あ
いだ」も音楽と美術の二元論では決してない。このことは本の構成によっ
ても示されている。そしてこの章は、長年にわたり音楽と美術のあいだで
電子的うなりを奏で続けてきた小杉武久の展覧会カタログ『音楽のピク
ニック』で終わる。近年の作品を扱いながら、さらに大きく蛇行していく
音楽ジャンル論としては、佐々木敦『これは小説ではない』（新潮社、2020
年）もある。

23

平倉圭

『かたちは思考する──芸術制作の分析』

東京大学出版会、2019 年

巻き込みがもたらす新たな身体の生成

　同書は私の身体を強く触発する。なぜ触発するのか？　それは対象の内側に入ってゆき、感覚して運動する平倉圭の身体が、その筆致からありありと感じられたからかもしれない。縦横無尽に対象を分析し記述する平倉の動的な筆致に触れるとき、私の身体は巻き込まれ、変形していくような感覚を覚える。この触発され、巻き込まれていく感覚は、平倉の言葉で言えば「グルーヴ」と言い換えられるだろう。対象と観者、あるいは著者と読者のあいだに生まれる複数の運動＝思考のパターンが、ずれつつも一つの形になるとき「グルーヴ」は生成される。

　平倉は同書の序章のなかで、あり得たかもしれない無数の可能性のなかから特定の形が実現するとき、形には「周囲の者を捉え、巻き込み、揺り動かす」（1 頁）力があると述べている。そのうえで、芸術を「人を捉え、触発する形を制作する技、またその技の産物」（2 頁）と定義している。この形＝芸術が内包する力とは、すなわち見る者の心を支配し触発する──人類学者アルフレッド・ジェルが「作用者性（agency）」と呼ぶ──ものだ。平倉は対象となる芸術作品を遡行的に分析することで、その制作過程に関わる人間のみならず非人間的な物質を含むさまざまな作用者の存在を露わにする。ここで「作用者性」が芸術の形を考えるうえで重要となるのは、作品を取り巻く人間や事物もまた互いに作用するものであり、作品の一部をなすからだという。

　序章でも言及されているロバート・スミッソンの《部分的に埋められた小屋》（1970 年）を例にするならば、梁が折れるまで載せた土によって徐々に小屋が崩れ落ちる過程自体を作品にするという作家の意図に加えて、第三者が放火して生じた

小屋の損傷や落書きまでもがその崩壊過程に作用しており、それらの要素もまた作品の一部を形作っていると考えることができる。つまり、作者だけではなく、作品を取り巻くさまざまな外的作用を含めた複合的な過程こそが芸術作品を成り立たせているのだ。

　そして、平倉はこの人間と事物の「複合的な過程の結び目をなすのは、作家ではなく、形象（figure）」（9頁）、すなわち形としての芸術であると述べている。この考えに沿うならば、読者に向けて対象を分析し記述する平倉もまたその延長上にあると考えることができるだろう。対象を深く見る平倉は芸術が内包する力を言葉に変換し、読者に伝える形象の一部をなしているのだ、と。読者もまた同書を通じて、その形象の一部となり得るのである。

　したがって、同書でもっとも問題となるのは、芸術（＝形）を深く見ること以上に「私」の身体を触発することにある。この触発する力を平倉は「巻込（convolution）」と言い換えている。私が同書で平倉の筆致から「グルーヴ」を感じたのは、この「巻込」の作用によるものだ。「巻込」とは人類学者グレゴリー・ベイトソンの「モアレ」の概念から発展したものであるが、順を追って説明していこう。

　平倉は形（＝形象）の基本的な思考形式は「モアレ」だとしている。「モアレ」とは複数の周期的なパターンがずれを伴いつつ重なり合うことで発生するメタパターンのことである。この「モアレ」には複数の異なる事象を結び合わせる力が備わっており、その力は見る者が差異のなかに類似するパターン、すなわちモアレの構造を見出すことによってなされる。同書では、このモアレの構造が芸術作品を分析する際の手がかりとしている。

　他方で平倉は、モアレによる諸々のパターンの統御は必ずしも調和的に結ぶものではないと述べる。なぜなら「パターン間の関係は、全体的ではなく局所から見れば、破壊的・闘争的・簒奪的なものでありうる。生きている局所的パターンはただ結び合うのではなく、互いを奪い合い、引き込みあう」（16頁）からである。このとき、形は観者の身体を巻き込み、変形する力の原理を発揮する。「形象が十分に強く造形されるとき、見る者もまた波及的に「造形」される。そうして見る者の心身は、形象の思考を外的に延長する記号過程の一部となる」（17頁）のだ。平倉が「巻込」と呼ぶのは、この形象と観者の間に起こる関係である。

　たとえば、序章で言及されているカラヴァッジョの《メデューサ》（c.1597–98年）の作品体験は、「振り返る途中で切り落とされて叫ぶその顔を見るとき、私の顔にもその驚愕と恐怖が写る」ような感覚を覚え、「見る私の動きはメデューサの顔に巻き

込まれ、私の顔はメデューサの情動と反響し始める」のだ（16頁）。このように形＝作品が内包する思考と力は、見る者を巻き込み変形させることによって引き継がれる。

　だとすれば、『かたちは思考する』で芸術作品を分析する平倉の身体はどのように巻き込まれ、形の思考と力を引き継いでいるのか。その例として映画『スパイラル・ジェッティ』と後期セザンヌの風景画の分析を見てみよう。

　スミッソンは三つの形式の『スパイラル・ジェッティ』——アースワークの《スパイラル・ジェッティ》、映画『スパイラル・ジェッティ』、テクスト版の「スパイラル・ジェッティ」を残している（各作品の括弧表記は同書に倣った）。平倉はこの三つの作品関係を踏まえたうえで、映画の空撮シークエンスの分析を行い、見る者が巻き込まれる力を明らかにする。『スパイラル・ジェッティ』では複数の螺旋のモチーフが反復されることによって、見る者が類似したパターン＝モアレ構造を見出し、異質なもの同士が連鎖していくような感覚を覚える。空撮のシークエンスで言えば、観者が突堤、スミッソン、ヘリコプター、カメラ——四つの物体が生み出す、ずれながら重なり合う複数の運動パターンを見出すことにより、人間と事物を横断的に連鎖するのである。この四つの運動の複合的なパターンに、ヘリコプターの主プロペラと尾翼プロペラの異なる周波数の音響が干渉することによって、視 – 聴 覚を横断する「うなり」を生むという。ここで重要なのは、この「うなり」が観者の身体にも作用することだ。というのも、平倉によれば「私の体もまた、物体の振動を反響する物体だから」（180頁）である。物体間のうなりに身体が巻き込まれながら、観者である「私」の身体もまた「うなり」を生む。映画のシークエンスを分析・記述する平倉の身体も例外ではなく「うなり」を生んでいるのである。

　人間と事物の複合的な連鎖のなかで生じる振動＝うなりは、後期セザンヌの風景画論（同書では1895年以降の絵画を「後期セザンヌ」と呼称）にも見出すことができる。セザンヌの代表作の一つである《サント＝ヴィクトール山とシャトー・ノワール》（1904年頃）には、複数の色調とストロークが生み出す多重化した周期構造（＝モアレ）があり、観者の視線は「複数の周波数のずれと干渉に巻き込まれ」るという（46頁）。平倉が「多重周期構造」と呼ぶ、その構造には見る者を巻き込み、振動する「うなり」を孕んでいるのである。

　そして後期セザンヌの風景画に「感覚」が「実現」されているのは、対象となる風景ではなく、私たちの身体だと平倉は述べる。「後期セザンヌの風景画を「見る」とは、見ることのただ中で視覚が砕かれていく経験」（51頁）であり、このとき、真の問題となるのは「絵画が、それを経験しうる新たな身体を発生させる」（51頁）

ことにあるのだ。実際にセザンヌの風景画の分析と記述からは、平倉の身体が振動に巻き込まれ、砕かれていくような様子がうかがえる。平倉の視線はグルーヴを生み、その記述を通して私たち読者にもまた波及する。

　『かたちは思考する』の読者は分析対象を直接的に体験しているわけではない。私たちが体験するのは、平倉の分析と記述を通して紙面上に再構成された対象の追体験である。にもかかわらず、読者の身体を強く揺さぶり、モアレのなかに巻き込まれるような感覚を覚えるのは、単に対象の見方を変えられたという批評的な価値観の転覆に留まらず、私たちの身体を解体し、再構築していくような――「作用者性」が同書そのものに備わっているからだ。そして、同書の読者もまた、人間と事物の連鎖が生むモアレの渦中にあり、その延長上に位置する作用者なのである。だからこそ、真に問題となるのは、対象そのものではなく、それを経験する身体の方なのである。

　芸術の形の鑑賞体験を通じて「私」の身体を作り変えることが同書の根幹をなす。果たして凝り固まった慣習に縛られた私たちの身体はその振動する「うなり」に耐えられるのだろうか？　そのような疑念を振り払い、同書の巻き込みに身を委ねた先に新たな身体が生成される可能性がある。　　　　　　　　　（佐久間義貴）

24

長門洋平
『映画音響論──溝口健二映画を聴く』

みすず書房、2014 年

鳴り響きとしての映画

映画館で映画を観るとき、われわれはスクリーン上の役者の口から声が出ていると常に錯覚している。しかし、「映画の音は物語世界から聞こえてくるのではなく、劇場内のスピーカーから聞こえてくる」。あまりに当然でありながら等閑視されてしまうこの大前提を、『映画音響論』はあらためて突きつける。映画、そして映画の音に関する研究が作品論に偏りがちであったということは言を俟たないが、その時々で各人が利用できる記録メディアや機器環境での視聴にもとづいて論を運ぶよりほかなく、そのようなアプローチの根底には「ひとたび完成された作品は一定不変である」という共通認識が（いくぶん共犯的に）存在してきたと言えよう。他方で、「リビングを映画館に」といった大型テレビのありふれた広告や、「ホームシアター」という用語それ自体が、映画を視聴する環境による体験の差異に自覚的ではなかったか。こうした差異をめぐる問題意識を同書は技術史的視点と結びつけ、トーキー黎明期の映画の音がどのように鳴り響き、当時の観客たちにどう聞こえていたか、という問いを導く。

同書では映画の音について考えるうえで根源的な論点が提示され、溝口健二監督による 6 本の映画を中心とした具体的な作品分析で検証される。たとえば、先の問題意識が生きてくるのが『ふるさと』（1930 年）の分析である。トーキー初期に製作された同作は公開当初「音質の悪さ」を批判されたが、現存版を視聴するとその音質が同時代の他作品と比べて遜色ないことから、封切時の音質が悪かった可能性、つまり、録音技術の質ではなく再生技術の質が作品への批判を生んだ可能性を長門は示唆する。このような視聴空間の技術的条件が観客に与える影響は、映画と音についての研究の関心事の一つである。近年ではドルビーサラウンドの登場によって劇場内のサウンドスケープが立体的に構築されるようになり、重低音域を増強す

る LFE（low-frequency effects）チャンネルは物理的な振動を以て、観客の身体に
じかに干渉してさえいることを、『映画を感じる――空間的アプローチ』（Palgrave
Macmillan, 2016）でベス・キャロルが指摘している。たとえ同一作品を観るとして
も、5.1ch サラウンドの映画館とスピーカー内蔵スマートフォンでは、画面サイズや
画質もさることながら、耳での映画体験として優劣はさておきたしかな相違がある、
ということは容易に想像がつくだろう。そしてこの場合、「オリジナルの音」なるも
のはどちらにも求め得ないのだ。こうした技術決定論的視座を言説分析に援用する
ことで、長門は公開時の視聴空間を現代に呼び起こす。

　「音・音楽と映像が合う／合わないとはどういうことか」という問いもまた、同
書で一貫して追究されている。実践と批評、研究で歴史的に議論が重ねられてきた
この問いの背景には、リップシンクのように、録音された音とその音を発している
（と想定される）スクリーン上のものの動きとが技術的に同期しているかという次
元もあれば、港のシーンの汽笛のように、視覚イメージや物語内容と音が調和して
いるように感じられるかという次元もある。ここで問題となるのは、その調和がし
ばしば「音が映像に対して従属的に奉仕しているか」という点で評価されてきたこ
とだ。もとより「劇伴」という語も、映画音楽が場面の引き立て役として認識され
てきたことを端的に表している（ミュージック・ビデオの先駆とも言えそうなディ
ズニーの『シリー・シンフォニー』シリーズ（1929–39 年）や『ファンタジア』（1940
年）、あるいはオスカー・フィッシンガーやノーマン・マクラレンらが「音楽の視覚
化」に取り組んだ実験アニメーションは、そのような慣習に抗おうとした例と言え
る）。「音と映像が」というより「音が映像に」合っていないという語りは、音と映
像の常套な関係性への期待に裏付けられ、同書があつかう『赤線地帯』（1956 年）
についての作曲家・黛敏郎と映画評論家・津村秀夫の誌上論争に直接的に現れてい
る（この論争に関しては、同書でも引かれているとおり、秋山邦晴による『キネマ
旬報』の連載「日本映画音楽史を形作る人々」が詳しく取りあげている。連載の完
全版が最近書籍化されたので参照されたい（秋山邦晴『秋山邦晴の日本映画音楽史
を形作る人々／アニメーション映画の系譜』高崎俊夫、朝倉史明編、DU BOOKS、
2021 年））。
　そもそも映画にはジャンルを問わず多様な編成や曲調の音楽が使われているは
ずであるが、あたかも「映画音楽」という独立したジャンルが存在するかのように
語られてきた。観客側にとってのこのジャンル認識は、いわゆるサントラ盤の普及
と不可分だろう。現に、図書館やレコード店の分類項目としても目にするし、ボリ

ウッド映画音楽を表す「フィルミー」のようなサブジャンルまである。つまり、映画音楽は映像への追従を求められてきたにもかかわらず、映像から独立した楽曲としても受容されてきたということだ。一方、理論家であり作曲家のミシェル・シオンは、映画の音のなかでも特にオリジナルの音楽ばかりが自律したジャンルとしてあつかわれてきたことへの批判的観点から、あらゆる映画の音を等しくその映像との関係性（仮想上の音源が画面上にあるか等）で分類する枠組みを示した。1980年代頃から目立つようになったこのような姿勢は、『映画音響論』はもちろん、この研究領域における現代の議論の素地を築いたと言えよう。ここで同書のタイトルに立ち返ってみると、「映画音響」という言葉からは、効果音の制作や選曲、音声編集といった音響技術が想像されるかもしれない。ところが紐解いてみると、従来「映画音楽」と見なされてきたような作曲家による作品の分析が多くの議論の中核をなしている。実際、早坂文雄や深井史郎、黛敏郎といった作曲家たちと溝口健二とのあいだの作家性の化学反応に対する著者の強い関心は、否定しがたく表出している。ここで面白いのは、同書で取りあげられる作曲家たちが、「音楽的構成のない断片が映画音楽になり得る」という考えを共有していたことである。そのように映像と音楽の関係を半ば実験的に追究した作品群は、映画における音楽を声や効果音などと同列視して、総合的にデザインされた鳴り響きと見なすための好例となる。

　同書のように特定の監督の映画の聴覚的要素に焦点を絞った学術書として、英語圏ではアルフレッド・ヒッチコックやスタンリー・キューブリック、ジム・ジャームッシュなど、音の使用に明確な傾向を聴き取れる作家があつかわれてきた。日本の映画監督でも、たとえば小津安二郎が軽妙で起伏のない音楽を好んだことはよく知られる。それを象徴するのが、斎藤高順によって作曲され小津自身が命名したと言われる《サセレシア》（シャンソンの《サ・セ・パリ》＋《バレンシア》に由来、『早春』（1956年）に初出）であり、長門も別稿「いつもお天気がいいにもほどがある──小津安二郎映画の音楽について」（松浦莞二、宮本明子編著『小津安二郎大全』朝日新聞出版、2019年、382-392頁）で論じている。他方で評者は正直なところ、「溝口映画の音楽」と言われても各作品を通底するような特徴が取り立てて思い浮かばなかった。しかもこの『映画音響論』も、包括的な作品分析によって特徴をあぶり出していく、という構成をもつわけではない。しかしその統一的なカラーのなさこそが、映画の音を固定的な機能から解き放っており、同書が溝口映画に着眼したことに説得力を与える。

　さらに、沈黙が重要な音響効果であることは、映画の音研究の古典で同書も負う

ところの大きいクラウディア・ゴーブマンをはじめすでに指摘されてきたが、溝口
映画は「劇伴排除期」があるという点で、沈黙や音の不在を議論の射程に入れるこ
とにも寄与している。この点で出色なのは、『浪華悲歌』(1936 年) の主人公であ
る電話交換手・アヤ子の分析である（そのフィルムは表紙の装丁にも使われており、
ついでながら左縁に走る細い帯が、本来サウンドトラックという語の意味する音声
記録部分である）。視覚的にも聴覚的にも交換室に疎外され、電話を介さずには対
話できないアヤ子を通じたモガ表象が、技術史的・社会史的に考察される。感情説
明的な伴奏音楽が廃されることで、アヤ子が観客との対話でも実質的に沈黙を余儀
なくされていることが巧みに暴かれる。『映画音響論』で示される多彩なテクスト
の読みの可能性は、いずれも「こんな解釈ができたのか」とハッとするような刺激
的なものである。

　そして巻末では、溝口映画の録音技師を務めた大谷巖氏へのロング・インタ
ビューが興を添える。学術書がインタビューを付録とすること自体は珍しくないの
だが、作品から推察される撮影・録音方法や段取り、使用機器などが次々と答え合
わせされていくような展開になり、インタビュアーの興奮が紙面から溢れ出すよう
だ。「擬音」（かごに小豆を入れて揺する音で波音を表現するなど、「本物らしい音」
を創作する効果音の手法）やサウンドトラックの逆回転、マイクロフォンコードの
速差し替えといったエピソードから垣間見える、限られた条件下の現場での大胆な
試行錯誤には瞠目するだろう。

　同書は音に対する映像の優位性と、作品内の聴覚的要素のあいだの音楽の優位性
という、映画の音に関する議論で前景化しやすい二つの前提を覆す。それらを等価
のものとして考えるための種々のアプローチを提示している点で目覚ましく、サウ
ンド・スタディーズの成果として読まれるべき理由もそこにある。　　　（葛西周）

25

ホリー・ロジャース
『ギャラリーを鳴り響かせる──
ヴィデオとアート-ミュージックの誕生』

Holly Rogers, *Sounding the Gallery: Video and the Rise of Art-Music*, Oxford University Press,
2013

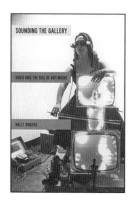

ヴィデオ・アートの二つの系譜

　同書においてもっとも目を引く主張は、ヴィデオ・
アートは「ヴィデオ・アート-ミュージック」である
というものだ。1960年代半ばにナム・ジュン・パイク
らが創始したヴィデオ・アートというジャンルはこれま
で、主に美術の文脈において論じられてきた。また、そ
の理論の中心にはたいていヴィデオという装置に特殊な
機能が置かれてきた。こうした議論の先駆けとして知ら
れるのは、たとえば、ロザリンド・クラウスがヴィデオ
の「フィードバック」に注目した1976年の論考「ヴィデオ ナルシシズムの美学」
（『ヴィデオを待ちながら』石岡良治訳、東京国立近代美術館、2009年）である。ロ
ジャースはこれに対して、ヴィデオ・アートを美術、そして音楽という二つの系譜
に連なるジャンルとみなして、その出現を二系譜の絡み合いとして理解しようとす
る。そうすることで、彼女はヴィデオ自体をヴィデオ・アート論の中心から外し、
その代わりに長い歴史をもつ諸実践のネットワークを強調する。「アート-ミュー
ジック」という造語にはこのような意味が込められている。
　ロジャースの姿勢は、リズ・コッツ『見るための言葉──1960年代の美術にお
ける言語』（MIT Press, 2007）やブランデン・ジョセフ『ドリーム・シンジケート
を越えて──トニー・コンラッドとケージ以後』（Zone books, 2008）といった、50、
60年代のアメリカにおける美術と音楽の交錯に注目する美術史家の著作と共通し
ている。とはいえ、ロジャースの主張に対する評価は、同書で主に取りあげられる
60年代の初期ヴィデオ・アートに関して、美術だけでなく音楽の系譜をも参照する
ことでどんな新しい理解がもたらされるかにかかってくる。

　近年、体系的なヴィデオ・アート研究であるイヴォンヌ・シュピールマン『ヴィ
デオ——再帰的メディアの美学』（海老根剛監訳、柳橋大輔、遠藤浩介訳、三元社、
2011 年）とクリス・メイ＝アンドリュース『ヴィデオ・アートの歴史——その形式
と機能の変遷』（伊奈新祐訳、三元社、2013 年）が翻訳され、日本語でもこのジャ
ンルを理論的に概観できるようになってきた。両者の議論を見ていくとたしかに、
ヴィデオという装置自体の機能がその中心に置かれている。シュピールマンはヴィ
デオの機能を他の映像メディアと比較して、フィードバックにもとづく再帰的プロ
セスをヴィデオに独自なものとみなし、これにもとづいて個々の作品を解釈してい
く。メイ＝アンドリュースはカッティングやミキシングといったヴィデオの技法
を整理し、作品の分類に活かしていく。もちろん、ロジャースがヴィデオの機能に
まったく言及しないわけではない。しかし、彼女が注目するのはあくまで、美術と
音楽という二つの系譜の絡み合いに関わる機能に限られる。

　ヴィデオ・アート‐ミュージックという言葉に込められたロジャースの姿勢は、
主だった初期作家の経歴を見ていけば、それほど意外なものではない。パイク、ス
タイナ・ヴァスルカ、ロベール・カエン、トニー・コンラッドらは音楽出身で、同
時代の音楽の展開からさまざまな影響を受けてヴィデオを用いた制作に取り組んだ。
先行する研究でもこのような背景は指摘されている。そこで、ロジャースがいかに
こうした美術と音楽の交錯を論じたのかが問題になる。

　同書の構成を大きく分けると、第 1 章から第 3 章までが前半、第 4、5 章が後半
になるだろう。前半は初期ヴィデオ・アート‐ミュージックが置かれた状況やその
前史が、後半は個々の作家の多様な活動や手法が論じられる。第 1 章では、初期
ヴィデオ・アート‐ミュージックの作家たちの実践を手がかりに、テクノロジーを
用いていわゆる「物語世界外の（nondiegetic）」イメージと音をつくりだす実践の
概要が描かれる。ロジャースはこの実践を見渡しながら、ヴィデオが初めて視聴覚
を完全に同期させた装置であると指摘する。しかし、彼女が強調するのはヴィデオ
の独自性よりも、異なるテクノロジーどうしの結びつきである。第 2 章は視点を変
え、ルイ＝ベルトラン・カステルが 18 世紀に構想したとされる「目のためのハー
プシコード」などのいわゆる色彩オルガンや、象徴主義絵画などから始めて、現代
美術と音楽における共感覚の探求の歴史をたどる。ここではゴットホルト・エフラ
イム・レッシング『ラオコオン』（1766 年）における古典的な議論からニコラス・
クック『音楽マルチメディアの分析』（Oxford University Press, 1998）まで、関連
する理論も簡潔にまとめられている。

　絡み合う二つの系譜を追うというロジャースの方法がもっとも成果をあげてい

るように見えるのは、第3章から第4章への展開だ。第3章では、美術家モホリ＝ナジ・ラースロー、建築史家ジークフリート・ギーディオン、美術評論家クレメント・グリーンバーグらの議論を参照しながら、現代美術と音楽の展開のなかで空間という主題が強調されていく過程がたどられる。そしてこの系譜をふまえ、第4章でロジャースは現実のさまざまな空間への拡張という視点から、初期ヴィデオ・アート−ミュージック作家の活動を年毎に追っていく。第5章では、70年代以降のヴィデオ・アート−ミュージックの実践が、同書前半で議論されたさまざまな系譜をいかに延長させていったかが考察される。

　同書の表題「ギャラリーを鳴り響かせる」（他動詞の「サウンド」には「鳴らす」という意味の他に「測る」という意味もある）は、第3章から第4章への展開と関わっている。ロジャースは第3章で、美術評論家ブライアン・オドハティ『ホワイト・キューブの内側で──ギャラリー空間のイデオロギー』（University of California Press, 1986）と音楽学者クリストファー・スモール『ミュージッキング──音楽は〈行為〉である』（野澤豊一、西島千尋訳、水声社、2011年）の議論を重ね合わせる。20世紀半ばの美術と音楽にはともに、展示やパフォーマンスのための特権的な空間を解体し、柔軟で分散した諸空間を再構築しようとする動向があらわれる。ロジャースによれば、この動向の延長として、初期ヴィデオ・アート−ミュージックはそれまでの中立的なギャラリー空間に次の三つの変化をもたらした。一つは、作品の構成のなかにパフォーマンスや観客のための空間を取りこむことで、環境を活性化する。次に、静止した物体に満たされた空間に運動するイメージを置くことで、時間の要素を導入する。最後に、無音の空間に音と音楽を鳴り響かせる。彼女はヴィデオ・アート−ミュージックが美術の文脈において、インスタレーションの分流として解釈できることを強調する。ヴィデオ作品は「ギャラリーのなかに空間的、時間的、そして聴覚的に拡張していった」（5頁）のだ。

　ロジャースはこうした認識にもとづいて、第4章でヴィデオ・アート−ミュージックの発生を一歩ずつ跡づけていく。たとえば、1968年という時期には重要な意義が見出される。なぜなら、同年は空間をめぐるヴィデオ作品の実践の多様化が加速した年だからだ。一方で、「サイバネティック・セレンディピティ」展が各国を巡回し、ニューヨーク近代美術館では「マシーン　機械時代の終わりに」展が開催された。ケルン州のテレビ局WDRはグループ・ゼロのオットー・ピーネと、アルド・タンベリーニによる、芸術家が制作した初のテレビ番組と評される《ブラック・ゲート・ケルン》を放送した。他方で、ニューヨークの「コメディエイション」、サ

ンフランシスコの「アント・ファーム」「ランド・トゥルース・サーカス」「エレク
トリック・アイ」といった、ヴィデオ作品を専門にあつかう小規模な空間が次々と
つくられたのも同年だ。また同時に、テリー・ライリーのような音楽家がコンサー
トにヴィデオを積極的に持ちこむようになった。このように、ロジャースは現実の
多様な諸空間への拡張という視点から、美術と音楽という二つの系譜がヴィデオ・
アート‐ミュージックにいかに流れこみ、そして展開していったかを説明する。

　くり返すが、冒頭に書いた『ギャラリーを鳴り響かせる』の主張は、初期ヴィ
デオ・アート‐ミュージックの作家たちの活動を理解していれば、さほど意外なも
のではない。しかし、二つの系譜の絡み合いが明確に浮かびあがる視点として、と
りわけ空間をめぐる実践に注目したことで、同書は先行する研究に新たな理解を加
えている。たしかに、この視点はヴィデオの機能を中心とする理論からは抜け落ち
てしまいがちだろう。ロジャースが語るヴィデオ作品は、テクノロジーについても、
感覚についても、ジャンルについても根本から中間的なものなのだ。

<div style="text-align: right">（金子智太郎）</div>

26

ジャネット・クレイナック
『反復されたナウマン』

Janet Kraynak, *Nauman Reiterated*, University of Minnesota Press, 2014

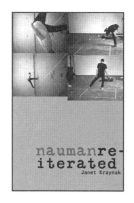

美術作品を聞くとはどういうことか

　美術家ブルース・ナウマンのインスタレーション《デイズ》（2009 年）は、空白のキャンバスに似た 14 枚のフラット・パネル・スピーカーを通路状に並べた作品だ。スピーカーからさまざまな言語で曜日の名前を読みあげる声が聞こえる。白い板からなる廊下、再生される声、包囲する音、反復とずれ、こうした要素の組み合わせは60 年代からナウマンのトレードマークだった。彼は自己を反復する作家である。自身のヴィデオ・アート作品の音だけを、テート・モダンのタービン・ホールに響かせた《ロウ・マテリアルズ》（2004 年）もそうだった。

　2003 年にナウマンの文章とインタビューを集めた本を出版したジャネット・クレイナックによる『反復されたナウマン』は、60 年代から 70 年代のナウマンの作品を、当時のメディア・テクノロジーとの関連を中心に論じている。注目したいのは「世界が違って聞こえる——音と、記録の新しい文化について」と題された第 3 章であり、彼女はその時期のナウマンの音と関わる作品を概観している。ナウマンはサウンド・アートの代表的作家の一人と呼んでいいだろうが、ヴィデオやネオン・サインを使った作品の方がよく知られている。だが、クレイナックはこの第 3 章を同書の中心とみなす。加えて、90 年代以降に大きく展開した聴覚文化研究、サウンド・スタディーズを幅広く参照している点も重要である。

　なぜ、クレイナックはナウマンの初期作品と音の関係に特に注目するのか。さらに同章の冒頭で、彼女は「美術作品を聞くとはどういうことか（What does it mean to listen to an artwork?）」という問いを立てている。この問いはクレイナックが美術批評とサウンド・スタディーズをいかに結びつけるのかに関わっている。彼女はこの問いにどう答えるのか。

　クレイナックは「世界が違って聞こえる」の議論を大きく二つに分けながら、実際には両者が絡みあっていると説明する。一つはナウマンがジョン・ケージ以後の実験音楽、特に短いフレーズを反復するミニマル・ミュージックの作家たちから受けた影響についての議論、もう一つはこうした作家たちと60年代の音響メディアやポピュラー音楽の動向の関係についての議論だ。

　ナウマンとミニマル・ミュージックの作家たち、なかでもスティーヴ・ライヒとの結びつきを象徴するものとして、クレイナックは1969年にニューヨークのホイットニー美術館で開催された「アンチ・イリュージョン──手続き／素材」展をあげる。同展は制作プロセスを重視する作家たちがジャンルを越えて結集したことで知られる記念碑的な展覧会である。展示とともに開催されたイベントでは、最終日にライヒの《振り子の音楽》（1968年）が上演された。この作品は四組の、床に上向きに置いたスピーカーと、その上を通過しながら揺れるマイクの振り子からなる。マイクがスピーカーの真上に来た瞬間だけハウリングが起きるため、その音が振り子の振幅に合わせてリズミカルに鳴る。四つの振り子は初めはいっせいに揺らされるが、振幅がだんだんとずれていくため、ハウリングのリズムが変化していく。ライヒが「聞こえる彫刻」と呼んだこの作品は、プロセス・アートのモデルの一つとして高く評価された。そして、ナウマンは同作品に美術家リチャード・セラ、作曲家ジェームズ・テニー、映画監督マイケル・スノウとともに振り子の振り手として参加した。彼はミニマル・ミュージックの作家たちと日常的な交流があり、ライヒがマイクをスイングさせることを思いついた機会にも居合わせていたという。

　ナウマン自身が同展に出品したのは、《パフォーマンス・コリドー》という移動壁で廊下をつくる作品である。この作品は後に彼が制作するたくさんの廊下の原型になった。クレイナックによれば、同作品はケージが《4分33秒》（1952年）などで探求した「タイム・ブラケット（時間枠）」という手法の造形版であり、時間ではなく空間を枠で限定することで鑑賞者の経験に働きかける。また、同展のイベントでは《パフォーマンス・アリーナ》という、ナウマンにはめずらしい「ライブ」作品も上演された。彼と彼のパートナーのジュディ・ナウマン、そしてヴォーカリストのメレディス・モンクによるこのパフォーマンスは、ヴィデオ作品《バウンシング・イン・ザ・コーナー》（1968年）のライブ版で、壁を背に立ち、後ろに倒れこんで壁に背中をはずませる動作をくり返すというものだ。クレイナックはダン・グラハムの言葉を引用して、この作品をライヒが考案した、重なり合った短いフレーズを少しずつずらしていく「フェイジング」という手法と結びつける。ナウマンによる

フェイジングの応用は他にもある。例えば、逆さまにされたナウマンの口が「リップ・シンク」とつぶやき続けるヴィデオ作品《リップ・シンク》（1969年）は音と映像のフェイジングである。

このようにクレイナックはナウマンとミニマル・ミュージックを関係づけながら、さらにその背景として音響メディアとポピュラー音楽の動向を見ていく。まず参照されるのはマイケル・シャナン『リピーテッド・テイクス——録音とその音楽に対する影響をめぐる小史』（Verso, 1995）、デヴィッド・モートン『録音——テクノロジーの伝記』（Greenwood Press, 2004）といった音響メディア史である。クレイナックは、60年代以降のポピュラー音楽に変革を起こしたテクノロジーの一つとして、マルチトラック・ミキシングをあげる。音楽家はこの技術を通じて彫刻家のように音を編集できるようになり、音楽業界にも聴取のあり方にもさまざまな変化がもたらされた。なかでも経済学者ジャック・アタリを参照しながらクレイナックが強調したのは、再生された音と現実の音のヒエラルキーの転倒である。録音編集技術の発展により、再生される音こそが真実であり、ライブはその付属物という認識が生まれた。レコードが上演の地位を奪い、音楽はより物質化して、造形作品により近づいた。そして、反復されるものに価値が置かれるようになった。

クレイナックは録音を、それまでに造形作家が利用してきた複製技術のなかでもひときわ、現実の認識を変えたものだったと考える。だからこそ、ナウマンの初期作品のなかでも音を使うものに注目したのだ。彼のインスタレーション《6つのサウンド・プロブレム》（1969年）は、一台のオープンリール・デッキとそこから長く引き伸ばされ、椅子に取り付けた鉛筆に掛けられた磁気テープからなる。デッキはナウマンによるパフォーマンスの音だけを再生する。先に述べた《ロウ・マテリアルズ》の原型である。ナウマンは自身の過去の作品を、そこに隠れていた内容を強調することで、新たなアイデンティティを与えて反復する。

クレイナックが指摘した音響テクノロジーの影響をもう一つあげておこう。ライヒとナウマンはフェイジングによる作品が独特な身体感覚を生みだすと語った。たとえば、ライヒは音が身体や空間の内部を動きまわるように感じたという。音楽学者デヴィッド・シュワルツは『聴く主体——音楽、精神分析、文化』（Duke University Press, 1997）において、ミニマル・ミュージックのような構成の音が、聴取者の身体を包みこみ、身体とその外部の境界が揺らぐかのような幻想をもたらすと論じている。クレイナックは彼の議論を参照しながら、ライヒやナウマンがこうした音による包囲に注目したことを、60年代に普及したステレオ音響やサイケ・

ロックと関連づける。さらに、彼女はナウマンがこの包囲感覚を《斜めの音の壁／聴覚の壁》（1970 年）など、吸音壁による作品群を通じて探求していったと考える。

　60 年代に普及した音響メディア、特に録音編集技術は作家に一時的な解放をもたらしたが、それは長続きしなかった、とクレイナックは指摘する。新しいテクノロジーはすぐさまマスカルチャーによる管理の道具になった。アタリが言うとおり、記録は権力である。そしてクレイナックは、ナウマンのサウンド・アートはテクノロジーによる解放を目指すものではなく、むしろ管理と向きあうものであると主張する。彼の作品はたしかに、監視、調整の経験が一貫してテーマになっている。さらに、クレイナックは「美術作品を聞くこと」自体が、沈黙し、観照しようとする鑑賞者の自律が破られ、管理のもとに連れだされる経験なのだと考える。展示空間に音を持ちこむことは、否応なく鑑賞者を力の相互作用の場に導くことになるのだと。

　ここまで、クレイナックがなぜナウマンの音を使う作品に注目したのか、それをどう批評したのかを見てきた。現実とその複製のヒエラルキーの逆転や、人間を包囲するものといったナウマンの作品の中心テーマは、たしかにこの時代の録音文化と深い関係にある。個々の作品解釈や、音響メディア一般との関係の考察、管理社会との対峙といった、一つひとつの論点自体は特に目新しくないかもしれない。しかし、『反復されたナウマン』の意義はサウンド・スタディーズの蓄積をふまえて、メディア史の流れと芸術批評の間により緻密なネットワークを作りだしたことにあるだろう。ナウマンや 60 年代を離れてネットワークを拡張していくことで、この意義はさらにはっきり見えてくるはずだ。　　　　　　　　　　　　　（金子智太郎）

27

大友良英
『音楽と美術のあいだ』

フィルムアート社、2017 年

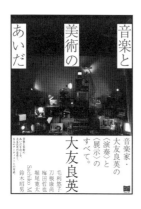

評価軸それ自体をあらたに生み出すこと

　音楽を厳密に定義することは難しい。音を用いた表現行為を必ずしも音楽と呼ぶことが適当ではないことは、数多ある「民族音楽」を眺めてみてもわかる。一方で、わたしたちが暮らす社会に音楽と呼ばれる営みが存在することもまた事実だ。たとえ定義し得なかったとしても、たとえばレコーディングされた音を CD やオーディオ・データとしてパッケージングし、そして流通させてしまえば、それを音楽と呼んで取り扱うことができてしまう。あるいはコンサート・ホールやライブハウスなどのステージ上で楽器を手にしてパフォーマンスを行えば、たとえなにも音を発さなかったとしても演奏と見做され、音楽として受け手に届けられることになる。すなわち制度としての音楽はたしかに存在しており、このことは同じように厳密な定義が不可能に見える美術においても、やはり額縁やギャラリーといった環境が作品を成立させてしまうという意味において、制度として社会のうちに存在していると言うことができるだろう。そして音楽と美術は、それぞれ異なるメカニズムの制度のもとに成立しているのであって、これらの差異を認識／自覚することが、旧来の制度にそのまま当てはめてしまうことのできないような表現や作品について考える際には必要なのである。

　同書はこれまで、いわゆる音楽ジャンルに限ってみても、映画音楽、ジャズ、音響、ノイズ、歌もの、テレビ・ドラマの劇伴など、非常に多岐にわたってきた著者・大友良英の活動のうち、音楽とも美術とも言い切れないような実践について振り返り、その思想的核心を抽出し、あるいはそうした名づけ難い実践の可能性と展望について解き明かした、400 ページ超のボリュームを伴う濃厚な 1 冊である。とはいえ、決して読者を選ぶような本ではない。全編が平明な語り口のインタビュー

形式で織り成されており、マニアックな固有名詞や音と音楽をめぐる原理的な思考
に話題が及んでも、そこで生まれる問いの数々に対して丁寧に説明がなされていく
ため、大著でありながら誰もが読み進めていくことのできる間口の広さを備えたも
のとなっている。

　出版のきっかけとなったのは、2014 年 11 月から 2015 年 2 月にかけて NTT イン
ターコミュニケーション・センター（ICC）で開催された大友による展覧会「音楽と
美術のあいだ」であるが、この展覧会がそもそも、2013 年に急逝したキュレーター
／梅香堂主・後々田寿徳による遺稿「美術（展示）と音楽（公演）のあいだ」を一
つの契機としたものだった。同書にも全文が収載されているその論稿では、近代的
なジャンルとしての音楽と美術のあいだにあるさまざまな相違、たとえば一回性と
反復可能性や、鑑賞における時間の取り扱い方、または観客と向き合う姿勢の違い
などが指摘され、そうした異なりがあるにもかかわらず、それらを考慮することの
ない美術の制度性が、音楽家が美術館で展示を行う際の「居心地の悪さ」を生み出
していることについて、より自覚的になることの必要性が書かれていた。言うまで
もなくこの論稿は、そこからどのように音楽家が美術とも交わる領域で活動を行っ
ていくことができるのかについて、さらに書き進められるところがあったはずであ
る。その意味で同書は、後々田が提起した問題を継承し、書かれることのなかった
「続編」を紡ぎ出している部分もあると言うことができる。

　同書は大きく二部構成に分かれている。第一部に収録されたテキストは、ICC 主
任学芸員である畠中実が聞き手役を務めた、「音楽と美術のあいだ」展のクロージン
グ・トークとその後二回継続して行われた対話をもとに加筆修正されたものである。
2005 年に築港赤レンガ倉庫で開催されたグループ展「現象と干渉〜音にならないオ
トを聴く」の衝撃を基調音に、それと響き合う大友自身の活動について、幼少期の
体験にまで遡りながら、章ごとに「音と空間」や「音楽と装置」、「展示と演奏」と
いった軸に沿って語られていく。最終的にこれまでの活動を、複数のアンサンブル
が共振する「祭り」という名のある種の社会実践として読み替えていく大友の言葉
は、普段は見えないような諸々の条件や解決することの難しい問題を作品や表現に
よって可視化するという議論へと至るのだが、このことはメディア・アートにおけ
るメディアの可視化という側面とも紐づけて考えることができるだろう。また、赤
レンガ倉庫での出会いはひとえにその出展作家たちの力量が呼び寄せたものであっ
たかもしれないが、あくまでも音楽家としての立場から作品に接した大友が「新し
い音楽」と述べたような驚きを覚えたのは、彼自身がそれまでの歩みのなかで、で

き合いのパッケージングされた音楽を生産／消費するだけでは良しとせず、音楽とは何か、音とは何かという根源的な問いを常に問い続けてきたためではないだろうか。自らの立場を切り崩すようにして新たな領域を切り開いてきたその経験が、展示作品から「音楽」を聴くことを可能にしたのだとも思われる。

　さらに『音楽と美術のあいだ』の第二部では、音楽とも美術ともつかないような活動を行ってきた6人のゲスト・インタビュイー（毛利悠子、刀根康尚、梅田哲也、堀尾寛太、Sachiko M、鈴木昭男）を迎え、大友とのあいだで対話が交わされていく。世代やバックグラウンドの異なるゲストたちは表現や作品の内容もさまざまだが、共通する点として、音楽大学で西洋音楽の専門的な教育を受けているわけではないこと、つまり程度の差こそあれ音楽をめぐる正統的なコンテクストの外部で活動していること、そしてその表現や作品に既存のジャンルに押し込めてしまうことのできない広がりがあることに加えて、いずれも大友自身の活動に影響を及ぼしてきた存在であることが挙げられよう。対話のなかではインタビュイーの経歴や作品の解説に加えて、自らの活動をどのように他者に説明するのか、または音楽や美術とどのような関係性があると考えているのかについても語られる。録音や録画によっては記録しきれない作品をいかにして後世へと伝え残していくことができるのかという問いに対して、大友が「たとえば、「誰かの人生を変える」という残し方もあるのかもしれない」と応える場面があるのだが、それを踏まえて言うならば、まさしくこの第二部には、他ならぬ人生を変えられた一人の受け手としての大友良英による、6人の作品を次の世代へと伝えていくための、一つのアーカイヴのしかたが残されているのだとも言えるだろう。

　「音楽と美術のあいだ」とはいえ、それは第三項を打ち出すこと──その第三項が新たにジャンル化することで「あいだ」としての意味合いを失っていかざるを得なかったのが、1950〜60年代に特異な実践として注目を集め、ディック・ヒギンズによって理論化された「インターメディア」だった──が重要なわけではなく、むしろ音楽または美術という語で回収しきれない表現について、両者の関係性のグラデーションとしての「あいだ」を探っていくことに要点があるということには気をつけなければならない。このことは作品や表現に接した際に、既存の評価軸で価値判断を下してしまうのではなく、評価軸それ自体をあらたに生み出す必要があるということでもある。たとえば同書のなかで大友は次のように述べている。

　すごい新しい物だから、批評軸をまだ持ってない。音楽から見たらこうである、

ということは言おうとしたら言えるんだけど、音楽だけで話すと片手落ちだなって気がするし、美術からだけ見てもそれも片手落ちだし、両方から見ても片手落ちで。だからこれは、全然違う軸を持って見なきゃいけないんじゃないか、と少しずつ気づいてきたんですよ。で、それがどういうものか、未だにオレはわからなくて、だから『音楽と美術のあいだ』っていうこんな本をつくろうとしてるわけです。(311頁)

　硬直化した既存の評価軸ではとらえきることができない、むしろあらたに評価軸それ自体の擁立を迫るような作品。そのような作品が位置する「あいだ」というのは音楽と美術に限らず、演劇や舞踊を持ち出すこともできるだろうし、いわゆる芸術ジャンルでなくとも、「凧揚げと音楽のあいだ」にも「ミュージカルと中高校生と大人のあいだ」にも存在し得るものだろう。そしてその意味では対話篇が収載されている同書は、大友良英と畠中実のあいだにあり、ゲスト・インタビュイーとのあいだにあり、さらには後々田寿徳と彼の遺した文章とのあいだにもあるといったふうに、それ自体がテーマを体現するいくつもの異なる評価軸が交わり合う関係性において編み上げられた書籍であるようにも受け取れる。　　　　　　(細田成嗣)

28

川崎弘二、岡本隆子、小杉武久編
『小杉武久 音楽のピクニック』
展覧会カタログ、芦屋市立美術博物館、2017 年

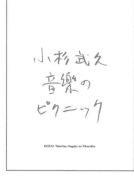

ひらかれた余白

　旅の様相はその時々によって変わる。心づもりをして始まる旅もあれば、いつのまにか旅になっていた旅もある。さまざまなかたちをした旅において共通するのは、新しい「何か」との出会いにひらかれているということである。知らない人、場所、言葉、物、現象、におい、音、風景との遭遇はもちろん、よく知っていると思っていた物や人──自分自身を含む──の新しい側面を発見することもある。いつもとは違う環境に身を委ね、未知・既知との邂逅を通じて、自身に何らかの変化が生じる可能性を許容すること、それが旅だ。

　戦後の実験的な音楽実践を 60 年にわたり行ってきた小杉武久は、正真正銘の旅人であった。一つは、国内外での活動にともなう物理的な移動の多さにおいて。もう一つは、作品の中ですべての要素を固定するのではなく、音がたゆたうことのできる余白を用意している点において。小杉の活動は、これらの異なる層の旅が重なり合うことによって成立していた。

　2017 年に兵庫県の芦屋市立美術博物館で行われた展覧会のカタログ「小杉武久 音楽のピクニック」で、そんな旅の一部を追体験することができる。同書では、国境、年代、ジャンルを越え、縦横無尽に世界を駆け巡った作家の足跡を、膨大な資料をもとに紹介している。小杉によるテキスト、高橋悠治、藤本由紀夫、∈Y∋、和泉希洋志、浜崎健の寄稿文やアートワーク、図録、川崎弘二による綿密な解説と、同館学芸員の大槻晃実による小杉と同館の歩みを記した文章、その他の付録資料からなる。メインの図録部分は、公演や展示の招待状、パンフレット、記録写真、楽譜、レビュー記事などの図像資料で構成され、活動年代とその内容に沿って五つの章に分けられている。以下で、活動の根幹をなす反音楽をキーワードに、その旅路を振

り返ってみたい。

　小杉は、常に反音楽を標榜していた。故に常に葛藤していた。それは、既存の音楽や芸術の制度へと回収されまいとする反発心と、それでもなお音楽という枠組みにおける新しい可能性を模索しようとする好奇心がぶつかり合っていたからだ。試行錯誤を重ねながら両端を行ったり来たりすることで、独自のスタイルが築かれた。

　反音楽のスタンスはキャリアの初期から顕著であった。1959 年に東京芸術大学楽理科の同級生を中心に結成した、集団で即興演奏を行う「グループ・音楽」はその一例だ。1961 年に行った第 1 回目の公演「即興音楽と音響オブジェのコンサート」のチラシには、「不当に縮小された「音楽」の意味を回復する」、「うっ積した音楽的エネルギーを、アンチ・アカデミックな形で放出」、「音響の新しい象徴と記号の探検」といった言葉がちりばめられている。事前に作曲された楽譜の演奏ではなく、その場で音楽が生成されていく即興演奏を通して、新たな音楽の姿を探求していた様子がうかがえる。

　既存の芸術の枠組みを革新しようとする姿勢には、時代と場所も影響していた。60 年代は、音楽に限らず美術やダンスなどにおいても反芸術の動きが活発化していた時代であることに加え、小杉が 1967 年から 2 年間滞在したニューヨークはこうしたムーブメントの中心地であった。日常的な行為やオブジェクトなどを積極的に取り入れた実験が数多く行われていた。印象的なのは、シアターやホール、ホワイトキューブ空間にとどまらず、公園やフェリーなど、芸術的な文脈とは異なる場も舞台になっていた点である。フルクサスはその代表例であろう。小杉の活動もその一端を担うもので、世界中から集まった実験芸術家たちとともに、パフォーマンス、インスタレーション、イヴェントなど変幻自在にそのかたちを変えながら、発表を重ねていった。

　日本帰国後、1969 年からはじまったタージ・マハル旅行団としての活動も、芸術制度へのプロテストとしての側面をもち合わせていた。それには、60 年代を通して行われてきた反芸術的な活動が、アートの一つとして制度の中に組み込まれていったことも多分に関係している。集団で即興演奏を行うこのグループは、即興演奏家、レコードエンジニア、グラフィックデザイナーなど異なる背景をもったメンバーで構成されていた。ジャズ・ホールでのセッションからはじまり、日比谷ロックフェスティバルへの参加、大磯海岸での「ピクニック音楽会 夜明けから日暮れまで」の開催と、活動は広範にわたった。長髪でカジュアルな服に身を包み、潮風に吹かれながら演奏したり、ロッテルダムからタージ・マハルまでワゴン車に乗って旅をし

たり、ほどよく脱力しながら、遊びと旅と芸術の境界をゆるやかにつなぎ合わせる。しかしながら、それは完全な反芸術へと振り切るものではなかった。ストックホルムの近代美術館での芸術祭参加をはじめ、ヨーロッパ各地の美術館でのパフォーマンスを多数行うとともに、個人の活動として能楽堂でのソロコンサートやギャラリーでの作品発表などを継続的に行っていたことからも明らかである。

反音楽、反芸術を目指しながらもその大枠から逃れきれない矛盾への苦悩は、70年代後半以降に展開されるインスタレーション作品においても引き継がれる。1991年に発行された著作『音楽のピクニック』のなかで小杉は、ギャラリーや美術館で展示されるこれらの作品を、即興のように生身の身体を介す表現の対照に位置する「完全な芸術作品」だと述べ、自身の戸惑いを吐露している（小杉武久、高橋悠治の対談「真空の柱」『音楽のピクニック』engine books、2017年）。とはいえ、予期せぬ結果が生まれる可能性が完全に遮断されたわけではなかった。電子的なクリック音を発生させる発振器を、砂、砂糖、塩の入った箱に埋めることで変質させる《五十四音点在》（1980年）や、窓の近くにソーラーパネル付きの音を発するオブジェクトを多数置き、観客の動きや天候によって変容させる《ライト・ミュージックⅡ》（2015年）などにおいて、聞こえてくる音は、その場の環境や鑑賞者との相互作用によって少しずつ変わり続けている。すべてを固定するのではなく、コントロールしきれない余白部分を残すことで、先述の著作において作家がいうところの「アートでありながら反アートへ開く回路」を保持し続けているのである。

ここまで反音楽、反芸術を軸に小杉の来歴を追ってきたが、最後に、活動の根底にあるもう一つの重要なコンセプト「キャッチ・ウェーブ」に触れておきたい。「キャッチ・ウェーブ」、直訳すると「波をつかまえる」とは何を意味するのか。例として、『小杉武久 音楽のピクニック』に記載された公演の記録写真、公演パンフレット、インストラクションおよび川崎弘二による解説を元に、1967年に小杉がニューヨークでナム・ジュン・パイク、シャーロット・モアマンとともに行った《マノ・ダルマ、エレクトロニック（キャッチ・ウェーブ）》の演奏をみてみよう。無線周波発振器とラジオが天井からつり下げられ、その周りに、発振器もしくは受信器がついた釣り竿を持った演奏者、チェロ奏者、そして電気扇風機が配置される。演奏者と扇風機、発振器とラジオの動きが互いに影響しあうことで、空間に生み出される音響が変化していくというものだ。小杉はこの演奏で、場の状況に応じて変化する不確定な要素を積極的に取り込み、新たな出会いを生じさせる枠組みを設定する。このような場において生み出された音を捕獲する行為が「キャッチ・ウェー

ブ」である。ここでつかまえられる音は予め決められているわけではなく、最終的な結果を事前に予測することはできない。これは、楽譜の存在によって、場所や人の固有性にかかわらず作品の同一性が担保される「制度化された音楽」への一つの抵抗として考えられるだろう。

　そして、また、「キャッチ・ウェーブ」は、作家にとっての音楽を続ける理由にもなっていた。『小杉武久 音楽のピクニック』冒頭で、小杉は「私が作品を作るというより、向こうから音がやってくるという感覚で、向こうからやって来た瞬間をキャッチ出来た時が私にとっての醍醐味で、その面白みがあるからこそ、今も音楽をやっているのだと思う」（5頁）と述べている。作品のなかで作家自身が旅をし、やってきた音と出会うこと。幾度となく繰り返されるこの遭遇こそが、小杉にとって音楽を続けるうえでの原動力となっていたのだ。

　小杉の作品／演奏にみられる反音楽、反芸術性や、インターメディア性——音楽でもあり、美術でもあり、パフォーマンスでもある——は最大の特徴である一方で、語りにくさを生じさせる原因ともなっていた。同書は、国内はもちろん海外での活動をも包括した総覧となっており、長年謎に包まれていた作家の全容を明らかにする貴重な資料である。また、一音楽家の活動記録を越えた、戦後の日本、欧米における実験的な音楽や芸術に関する歴史的資料としての価値も高い。さらに付け加えたいのが、旅行記としての側面だ。ページをめくっていると、眼に飛び込んできた写真をみて自然と自身の旅が思い出されたり、キャプションを読んで60年代ニューヨークでの破天荒なパフォーマンスの様子が浮かんできたり、知らない間にどこかへ連れ出されていることに気づく。小杉武久という一人の旅人によって生み出された磁場は、今も閉じられることなく、新たな出会いを誘発し続けている。

（北條知子）

第7章

音の生政治学
音による管理と解放

　本章にまとめた本はいずれも音による生命の管理を主なテーマとする。ミシェル・フーコーは「生命に対して積極的に働きかける権力、生命を経営・管理し、増大させ、増殖させ、生命に対して厳密な管理統制と全体的な調整とを及ぼそうとする権力」をめぐる政治を「生政治」と呼んだ（ミシェル・フーコー『性の歴史Ⅰ 知への意志』渡辺守章訳、新潮社、1986年）。また彼は、生命を増大させながら従順にさせるこのような権力を求めたのは、資本主義の発達だったと考える。

　ティモシー・D・テイラー『資本主義の音──広告、音楽、文化の征服』は、音楽産業と広告産業が20世紀以降に結びつきを深めていく歴史をたどる。マイケル・カーワン『ヴァルター・ルットマンと多様性の映画──前衛 - 広告 - 近代性』は、「耳のための映画」と称される音響作品《週末》（1930年）の作者であるヴァルター・ルットマンの表現が、人間の感覚のはたらきを管理しようとする同時代の広告文化や「精神物理学」の動向を背景としていたと主張する。スティーヴ・グッドマンも『音の戦争──サウンド、情動、そして恐怖のエコロジー』において、現代の「音のブランド戦略」に加えて、いわゆる「音響兵器」など、身体の管理に関わるさらにさまざまな音を取りあげながら、対抗する実践の可能性を探る。これらがいずれも広告を論じているのに対して、若尾裕『サステナブル・ミュージック──これからの持続可能な音楽のあり方』はクラシック音楽、現代音楽、音楽療法について同じように生政治という視点から考察する。日本の音楽療法史をめぐっては、光平有希『「いやし」としての音楽──江戸期・明治期の日本音楽療法思想史』（臨川書店、2018年）が、その来歴を詳細に描きだしている。

29

ティモシー・D・テイラー
『資本主義の音——広告、音楽、文化の征服』

Timothy D. Taylor, *The Sound of Capitalism: Advertising, Music, the Conquest of Culture*,
University of Chicago Press, 2014

消費者をつくる音楽

　コマーシャルで流れる音楽は、アメリカでは 1920 年代よりラジオにおいて発展し、30 年代には歌詞で商品をほめる「シンギング・コマーシャル」というスタイルが確立された。1944 年、「チキータ・バナナ」のコマーシャルの陽気なジングルが大流行すると、多くの有名歌手にカバーされ、レコードもつくられた。『資本主義の音——広告、音楽、文化の征服』の著者ティモシー・D・テイラーによれば、テレビが普及した 50 年代、広告で流れる音楽にも大きな変化が生じた。それまでの音楽はどれも楽しげで、聴取者の消費欲をあおるものだったのに、このころからテレビ・コマーシャルの音楽はずっと情緒的に、視聴者の繊細な感情に寄り添うようになった。テイラーはこの変化をメディアの性質の違いから説明する。視覚情報のないラジオでは音楽によって商品の魅力を強調する必要があった。一方、商品を視覚的にアピールできるテレビでは、消費者の感情を精緻にコントロールすることが音楽の役割として重視されるようになった。さらに彼はこう主張する。こうした変化を、たんなるメディアの転換の結果ではなく、広告産業や資本主義がだんだんと移り変わっていった長い過程の一幕として考えるべきだ。そして、この過程でたえず追求されてきたのは、いかにして消費者を生産するかという課題だった、と。

　『資本主義の音』は、テイラーによれば、広告音楽の歴史をめぐる初めての学術書である（とはいえ、アンソロジーなら日本でも『メディア時代の広告と音楽——変容する CM と音楽化社会』（小川博司、小田原敏、粟谷佳司、小泉恭子、葉口英子、増田聡、新曜社、2005 年）など、先行する著作がある）。同書であつかわれる広告音楽には、コマーシャルのために制作された楽曲も、コマーシャルで使われた既存の楽曲も含まれる。テイラーは同書がテオドール・アドルノやジャック・アタリの

議論を受けついでいることを認めるが、彼らの議論が実証データを欠くことに不満を述べる。同書の魅力はまずこのデータ、つまりラジオからインターネットに至るまでの広告音楽の、たくさんの楽曲、音楽家、統計、エピソードについての記述である。取りあげられた歴史的楽曲のいくつかは動画共有サイトなどで聞くことができる。興味深いエピソードの一例をあげると、初期のラジオ・コマーシャルではクラシックとジャズのどちらがふさわしいかという論争があったという。スポンサー側は刺激的なジャズを好んだが、広告代理店側は自分たちの品位を高めるためにもクラシックを使いたがった。ジャンルの比較は後にマーケティング手法の発達と結びついて、70 年代には詳細な図表になっていく。テイラーが描く広告音楽史はスポンサー、代理店、音楽家、消費者などの異なる立場の集団と、さまざまな音楽ジャンルが絡み合いながら展開する。

　『資本主義の音』は個人の社会的実践としての消費をめぐるものではなく、広告音楽を「読む」ことにはあまり関心がない、とテイラーは書いている。彼が目を向けるのはますます融合していく音楽産業と広告産業の関係であり、すべての音楽が広告音楽でありうるという現状だ。消費者という役割をいかに生産するか、この課題はラジオ・コマーシャルが登場したころからすでに広告産業の主な関心事であり、現在もそうであるとテイラーは主張する。広告代理店は広告を通じて商品やサービスをアピールするだけでなく、視聴者がそれらを熱心に消費するような文化をつくろうとする。音楽はそのために重要な働きを担ってきた。テイラーによれば、消費者の生産は資本主義の基礎であり、社会状況の変化、たとえば人口動態の変化とともに方法を変える。広告音楽の歴史もこうした変化に沿っていく。

　この本の副題の「文化の征服」は政治評論家トマス・フランクの『クールの征服』（University of Chicago Press, 1997）に由来する。フランクは同書でこう語った。「六〇年代に起こったのは、ヒップ（あるいはクール）が、資本主義が自分自身を理解し、大衆に対して自分を説明する際の、中心概念になったことである」（『クールの征服』26 頁）。若者文化が伝統文化に取って代わるなかで、クールな価値観を表現することは消費者を生産するための重要な方法の一つになった。さらにテイラーはこう論じる。80 年代、レーガン政権時代にあらわれた消費文化以降、ピエール・ブルデューが「新興プチブル」と呼んだ社会集団によって、あらゆる文化を用いて消費者の生産が行われるようになった。新興プチブルとは例えば、人に商品を勧めたりイメージをつくりだしたりする職業に就く人々のことだ（ブルデュー『ディスタンクシオン――社会的判断力批判 Ⅱ普及版』石井洋二郎訳、藤原書店、2020 年、

693 頁）。テイラーの広告音楽論の理論的な意義はこのあたりにありそうだ。彼は広告音楽の変化を資本主義そのものの変化としてとらえる。

　ここでテイラーが物語る、広告−音楽産業がおよそ 1 世紀にわたって展開した戦略の変遷をかけ足で見てみよう。そうして彼の議論を大まかにとらえても、『資本主義の音』に集められた事例の豊かさが失われることはないだろう。テイラーはアメリカの広告音楽の歴史には三つの大きな波が訪れたと考える。

　1920 年代の最初の波においては、ラジオ・コマーシャルと音楽が結びついた直後から、音楽が商品に「人格」のようなものを付け足し、聴取者の「善意（グッド・ウィル）」を引きだす効果をあげることが期待されていたという。しかし、大恐慌後の 30 年代以降はそうした穏やかな戦略ではなく、「ハード・セル」と呼ばれる直接的なアピールが主流になる。そのなかで広告音楽の陽気なスタイルが定まり、音楽産業と広告産業が融合していく。第二の波が訪れたのは、冒頭に書いたとおり、テレビが普及した 50 年代だった。消費者をいかに生産するかという方法自体は時代やメディアとともに変わったが、二つの産業の融合は後戻りせずに進んだ。

　人口動態の変化にともない、70 年代までには広告産業が「若者」というターゲットを確立し、広告音楽からたくさんのヒット作が生まれるようになる。その結果、広告音楽とそうでない音楽の境界はますますあいまいになった。80 年代初めは音楽つきコマーシャルが半分ほどだったが、MTV の流行とともに、80 年代半ばになるとほとんどのコマーシャルが音楽つきになる。この時代の変化がテイラーの語る第三の波にあたる。広告−音楽産業はマーケティングを通じてより特定された集団にアプローチするようになっていく。若者消費文化の担い手だったベビーブーマーが企業幹部になると、彼らはトレンドを探すのではなく、トレンドをつくる側に回ろうとした。たとえば、あまり知られていない音楽、オルタナティブ・ミュージックなどを取りあげて、自分たちが若者文化の権威になり、文化を征服しようとする。テイラーは、80 年代半ばに訪れたこうした変化をデジタル・テクノロジーが助長したことも論じている。

　テイラーの以前の著作には、新しい音響テクノロジーが生みだす新しい音をめぐる『ストレンジ・サウンズ──音楽、テクノロジー、文化』（Routledge, 2001）がある。このなかで彼は、音楽とテクノロジーの結びつきを同時代の文化全体のなかに位置づけるためのロジックを模索していた。そして、アクターネットワーク理論で知られるブルーノ・ラトゥールや、社会学者アンソニー・ギデンズを参照しながら、テクノロジーに対する社会の不安と期待が、テクノロジーを利用する音楽にい

かにあらわれるかを考察した。こうしたアプローチによって彼はミュジーク・コンクレートの先駆者のひとり、ピエール・アンリの音楽の特異性や、インドのゴアで生まれたためにそう呼ばれるサイケデリックなダンス・ミュージック、ゴア・トランスの多面性、さらには中東音楽と電子音楽をミックスしたムスリムガウゼの戦略まで、さまざまな音楽の個性を並べて論じることができた。

　『ストレンジ・サウンズ』と『資本主義の音』は対象こそかなり異なるが、アプローチには共通するところがありそうだ。それは、ある文化のなかに起こった一つの動揺をめぐって、音楽がそれを助長したり、そこから影響を受けたりしながら、再配置される過程を追っていくというものである。『ストレンジ・サウンズ』では新しいテクノロジーの出現が、『資本主義の音』では資本主義に生じた変化がこの動揺に当たるだろう。広告音楽の展開はこの動揺のたんなる帰結ではなく、むしろ動揺を構成するものなのである。　　　　　　　　　　　　　　　（金子智太郎）

30

マイケル・カーワン
『ヴァルター・ルットマンと多様性の映画――前衛 - 広告 - 近代性』

Michael Cowan, *Walter Ruttmann and the Cinema of Multiplicity: Avant-garde – Advertising –
Modernity,* Amsterdam University Press, 2014

ワイマール視覚文化における「光の音楽」

　ドイツの映画監督ヴァルター・ルットマンによる《週末》（1930 年）は、録音された音を用いて作曲するミュージック・コンクレートの創始者、ピエール・シェフェールが最初の作品を発表するおよそ 20 年前に制作された「耳のための映画」である。教会の鐘や鶏の声などを交えながら労働者の週末を音のみで表現したこの作品を聞くたびに、冒頭 1 分ほどの歯切れのよいモンタージュの印象が残る。シェフェールの《エチュード》連作（1948 年）がそれぞれの音の響きを強調するような、ゆったりした構成からなるのに対して、《週末》の冒頭はダンス・ミュージックのような躍動感がある。ルットマンが同時期に制作したサイレント映画『ベルリン――大都市交響曲』（1927 年）の冒頭からも似たような印象を受ける。疾走する列車のモンタージュによって、彼の「絶対映画」を思わせる幾何学的構成がリズミカルに展開していく。全体の構成も似ており、『ベルリン』は大都市の一日を描いたドキュメンタリーだ。《週末》が「耳のための映画」と呼ばれたのに対して、『ベルリン』は「光の音楽」と称された。

　ルットマンは「絶対映画」と呼ばれる、1920 年代にドイツで生まれた抽象アニメーション映画の作家の一人として知られる。しかし、ハンス・リヒターやオスカー・フィッシンガーら、他の絶対映画作家と比べて、彼は二つの点で異質だった。まず、彼は光だけでなく、音による実験にも早くから関心をもち、《週末》の他にもドイツ最初のトーキー映画『世界のメロディ』（1929 年）などを制作した。もう一つの点は、リヒターらはファシストが政権をとると国外に渡ったのに対して、彼はドイツに残ってファシストのために映画を制作したことだ。20 年代に映画芸術国民同盟など左翼的組織を先導したにもかかわらず、ルットマンはナチスのプロパガンダ映画『意思の勝利』（1935 年）を制作するレニー・リーフェンシュタールの助

手も務めた。

　環境音の記録を用いた創作の歴史を考えるとき、その先駆者の一人であるルット
マンの、ヒトラーが政権を握った 1933 年以降の活動は、この創作が政治と結びつい
た顕著な事例として注目せざるをえない。《週末》や『ベルリン』の躍動感や周期的
な構成は、後にファシズムに結びついていったのか。マイケル・カーワンの『ヴァ
ルター・ルットマンと多様性の映画——前衛−広告−近代性』は、ルットマンと
ファシズムの関係から目を逸らすことなく、彼の作品と当時の社会的・文化的状況
のつながりを読み解きながら、一つの解釈を導こうとする。

　カーワンが描き出したのは、第一次世界大戦直後の激変するドイツの大衆文化の
なかで、徹底して職業映画作家として活動しようとするルットマンの姿である。彼
は映画の芸術的可能性を追求するとともに、同時代の大衆視覚文化の流行に歩を合
わせ、産業や政治の要求に応えることを旨としたのだ。ルットマンはフランスで活
躍した映画監督アルヴェルト・カヴァルカンティと比べて詩情に乏しく、ロシアの
セルゲイ・エイゼンシュテインのような政治性もなく、形式主義的、官僚的だと評
されることがある。カーワンによれば、彼の作品のこうした印象は、形式主義的な
芸術観ではなく、大衆文化とのつながりから説明できる。カーワンが参照するのは
民主主義がもたらすイメージの洪水に対応したワイマール時代の広告理論、アーカ
イブ、統計学などである。

　カーワンによれば 1920 年代のドイツには、社会民主主義政府による戦前の広告
法の徹底した緩和によって新しい視覚文化が開花した。印刷物だけでなく、あらゆ
る公共領域が広告の舞台となり、カーワンの言葉で言えば「すべての表面が広告の
標的になった」(34 頁)。電光掲示板や広告宣伝車などの登場もこのころだった。な
かでも、映画は主要な新しい広告メディアとして注目を集めた。絶対映画作家たち
はみな広告映画を制作しながら前衛的作品に取り組んでいた。

　広告産業の拡大とともに広告理論もこの時期に発展した。広告理論家はベンヤミ
ンよりもずっと早くから「気散じ」や分裂した知覚について論じていたとカーワン
は指摘する。そして、広告理論家が頼りにしたのは、ヘルマン・エビングハウスら
の精神物理学、つまり刺激と感覚の対応関係を測定しようとする学問だった。新印
象派が参照した化学者ミシェル＝ウジェーヌ・シュヴルールらの色彩理論も重視さ
れた。こうした理論にもとづいて広告理論家が探求したのは、消費者の注意に対し
て広告の効果をいかに最大化するか、イメージによっていかに明確かつ迅速に情報
を伝えるかという問題である。この時代のドイツを代表するグラフィック・デザイ

ナーであるルシアン・ベルンハルトのポスターに見られる幾何学的形態、ハイコン
トラストな色彩、リズミカルな構成はこうした問題に対する解答の一つだった。

　『ヴァルター・ルットマンと多様性の映画』においてカーワンは、ルットマンの広
告映画だけでなく、彼の絶対映画作品『オーパス』連作（1921–25 年）にもこうし
た広告理論とのつながりが見られると考える。職業映画作家たらんとしたルットマ
ンが同時代の広告理論を無視したはずはなかった。広告理論家もルットマンの作品
に注目したようだった。カーワンによれば、当時の広告理論家ケーテ・カーツィグ
は 1926 年の論考「さまざまな広告映画」で、広告映画の主要なスタイルの一つを
「絶対」広告映画と呼んだ（40 頁）。これは偶然の一致ではなかった。ルットマンの
作品はよく、リズミカルな運動によって観客の心をとらえることが評価された。こ
うような効果は精神物理学にもとづく広告理論においても特に重視されていた。そ
して、ルットマン自身も『ベルリン』について「ベルリンという都市を経験しても
らうために、観客を振動させることに成功したら、私は目的を達成したということ
だ」（41 頁）と表現した。カーワンはこの振動が美的なものであるのみならず、広
告が目指すものでもあったことを強調する。

　カーワンによれば、『ベルリン』の具象的な映像には広告や精神物理学とは別の
文化的な対応物がある。それは、商品カタログや科学的図解、写真アーカイブなど、
同時代の視覚文化にくり返し見られた「横断的（cross-sectional）」なイメージの配
置である。『ベルリン』には、別の場所にある別の対象が同じような形態になったり、
動作をしたりする場面が何度もある。さまざまな建物の似かよったブラインド、居
眠りするベンチの男と動物園の象、人間と人間、人間と機械など、異なる文脈にあ
る存在が並置される。こうした映像をカーワンは「〈横断的〉モンタージュ」と呼ん
でいる。

　カーワンはこの横断的イメージを同時代人の統計学的認識が視覚化されたものであ
ると論じる。19 世紀後半に影響力を増した統計学は、一般的な法則に従わない個別
的なもの、偶然的なものを対象とし、それらを一つの図式に取り入れるための手段で
ある。個別性と図式の緊張関係が統計学的認識の原理なのだ。カーワンはこの緊張関
係が、厳密さをまったく欠いたかたちで、商品カタログや写真アーカイブにおける個
別的なものの類似にもとづく配置にも見られると考える。さらに、ルットマンによる、
多様で個別的な物事を都市という一つの図式に取りまとめていく横断的モンタージュ
も、こうした統計学的認識を表現しているのだという。カーワンの指摘で興味深いの
は、ルットマンを酷評した映画理論家のジークフリート・クラカウアーが『大衆の装
飾』（船戸満之、野村美紀子訳、法政大学出版局、1996 年）において、ゲオルグ・ジ

ンメルの思想のなかにこの横断的イメージを発見したということだ。

　カーワンの主張どおり、ルットマンの作品が精神物理学にもとづく消費者の管理や統計学的認識における個別的なものの把握と深い関係があるとすれば、彼が30年代以降、公衆衛生や人口問題といった主題をあつかい、ファシズムと関わるようになった理由や経緯も推察できそうだ。カーワンは同書の後半でこれらを論じている。『ヴァルター・ルットマンと多様性の映画』はルットマンの作品に対する印象を一変させるものではないが、形式主義的な前衛芸術家という作家像には修正を迫っている。では、ワイマールの音の環境のなかで横断的イメージに対応するものは何だろう。残念ながらカーワンのこの本は《週末》や聴覚文化についてほとんど論じていないが、これらを考察するための手がかりに満ちている。（金子智太郎）

31

スティーヴ・グッドマン
『音の戦争──サウンド、情動、そして恐怖のエコロジー』

Steve Goodman, *Sonic Warfare: Sound, Affect, and The Ecology of Fear*, MIT Press, 2010

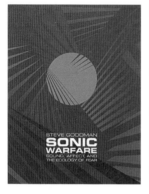

震えるモノたちの宇宙

　同書の著者スティーヴ・グッドマンは「Kode9」の名で世界的に活躍する DJ であり、UK のインディペンデントレーベル「ハイパーダブ（Hyperdub）」の主宰者としても知られる。ジル・ドゥルーズとフェリックス・ガタリによる『千のプラトー──資本主義と分裂症』（宇野邦一、田中敏彦、小沢秋広、豊崎光一、宮林寛、守中高明訳、河出書房新社、1994 年）の向こうを張って各々特定の年数を冠した 34 章からなる同書では、過去‐現在‐未来が縦横無尽に行き来され、認知心理学や映画、哲学、SF といった諸ジャンルの素材が巧みにリミックスされる。グッドマンは英国のウォーリック大学で博士号を取得したのち大学で教鞭も執っているが、具体例と思弁とを織り交ぜながら展開されるその議論は、実践家と理論家という二つの顔を併せもつ著者の面目躍如といったところである（グッドマンの略歴と作品については、髙橋勇人「スティーヴ・グッドマン諸作における人類消滅後の全自動ホテルが示すもの」（『現代思想』47 巻 8 号、2019 年）を参照）。

　「音の戦争」という幾分禍々しいタイトルをもつ同書において争点とされるのは、音楽や音が物理的な振動や震えとして何をなすか、ということである。ここでいう震えとは、友愛や共感といったニュアンスを孕む「共鳴」という言葉でイメージされるような「良い感じ（good vibe）」ではなく、さまざまな「音の戦争機械（sonic war machines）」が生み出す、往々にして恐怖を引き起こすような「嫌な感じ（bad vibe）」である。一体「音の戦争機械」とは何なのか。それには大きく分けて二つのタイプがある。

　一つ目は、音やノイズを用いて、身体的なレベルで暴力を行使するタイプである。イスラエル軍がガザ地区で引き起こすソニックブーム。フランシス・コッポラ

の『地獄の黙示録』（1979年）のモデルにもなった、アメリカ軍がゲリラ兵の潜むベトナムのジャングルに爆弾と一緒に注ぎ込む120デシベルを超える大音量。それに付随する技術革新が戦後のHi-Fiオーディオの発展の礎になったことでも知られる、通称「ゴースト・アーミー」（第二次世界大戦時のアメリカ軍第23本部付特殊部隊）による音を用いた欺瞞作戦。それから、パナマ侵攻の際、バチカン大使館に立て籠ったマヌエル・ノリエガに連日連夜浴びせかけられる騒々しいロックとポピュラー音楽。あるいは、ギャスパー・ノエの『アレックス』（2002年）において観客に不快感をもたらすために挿入される低周波音、などなど。「音の戦争機械」は、振動によって身体を内側から揺さぶり、恐怖を与え、目眩や吐き気を引き起こし、敵対する集団を崩壊・分散させる。

　もう一つのタイプは、よりミクロなレベルで機能する。神経システムを横断しながら情動的な感染を引き起こし自己増殖を繰り返す「音‐ウィルス」である。さながら細菌兵器のような「音‐ウィルス」は、人々のムードや気分、雰囲気に作用を及ぼす資本主義的な力である。それに対する診断は「音‐ウィルス学（audio virology）」と呼ばれるが、その一例として「音のブランド戦略」をめぐる議論に耳を傾けてみよう。

　グッドマンによれば、現代の「音のブランド戦略」は、もはや単にキャッチーな曲を用いるだけではなく、記憶に働きかける方法の探究に乗り出している。彼はブランドコンサルタントであるマーク・ゴーベによる議論（『エモーショナルブランディング──こころに響くブランド戦略』福山健一監訳、宣伝会議、2002年）を参照し、二つの効果をミックスすることで「既聴感（déjà entendu）」を与える仕方について論じる。一つは、ある特定の状況や雰囲気を聴き手の意識に呼び戻す想起の効果。いま一つは、実際に体験したことのない記憶を植え付ける効果。これら二つの効果は、リアルにせよヴァーチャルにせよ、「わたしは以前にもこれを楽しんだことがある」という感覚をもたらし、さらなる消費の反復を煽る。新しい、けれども親しみを抱かせるサウンド・ロゴを開発することで企業が目論んでいるのは、こうしたことだ。資本主義の力とは先回りする力なのであり、それは本来開かれてあるはずの未来を現在の欲望に従属させ、生成を管理へと変えてしまう、とグッドマンは指摘する。

　このように音を介して情動や記憶の管理を図る資本主義に、グッドマンはまた別の感染性の振動、ないしは「情動の流通」を対置させる。そこで重要な位置を与えられるのが、かつてポール・ギルロイが論じた「ブラック・アトランティック」の

ディアスポラの音楽、特にジャマイカン・ポップスである（ポール・ギルロイ『ユ
ニオンジャックに黒はない——人種と国民をめぐる文化政治』田中東子、山本敦久、
井上弘貴訳、月曜社、2017年）。レゲエ、ダブ、ダンスホールは、ヨーロッパのポ
ピュラー音楽文化だけでなく、ジャングル、ハウス、テクノ、アンビエントなどに感
染し、それらを変異させてきた。『音の戦争』は、こうしたジャマイカン・ポップス
のサウンド・システムを説明するために「低音−物質主義（bass materialism）」と
いう概念を発明する。低周波音は、周囲の身体＝物体に震えをもたらし、そこでは
サウンドと触覚が一体化し、振動をめぐる環境が集合的に構成される。低音−物質
主義とは、こういってよければ、身体＝物体のあいだを走る境界線を取り払い、ひ
としく震えるモノ（身体＝物体）たちの宇宙を称揚する、脱人間中心主義的なプロ
グラムなのである。念頭に置かれているのはアルフレッド・ノース・ホワイトヘッ
ドの哲学であるが、グッドマンによれば、ダブが蔓延させたものとは、単にサウン
ド・システムそのものだけでなく、こうした振動によって生起する関係性のダイア
グラムであり、「振動の関係のネクサス」である。しかしながら、資本主義は、こう
した情動の流通の技術に満ちたジャマイカン・ポップス、それからアメリカのヒッ
プホップのサンプリング、ディスコ、ハウス、テクノのリミックス、そしてハイパー
ダブのやり方に寄生し、乗っ取り、それを、またもや情動の調整のための管理プロ
グラムへと変化させてしまおうとする。

　こうした同書の診断を追っていると、いまや世界は消尽し、資本主義によって絶
えず供給される、偽の新しさの反復だけが残されているかのようである。とはいえ、
グッドマンは、開かれた未来としての潜在性の領野を探究してもいる。それが人間
の可聴域の周縁部に潜む「不音（unsound）」の領域だ。

　この「不音」という概念は「聴覚システムをめぐる生理学の不十分さによる限界」、
あるいは階級や人種、性別、年齢などによって決定論的になされる「感覚能力に対
するポリシング」によって隠されてきた、「知覚できない振動のネクサス」を名指す
ためのものである。「不音」の領域とは、神経や生理にたしかに作用し、私たちが
まだ十分に理解できていない仕方で情動的な感覚の変化を引き起こしている「まだ
聞こえないもの（the not yet audible）」の場であり、そこには新しいリズムや響き、
テクスチュアが潜んでいる。グッドマンにとって、この領域の探究は音の高低をめ
ぐる「周波数の政治学」を意味し、それはこれまでノイズと沈黙という二つの概念
を軸になされてきた、音の大小をめぐる「振幅の政治学」を補完するプロジェクト
となる。もっとも、すぐさま指摘されるように、新たな領域の探究は、またもやそ
れに対する征服や管理を招き寄せもするだろう。わたしたちは、つねに管理と生成

がせめぎ合う戦争状態に置かれていることを忘れてはならない。

　以上に概観してきた他にも、マイク・デイヴィスの『スラムの惑星――都市貧困のグローバル化』（酒井隆史監訳、篠原雅武、丸山里美訳、明石書店、2010 年）に対抗した「ドラムの惑星」、アンリ・ベルクソン、ガストン・バシュラール、アンリ・ルフェーヴル、ドゥルーズ、ミシェル・セールなどを召還し、そして、ここでもやはりホワイトヘッドの哲学に依拠しながら展開されるリズム論など、『音の戦争』は耳を傾けるに足る刺激的な議論に事欠かず、もはや語り尽くされたかのように思われる「音」について、まだ思考すべきことが多く残されていることをわたしたちに教えてくれる。グッドマンがバールーフ・デ・スピノザの言葉をもじっているように「わたしたちは、音の身体＝物体がなにをなしうるかを、まだ知らない」のだ。

<div align="right">（原塁）</div>

32

若尾裕

『サステナブル・ミュージック──
これからの持続可能な音楽のあり方』

アルテスパブリッシング、2017 年

音楽とのサステナブルな付き合い方

　同書は臨床音楽学を専門とし音楽教育や音楽療法の分野を中心に活躍する著者が、2000 年代後半から書き綴ってきたテクストを「反ヒューマニズム音楽論」「クラシック音楽という不自由さ」「現代音楽は音楽を解放したか」「アウトサイダー・ミュージック」「サステナブル・ミュージック」という五つの章のもとに集成したものである。各章で展開される議論は、戦後フランスの思想家ミシェル・フーコーが提示した「生権力」をめぐる一連の考察に通じるものである。そこでは、西洋近代音楽とそれをめぐる言説・制度が孕む、人々を内側から管理・規律化する技術としての側面が問いに付される。こうした管理の手から音楽がもつ可能性を解放すること。音楽を、私たちの生が終わりを迎えるその時まで付き合うことのできる持続可能なものへと一歩ずつ変えてゆくこと。同書は、そのための診断書であり処方箋である。

　同書で主に批判的考察の俎上に載せられるのは、18 世紀頃から飛躍的に発展した調的和声のシステムに支えられた、いわゆる「クラシック音楽」や「ポピュラー音楽」と呼ばれる類のものである。調性音楽は、長三和音は明るく、短三和音は暗いといった単純なレベルだけでなく、さまざまな情動のレパートリーを整理し、和声技法とのあいだに対応関係を築き上げ、その展開は転調を容易にする人工的で合理的な音律である平均律によって支えられてきた。著者は、このように主情主義と合理性という、一見したところ相反する二つの態度をとる西洋音楽の特殊性を主張したうえで、こうしたあり方があたかも普遍的なものとみなされ、こんにちのさまざまな音楽実践の暗黙の前提とされてはいないか、と問いかける。

　この出発点から敷衍される幾つかの議論に耳を傾けてみよう。まず、大量生産される「ポピュラー音楽」をめぐって（実験性や芸術性を追求する「ポピュラー音楽」については、大衆性を回復させようとする「現代音楽」とのあいだの鏡像的な関係が指摘されたうえで、そもそも「芸術性／大衆性」という二項対立の図式に捉われない意識の必要性が説かれているが、ここではおく）。人は自分の感情をよく代弁してくれる歌を求め、その歌を通じて感情とは何かについて学ぶ。多くの人々の共感が得られた楽曲の表現とそれに対応するコード進行のパターンは、精選され次に生産される音楽にフィードバックされていくだろう。著者は、この精選とフィードバック、消費と再生産の無限ループのなかで、消費者の感情や情動が資本主義によってコントロールされ、次第に画一化されていく危険性に注意を促す。ここには法律による禁止や処罰による抑圧／被抑圧とは異なる、ミクロなレベルでの管理がある。

　あるいは、公共空間や公衆の場に流れるBGMについて。これまでBGMをめぐっては、マリー・シェーファーらによって、各々の空間に固有の環境音や共同体にとって重要なサウンドをマスキングしてしまう点が批判されてきた（『世界の調律──サウンドスケープとはなにか』鳥越けい子、小川博司、庄野泰子、田中直子、若尾裕訳、平凡社、2006年）。それとは異なる角度からアプローチを試みる同書は、合理化され単純化されたコード進行のパターンに従う音楽を「三和音の壁紙」と呼び、それは実のところ「秩序があり、清潔であり、なんでも商品として手に入れることのできる、心地よく安心感のある生活を象徴する記号」なのであり、「「ここは未開で危険な場所ではなく、安全で清潔な資本主義がいきわたった空間なのですよ」というメッセージを伝えるためのもの」になっていると指摘する。

　この論点は同書の別の箇所で論じられる「感情労働」という問題と接続可能ではないだろうか。社会学者のアーリー・ラッセル・ホックシールドが精緻に分析したことで知られる「感情労働」とは、訓練された「にこやかな笑顔」を顧客に提供するという新たな労働のかたちであるが（『管理される心──感情が商品になるとき』石川准、室伏亜希訳、世界思想社、2000年）、「三和音の壁紙」は、私たちがこうした笑顔を違和感なく享受するためのアンビエンスとしても機能するだろう。「三和音の壁紙」に取り巻かれることで、労働者も私たちも共犯的に「感情労働」という不自然な労働形態を受け入れ、それをスムーズに内面化・規律化していく。こうして遍く行き渡った「にこやかな笑顔」は旅行やショッピングといった娯楽の質を高め、日々の仕事のための労働力をスムーズに回復させる。「三和音の壁紙」が貼られているところはどこでも、労働の延長線上の空間と化す。ここにもまた人々と音楽の関係を通じて発生するミクロなレベルで作用する権力の問題が見いだせる（実際

に「音楽を用いた感情労働への負担軽減法」といった科学的な実験も既に行われているようだ）。公衆の場や労働空間におけるサウンドの使用を考えるうえでは、環境という論点に加え、同書が提示する権力や情動、資本主義といった観点から、さらに議論を深める必要があるだろう。

　さて、著者は自身の専門である音楽療法をとりまく諸問題についても権力という切り口から鋭く迫る。とくにフォーカスされるのは自閉症をめぐる議論である。これまでの音楽療法においては専ら定型発達者の世界への適応を促すために音楽が用いられる傾向にあった。そのバックボーンとなっているのが、「クラシック音楽」は人生について教えてくれる「まじめ」で「正しい」音楽だ、という規範的な見方であるという。

　もちろん、「正しさ」を教えてくれるものとしての「クラシック音楽」という思想は歴史的に構築された特殊なものに過ぎない。それに一役買っているのは「困難を果敢に乗り越えた作曲家」というベートーヴェン像であるが（ジョセフ・ストラウス『常ならぬ仕方――音楽における障碍』Oxford University Press, 2011）、音楽療法はこうした特殊な規範性をもった見方を前提とすることで、自閉症者自身による世界のとらえ方や音楽性に対する眼差しを欠いてはこなかったか。そこには「正しい／異常」「健康／病気」といった線引きの論理が働いてはいなかったか。これもまた、フーコーが切り拓いた地平に立つ著者ならではの問いだ。

　これまでもサウンド・スタディーズの分野では、ジョナサン・スターンのような論者が聴取を考えるうえで「ろう」というあり方がもつ重要性を指摘してきた（ジョナサン・スターン『サウンド・スタディーズ・リーダー』（Routledge, 2012：☞本書72-75頁））。近年では、自閉症者からみた定型発達者を指して「ニューロティピカル（neurotypical）」という言葉も用いられている。求められるのは自閉症者の声に耳を傾けながら、私たちが半ば自明視している規範や規律を批判的にとらえ直し、その固着した枠組みを鋳直していくことではないか。そのうえで、これからの臨床的音楽活動においては自閉症者という生き方を反映した音楽との積極的なコラボレーションを考えるべきであり、そこに従来の音楽療法とは異なる意味が萌し、新しい時代の音楽作りが促される可能性も生まれうる。著者はそのように述べる。もちろん、こうした議論は「われわれ自身が他者というものを作り出し、その了解に置いてどうしても暴力性を介在させてしまう、その痛みの感覚」を忘れ去ることなくなされねばならない。

　最後に、同書のなかでもとりわけ示唆的な議論に触れておこう。2005 年に逝去したイギリスのギタリストで即興演奏家のデレク・ベイリーによる実践をめぐる記述である。晩年のベイリーは「手根管症候群」という病を患い、徐々に手の自由を失っていった。しかしながら、彼は医者の勧める手術を拒否し、病状が進行するにつれて次第に脆くなっていく自らの身体に寄り添いながら、音楽を紡ぐ道を選択した。死の数ヶ月前に制作された CD には、この試みを始めてから 3 週間後、5 週間後、7 週間後、9 週間後、12 週間後の演奏が収録されている。著者は、ベイリーの演奏について、最初は力みが感じられ、充分に思ったようなサウンドが出せない印象だが、次第にその身体の状態と音楽表現をなじませながら自分の音楽を作り出してゆく過程を読み取ることができると評する。「なじませる」という言葉は、言い得て妙だ。外部に存在する規範にかかずらうのではなく、もはや他者となってしまった身体の、その状態と変容に気遣いながら、ゆっくりと無理なく、音楽を通じてそれとうまくやっていくこと。ここには、たしかに自己と向き合うテクノロジーとしての音楽を認めることができよう。このベイリーの実践は、後年のフーコーが思考した「生存の技法」としての芸術、そして、死のその時まで続く音楽とのサステナブルな付き合いを考えるうえで、今なお多くの手がかりを与えてくれるのである。（原塁）

第 8 章
蒐集と驚異
多種多様な思考の目録

　コンピレーション・アルバム『アンソロジー・オブ・アメリカン・フォーク・ミュージック』（1952 年）の編纂者であり、錬金術と魔術に精通した画家で映像作家のハリー・スミスは、レコードだけでなくいくつものコレクションの作者だった——紙飛行機、あやとり、パッチワーク、イースターエッグ。『ハリー・スミスは語る』に収録されたインタビューで、彼はこれらを「多種多様な思考の目録」と表現した。スティーヴ・ロデンは自分で蒐集した戦前の SP 盤のコンピレーションと音楽家の肖像写真からなる美しい本『…私の痕跡をかき消す風を聴く——ヴァナキュラー・フォノグラフの音楽 1880–1955』のなかで、スミスを「忘却の縁にある慎ましい物たちにつながり（と愛情）をあたえ直した先駆者のひとり」と評した。

　レコードの蒐集活動の延長から、韓国では一つの研究領域「音盤学（discology）」が育った。裵淵亨（ペヨンヒョン）の『韓国蓄音機レコード文化史』は、付録 CD を聴きながらこの学問の成果をたどることができる。前衛レコードの蒐集家に大きな影響をあたえた『ブロークン・ミュージック（ファクシミリ版）』の書評も本書第 9 章に収めた（☞本書 192–195 頁）。デヴィッド・バーン『音楽のはたらき』を本章に入れたのは、他に適当な章がなかったのも大きいが、彼が自分の創造の本質をロマンティックなゼロからの創造ではなく、「コンテクスト（文脈）」によってかたちづくられる「逆からの創造」と表現し、彼をとりまく膨大なコンテクストをこの本に詰めこんだからだ。本書ではあつかえなかったが、物ではなくデータの蒐集なら、現代芸術のオンライン・データベース「ユビュウェブ」を設立したケネス・ゴールドスミスの『デュシャンは我が弁護士——ユビュウェブの論争、実践、詩学』（Columbia University Press, 2020）が興味深い。デイヴィッド・グラブス『レコードは風景をだいなしにする——ジョン・ケージと録音物たち』（若尾裕、柳沢英輔訳、フィルムアート社、2015 年）にもゴールドスミスの活動をめぐる考察がある。

33

ラニ・シン編

『ハリー・スミスは語る──音楽／映画／人類学／魔術』

湯田賢司訳、カンパニー社、2020年

ハリー・スミスの驚異濫溢劇場

　「ハリー・スミスは宇宙論の大家、映像作家、画家、人類学者、言語学者、オカルト研究家に収まりきらない存在だった」という編者ラニ・シンの書き出しに、まず我々読者は狐につままれたような印象を覚える。一般にこのハリー・スミスなる謎多き人物の最大の功績とされているのが、NYのフォークウェイ・レコードより発売された『アンソロジー・オブ・アメリカン・フォーク・ミュージック』（1952年、以下『アンソロジー』）の編纂である。60年代フォーク・リヴァイヴァル運動を準備した歴史的傑作とされ、グリール・マーカスによればボブ・ディランがザ・バンドとともに作り上げた異色作『ベースメント・テープス』（1975年）はこのアンソロジーのもつ「古くて奇妙なアメリカ（The Old, Weird America）」のファンタスティックな想像力の再現であるとさえ言うから、その影響圏はフォークを超えてロックにまで及んでいる。

　しかし1926年から32年にかけてリリースされたレコード84曲を蒐集し、2枚組LP3巻に収録したこの『アンソロジー』は、解説に神秘思想家アレイスター・クロウリーの有名な「汝の欲するところを為せ」が引用され、表紙にはロバート・フラッド『両宇宙誌』（1617年）に掲載されていたヨハン・テオドール・ド・ブライによる神聖一弦琴のオカルト図像が用いられていると知るとき、このハリー・スミスを同じく著名な民俗音楽の収集家であったアラン・ローマックスと同じフォルダに入れることなど、果たして可能なのかという疑問がふと頭をよぎる。

　曾祖父ジョン・コーソン・スミスは高位フリーメイソンで、父親は膨大な秘教的蔵書を持ち息子に錬金術用の鍛冶用具を買い与え、挙句に母親はアレイスター・クロウリーの恋人であったということが暴露されるこのインタビュー集には、文科省公認の「学際」なる血の気の失せた言葉を再度賦活するパラケルスス的香具師の手

つき、領域と領域を「つなぐ」魔術の残響が聞こえる。

　とにかく脱線・横転・事故に見舞われるばかりのインタビュー集である。音楽の話をしていたかと思えば実験映画の話にすり替わり、紙飛行機やらイースターエッグやら錬金術やら、挙句の果てには自らの精液でホムンクルスを作ったという話題まで飛び出し、収拾がつかぬほどの会話のスラップスティックであるが、出鱈目なようでいて実のところ、碩学エルネスト・グラッシが『形象の力──合理的言語の無力』（原研二訳、白水社、2016 年）で言う所の「天啓（レリギオ）」のなせる業であると知れる。スキゾ的な関心の移り変わりには、彼のみに見える「結ぼれ」があるのだ──つまり結びつくはずのないもの、かけ離れた二つのものが類推によって結び付くのに必要な「鋭察」が。

　たとえば同書を繙くと「色のパターンと特定の音にどのように関係があるか」（110 頁）といった共感覚・インターメディア的な発言がやたら目を惹く。実際ディジー・ガレスピーの「マンテカ」という曲のパターンをスミスが絵に置き換え、それを冒頭ショットで使った『ナンバー 4』（1947 年）という映像作品もあるほどだ。スミスが眼と耳の共鳴に関心を寄せていたことがわかるが、以下のようにとどめを刺す。「レコードを吹き込んだアンクル・デイブ・メイコンやセーラ・カーターといった人たちからパッチワークキルトをたくさん集めたら、音楽についてはすべて解明できるはずだよ。たとえば、音楽の中で気持ち良い音があるように、眼で見て美しいと感じるものがあり、この二つはあるレベルで関連している」（123 頁）。

　こうしたジャンル越境じみたアナロジーは、ランボーの有名な「俺は母音の色を発明した」や、超現実主義土星音楽家サン・ラーの「色彩は音楽だ」にまで通じる神秘主義の言説でよく確認されるもので、スミスもこの系譜に位置づけてもよいかもしれない。しかし神秘主義だのオカルティズムだの勘弁して、というスクウェアな方々には、先述したグラッシの『形象の力』を再び引いて、こうした異次元領域の結合はフマニスム伝統の「インゲニウム」の働きである、と学術的にラベル替えしたほうが無難かもしれない。

　論証よりも天啓、真理より類似、デカルトよりもヴィーコの優位を説いたグラッシは、世界はメタファーやアナロジーによって異次元なものを「つなげる」ことでしかその「原理」に接近しえないことを語った。たとえばジョヴァンニ・ペレグリーニが『鋭察、または通称、機知、才気、綺想』（1639 年）のなかで〈鋭察体（アクテッツァ）〉と呼んだものの本質とは、「二つのものの関係を介在なしに瞬時に洞察することによって、それは突然襲いかかる」ものだという。グラッシの補足によると、「それ

は驚愕を呼び、これにて指し示されたものが深く記憶に刻まれ、内面を衝き動かす。こうしたさまざまな〈鋭察〉定義——その不意打ち、ないし演繹不能性、驚嘆を煽って直接に本質にせまり、最もかけ離れた要素を関係づける能力——は、〈古代的〉な特性であり、天与の力の活動に属する」という。

　以上を踏まえると、このインタビュー集のなかでのハリー・スミスの語り口は単なる鬼面人を驚かす連想ゲームにしか見えないようでいて、ある説明不能な「原理」にもとづいてなされたアナロジーと知れる。ラニ・シンが「はじめに」で語るように「天球の音楽からアパラチア山脈の音楽まで自在に話題を切り替え、なぜ両者が一つなのかを示した頭脳」の秘密がインゲニウム——天才の語源でもある——というわけだ。

　またグラッシの議論を敷衍すると、メタファーやアナロジーといった曖昧なレトリックを基本表現としたG・R・ホッケ的なマニエリスムの文脈にもハリー・スミスはすっぽり収まる。ウアルテの「遊察的天啓」はかけ離れた二つのものを結び合わせる天啓を「気まぐれ」に結びつけたが、画家ゴヤの愛したこの言葉がマニエリスム言説の定番だとわかるとハリー・スミスの遊戯的マニエリストぶりも自然と理解される。マジメ人間には決して見えてこない驚異的「つながり」が見えるのは狂人のみである。

　スミスとマニエリスムに共通するキーワードは「驚異」である。マニエリスム理論家E・テサウロによる『アリストテレスの望遠鏡』（一六五五年）の中心的話題を占めるのは〈鋭察体〉というもので、その目的は「現実の嘔吐と退屈の克服」であるという。またソクラテス曰く「……それは英知をとても愛する男の状態である。驚くこと。これ以外に哲学の原理はない」。小説家・ノイズミュージシャン・悪趣味B級映画批評家・画家・蒐集家と、ハリー・スミス的に分類困難な中原昌也の『人生は驚きに充ちている』（新潮社、二〇二〇年）に筆者が唸ったのは、氏の口癖が「くだらない」「つまらない」「死ね」であるにもかかわらずタイトルに「驚き」が入っていたことで、こうした人生に退屈を感じる不思議の国のアリス的人種というのは、さまざまなワンダフルなものにジャンルを超えて関心をもつという逆理めいた真理がある。吐き気に抗して驚異を求めたボードレール然り。

　またハリー・スミスの膨大なレコード・書物・イースターエッグ・キルト・紙飛行機のコレクションも澁澤龍彦偏愛の「驚異の部屋」の文脈で考えなければ大きなポイントを逃してしまう。言ってしまえばミュージアムとして制度化される前の、「野生の知」でもって蒐められ並べられた品々なのである。ヴィーコ曰く、「知

の格別の能力とは天啓^{インジェーニョ}のことであり、その助けによって人間は事物を蒐集するのであり、事物は天啓なき者には何の脈絡もなくばらばらにあるように見える」。それゆえ「天啓は、散らかったもの、互いに異なるものをひとつに束ねる能力のことである」というから、一見雑多に放りこまれた84曲という印象を受ける『アンソロジー』も論証不可能な「原理」の賜物なのである。ちなみに3巻セットの『アンソロジー』は元々第4集まで予定されていたらしく、それによってスミスは地、空、火、水の四元素による宇宙的調和のヴィジョンを示すはずだったという。ヴンダーカンマーの元祖である「ストゥディオーロ」において、部屋の四隅に地、空、火、水を寓意する小象を配置し、それに従って蒐集品を分類し、四元素のバランスを整えて小さな部屋の中に大きな宇宙の秩序を実現した伝統との、時代を超えた「つながり」が感じられる。

　ラニ・シンはハリー・スミスの万能人ぶりを「アメリカのルネッサンス的教養人」と評したが、たしかにこのインタビュー集『ハリー・スミスは語る』ではあらゆる領域や学問が宇宙的調和をなしてつながっている。ルネサンス宇宙観でいう「存在の大いなる連鎖」の、相互間交感作用^{テレパシー}のようなものが濃厚なのだ。ピュタゴラス以来の「宇宙は音楽的調和で包まれている」というヴィジョンを、『アンソロジー』表紙の神聖一弦琴とそれを調律する何者かの手は象徴している。つまる所、副題「音楽／映画／人類学／魔術」の「／」という壁の分断は「⇄」で融通無碍すべきものなのではないか。

　最後になるが、工藤遥の傑作解題「語るハリー・スミスを考える」では、『アンソロジー』と同じ1952年に《4分33秒》が発表された年代的一致をユングの「共時性」のもとにとらえ、ジョン・ケージとスミスの有意義な比較がなされている。敷衍するとこの両者の関係は、エジソンに対するニコラ・テスラ、柳田國男に対する南方熊楠の関係とパラレルとみて間違いない──天才に対する奇才、中心^{センター}に対する中心‐外^{エキセントリック}な存在たち。『形象の力』解説で原研二が熊楠の非体系的なアナロギアの力を大いに顕彰するとき、スミスの隣人はアラン・ローマックスなどではなく、南方熊楠だったという見えざる魔術的「つながり」が浮かび上がってこよう。

<div align="right">（後藤護）</div>

34

スティーヴ・ロデン

『…私の痕跡をかき消す風を聴く──ヴァナキュラー・
フォノグラフの音楽 1880-1955』

Steve Roden, … *I Listen to the Wind That Obliterates My Traces: Music in Vernacular
Photographs 1880-1955*, Dust to Digital, 2011

フォノグラフィとフォトグラフィ──
フィールド・レコーディングをめぐる欲望

　同書はSP盤の復刻音源CDと、その同時代の無名の
人々を写したいわゆる「ヴァナキュラー写真」、そして主
に小説から取られた文章の断片からなる。著者であるサウ
ンド・アーティスト、スティーヴ・ロデンは周囲の雑音に
紛れてしまうような微細な音からなる音響作品「ロウワー
ケース・サウンド」で知られている。同書は彼のコレク
ションが元になっているという。CDの内容はアメリカのルーツ音楽が中心で、な
かには自主制作盤や環境音のサウンド・エフェクトも収録されている。写真のほと
んどは楽器や蓄音機を手にした人物の肖像だ。多数の楽器を組み合わせた自作演奏
装置に腰かけるものや、宙を舞う音符が描きこまれているものもある。写真の合間
に挿入された文章の断片はハムスン、メルヴィル、ナボコフらの、聴取の経験を表
現しようとした一節が多いようだ。出版元はSP盤の復刻アンソロジーを手がける
アメリカの音楽レーベル、ダスト・トゥ・デジタル。このレーベルはルーツ音楽だ
けでなく録音文化自体にも関心があるようで、レオン・スコットが1960年にフォ
ノトグラフで記録した〈月の光に〉の「録音」も発表している（Parlortone, 2009）。
　ロデンが選んだルーツ音楽はどれも穏やかで、恍惚感に満ちている。SP盤の濃
密な針音が写真の色あせのように時間の隔たりを感じさせる。雨音、雪の上を歩く
足音など、ときおり挿入される環境音のサウンド・エフェクトはロデン自身の作品
を思わせる。鳥や虫の声は本物を録音したようだが、鉄板を叩いたような雷の音は
タイトルに人工音と記してある。汽車の音や犬の声など、具体音がコラージュされ
た楽曲もいくつか選ばれている。CD冒頭に置かれた風の音は、同書のタイトルの
「私の痕跡をかき消す風」というフレーズを思わせる。針音にまみれたこの録音の

発表時期は 1935 年前後とある。本物の風の音を録ったように聞こえるが、道具を使ってつくられた音かもしれない。

　環境音の録音を作品として提示する、または楽曲やインスタレーションの素材として使用する、フィールド・レコーディングという手法は現在も音による実践のなかで重要さを増している。ロデンもこの手法を代表する作家の一人だ。定番の水音や鳥の声から機械の轟音、可聴域外の振動まで、無数の音が作品に使われるが、なかでも風の音は近年の作品のなかでは特別な音のようだ。クリス・ワトソンの『ステッピング・イントゥ・ザ・ダーク』（Touch, 1996）の 1 曲目や、フランシスコ・ロペスの『ウインド［パタゴニア］』（and/OAR, 2007）などは両者の代表作の一つだろう。彼らのハイファイな録音を聴くと、風が無数の支流からなる束なのだと気づかされる。一方、ロデンが探しだした 30 年代の風音は口笛のようで、ゆっくりとあらわれては消えてをくり返す。室内から窓の外で鳴る風を聴くような、もしくは記憶のなかで鳴っているような、奇妙な陶酔感のある音だ。

　『…私の痕跡をかき消す風を聴く』に収められた写真に映る人物の多くは正装し、自分の人格の一部であるかのように楽器を携えている。ジェフリー・バッチェンらのヴァナキュラー写真研究のように、これらの肖像の細部から、人格と音楽の結びつきや音の視覚表現といった、同時代の文化背景を考察できるかもしれない。また、ロデンがこうした匿名の写真と自主制作盤をふくむ同時代の録音を並べたことで、「ヴァナキュラー録音」という言葉を思い浮かべる読者もいるだろう。

　写真と録音の比較は近年のフィールド・レコーディングの実践における顕著な動向の一つだ。たとえば、フィールド・レコーディングに代えて「フォノグラフィ」という用語が使われだしている。この用語は「フォトグラフィ」と対になり、写真家にならってアメリカの諸都市や東京で「フォノグラファーズ・ユニオン」を名のるグループが結成されている。ウィル・モンゴメリーは論文「サウンドスケープを超えて──現代のフォノグラフィにおける芸術と自然」（ジェームズ・サンダース編『アシュゲート実験音楽研究論集』Ashgate, 2009）で、近年のフォノグラフィ実践としてワトソンや水谷聖、角田俊也らの作品を論じた。そのなかで、フォノグラフィという用語の参照先として、ダグラス・カーンの論文「ろうの世紀のオーディオ・アート」（ダン・ランダー、ミカ・レキシア編『サウンド・バイ・アーティスツ』Art Metropole and Walter Phillips Gallery, 1990）をあげている。この論文でカーンは、録音はこれまで主に既存の文化の複製に使われてきたため、フォノグラフィ芸術はフォトグラフィ芸術とくらべて遅れをとってきた、と主張した。

写真との比較はフィールド・レコーディングの実践や理解にどんな発想をもたらすだろうか。たとえば、これまで環境音の録音を理解するために参照されてきた、ミュジーク・コンクレートとサウンドスケープ・レコーディングという二つの実践・理論から、いったん距離を取ることができる。原理的には、ミュジーク・コンクレートは録音された音のみをあつかい、録音と音源の関係については判断を中止する。他方、サウンドスケープ・レコーディングでは音源のあり方やサウンドスケープとそこに生活を営む人間の関係が重視され、録音はあくまで調査手段とされるか、音源と人間を切り離す害悪とされてしまう。

これらに対して、フィールド・レコーディングと写真の比較は録音による音の変形の意義、録音が音を音源から切り離して固定することの意義をあらためて問い直すことになる。写真研究ではすでに、写真家やアマチュアによる撮影・現像・収集実践が社会にとって、また個人にとってどんな意義をもつのかがさまざまな視点から検討されている。では、録音の実践という大きな文脈のなかで、環境の音にマイクを向けることはどんな意義をもつだろうか。写真との比較から導かれる発想の一つがこうした問いかけだ。ここで、写真のモダニズム（フォーマリズム）とポストモダニズムという対立する理論が、ともに文化と自然の二項対立を前提にしていたと指摘するバッチェンの議論を参考にしてもよいだろう。録音と音源の対立にも重なるこの二項対立を疑う彼は、写真のパイオニアたちが語った写真を撮影する欲望を考察の対象にしていった。

フォノグラフィという用語が使われだした近年のフィールド・レコーディング作品に共通する傾向は何だろう。モンゴメリーはこう語る。「私が知ってほしいのは、現代のもっとも冒険心に富んだフォノグラフィは、この堕落した世界のなかにある神秘的な自然音を写真のように再生させたいなどとは望んでいないということだ。反対に、そういう作品はたいてい、芸術と自然世界の関係のはるかに複雑なあつかい方を含んでいる。もしくは伝えてくれる」（146頁）。モンゴメリーがあげた作家らは、誰にとっても美しい環境が発する美しい音ではなく、たとえば特殊な記憶と結びつく音、つねに身の回りにあるけれど普段は聞こえない音、録音という実践自体を意識させる音などにマイクを向けるのだ。

ロデンが発掘した70年以上も前に制作されたサウンド・エフェクトのSP盤にも、このような現代の作家の作品に通じる魅力がある。極端に劣悪な音質のため、いくつかの録音は自然音なのか人工音なのか判別が難しい。環境とその録音のどちらかだけに重心を置くようなフィールド・レコーディング解釈では、この正体不明さを

評価することはできないだろう。このいわばウルトラローファイな環境音は、美し
い自然へのあこがれを誘うわけではないが、まったく抽象的でもなく、だからあい
まいで個人的な記憶と結びつきやすい。ただし、ノスタルジックな共同幻想を受け
容れるような音でもない。安易な共感や没入をさまたげる不可解さ、距離感がつね
にあるからだ。

　この本の前書きで、ロデンは美術史家アビ・ヴァールブルクやハリー・スミスに
言及しながらSP盤コレクションを通じて得た経験について語る。収集を続けるな
かで、ふと目に止まった一枚のレコードを特に理由もなく手にとり、その聞き慣れ
たはずの楽曲を再生してみると、どういうわけか心を揺さぶられる。あらゆるコレ
クターがある程度は共有する体験だろう。音は一度録音されると通常は何らかのコ
レクションに組みこまれる。そして、ひとたび生成したコレクションはその大きさ
にかかわらず、それ自体の個性をもちながら成長するようになる。ロデンが自分の
経験をもとに言いあらわそうとしたのは、目的のない収集の実践につきもののこう
した現象であり、コレクションと一体になったコレクターがその成長のなかで遭遇
する特異な感覚ではないだろうか。ロデンはヴァナキュラー写真も収集と関連づけ
て考えているようだ。コレクションをかきまわして夜を過ごし、「私はそれぞれの
星が大きな星座の一部になるのを目に（耳に）しながら、一つの世界をつくりはじ
める」。フォノグラフィとフォトグラフィの対比は環境音の収集という実践の意義
にも光を当てるように思える。

　スウェーデンの作家、ペール・ラーゲルクヴィストの著作から引用された同書タ
イトル「私の痕跡をかき消す風を聴く」は、ロデンのフィールド・レコーディング
観として解釈できる。このフレーズが表現しているのは「芸術と自然世界の関係の
はるかに複雑なあつかい方」なのだろう。　　　　　　　　　　　（金子智太郎）

35

<ruby>裵淵亨<rt>ペヨンヒョン</rt></ruby>

『韓国蓄音機レコード文化史』

배연형 『한국유성기음반문화사』 지성사, 2019

「<ruby>音盤<rt>ウンバン</rt></ruby>」研究とディスコグラフィ

　最初に韓国における<ruby>音 研 究<rt>サウンド・スタディーズ</rt></ruby>の動向について紹介しておきたい。まず音に関する語彙から始めよう。韓国語には「ソリ（소리）」という固有の言葉がある。これは、日本語の「音」よりも広義で、「声」のニュアンスもあり（より明確には「<ruby>喉<rt>モッ</rt></ruby>」を加えて「モッソリ」となる）、さらに「歌」の意味もある（「<ruby>広場<rt>パン</rt></ruby>」を加えた「パンソリ」、また各地方の民謡を意味する「京畿・西道・南道ソリ」など）。この韓国語の「ソリ」には人間主体の息吹が深く込められている。他にハングルで「サウンドゥ」と表音表記される言葉もある。こちらはもっと無機質な外来語のニュアンスが強い。一般に韓国語で音研究は「ソリ研究」となる。以後、この言葉を用いる。

　この「ソリ研究」に連なる系譜として、まず「ソリ風景研究」、すなわちサウンドスケープ研究がある。これについてはハン・ミョンホによる一連の翻訳を挙げておこう。ハン氏の専門は建築工学だが、今世紀に入る頃からサウンドスケープ研究に着手し、マリー・シェーファーの各種書籍の翻訳を手掛けてきた。鳥越けい子の『サウンドスケープ──その思想と実践』（鹿島出版会、1997 年）も訳出している。また、ジョナサン・スターンの『聞こえくる過去──音響再生産の文化的起源』（中川克志、金子智太郎、谷口文和訳、インスクリプト、2015 年）の韓国語訳は、日本よりひと足早く 2010 年に刊行されている。訳者は視覚文化研究者のユン・ウォンファで、訳書のタイトルは『聴取の過去──聴覚的近代性の諸起源』である。原題の「音の再生技術」が「聴覚的近代性」に変更されているのは気にかかる点だ。明確に「ソリ研究」を掲げている研究機関としては、漢陽大学校音楽研究所がある。同研究所は 2019 年から「ソリと聴取の政治学──文化と技術を批判的にきく」というプロジェクトに取り組んでいる。所長のチョン・キョンヨンは同年に「音楽学

からソリ研究 Sound Studies へ」という論文を発表し、音楽学の系譜を重視する視点を打ち出し、また同所の研究員クォン・ヒョンソクは 2018 年に「ソリ風景を再び聴く──「複合的聴覚主体」の実現可能性に関する研究」という論文を公刊した。こちらはサウンドスケープ研究の流れの重要性をうかがわせるものである。この他、K-pop の隆盛と結びつきつつ、「実用音楽」と呼ばれる分野が急ピッチで制度化されてきており、そのなかでボーカルやサウンド制作などの実践と結びついた「ソリ」への関心が台頭している点も指摘できる。

　こうしたなか、韓国において独自の展開を遂げたのが、古くは「ソリ盤」とも呼ばれたレコードの研究である。現在では通常「音盤」というが、特に 20 世紀前半期を代表する SP レコードは「留声機音盤」（蓄音機レコード）または単に「古音盤」と呼ばれ、「音盤学（discology）」という研究領域を生み出した。その方法論の基盤にあるのがディスコグラフィである。ここに紹介する『韓国蓄音機レコード文化史』は、その代表的な業績である。以下、同書の完成に至るまでの歩みを簡単に紹介しながら、韓国における同分野の誕生や意義について綴ってみたい。なお、以下の内容は『韓国朝鮮の文化と社会』（19 号、2020 年、155-163 頁）に掲載された拙評と一部重複がある。細かな内容の紹介はそちらをご参考いただきたい。

　著者、裵淵亨はソウル市内の高校教師として働きはじめた 20 代から SP レコードの収集に着手した。1980 年代のことである。10 代の頃は、西洋クラシック音楽を愛好し、東国大学校在籍中に見たパンソリの名人・朴東鎮（パク・トンジン）の公演をきっかけにパンソリに開眼し、その歴史的展開への関心から SP レコードを求めるようになった。

　韓国の音響メディア史の文脈から SP レコードの位置づけをみてみよう。SP レコードは朝鮮戦争後の 1950 年代後半まで広く用いられたが、1960 年代に LP レコードに取って代わられ、さらにより廉価なコンパクトカセットが音響メディアの新旧交代に拍車をかけた。1980 年代には、一方に LP レコードとカセットを主力とする「大衆歌謡」の「制度圏（チェドクォン）」と、他方にカセットの録音・複製機能を生かしたアンダーグラウンドな自主制作と流通による「民衆歌謡」の「非制度圏」が二極化していった。ここで「制度圏」とは、民主化運動の担い手が批判の矛先を向けた主流文化産業の資本主義体制を指す。こうした対立構造のなか、SP レコードは過去の遺物となり各地で廃棄処分されていた。著者が退勤後や週末にソウル市内の蚤の市（ビョッシ・シジャン）や骨董品屋に足繁く通い、玉石混交の SP レコードの山をかき分け、今は亡きパンソリ名人の「遺声（ユソン）＝留声」を求めるようになったのはこうした時代である。

　著者が自らの収集の成果を基に最初に取り組んだのが SP レコードの「復刻」、す

なわち新しい音響メディアへの変換作業である。それはまず 1988 年に『パンソリ
五名唱』という一枚の LP レコードに結実する。これはまた 1960 年代以来の SP
レコード収集の先駆者で民俗音楽学者の巨頭である李輔亨と出会うきっかけとなっ
た。これが 1989 年、李氏を会長に「韓国古音盤研究会」という私的な学術同好会
の創設へとつながる。同会は翌年に初の展示会と学術大会を開いた後、1991 年から
『韓国音盤学』という年会誌を発行しはじめる。創刊号と同時に歴史的意義の高い
SP レコードを厳選のうえ収録した『黎明のうた』が出された。これは当時「劣化」
のない最新のデジタル音響メディアと認知されていた CD による最初期の復刻であ
る。韓国伝統音楽を中心とする同会のこうした活動は、流行歌など異なるジャン
ルの SP レコードに関心を寄せる他の愛好家グループをも刺激する。こうして 1990
年代には各種の SP レコード復刻 CD が世に問われることになった。

　著者の SP レコード（以下、レコード）研究は、ディスコグラフィーの編纂作業
を基軸とする。その成果は『韓国音盤学』の創刊号から公刊されはじめる。そこで
は日蓄を手始めに、日東、オーケー、ビクター、コロムビアなど主要なレコード会
社の長い目録が毎号のごとく掲載された。著者の作業を基礎に 1998 年に出版され
たのが韓国初の総合的ディスコグラフィー『韓国留声機音盤総目録』（민속원）で
ある。著者のディスコグラフィー的研究はその後も継続され、2006 年からは東国大
学校附設の韓国音盤アーカイブ研究所の所長として関連データベース構築に着手す
る。それを土台に 2011 年にはこの方面の総決算というべき『韓国留声機音盤 1907
–1945』（한걸음·더）全 5 巻を出版するにいたる。この第五巻「解題・索引」におい
て筆者は図像資料や音盤目録を豊富に交えた通史的取り組みを提示する。それから
8 年、満を持して上梓したのが『韓国蓄音機レコード文化史』である。レコード収
集の開始から数えて実に 40 年後の出来事であった。

　全 900 頁近い大作である同書は全三部からなる。第一部「韓国留声機音盤の歴
史」の全 6 章は植民地朝鮮のレコード産業史の全般的な流れを、第二部「留声機音
盤と社会」の全 3 章はレコードの社会性に関する諸テーマを、第三部「留声機音盤
時代の音楽」の全 5 章は録音内容をあつかっている。第三部で述べられた音楽の事
例の一部は 2 枚の付録 CD で聴くことができる。CD1 には 1920 年代半ば過ぎまで
の機械録音時代から 17 トラック、CD2 には 1920 年代末以降の電気録音時代から
20 トラックが収められている。

　この全 3 部のなかで、昨今の欧米圏の音研究の問題関心と共振しやすいのは、特
に第二部だろう。その第一章では、最初期のレコードの販売戦略から、1920 年代半

ば以降の朝鮮人企画者、そして 1930 年代のメジャー各社の文芸部長の登場までが述べられる。全般的に、業界がいかに社会の動向を探りつつ市場開拓を模索するのかという文化的媒介に関わる問いを中心としたレコード産業へのミクロなアプローチである。同部の第二章では、「日常」という主題の下、知識人社会のレコード批判、朝鮮商人のレコード販売網、レコードの購入や消費の動向、日常生活の中のレコードに関する各種表象、「蓄音機祭」というイベント、さらに蓄音機という機械に対する同時代の理解や常識といった多種多彩なテーマが詰め込まれている。これは既往研究のなかで相対的に手薄だった部分を徹底して資料に語らせるスタイルで埋めようとするものである。

　全体として萌芽的に垣間みえるのは、韓国の音盤学におけるディスコグラフィ的研究からフォノグラフィ的研究へのシフトである。すなわち、「盤」への書誌的関心を土台に、「音」の多彩な媒介性や社会性へと問題意識が展開する様相である。『韓国蓄音機レコード文化史』は、これを具体化していくためのリソースに溢れている。とはいえ、やはり同書の強みはディスコグラフィにあり、ここに同書を生み出した韓国のレコード研究の重要な意義がある。

　この点は、広く東アジアと東南アジアの研究の状況を垣間みることでより明確になる。これまで両地域ではレコード通史というべき出版物が幾つか刊行されている。一部挙げると、日本では倉田善弘の『日本レコード文化史』（東京書籍、1979 年）が先駆的である。中国についてはアンドレアス・シュテーン『娯楽と革命のあいだ——上海における蓄音機・レコードと音楽産業の黎明 1878-1937』（Harrassowitz, 2006、中国語訳 2015 年）などがある。また台湾では黄裕元『流風餘韻——台湾レコード歌謡の黎明期』（國立臺灣歴史博物館, 2014 年）、香港に関しては容世誠『粤韻留聲——レコード産業と広東の語り物（1903-1953）』（天地圖書有限公司, 2006 年）などが刊行されている。インドネシアについては英語で、ミャンマーについては現地語で博論と書籍がそれぞれ出ている。以上は評者がイリノイ大学出版会から 2024 年に刊行予定の東アジア・東南アジアレコード史の概論にもとづく情報である。すべて意義深い力作というべきだが、その大半は著者が同書の礎とした総合的ディスコグラフィーにもとづく研究と性格を異にする。たとえば、日本の場合、SP 時代に発行されたレコードの分量が多く、また研究者やコレクターがジャンルごとに分散する傾向が強いため、真に全体を俯瞰できるようなディスコグラフィーは存在しない。こうした観点からすると、著者に代表される韓国のレコード研究の基盤研究の長年の蓄積は目を見張るものがある。そのうえに公刊された同書の価値もまた然りである。

　　　　　　　　　　　　　　　　　　　　　　　　　　　　（山内文登）

36

デヴィッド・バーン
『音楽のはたらき』

David Byrne, *How Music Works*, McSweeney's Books, 2012（野中モモ訳、イースト・プレス、2023年）

音楽プラス1、あるいは音楽は
どのように建てられるか

　どの分野の芸術にも「天才神話」というものはつきものである。ある一人の芸術家の脳裡へアイディアやモチーフが、突如として——まるで雷で撃たれたように——降りてきて、マスターピースが完成するという神話は古来より連綿と、同工異曲に繰り返し語られてきた。しかし、本当に芸術は一握の「天才」たちによって規定され、更新されてきたものなのだろうか。音楽に関するさまざまな話題のあいだを飛び移り、一見、音楽に関する膨大なメモランダムの集成にも見える同書を通底するのはこの疑問である。

　この『音楽のはたらき』のなかでは、トーキング・ヘッズ〜ソロを通してのデヴィッド・バーンの音楽活動におけるエピソードや信念を織りまぜながら、建築、テクノロジー、歴史、ビジネス、スタジオ、果ては音楽レーベルのハルモニア・ムンディまでさまざまな要素と音楽の関係が例証され、考察される。膨大な要素たちはそれぞれ音楽に変化を加えるものであり、思想やシステム、あるいは場所など多岐にわたっている。要するにここであつかわれるのは音楽に影響を及ぼすかたちで存在し、変革を及ぼしてきた「装置」についてであり、バーンが一見無手勝流とも思える方法で試みているのは、音楽の装置論なのである。

　もちろん、メディアが音楽にどう影響を及ぼしてきたか、バッハがどのような環境・場所で音楽を制作していたかといった個別の考察はありあまるほど存在する。しかし、まったくもって音楽の実作者たる人物によって、自らの作品に限定せず、他者によって制作された多岐にわたる音楽をも対象とし、それを取り巻く環境＝装置についてこれほどまでに広範にわたって考察された仕事は過去に類をみないだろう。同書はバーンの視点を通して、音楽をめぐるさまざまな装置についての情報や

考察が統合された、非 - 凡<ruby>シンセサイズ</ruby><ruby>エクストラ・オーディナリー</ruby>な仕事ということができる。

　実は第一章「音楽と建築」の基になった講演がある。2010 年に TED Talks として行われた「いかにして建築が音楽を進化させたか」という約 16 分間の講演である。この講演では同書の第一章にあたる内容のみが濃縮されたかたちで語られたが、ここで主張されるのは前述のとおり、「音楽がいかにまわりの環境＝建築・場所に左右されたか」ということだ。この思考法が最大限に敷衍されたのがこの怪物じみた情報量からなる大著、『音楽のはたらき』ということになる。基調となった講演でバーンが「建築」を取りあげているのは同書の内容を象徴している。バーンは音楽を建築に近いものとしてとらえている節も感じとれるのだが、同書の頻出語として、まず思いつくものに「場（Venue）」がある。ある場に音楽が構築され、その「場」自体とプラスの要素が音楽を規定していくという彼の思考は、同書のはしばしから読みとれる。音楽が「構築物として場を持つ」ということが重視されており、それを軸として考察される音楽の概念は——ヤニス・クセナキスと建築の関係を想起するまでもなく——西洋的である。

　以上のように、バーンの思考は西洋的であると考えられるが、実は彼自身は非 - 西洋的なものに惹かれる部分が大きいらしい。同書で挙げられるエピソードに、トーキング・ヘッズ時代の彼が、ライブを演出するときに日本の能とバリ島のガムラン音楽を伴う劇を参照項にしたというものがある。曰く、西洋の演劇はステージで起こっていることを自然なことに見せかけようとしているが、能のような非 - 西洋のある種の演劇では自然とは完全に異なるものとして、差異を強調して演じられていることに衝撃を受けた、とのことだ。また、バリ島の劇については生活とガムラン劇が地続きのものとして境界なく演じられたことに感銘を受けたという言及がある。前者の「能面」に代表される異化効果と呼ぶべきものは、トーキング・ヘッズ時代のバーンのトレード・マークとも言えるダボダボのスーツに結実し、後者のバリ島の劇は、演奏者が一人ずつ登場し、彼らが増えていくにつれ、徐々にステージができあがっていくという、過程を見せるステージングに結実した、と彼は述べる。

　同書ではほかにも非 - 西洋の音楽についての言及が数多くなされる。非 - 西洋音楽への積極的な姿勢はトーキング・ヘッズの代表作『リメイン・イン・ライト』（Sire Records, 1980）の頃から、サポート・メンバーとしてアフリカをルーツにもつミュージシャンを加入させたということにも顕著である。彼はそのことについて「みんながバンドの一部となって、一緒に演奏するということが新しいことだった」（第二章）と発言し、人種問題への怒りが背景にあったことを述べる。しかし同時に、

「西洋／非西洋」というダイコトミーにこだわることこそが、彼が多分に西洋的な人間であることの証左になっていることは否めない。だからこそ、バーンは、彼にとっての「プラス1」である非-西洋の音楽とそのマナーに非常に惹かれ、それとの接合を試みる。

　いま、「接合」について触れたが、バーンの定石である「AをBというまったく違ったものに接木する」という発想法にも言及したい。同書第二章に、トーキング・ヘッズ結成前のバーンが、よく知られた曲を違うコンテクストに置き換えて演奏することを常としていたというエピソードが記されている。チャック・ベリーやエディ・コクランをウクレレで演奏したり、スタンダードがインストゥルメンタルで演奏されているあいだ、バーンはただ変なポーズを取っているだけの担当だったり、というようなことである。彼はクラシック音楽に代表される、「よく知られた曲をクラシカルなスタイルで上手に演奏する」ようなパフォーマンスをかたくなに拒み、変な要素を注入しようとする。要するに、彼は極めて西洋的な人間でありながらも、伝統的な、クラシカルな西洋的人間であることに飽き飽きしてしまっているのだ。そうすると彼が同書で膨大な量の「プラス1」への代入を試みた理由も自明であろう。愚直なまでにいくたびも繰り返し行われる「プラス1」への代入実験は、バーンがいかに音楽それ自体とがっぷり四つに組み合ってきたかということの証明であり、極めて西洋的な音楽の西洋からの見つめ直しであり、同時にそこからの脱出でもある。きわめて西洋的な人間が非西洋の文化を見つめ、反射的に西洋文明への疑義を投げ返す、というこのアティテュードは、どこか人類学者レヴィ＝ストロースの姿勢を想起させられる部分があることも付言したい。

　音楽について、途方もなく広範囲の話題があつかわれるこの大著を、隅から隅まで一律に楽しめるという人はなかなかいないかもしれない。この本のなかのトピックは矢継ぎ早に繰り出される手品のようなものであり、素直に驚けるものもあれば、これなら自分にもできそうだ、使えそうだ、というネタもある。一方で種も仕掛けも知っていて楽しめないものもあるかもしれないし、退屈で見ていられないネタやあまりに地味な小ネタも混在しているはずだ。ただ、少しでも音楽に興味をもつ人であれば、ここに書いてあることのどこかに引っかかりを見つけることができるはずである。それはトーキング・ヘッズ時代の思い出話かもしれないし、音楽メディアの歴史についてかもしれない。あるいは、スタジオにおけるレコーディング方法のアイディアかもしれないし、音楽で稼ぐための心得かもしれない。つまり、この本は音楽を聴く人／奏でる人／作る人／学ぶ人／批評する人たちすべてにとって役

立つエンサイクロペディアなのである。バーン自身が序章で述べるように、どこから読んでも構わない。建築、民族、東洋、西洋、歴史、メディア、ファッション、アナログ、デジタル、コラボレーション、ビジネス、調和……どこを読んでもバーンが音楽を取り囲む「プラス1」の部分に膨大な量の事物を代入しつづけている。

　同書の第二章を読めば話題の充実ぶりが感じられるように、トーキング・ヘッズの活動などについての話だけでも、一冊の自伝として充分おもしろいものになったであろう。しかしこの本では、敢えてその話題に終始することを排している。ここに提供されたものはデヴィッド・バーンの音楽活動の単純な「記憶」だけではない。バーンが一人の音楽家として考えていることをできるだけ多く一冊の書物に記録しようとした「思考」の集成である。この思考の束によって同書は、「音楽は天才の頭から突然出てくるものではなく、これだけ多くの要素の集積の結果の構築物なのだ」ということを明示した。バーンが試みたように、普段聴く音楽について、それがどのような「装置」において成り立っているのか、実例に即して考えてみることは、その音楽がどのような建築物であるかをくっきりと浮かび上がらせ、場合によってはわたしたちの聴き方にも作用してくるかもしれない。音楽と向き合っていくうえでの方法論としても非常に実践的な一冊であることは間違いない。　　（千葉乙彦）

第 9 章

自由の雑音

実験の政治経済学

　「今、かすかに、ほとんど聴きわけがたいほどであれ、新しい雑音（おと）の産声が、これまでの政治闘争の場や機構とは違ったところから、聞こえる。《祭り》の、そして、《自由》の雑音（おと）、それは、その領野の彼方に、厳とした不連続性の諸条件を創り出すはずだ。それは、実際に新しい社会が現れるための効果的戦略の本質的要素たり得るのである」（ジャック・アタリ『ノイズ──音楽／貨幣／雑音』金塚貞文訳、みすず書房、新装版 2012 年）。アタリが自由の雑音に対する期待をその困難とともに語った文章は、ノイズの芸術的意義を問おうとするさまざまな議論のなかで参照されてきた。何東洪、鄭恵華、羅悦全編『造音翻土──戦後台湾のサウンドカルチャーの探究』もそうした一冊である。台湾のポピュラー音楽史、オルタナティブ音楽史を論じたこの本は台湾の近代化に対する再検討であり、ノイズを通じた解放の試みをめぐる省察でもある。

　アンドレイ・スミルノフ『サウンド・イン・Z──20 世紀初頭のロシアにおける音の実験と電子音楽』は、1920 年代にもっとも過激な音を生み出していたと言われるロシアの「Z 世代」による音の実験を描きだす。この時代、アマチュア発明家たちが前衛演劇の影響の下、プロレタリア文化協会プロレトクリトの支援を受けながら、さまざまな自作騒音装置を作りだした。しかし、こうした実践はスターリンが政権につくと急速に勢いを失った。美術家によるレコードの情報を多数収録した『ブロークン・ミュージック』は長いあいだ、未知の音に焦がれる蒐集家にとってのバイブルだった。このカタログをあらためて読むと、レコードの破壊や編集を通じて盤面に書かれた音を上書きすることで、音を書く（フォノグラフィ）という行為を問い直そうとする実践の系譜が浮かびあがる（本書第 3 章参照）。ポール・デマリニス『ノイズに埋もれて』のタイトルは情報通信技術によく用いられる表現を思わせ、彼の表現がシグナルとノイズのあいだに込められた特異な歴史や文化を掘り返そうとする試みであることを示唆する。その考古学的姿勢の背景には、アメリカ西海岸の自由な実験精神がある。デヴィッド・ノヴァック『ジャパノイズ──サーキュレーション終端の音楽』（若尾裕、落晃子訳、水声社、2020 年）も本章のテーマに欠かせない。

37

ホー・ドンホン　ジョン・フェイファ　ルォ・ユェチュェン
何東洪、鄭恵華、羅悦全編

『造音翻土——戦後台湾のサウンドカルチャーの探究』

何東洪，鄭恵華，羅悦全編『造音翻土——戦後台灣聲響文化的探索』遠足文化, 2015 年

〈造音<ruby>ザオイン</ruby>〉と本土主義——その多面的な系譜

　台湾において音への関心は高い。関連書籍は少なくないが、なかでも同書は重要度の高い一作である。紹介に入る前に、必要最低限と思われる音関係の語彙からみておこう。台湾は多民族・多言語社会であることを政策的に掲げているが、ここに述べるのは「国語」と公称される台湾華語または台湾式の中国語である（以下、中国語。表記は「繁体字」だが、本稿では基本的に日本の常用漢字を用いる）。まず「音」や「声」という古代以来の漢字があるが、通常は二字熟語のなかで用いられる。最も広く使われるのは「声音」という言葉である。字面が示唆する通り、文脈によって「こえ」と「おと」のいずれの意味にもなり得る（以下、「声・音」と表記し、意味が明確な場合は訳し分ける）。字順を反転させた「音声」は日本語で常用されるが、中国語では学術的な場面で用いる程度である。なお声のみを指すには「嗓音」と言う。日本語にいう「サウンド」により近い用語には「声響」がある（例えば Taiwan Sound Lab は「台湾声響実験室」である）。「音響」も使われるがもっと「オーディオ」寄りである（代表的なオーディオ雑誌に『音響論壇』がある）。

　台湾における「声・音」への関心は、「本土化」と呼ばれる問題意識や運動と微妙に連鎖している。それは、政治から経済、文化にわたる台湾の主体性や独自性を求める動きの総称である。英語でいえば nativism に対応し、日本語でしばしば「排外主義」と訳される通り、否定的なニュアンスにもなる。しかし、この「本土化」の背景には、度重なる外来政権の統治下で、「本土」が常に台湾の「外」にあると喧伝されてきた長い歴史がある。日本統治期には日本列島が「内地」であり、1949 年から 1987 年までの世界最長の「戒厳時期」には中国大陸が「本土」といわれた。さらに今も続く大国中心の主権国家体制からの構造的な排除も深く影を落としている。

よって、「台湾こそが本土である」という主張には、重大な認識転換や異議申し立ての意味合いが埋め込まれている。こうした「本土化」のエートスは、人間の個人的・集団的な主体性や固有性を含意する「声」の言説と結びつきやすい。台湾の音研究にもまた「本土」に固有の「声」を発掘し、「発声」させる――声を上げさせる――という志向性が埋め込まれることになる。ただし、そうした取り組みは決して一枚岩ではなく、またアポリアを抱えてもいる。

　こうした問題を意識的に取りあげたのが同書である。これは 2014 年に開かれた展覧イベントを書籍化したもので、三人の編者による。何東洪は台湾のポピュラー音楽研究の代表者で、本書でも触れられる「水晶レコード」の製作企画やライブハウス「地下社会」の経営にも携わった。鄭恵華は独立系キュレーターで、2010 年に「TheCube Project Space 立方計画空間」の設立に関わっている。羅悦全もまた「TheCube」の設立者の一人で、台湾のインディーズ音楽にも造詣が深い。この外、執筆陣は総勢で 20 人以上に及び、「本土化」の現場に関わってきた音楽家、活動家、研究者など多種多様である。

　同書はそのタイトルから漢字の造語力を駆使した批評的な言葉遊びの巧みさが光っている。まず「造音」とは編者による新造語である。それは名詞としても、また「音を造る」という動詞としても用いられる。この語には声調も含めて同じ発音となる「噪音」（ノイズ）の言葉がかけられている。編者三人のイントロによると、同書における「音」には、フランス語の bruit、すなわち「ノイズ」の意味合いを加味した「サウンド」のニュアンスが込められている。ここにはジャック・アタリの著名な同名書（邦題『ノイズ――音楽／貨幣／雑音』金塚貞文訳、みすず書房、2012年）の議論が引かれている。こうして「造音」には、アタリが同書の最終章でその到来を強調した「作曲」の系、すなわち権力や資本に服さず自律的に音楽を享受する行為といった含意が重ねられ、さらに拡張する意図が込められる（以下、こうした概念的創造性を勘案して〈造音〉と表記する）。同書のサブタイトルには前述した「声響」が用いられ、英訳として sound が当てられている。

　一方、「翻土」は、名詞よりも「土を翻す」といった動詞的な意味が強い。ここで「土」とは「本土」を含意する。そこにあるのは、〈造音〉における「本土化」の系譜をあらためてたどりつつ、さらに再考するという意味合いである。これは、「ALTERing NATIVism」という英語のメインタイトルに絶妙に表現されている。これは alternative という言葉の流用でもあり、あらためて後段で触れる。

　『造音翻土』は全 5 章からなる。これは台湾における音研究をめぐる五つの系譜

ということもできる。各章は短い論考や対談記事をメインに、短いコラムが付されている。以下、各章を駆け足でみていこう。

第一章「統制と亀裂――冷戦戒厳体制下の文化構築」は、国民党政権による文化統制の流れを追うと同時に、米軍の進出に伴い流入したアメリカのポピュラー音楽（「熱門音楽」と総称される）をめぐる統制の「亀裂」に目を向ける。前者については、台湾在住の台湾ポピュラー音楽研究家エリック・シェイヘイゲンが歌謡検閲の流れを概観する。後者については、「熱門音楽」シーンを担った「陽光合唱団」（陽光楽団）の元成員たちに対して王淳眉、何東洪、鍾仁嫻が行ったインタビューが置かれる。冷戦体制のアメリカの影響の下に生まれた「熱門音楽」が、いかに戒厳体制の厳しい文化統制に間隙を縫って、「サウンドと身体の解放」をもたらしたかが強調される。

第二章「声響翻土――自己の声・音を求めて」は、まず民族音楽学者の范揚坤が、1960年代後半に許常惠や史惟亮らが行った民謡採集運動、および戒厳令解除後の1990年代に入って独立系の水晶レコードが取り組んだ「台湾の低層からの声・音」「台湾有声資料庫」のCDシリーズ企画などをたどる。続いて、視覚芸術家の張照堂が、台湾南部の恒春出身の民謡歌手・陳達について語る。現在、伝説と化しているこの半盲の月琴弾き語りの名手が、1970年代に台北の知識人の世界で「発掘」されていく現場に立ち会った際の回想録である。関連して、1960年代末に台湾大学の学生として民謡採集運動に参与した人類学者・丘延亮のインタビューも収める。

第三章以降の三つの章は、それぞれ「另翼造音」「另逸造音」「另藝造音」と題され、これらは声調を含めてすべて同音である。前述したalternativeの中国語訳の一つが「另翼」で、残りはこの「另」のニュアンスを生かした造語である。

第三章「オルタナティブな〈造音〉――異議申し立ての声」は、非主流の社会参与的な歌の運動の系譜を追う。冒頭は、「交工楽団」の鍾永豊が何東洪と行った対談である。1970年代の台湾文学における「モダニズム」と「郷土主義」をめぐる論争が行政の介入により立ち消えになったために、陳達に託された「人民性」や、音楽や聴覚の位置づけといった問題が突き詰められなかったと述べる。続いて、1990年代の本土化運動の波のなかで登場した「台湾新音楽」について、何頴怡の1991年の文章が再掲載されている。そこでは、「本土のトーテム化」――平板化された「本土」への崇拝――の問題がいち早く触れられている。次に、「台湾新音楽」を代表する「黒名単工作室（Blacklist Studio）」と創立者の王明輝に関する劉雅芳の論考では、戒厳時代に身体に刻印された排外的な「ファシズム」や「漢族中心主義」に対

して自己省察を深めていく経緯が述べられる。最後に、ライブハウス「地下社会」の誕生と行政の介入による強制的な閉幕に至るまでの経緯を当事者の一人である何東洪が語る。

　第四章「逸脱する〈造音〉——空間・身体と音の解放」は、戒厳令解除後の〈造音〉の身体的叛乱が、「ノイズ運動」から「レイヴ運動」へと展開する流れが述べられる。1990年代のノイズ運動については、「零与声音解放組織（Zero and Sound Liberation Organization）」の成員だった林其蔚が、学生運動のカウンターカルチャーの文脈から詳述する。続いてノイズ運動のなかでも特に異彩を放った1994〜1995年の「破爛生活節（Broken Life Festival）」とそれを主導した呉中煒に関して游崴による紹介が続く。1995年から2005年まで隆盛したレイヴ・カルチャーについては、同テーマで博士論文も書いた黄孫権による論考が置かれる。

　第五章「代替芸術的な〈造音〉——〈造音〉の今一つの経路」は、2000年前後に「声音芸術」（サウンド・アート）という言葉が広がり、シーンとして確立していく経緯を述べる。まず1995年設立の「在地実験」は、2003年と2005年の「異響」サウンド・アート芸術展の企画などを通じてシーン形成に大きな役割を果たしたが、これについて葉杏柔が素描する。続いて、2007年に立ち上げられたサウンド・アートの定期イベント「失声祭」について、実行に関わった馮馨が紹介する。「失声」とは、「破爛生活節」や「異響」といったイベントへのサウンド・アートの依存という認識を表現したものである。これに対し、「旃陀羅公社」は、行政からの独立志向がより強く、「サウンド・アート」と括られる割に「音楽」志向が強いと創立者の張又升が述べる。最後に、張は「黒狼那卡西」（黒狼流し）の二人組、特に黄大旺の実践を紹介する。自室で本場のロックを拝聴してきた台湾のロックファンにとって、「本土オリジナルのバンドを支持すべし」という本土化の理念を実践するのは本来「疲れる」ことであり、「黒狼那卡西」のパフォーマンスはそれを逆なですると論じている。

　「他人にはあるのに我々にはない」（「別人有、我們沒有」）——羅悦全はイントロのなかで、これが台湾の「近代性」への問いの立て方のパターンであり、「声・音」の探求へと導いてきたと省察的に指摘している。欧米の音研究においても「近代性」の再審は重要なテーマだが、それと共振しつつも特有の歴史的文脈と問題意識がここにある。瞠目すべき『造音翻土』の存在は、音研究の伝統が「台湾・我々にある」ことを如実に示している。　　　　　　　　　　　　　　　　（山内文登）

38

アンドレイ・スミルノフ
『サウンド・イン・Z——20 世紀初頭の
ロシアにおける音の実験と電子音楽』

Andrey Smirnov, *Sound in Z: Experiments in Sound and Electronic Music in Early 20th Century Russia*, Walther König, 2013

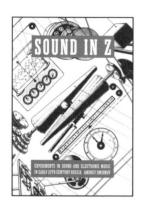

十月革命後のロシアに開花した音の実験

　1922 年、レーニンはクレムリンで発明家レフ・セルゲーエヴィチ・テルミンの手を借りて「陰極管による音楽装置」を演奏した。当時の共産党による電子技術の支援をものがたるエピソードだ。同書によれば、十月革命を経た 1920 年代のロシアには科学的思考を重んじる芸術文化が生まれ、そのなかでさまざまな音の実験も行われた。この文化は同時期のグラフィックによく見られたスパークの形から「Z 世代」と呼ばれている。Z 世代の音の実験にはテルミンを始め、音楽の専門教育を受けていない学者、発明家、画家、詩人、俳優などが数多く関わった。

　モスクワ（2023 年よりギリシアのテッサロニキ）を拠点とする芸術家、キュレーターのアンドレイ・スミルノフによる同書は、電子回路やラジオの発達に強い影響を受けたロシアの Z 世代による音の実験、電子音楽のあらましを描いている。レフ・テルミンや映画監督ジガ・ヴェルトフ、《サイレン交響曲》（1922 年）を作曲したアルセニイ・アヴラアモフ、光学式オルガン「バリオフォン」を発明したエフゲニー・ショルポ、音響装置の発明家でもあった俳優のウラディミール・ポポフら、多彩な人物の活動や交流が物語の中心にある。それとともに、Z 世代の作家たちを育んだプロレタリア文化協会プロレトクリト、美術家カジミール・マレーヴィッチが所長を務めた国立芸術文化研究所といった組織の働きを論じるというかたちで、社会状況との関わりも考察されている。初出版、初英訳の内容が少なくないというが、多数収録された装置類の図版だけを見ても楽しめる。

　同書があつかう内容の一部は近年、他の書籍のなかで少しずつ紹介されてきたものだ。たとえば、ダグラス・カーンとグレゴリー・ホワイトヘッドによる 1992 年

のアンソロジー、『無線想像力──音、ラジオ、前衛』（MIT Press）にはアヴラアモフの文章とメル・ゴードンによる広範な解説が掲載されていた。日本でも竹内正実『テルミン──エーテル音楽と 20 世紀ロシアを生きた男』（岳陽舎、2000 年）が時代背景を交えながらテルミンの生涯を書いている。書籍以外では一際貴重なのが、2008 年に RēR レーベルが発表した 2 枚組 CD『バクー──サイレン交響曲』である。表題曲の再演とヴェルトフの映画『熱狂──ドンバス交響曲』（1930 年）の音源を中心に Z 世代の作品が多数収録され、詳細なブックレットも付いている。

　アレックス・ロスの『20 世紀を語る音楽 1』（柿沼敏江訳、みすず書房、2010 年）は、作曲家ショスタコーヴィチとプロコフィエフを中心に、20 世紀前半のロシアの音楽を取り巻く状況を描いている。そのなかで、ごく短くではあるが Z 世代の政治的背景も説明されている。実利主義者レーニンは前衛芸術をどちらかと言えば嫌っていたが、不干渉、黙認という態度を取っていた。彼の政権下で文化に携わった教育人民委員のアナトーリー・ルナチャルスキーは哲学を学んだ人物で、社会の革命は芸術の革命とともにあると信じ、前衛芸術を支援した。さらに先端技術を重んじる共産党の姿勢が加わり、反伝統文化、反ブルジョワ文化を掲げるアナーキーで物質主義の芸術が生まれる環境がととのった。しかし、レーニンとは異なり積極的に芸術に干渉するスターリンが 29 年に政権につくと、Z 世代は急速に力を失ってしまう。

　スミルノフは『サウンド・イン・Z』を「運動の芸術」、「革命的音響機械」、「音対イメージ」、「図形音響」といったテーマごとに章に分けて構成している。ここではこれらに順にふれていくより、ロスが「当時もっとも過激な音を生み出し、しかも多くの場合、それらは西欧の作曲家たちを凌ぐほど不協和な響きを持っていた」（213 頁）と評した、Z 世代による音の実践のいくつかを個別に紹介してみたい。

　『カメラを持った男』（1929 年）などの作品で知られるヴェルトフは映画を手がけるようになる前に、自己流の聴覚の探求を試み、音響詩のような創作を行っていた。1912 年、16 才の彼は音楽学校に入学し、単語をリズミカルな順序に並べて暗記する記憶術に関心をもった。兵役を終え、二月革命以前に唯一ユダヤ人を受けいれていたペトログラード神経学研究所に入所すると、聴覚に対する興味はさらに深まった。彼は休暇を利用して、自ら「聴覚実験室」と名づけた活動を始める。それはたとえば、製材所が発するあらゆる騒音をあたかも視覚障害者が聴くように聴き、文字にしていくという創作だった。ヴェルトフは文字にならないメロディやモティーフを表現するための記号も検討した。しかし最終的に、音を記録して分析するための手

段がいまだ欠けていると悟ったという。

　ヴェルトフは二月革命後にモスクワ大学に入学するが、すぐに退学し、映画委員会に事務員として雇われた。そして、次第に映画雑誌の編集に関わり、映画制作も手がけるようになる。撮影装置は彼が求めていた録音装置に代わるものだったのだ。

　ヴェルトフが聴覚の探求を再開したきっかけの一つは、発明家アレクサンドル・ショーリンが開発した携帯型サウンド・オン・フィルム装置だった。ヴェルトフはこの装置を使って工場、港、駅、街路などでの撮影と録音を始めた。そして、現地録音、音声編集を駆使した映画『熱狂──ドンバス交響曲』を 1930 年に発表することになる。ドイツで映画監督ヴァルター・ルットマンが、ミュージック・コンクレートの先駆けという評価もある録音作品《週末》を発表したのとちょうど同じ年だ。ヴェルトフの作品はロンドンでの上映会の後、かの喜劇役者チャーリー・チャップリンに「私が聞いたなかでもっとも爽快な交響曲の一つだと思う」（167 頁）と評された。

　Z 世代による音の実験は際立った個人ばかりでなく、非専門家の集団によっても担われた。美術家ソロモン・ニクリーチンらの投影劇場や、振付家ニコライ・フォレッゲルの劇団マストフォル、映画監督セルゲイ・エイゼンシュテインが率いたプロレトクリト第一労働者劇場などは、イタリア未来派とは異なる思想のもとで舞台に独創的な騒音発生装置を取りいれ、騒音音楽を奏でた（なお、フォレッゲルの演劇は山口勝弘『ロボット・アヴァンギャルド──20 世紀芸術と機械』（PARCO 出版局、1985 年）のなかで紹介されていた）。彼らの活動に衝撃を受けたアマチュアたちが 1920 年代にはさまざまな自作騒音装置を発明し、特許を取得していった。スミルノフによれば、こうした実践はプロレトクリトの支援を受けた「DIY 活動」であり、都市民俗活動に近いものだった。熱心な若者たちは「シューモヴィクス」と呼ばれ、彼らの創作は次第に大衆運動へと成長していった。アヴラアモフらによる具体音を取りいれた作曲もこのような運動のなかで生まれたものだった。

　シューモヴィクは次第に劇場だけでなくラジオ局や映画制作所にも進出し、騒音音楽だけでなく、いわゆる効果音の装置も手がけるようになる。モスクワ芸術座の俳優ウラディミール・ポポフはそうしたシューモヴィクの動向を代表する人物の一人だ。1920 年代、舞台用騒音装置の制作は彼の一番の趣味だったが、次第に彼はサウンド・デザインの専門家となり、モスクワ芸術座で教鞭をとるまでになった。『サウンド・イン・Z』にはポポフが考案した効果音装置の図面や、バッタの音や遠くの汽笛を再現する装置の写真も収められている。

　Ｚ世代による騒音発生装置の開発、映像と音の組み合わせの探求、図形を用いた音のコントロールといったさまざまな音の実験を、スミルノフは「サウンド」という言葉で一括りにする。彼は第１章の冒頭で「サウンド・アート」という言葉にわざわざ「音楽、音響学、多様な実験的メディアの交差点における新しい美的動向」（21頁）という脚注をつけた。これまでは音楽、美術、文学、演劇、映画といったジャンルごとに論じられてきた実践や、それらの背景にある政治、科学、技術などの実践が、サウンドという視点を通じて相互に結びつき、ひとまとまりのネットワークとしてこの本のなかで浮かびあがっている。より正確に言えば、この言葉によって各芸術ジャンルのあいだにあった人的、物的、理論的、制度的つながりがダイナミックな交流として描き出された。それぞれのつながりは、各ジャンルの歴史のなかでは、著名な芸術家の生涯をめぐる記述などに埋もれがちである。ここに描かれたのはたんなるジャンルどうしの接点ではなく、芸術ジャンルの枠組みに対する問いかけでもある。スミルノフによるサウンドという言葉の使い方は、新しい芸術ジャンルの成立や、既存のジャンルの新しい展開、既存のジャンルの接点を語るというより、ジャンルを越えたつながりに光を当てることで、これまでの歴史を問い直そうとする。この意味でいわばヒューリスティック（発見的）なのだ。

<div style="text-align: right">（金子智太郎）</div>

39

アースラ・ブロック、ミハエル・グラスマイアー編
『ブロークン・ミュージック（ファクシミリ版）』

Urscula Block & Michael Glasmeier ed., *Broken Music. Facsimile Edition*, Primary Information,
2018

「破壊された音楽」とそこから立ち上がる
レコードの芸術性

　同書は 1988 年にベルリン DAAD ギャラリーで
ジョン・ケージやナム・ジュン・パイクなどのレ
コードを題材にしたインスタレーション作品を集め
た同名の展覧会に合わせて、その翌年の 1989 年に
出版されたものである。長年絶版となっていたが、
2018 年に付録のソノシートをも含む忠実な復刻版
が出版された。再発したのはアンダーグラウンドな
アーティストやコレクティブによる書籍の再プレスを精力的に進めているアメリカ
の非営利団体プライマリー・インフォーメーションである。

　展示のキュレーションおよび図録にあたるこの本の編集を担当したのは、「ゲル
ベ・ムジーク」を主宰するアースラ・ブロックと美術史家のミハエル・グラスマ
イアー。ゲルベ・ムジークとは 1981 年から 2014 年までベルリンにあった名物レ
コード店で、商業的にリリースされる普通の音楽レコードではなく、現代美術の
作家や実験音楽家が制作した希少なレコードを専門的に取り扱っていた。お店の
ショーウィンドウや店内は展示スペースとしても使われ、マリアン・アマシェやク
リスティーナ・クービッシュといった、美術・音楽・テクノロジーが交差する領域
で活動する気鋭の作家たちの展示も行ってきた。またレーベルとしても日本のサウ
ンド・アートの先駆者的存在の鈴木昭男や、フルクサスの作曲家として知られるヘ
ニング・クリスチャンセンの音楽作品などをリリースしている。さらにアースラの
夫、ルネ・ブロックはキュレーター、ギャラリストとして、ゲルハルト・リヒター
やヨーゼフ・ボイスといった戦後ドイツを代表する現代アートの作家たちを支えて
きた存在として知られている。レコードや音の表象をあつかうアーティストとして
最も有名なクリスチャン・マークレーも、ヨーロッパでの最初の個展はゲルベ・ム

ジークで行っている。

　さて同書の特色は実際に展示された作品の写真や解説以上に、膨大な数のレコード・カバーやレコードをモチーフにしたアート作品のイメージが収められていることだ。これらは以下の四つの条件のもとで選択されている。

　1）カバーがビジュアル・アーティストによるオリジナル作品であるもの
　2）録音物または音を発するものである（複製、エディション、彫刻を含む）
　3）書籍などの出版物にレコードや録音メディアが付随するもの
　4）ビジュアル・アーティストによる音のレコードまたは録音メディア

　ミラン・ニザのレコードを燃やしたり盤面に色を塗ったりした連作《ブロークン・ミュージック（破壊された音楽）》（1965年－）を筆頭に、マルセル・デュシャンの回転するオプティカルディスク、ヨーゼフ・ボイスの抽象化されたターンテーブル彫刻、クラウス・ファン・ベバーの表紙カバーが溶けて盤面と一体化したレコードなど、見応えのある作品が次々と登場する。またレコードカバーもヘルマン・ニッチュの血生臭いものから、ブライアン・イーノが立ち上げたオブスキュア・レーベルの連作カバー、そしてザ・レジデンツの目玉頭のジャケットなど、幅広く紹介されている。
　レコードに関連する前衛的なアートを網羅するような同書だが、レコードを使った演奏やパフォーマンスはほとんど取りあげられていない。ミラン・ニザ、クラウス・ファン・ベバー、クリスチャン・マークレーらは加工したレコードを使用したパフォーマンスやターンテーブルを楽器のように操る演奏家としても当時から活躍している。これらの活動が紹介されていないのは残念だが、その代わりに同書に含まれる独・仏・英語に訳されたエッセイが、ヒップホップやDJカルチャーとは異なる文脈で発展してきた実験ターンテーブリズムの歴史的・美学的な枠組みを示唆すると私は考える。

　ターンテーブリズムにまつわる言説のなかで、聴者から演奏者への転換、または再生機械から楽器への転用というものがよく登場する。たとえばマークレーはレコードをパフォーマンスに使うことによって自身の役割が受動的なリスナーから積極的なパフォーマーになるのだと言う（ジャン・ピエール・クリキ編『オン・アンド・バイ・クリスチャン・マークレー』MIT Press, 2014）。その原点はグラスマイ

アーの寄稿文「天使の音楽」のなかでも紹介されているモホリ＝ナジ・ラースロー
の論考「生産－再生産」（1922 年）に見いだすことができる。モホリ＝ナジは、芸
術の本質とは新しい関係性の生産であると定義したうえで、すでに確立された関係
性を繰り返すだけになってしまった複製技術を芸術的な用途に転用するように呼び
かけている。そして『ブロークン・ミュージック』にも含まれている 1923 年に書か
れた「音楽における新造形主義」のなかで、モホリ＝ナジはその実践として「音の
アルファベット」をレコードの盤面に刻むという、過去の再生でもなく演奏者とい
う媒介もいらない、最も直接的な音と音楽の生成方法を提唱している。またグラス
マイアーとモホリ＝ナジの文章に挟まれるかたちで同書に登場するのが、テオドー
ル・アドルノの 1934 年の論考「レコードのフォルム」。ここでは、レコードの芸術
的な価値はその限られた録音時間といつでもどこでも再生できる日常性によって否
定されるが、同時にその本質は音の直接的な書き込みにあると主張される。アドル
ノは文字の形とそれがあらわす意味との間に差異のない、「音を音で「書く」」（細川
周平『レコードの美学』勁草書房、1990 年）ような普遍的な言語と音楽の可能性を
レコードというメディアに見出している。

　このようにモホリ＝ナジとアドルノは、音の振動を媒体に刻み込むことによっ
て記録するというレコードの特質に、このメディアの最も本質的な芸術表現を見出
そうとする。それはレコードが蝋管から商品としてより生産性が高い円盤へと移り
変わってゆく過程で失った、誰もが自らの声を録音できるという機能の復興でもあ
り、それが大衆文化から芸術を取り戻すための前衛的な行為に重ねられている。つ
まりレコードの真の芸術性は録音された音の中にあるのではなく、その再生を可能
にする物質的特性にある。しかしモホリ＝ナジが提案した「音のアルファベット」
は、技術的な難しさからレコードでは実現に至らなかった。そのため音を書くとい
う行為は、ニザの一連の作品群を通して、すでに書かれたもの＝録音された音楽に
上書きしてゆくようなかたちで引き継がれてゆく。レコードを切り刻んで再度貼り
合わせたり、溶かしたり、ペンキを塗ったりしたものを再生すると「予測のできな
い、激しくて神経をすり減らすような」全く新しい音楽が生まれたと、ニザは同書
の中の短い文章で書いている。そしてこの音楽は楽譜で再現することができず、レ
コードの形状そのものがスコアであると主張する。ニザにおいて既存のレコードを
破壊し、その再生を断絶することでメディア固有の物質性やノイズが強調され、そ
れらの表象の関係性のなかで独自の芸術性が立ち現れる。

　ルネ・ブロックは序文のなかで、『ブロークン・ミュージック』に集められている

レコード・アートを「滑稽じみていて、コレクターは恐怖を感じる」ようなものだと書いている。しかしそういった一般的な認識とは相反して、マークレーや大友良英といった音楽家は積極的にレコードを傷つけ、そこから生じるノイズと予測のできない音のコラージュ作品を制作し、実験ターンテーブリズムという領域を切り開いてきた。この音楽スタイルがヨーロッパを中心に受容されてきた背景には、1920年代から続く前衛的な芸術実践と理論の系譜があるということが、この本を通じて明瞭になる。

　ちなみに 2019 年にはアースラ・ブロックのレコードコレクションがドイツ国立美術館財団に収蔵され、1988 年の展示の続編として 2022 年 12 月から 2023 年 5 月までの間ハンブルガー・バーンホフ現代美術館で「ブロークン・ミュージック Vol.2-アーティストによるレコードとサウンド作品の 70 年」が開催された。また関連するイベントとして「ブロークン・ミュージック Vol.2_Live」というコンサートシリーズも企画され、マークレーやレバノン出身のラエド・ヤシンなど、新旧のアーティストたちによるレコードを使用した演奏が 7 日間に渡って行われた。

<div align="right">（dj sniff）</div>

40

ポール・デマリニス
『ノイズに埋もれて』

Paul DeMarinis, *Buried in Noise*, Kehrer Verlag, 2010

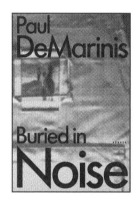

アメリカ西海岸の実験音楽とメディア考古学の共鳴

　CD を読み取るためのレーザー光線を針の代わりに使ってレコードを再生する《エジソン・エフェクト》シリーズ（1966-1989 年）はサウンド・アーティスト、ポール・デマリニスの代表作だ。ビニールとレーザーという別世代の録音メディアの「キメラ」（作家本人がこの語をよく使う）を母体に、さまざまな装置の異種交配がくり返される。ターンテーブルにはビニールのレコードの他にホログラフのレコード、蜜蝋のレコード、太古の陶器が乗せられた。再生装置はテレビやガイガー・カウンター、注射針などと接続され、歪んだ動きを見せる。70 年代から活動するデマリニスのキャリアを総括したカタログ『ノイズに埋もれて』に収録された論考で、サウンド・アート研究者ダグラス・カーンはこの作品を、録音の多数の次元を同時に聴かせる装置と評する。

　サウンド・アートという用語が普及するのは 80 年代であるが、それ以前の 70 年代から活動する、音をあつかう作家のカタログが近年になって見られるようになった。テリー・フォックス、パウル・パンハウゼン、デマリニス、ゴードン・モナハン、トリンピン。なかでも同書収録の「ポール・デマリニスの文脈を論じる」と題された論考集は、とくに充実している。カーンの他にメディア理論家のフレッド・ターナー、エルキ・フータモ、美術批評家のベルント・シュルツらが同時代の芸術、文化や出来事などの文脈を参照してデマリニスの作品を解説する。現在、サウンド・アートがいかに論じられるのか、それぞれの視点を比較しながら考えることができる。

　日本ではデマリニスはサウンド・アートよりメディア・アートの作家として知られているかもしれない。特にフータモは自身が提唱する「メディア考古学」を実践する作家としてデマリニスを紹介してきた。メディア考古学とは、メディアとテク

ノロジーの過去から抑圧され、忘却された歴史を発掘することで、一本道の発展ばかりを強調する支配的な歴史に対抗する研究とされる。たしかに、特に90年代以降のデマリニスの作品にはこうした説明がよく当てはまる。

　フータモが賞賛を惜しまないのが、2006年のアルス・エレクトロニカ受賞作《ザ・メッセンジャー》（1998年）だ。このインスタレーションは会場に並ぶ三つのアルファベット表示機が電子メールに接続され、受信した文章をそれぞれの仕方で表示するというものだ。インターフェースである三つのアルファベット表示機はAからZが割り当てられた26個ずつの話す洗面器、踊る骸骨、電解質の詰まったビンで、文字を受け取ると振動したり気体を発生させたりする。この作品はカタロニアの科学者フランセスク・サルヴァによるごく初期の電報の奇抜な構想を元ネタにしている。サルヴァは19世紀初頭、電線の先に電解質のビンや26人の人間を結びつけ、電気分解で生じる気体や電気ショックに反応した叫び声で情報を伝えようと提案した。

　フータモによれば、サルヴァの非双方向メディアの構想は当時の社会状況を克明に反映した。文字通り電線につながれた人間は植民地の奴隷または工場労働者を思わせる。インターネットと関わる作品のほとんどがそれをまったく新しいメディアとしてあつかうのに対して、デマリニスのこの作品は説教臭さなしでネットワークの歴史の暗部を表現する。この作品が受信するメールのほとんどは発信元のわからないスパムである。

　たしかにデマリニスの近作はメディア考古学の模範であり、フータモ以外の論者も彼の作品をテクノロジー史の文脈を参照して評する。それゆえ、サウンド・アートの作家であり研究者でもあるガスシア・ウズニアンが序文で紹介する彼の初期の経歴に、アメリカ西海岸の実験音楽の中心人物たちとの交流が見られることを意外に思う人がいるかもしれない。デマリニスは70年代前半、当時ロバート・アシュレイがディレクターだった現代音楽センターにいた。ヴィデオ・アート作家ビル・ヴィオラらとデヴィッド・チュードアのサウンド・インスタレーション《レインフォレストⅣ》（1973年）の制作に関わり、アシュレイとも共作した。デマリニスが音楽と言語の関係に関心をもち続けていることにはアシュレイの影響が見られる。

　70年代後半、彼は世界で初めてマイクロプロセッサーを使ったアンサンブル、リーグ・オブ・オートマティック・ミュージック・コンポーザーに参加した。デマリニスのデビュー作《ピグミー・ガムラン》（1973年）は自動車のダッシュボードに取りつけられ、電磁波に反応して作曲する自動音楽装置である。「60年代初頭に

作曲家たちは実験音楽に電子音響装置を導入しだした。50 年代に発展した電子ス
タジオ機材をコンサートホールに持ちこむのではなく、演奏の不確定性という開
かれた世界に適応しやすいように、携帯型の電子テクノロジーを発明し、改良して
いった」。マイケル・ナイマン『実験音楽──ケージとその後』(椎名亮輔訳、水声
社、1992 年) のこの文章は、若きデマリニスが過ごしたサンフランシスコ実験音楽
シーンの描写にふさわしい。

　実験音楽との関わりや自動音楽装置の開発は、その後どのようにメディア考古学
へと展開していったのか。カーンは自動音楽装置の開放性が後に政治や歴史に対す
るデマリニスの感受性につながったと推測する。ウズニアンはデマリニスが経歴の
初期から音楽の伝統の外に出て、唯一無二のオブジェに価値をみとめる視覚芸術の
文化に身を移したと評し、実験音楽からの「跳躍」(11 頁) を強調する。『ノイズに
埋もれて』の論考集には、デマリニスが実験音楽の姿勢をどう受け止めたのか、音
を作品の素材に選んだ理由は何なのかといった疑問に直接向きあう議論はない。
　しかし、この論考集のなかでもデマリニスのデビュー以前の歴史的文脈を参照し
た議論は、そのような疑問に間接的に答えてくれるかもしれない。次に紹介する文
脈はエレクトロニクスを用いた当時の実験音楽とテクノロジーの過去を発掘するメ
ディア・アートの両方を育んだ土壌と考えられそうだからだ。過去に遡ってデマリ
ニスの作品を解説するために取りあげられた歴史的文脈は大きく三層に分かれる。
　①カウンター・カルチャーとバックミンスター・フラー
　ターナーは《ピグミー・ガムラン》の背景として、カウンター・カルチャーの
テクノロジー観を参照する。60 年代アメリカのカウンター・カルチャーが特に批
判したのは、テクノクラートや軍産複合体によるテクノロジーを利用した支配だっ
た。管理されたテクノロジーは非人間的で、知性を感情、身体、自然から切り離す
ものとされた。一方、当時は自動車から LSD まで、若者が新しいテクノロジーの
産物を享受した時代でもあった。そんななかでカウンター・カルチャーが手本とし
たのはバックミンスター・フラーの理論だった。彼は官僚や産業の手から個人がテ
クノロジーを奪いとり、意識を拡張するためのツールにしようと提唱した。カウン
ター・カルチャーの中心地の一つ、サンフランシスコでデマリニスが制作した《ピ
グミー・ガムラン》は、産業用のテクノロジーを利用して電磁波という感覚できな
い現象を意識させる。ターナーはこの作品がフラーの思想に忠実であると指摘し、
同時期に同じ思想背景のもとで生まれたアップル・コンピューターとこの作品を並
べている。

②ボーイ・メカニック

　カーンが参照したのは 40、50 年代アメリカの子ども文化だ（デマリニスは 48 年生まれ）。テレビなど電気製品が普及しだしたこの時期、子どもたちはその用途だけでなく、メカニズムに心を奪われた。雑誌『ポピュラー・メカニクス』の子ども版『ボーイ・メカニック』や、テレビ番組「ウォッチ Mr. ウィザード」（1951–1965 年）などが当時の子どもの興味の受皿になった。こうした時代背景に言及したのはデマリニス本人だった。亡くなった友人のアーティスト、ジム・ポメロイについて語った文章で、彼はポメロイのような「ボーイ・メカニック」がメディア・テクノロジーの用途を無視し、そのヒエラルキーを混乱させることを好んだと書いた。カーンはこれを参照して、デマリニスもまたそうしたボーイ・メカニックに他ならないと評する。

③技術的崇高

　技術史家デヴィッド・E・ナイは『アメリカの技術的崇高』（MIT Press, 1994）において、アメリカ人のテクノロジーに対する熱狂や発明家の英雄視を「技術的崇高」という言葉で説明した。カント以降のドイツ哲学では自然の崇高さが人間に道徳の自覚をうながすとされたのに対して、ヨーロッパよりも厳しい自然に直面したアメリカ人はテクノロジーに崇高さを感じてきたとナイは主張する。シュルツはこれを受けて、アメリカではドイツとは違う文化とテクノロジーの関係が育ったと語る。ドイツではテクノロジーは文化の手段（に過ぎない）か、両者はときに対立するという考えが根深いのに対して、アメリカではテクノロジーと文化が対等な関係にある。この違いは、デマリニスも作品に使った初期のラジオが、ドイツでは統治の手段という性格が強かったのに対し、アメリカでは双方向コミュニケーションのツールだったことにも見てとれるという。シュルツはこうしたアメリカの伝統がデマリニスの作品にも受け継がれていると考える。

　これらはデマリニスの作品を解説するために参照された歴史的コンテクストだが、実験音楽の祖ジョン・ケージともたやすく結びつくだろう。ロサンゼルス出身のケージは 60 年代にフラーに深く傾倒し、ボーイスカウトでラジオ放送を務め、発明家の父親をもつ。これらのコンテクストに照らしてみると、アメリカ西海岸の実験音楽とメディア考古学が緩やかに通じ合う流れとして見えてくる。これをふまえたうえで、デマリニスの作品が実験音楽の理論のなかで執拗に問われてきた、音を発する、あるいは音を聴く主体のあり方、または偶然性や沈黙というテーマをどうあつかうのか、あらためて考えてみたい。　　　　　　　　　　　（金子智太郎）

座談会

音の本とサウンド・スタディーズ
音による思考と音をめぐる思考【後編】

秋吉康晴、阿部万里江、葛西周、山内文登　　司会 金子智太郎

■ローカルな存在論

　金子　後編では順に本を紹介していきましょう。古いものも新しいものも。話の途中で思いついた本もあげてください。一冊だけを長く取り上げるより、たくさんの方法を比べていけるといいです。山内さんからお願いしましょうか。

　山内　前編はいろんな話が出ましたね。葛西さんがおっしゃっていた、聴覚を語るときにも視覚の言葉を使わざるを得ない状況。阿部さんがおっしゃっていたような、植民地化を問うときにも西洋の概念をアジアに当てはめて考えるような状況。秋吉さんのお話では、健常者の概念を使って「ろう」のことを語ってしまうという状況。これもろうの植民地化と呼ぶとすると、どれも通底する問題があるような気がします。こういったことを考えるときに、音や耳、「ろう」、非西洋といった方向から物事を考えていくことの重要性があるのかなと。

　サウンド・スタディーズはこうした問題に取り組むことになる。でも、金子さんもおっしゃっていたんですけど、視覚中心に対して聴覚中心をもってくれば済む話ではない。西洋中心主義に対して帝国日本の「東洋」をもってきても仕方がない。中心主義に対して中心主義をもってきても、それは本当の意味で代案にはならない。それで、私は金子さんが言われた、「協働」とか、「共創」みたいなことに関心をもっています。前編の討論でそういったことを考えながら聞いていました。

　金子　前編のふりかえりをしていただいて助かります。

　山内　前編で『キーワーズ・イン・サウンド』[1] について話したいと言いましたね。授業で取りあげることも多く、先のような問題意識と関係しています。これは便利な本で、とりあえず押さえておきたい英語の概念が並んでいます。ゼミなんかで、とりあえず音に関わる概念をさらっと見ておこうということで使います。

1) David Novak, & Matt Sakakeeny eds., *Keywords in Sound*, Duke University Press, 2015.

ただ、この本には「サウンド」という項目はないんですね。「ボイス」とか「ノイズ」とか、「サイレンス」、「ミュージック」といった項目があります。「サウンド」はイントロに少し書かれているんですけど、一つの項目として立てにくい。でも、これがないということが何を語るのか、というのを考えてもいい。聞くほうに関していうと「リスニング」、「ヒアリング」、あと「デフネス」などがあります。とりあえずこういった概念を中心に、音に関わるもの、聞くことに関わるもの、そういった基本概念を押さえている。

この論集の一つの特徴は、編者のノヴァックさんも日本の研究[2]をしていますけど、いわゆる非西洋の側にも目を向けている執筆者が多い。なので、西洋中心主義的な話の進め方というより、西洋以外の事例研究や議論を踏まえた項目が少なくありません。たとえば、ノヴァックさんが担当している「ノイズ」部分の後半では、日本語の「ノイズ」に相当するものを、対比というか、並べるようにして考えていく。

「ボイス」に関しても、この項目を書いているアマンダ・ウェイドマンはインドのことを研究[3]しています。「ボイス」を取りまく西洋近代的な理解のしかたをまず整理したうえで、それをいかに克服するかというような問題意識を強くもっている。取りあげているのは、インドの映画で「プレイバックシンガー」と呼ばれている女性の歌手たち。彼女たちの歌は、俳優たちによって口パクされる。なので、その歌には自分の感情を込めてはいけないし、自己表現としての歌ではない。「プレイバック」と言うぐらいですから、機械的な歌い方というか、ある型にはまった歌い方が要求されるんです。西洋的な「ボイス」は、人間の主体性であるとか個人の魂、精神的なものに関わる大事なものっていう観念が強い。それに対して、彼女たちの「ボイス」は自分ではないと言うのか、自己表現ではないものだから、自分を忘れて歌うべきであるという考え方が出てくる。

けれど、ウェイドマンさんが話を重ねたあるベテラン歌手に言わせると、いや、そういう風にやっていてもなお、自分が誰なのかは忘れてはならない。実際にはマイクを使ったり、いろんなかたちでテクノロジーによっても媒介されているので、いわゆる生の声でもないし、自分自身の表現でもないけれど、それでもなお自分の

2）デヴィッド・ノヴァック『ジャパノイズ——サーキュレーション終端の音楽』若尾裕、落晃子訳、水声社、2020年。

3）Amanda Weidman, *Singing the Classical, Voicing the Modern: The Postcolonial Politics of Music in South India*, Duke University Press, 2006. Amanda Weidman, *Brought to Life by the Voice: Playback Singing and Cultural Politics in South India*, University of California Press, 2021. 以下の話の詳細は後者を参照。

声であり、自分が誰であるかを忘れてはならない。ウェイドマンによると西洋近代とは違う、「インド近代」的な「ボイス」の観念があって、必ずしも声と主体性がわかりやすく結びついているようなものではない。

『キーワーズ・イン・サウンド』の便利なところは、西洋の文脈では歴史的にこうだったと整理したうえで、なおかつ必ずしもそうではないよねって相対化するような視線も共存していることで、授業でもディスカッションを進めるうえですごく使いやすいです。

金子　意識的に多様な視線を共存させていて、たんなる事典ではなくなっていると。

山内　そうです。ただ、ここからは前編で阿部さんに質問されたことへの応答なんですけど、この本を読んだ後に討論になるわけですね。たとえば、「ボイス」は中国語では何というのか。実は、中国語でも、韓国語でも、日本語でも「ボイス」に一応相当する単語があるけれど、完全には対応していない。たとえば中国語では「声音」といいますが、「サウンド」と「ボイス」をあまり区別しない。国民の声に耳を傾けますみたいなときに「声音」と言うと、声と理解するし、自然の環境下における「声音」と言った場合は、音だと了解するので。

「サウンド」と「ボイス」の区別は西洋近代では重要で、サウンド・スタディーズとボイス・スタディーズの関係にも関わります。基本的に「ボイス」は「サウンド」のなかの特別な存在と考えられている。でも、この区別がどの言語圏でも文化圏でも通用するわけではないというのが、ゼミで議論しているとまずは出てくる。西洋の「ボイス」だって、「地方的（プロヴィンシャル）」[4]なものとして考えていかないといけない。そういう話から始まります。

■異なる響きの間で

山内　ただ、さらに考えないといけないのは、英語で物を書くとき、阿部さんの言われる「響き」にしても、ある文化に特有の言葉を表記する場合には、「*hibiki*」とローマ字で表記してイタリック体で書く。同時に「レゾナンス」という対応する英語の言葉をあげるけど、「響き」にはこの言葉に含まれない、いろんな意味のひずみたいなものがある。日本、特に大阪でのフィールドワークから出てきた概念。ここで問題になるのが、韓国について、台湾について、あるいは南米についてものを書く場合、「*hibiki*」という言葉をそのまま使って分析するだろうか、ということなん

4) Dipesh Chakrabarty, *Provincializing Europe: Postcolonial Thought and Historical Difference*, Princeton University Press, 2000.

です。おそらく「レゾナンス」という英語の言葉が媒介するんですね。いろんな文脈、韓国でも台湾でも日本でも、どこでも通用する概念として広く使えてこそ、ある種の理論的な普遍性を獲得する。「ボイス」もそうで、ヴァナキュラーな「*koe*」だと日本文化論になってしまう。これはいつも考えさせられている難しい問題です。

金子 たしかに。複数のアジアの国で仕事をされている山内さんらしい問題提起だと思います。阿部さんいかがでしょうか。

阿部 私もいつも考えあぐねているところです。英語の本を、他の言語圏の学生と討議しながら出てきたという話で、ますます考えさせられます。私は、「*hibiki*」にこだわることで、良くも悪くも地方的な特異性、文化的な特異性を民族誌的な方法でとらえようとしました。聞くっていう実践は生物学的ではなくて、社会化（ソーシャライズド）されたものとして議論し、エスノグラフィで考察しようっていう意味で、あえて日本語のままイタリックにしているんです。でも、結局は概念化するときに、やっぱり西洋概念を使うわけですよ。ルフェーヴルとホールとフェルドと。私は「*hibiki*」を、日本の土着性から出たものだけれど、そこから考えられることは大阪に限ったことではない、ということを提示したくて、この言葉を編みだしたので。

それで、そのために理論が必要になってくる。そうなると私は西洋の知識の形態のなかで教育を受けてきたので、そこに寄りかかってしまうという矛盾があるのは自覚しています。でも、広く知られている概念を使うことで、「*hibiki*」っていう概念を通じて示したかったのは、社会性と空間性と音を同時に具体的にとらえる考察法です。「*hibiki*」とは、潜在的な社会性と、音響的な慣行と環境と、蓄積されてきている歴史をつなぎ合わせる音づくりであり、また、音響的、情動的な差異を同時に考える方法だっていうふうに定義したんです。そうすることで、「*hibiki*」って呼んでも呼ばなくても、似たようなことを考察している人たちは関連性を考えられるのではないか、と願ってつくった概念です。それぞれのエリア・スタディでその文化の文脈に合わせることができるかもしれないけれど、そこにどれだけのジェネラリティ（一般性）とパティキュラリティ（特殊性）があるのかを考える。これは理論が必要になってくる場面で、英語文献の理論に寄り掛かってしまうのは、私も限界というか壁を感じているところです。

金子 西洋と東洋だけでなくて、文化研究全般に話を広げられるかもしれないですね。研究対象は特殊でも、それを取りあげる研究者は広がりのある学術の世界と関わっている。研究者は特殊な研究対象と自己を重ねすぎてはいけない。だから、イタリックにされる現地の言葉は、研究者自身でも完全に理解しているわけではないという、異物感があるほうがいいんじゃないでしょうか。

　阿部　それは意識していますね。概念化するとき、自己批判はエスノグラファーとしては必要な要素ですし。それでも、理論的に寄りかかるものが日本の学者さんだったら良かったのかとか考えます。難しいところですけど。

　金子　日本人でも時代や地域の違いがありますし。葛西さんも前編で、時空間が遠く離れた場面の聞こえの話をされていました。たぶんこの話と無関係な歴史研究はないので、だからこそ『キーワーズ・イン・サウンド』には「サウンド」っていう項目があってもよかったのかな。そろそろ次に移りましょう、葛西さんお願いしていいですか。

■ポジショナリティ

　葛西　私が紹介しようと思っていたのは、ディラン・ロビンソンの『ハングリー・リスニング』[5) です。ここまで何度もジョナサン・スターンが出てきていますけど、彼の『聞こえくる過去』にはアメリカ先住民の声を死にゆく文化として聞くという話があります。これは入植者の耳で聞く、ということですよね。『ハングリー・リスニング』はカナダの先住民音楽を事例として、聞くことと権力構造の結びつきを論じる、つまり聞くという行為自体を政治的、文化的なものとして論じるという立場をとっている本です。阿部さんと山内さんのお話にも関連するような、マジョリティの、白人シスジェンダーの耳で聞く特権性への自覚を呼び起こそう、といった動向は、アカデミアで最近目立つ印象ですね。先に出てきたストーバーもそういうところがありますし。この本のタイトルは、先住民の言葉で白人入植者を指す「飢えた人々」から取っていて、先住民音楽に対する白人入植者を論じるうえで「聴取のポジショナリティ」という言葉を使っています。

　金子　これまでの話題とも関わってくる、広がりのある用語ですね。

　葛西　そう思います。特に 20 世紀初期は、先住民の音楽が完全にナショナリズムに回収されていましたが、昨今はたとえば社会包摂的な異文化コラボレーションのなかで、先住民音楽が積極的に取り入れられるようになっています。先住民音楽に限らず、「非西洋的」な音楽がクラシックの演奏家やオーケストラとのコラボレーションというかたちで実演される例があります。そうすると先住民音楽の出番は増えるのですが、本来の文脈から完全に切り離されて、コンテンツとして抽出される。その抽出されたものが権力的に不均衡なコンタクト・ゾーンのような場所で、西

5) Dylan Robinson, *Hungry Listening: Resonant Theory for Indigenous Sound Studies*, University of Minnesota Press, 2020.

洋音楽のシステムに適合されて、それに貢献することを余儀なくされている。コンサート・ホールなんて、完全に西洋芸術音楽優位の場ですよね。こうしたことは入植者の価値体系を強化しているんじゃないかとロビンソンは批判しています。

　著者自身がカナダの先住民にルーツをもっていて、イントロダクションの最後には、先住民の読者だけに向けたパートが設けられています。「あなたが先住民でない場合はここを読み飛ばしてください」というような但し書きがついていて。そこには先住民の言葉も使いながらメッセージが書かれているんですが、「現時点では先住民の読者は少ないかもしれないけれど、将来の読者のために」という意図があらわれているところも印象的です。この本は、結果的に先住民の表現の場が増えているにもかかわらず、表現の機会自体が入植者側の論理の強化に加担することになってしまうということを指摘しています。さらに、その解決の糸口として、コンテンツの抽出と消費の流れを断ち切ることとか、自分の聴取のポジショナリティを批判的にとらえ直すことの必要性を提示しているわけです。

　面白いことに、この聴取のポジショナリティというのが、アイデンティティといつも直結するわけではなくて、時間とか場所といった諸条件でかなり揺らぐという話も出てくるんですよね。人種や民族、あるいはジェンダーといった属性が、場や時間といった条件とともにポジショナリティをつくっているという考え方なんです。一つの属性に固定されたものとしてではなく聴取態度をとらえるということは、私の立ち位置に近いなと思っていて。議論を喚起する可能性を最近感じた本として紹介しました。

　金子　80 年代、90 年代のワールド・ミュージック論と比べて、この本がアップデートしているのは、最後にあげられたところでしょうか。

　葛西　そうですね。もちろん当事者性も一つの強みかもしれないですけど、もう一つ新しいなと思ったのは、入植者側が共に考え、記述できるような仕掛けを作ろうという態度が現れている点ですね。実際、結論では著者の研究仲間、入植者側の人たちが議論に加わる展開も用意されています。当事者からするとこれが違うとクレームを申し立てるだけでなく、それぞれの聴取を相対化することで生産性のある対話のスタイルを示すというのが新鮮に感じました。

　金子　面白いですね。葛西さん自身も、必ずしも当事者だけでなく、さまざまな立場や場所や時間などがポジショナリティをつくっていくという見方を、研究に取り入れていこうとしていると。

　葛西　そうです。それこそ植民地政策を進めていた帝国日本でも、聴取のポジショナリティに非常にぐらつきがあるというか、フェーズによってかなり変わって

しまいますし。帝国主義的にこのような聞き方をしている、と言うことは容易ではありますけれど、そうした一元化はあまり現実的ではないといつも感じていたので。

　金子　たしかにそう思います。では、次は秋吉さんにお願いしていいですか。

■轍（トラック）

　秋吉　近年盛んになってきているボイス・スタディーズの関連書で、ノーリー・ニューマークの『ボイストラックス』[6]という本です。著者はオーストラリアのメディア・アーティストあるいはサウンド・アーティストです。

　声という概念は複雑で地理的にも多様だとは思うんですが、いわゆる西洋の内部でも声という概念自体を問い直そうという動きが最近活発になっていると思うんです。西洋哲学では声は主体の象徴とみなされてきたわけで、それは音声中心主義[7]という言葉で批判されてもきました。最近は少し違うアプローチとして、声という概念を人間中心主義から解放していこうという動きがあると思うんですよね。『ボイストラックス』もその一つです。

　この本の面白いところはあくまでもアートを通じて考えながら、しっかり理論とも結びつけているところにあります。最近の人文学の動向を踏まえながら、声を人間だけのものじゃなくて、非人間にも開いていこうとする姿勢が見られます。たとえば、動物、機械、あとは「アース」と著者が総称しているものです。これは何と訳すのが適切なんでしょう。

　金子　「大地」とか「土壌」とか。身近なのは「地面」かな。非人間化というか、近年よく見かける考え方ですね。

　秋吉　そうですね。少し前だと、ダグラス・カーンの『アース・サウンド、アース・シグナル』[8]にも同じような関心が見られますよね。哲学では人間を定義するときに、人間と動物と機械を比較したりしますが、『ボイス・トラックス』ではこの区別を超えていくものとして、声をとらえようという考え方をしています。

　また、この本ではたびたび人類学の考え方も導入しています。タイトルにある「トラックス」は「サウンドトラック」からとった言葉ですが、人類学者ティム・イ

6)　Norie Neumark, *Voicetracks: Attuning to Voice in Media and the Arts,* MIT Press, 2017.
7)　音声中心主義（phonocentrism）とは言語のメディアとして、文字よりも声（話し言葉）を特権化する立場。ジャック・デリダ『根源の彼方に——グラマトロジーについて（上）（下）』足立和浩訳、現代思潮新社、1972 年。
8)　Douglas Kahn, *Earth Sound Earth Signal: Energies and Earth Magnitude in the Arts,* University of California Press, 2013.

208

ンゴルドの「ライン（線）」概念にも関連づけられています。インゴルドの『ラインズ』[9] は人類の文化史を、線を引くということから振り返ろうという本です。文字や楽譜を書くだけでなく、話すことや歌うことも、歩いて移動することも輸送機関で移動することも全部、線を引くという行為としてつなげていくんです。これまで別々に考えられていたものどうしをつなぐために「ライン（線）」を使っているのが面白いんですよね。先ほどのニューマークは「トラック」をそれと似たようなものしてとらえています。「トラック」は「轍（わだち）」や「道」という意味がありますが、ニューマークが「ボイストラック」と言うときには声自体が何かと何かをつなぐ「轍」になっているというニュアンスが込められています。つまり、ニューマークの著作『ボイストラックス』は人間と動物、人間と機械、人間と大地、そうした異質なものどうしの間につながりを再発見するために声を再考している本なんです。

　金子　機械と動物とかまでは想像できる気がするんですけど、その大地と声の関係というのはどう語られるんですか。

　秋吉　やや怪しい部分もあるんですが、ニューマークは地面とか雲とか空にも声はあるという考え方をしています。

　金子　なんだろう、風とか波が声ということならわかるような。やはりダグラス・カーンの本とつながっていそうですね。

　秋吉　そうですね。関連していると思います。大事なのは「声」をあつかっているとはいえ、必ずしも人間を中心にしていないということです。そうした音に関連する概念の脱人間化はサウンド・スタディーズにとってもますます重要になってきているのではないかと、僕は考えています。少し飛躍するかもしれませんが、「サウンド・スタディーズ」という用語が定着するまでは、その広い研究対象を指すために「オーディトリー・カルチャー」や「ヒアリング・カルチャー」といった表現が使われていましたよね[10]。しかし最近では「聴覚」ではなく「音」がこの分野の旗印として採用されています。この違いはかなり重要だと思うんです。音は必ずしも人間の聴覚で聞こえるものとは限らないですよね。音は見たり聞いたりすることもあるものですし、他の生物のなかには聴覚以外で音を知覚しているものもあります[11]。聴覚や耳ではなく音というカテゴリーを採用することで、サウンド・スタディーズ

9) ティム・インゴルド『ラインズ──線の文化史』工藤晋訳、左右社、2014年。
10) 前編の註 22、24 を参照。2000 年代前半に出版されたアンソロジーのタイトルから。どちらも日本語に訳せば「聴覚文化」となる。
11) 生物音響学会編『生き物と音の事典』朝倉書店、2019年。

は人間を超えたものを志向しはじめている気がするんです。ニューマークの著作はボイス・スタディーズにカテゴライズされるのかもしれませんが、僕はそれと同じような志向を感じます。

　金子　複数の項目をつなげていくのは、ヒアリングやオーディオでもいいような気がします——大地が聞くとか、機械の耳とか言ってもよいかなと。

　秋吉　たしかに、そうかもしれません。しかし、ヒアリングだと音を発する側は抜けてくるのではないでしょうか。サウンドは「音を発する側」と「音を受け取る側」の間を意識することができるので、そこが良いところなのかなと思いますが。

　金子　なるほど。それでは、次に阿部さん、お願いします。

■地図を描き直す

　阿部　2冊、どっちにしようか迷っているんですけど。音の研究のなかでの脱植民地化とグローバル・サウスからの再配置についての編著で、『リマッピング・サウンド・スタディーズ』[12]。もう少し具体的な、スリランカのエスノグラフィで、ジム・サイクスの単著『ミュージカル・ギフト』[13]。どっちがいいでしょう。

　金子　司会の権利で決めさせていただくと、葛西さんがカナダの先住民の本をあげてくれたので、次は一般化して『リマッピング』にしましょう。

　阿部　はい。ある意味、『キーワーズ・イン・サウンド』のアップデート版です。『キーワーズ』が2015年で、『リマッピング』が2019年かな。出版されたのは2019年ですけど、書かれたのは2016、17年。出版にすごく時間がかかったので、執筆は『キーワーズ』が出た時期とあまり変わらない。編者は南アフリカ出身のギャヴィン・スタインゴと、アメリカ人のジム・サイクス。二人とも白人の男性ですけど。『キーワーズ・イン・サウンド』は西洋的な論理立ての後にエスノグラフィックな事例をあげているとはいえ、やはり西洋、知識の体系というと西洋近代の理論、コンセプトを残したままのものが多い。そこで、この二人がほとんど同時期に、サウンド・スタディーズの「リマッピング」が必要だと提言しています。山内さん、なんて翻訳していましたっけ。

　山内　翻訳はかたく「再配置」としましたけど[14]。「地図を描き直す」とかですよね。

12) Gavin Steingo, & Jim Sykes eds., *Remapping Sound Studies*, Duke University Press, 2019.

13) Jim Sykes, *The Musical Gift: Sonic Generosity in Post-War Sri Lanka*, Oxford University Press, 2018.

阿部 サウンド・スタディーズの地図を描き直すという感じですね。先に話してしまいましたが、東と西ではなくてグローバル・サウス、ノースという枠組みから。新自由主義、帝国主義によって生みだされた「グローバル」のなかにある外在性を全部ひっくるめてグローバル・サウスと呼んでいます。そこにある植民地主義は、定義どおりの植民地もあれば、現代の北米とかパレスチナのような入植主義のタイプと両方ある。

この本はスターンの「視聴覚連禱」が実は、グローバルな南北の対立によって暗に補強されているという批判から始まります。面白いのは、彼らがイントロダクションでマニフェストみたいなことを三つ言っていて。

一つ目はテクノロジーを、音の再生の効率化を進める西洋の実践、近代西洋の実践であるとみなさないで、マイケル・ガロペの言葉を借りて「構築的技術性」[15]として分析しようと。グローバル・サウスの視点からテクノロジーという意味を根底から洗い直して、概念を変えましょうと。テクノロジーが前提とする効果とか帰結という想定を問い直そうというのが一つ。たとえば、お医者さんの使う聴診器を使って、コロンビアでの産婆さんが命を聞きとる実践などを通して、テクノロジー自体を問い直す。一つのテクノロジーがいつも同じようにメディエーションするわけではない。場所によって、流通の流れが溜まる場所があったりするとか、そういう不安定なところに目をつけよう。二つ目は、文化相対主義に陥らないように注意しながらも、ヴィヴェイロス・デ・カストロの「存在論的転換」[16]を勧めています。音の存在論を非相関的な視点から考慮しながら、同時に文化的な差異を認めるような姿勢を提案している。最後は歴史。これが面白いと思うんですけど、音に

14) 山内文登「方法としての音――フィールド・スタジオ録音の「共創的近代」論序説」『音と耳から考える』、173 頁。

15) Michael Gallope, "Technicity, Consciousness, and Musical Objects" in *Music and Consciousness: Philosophical, Psychological, and Cultural Perspectives*, David Clarke, & Eric Clarke eds., Oxford University Press, 2011, pp. 47-64.

16) Eduardo Viveiros de Castro, "Exchanging Perspectives: The Transformation of Objects into Subjects in Amerindian Ontologies," in *Common Knowledge*, vol.10, no.3, 2004, pp. 463-484. Martin Holbraad, Morten Axel Pedersen, & Eduardo Viveiros de Castro, "The Politics of Ontology: Anthropological Positions," Theorizing the Contemporary, *Cultural Anthropology* website, January 13, 2014. 邦訳のあるヴィヴェイロス・デ・カストロの著作は『インディオの気まぐれな魂』(近藤宏、里見龍樹訳、水声社、2015 年)、『食人の形而上学――ポスト構造主義的人類学への道』(檜垣立哉、山崎吾郎訳、洛北出版、2015 年)。「存在論的転回」をめぐる日本語文献としては『Lexicon 現代人類学』(奥野克巳、石倉敏明編、以文社、2018 年)などがある。

よってオルタナティヴな歴史性と文化的差異に関する語りができるんじゃないかと。非線形で、摩擦に溢れていて、同時に重なりあっているような歴史のとらえ方を音で洗い直そうという提言をしています。

　この三つがマニフェストにあがっています。13人の著者全員がきれいにマニフェストに即して書いているかというと、そうではないかもしれないですけど。でも、刺激的な提言で、さっきから出てきているような脱植民地とか、近代性を問い直す、など今日話していたいろんなテーマがこうギュッと、理想的ではありますけれども、つまっている。ケース・スタディも面白い読み方ができるので、実験的な事例として読める。訳したらたぶん教科書になるんじゃないかなっていう本だと思います。

　金子　東西ではなくて南北というリマッピング。それから技術のリマッピング、音の存在論のリマッピング、最後に歴史のリマッピング。網羅的ですね。詳しい主張は読んでみないとわからないかなあ。

　阿部　たとえば、ジム・サイクスが研究してきたのはスリランカの太鼓です。いままではこの民族はこういう太鼓を使う、という風に音楽を民族的差異の指標としてとらえられてきた。それを、スリランカ内戦を通じた地理的な分断としてとらえ直す。それから、そのいわば摩擦的、重層的な分断の歴史は、「音楽は自分の内面の表現」という西洋近代的発想が入ってきたと同時に始まったと指摘する。その分断の歴史を、音楽は神々と人間のあいだの贈り物だったという帝国主義以前の土着的なとらえ方、音もアイデンティティも神々に与えて、返ってきて、そのやりとりのなかで生まれてくるものだという視点から、歴史と地図を描き直していく。そういうリマッピングの仕方をするんですね。

　金子　音楽の話に留まらないんですね。

　阿部　ではないです。

■音響技術のジェンダー

　金子　さて、2周目の紹介に移りましょう。ふと思ったのですが、ジェンダーの話は出てこなかったですね。何か本と結びつけて話せる方がいらしたらぜひ聞きたいのですが。

　阿部　論文は思いつきますけど、一冊の本というと少ないかもしれないですね。

　金子　僕は以前、リュス・イリガライの議論を音と結びつけたアールマンの論文 [17) を翻訳したんです。そのときは、視覚優位に対する音と、男性優位に対する女性を結びつけることの難しさもあるなと感じて。こういった議論が近年どうアップ

デートされているのか、興味があるのですが。

秋吉 新しくはないですが、フェリシア・ミラー・フランクの『機械仕掛けの歌姫』[18] ですかね。著者はフランス文学研究者なんですが、フランスでは「崇高」の概念が女性の声と関連づけられてきたという歴史的な見地に立っています。そして、女性の声が感覚と論理を超越したものとして崇拝されてきた歴史と、そのイメージが変遷してきた過程を文学から読み取っています。この歴史は女性を崇拝しつつも排除するという問題を含んでいるんですが、その具体的な形象は「天使」から「アンドロイド」へと変遷していったというんですね。事実、現代に近づくにつれて「歌姫」として表象されるアンドロイドは増えていってますよね。ヴィリエ・ド・リラダンの『未來のイヴ』[19] しかり、つい最近だと初音ミクのような「ボーカロイド」もそうですね。音というより声ですが、そうした技術史のなかに潜むジェンダーの問題をあつかった本は増えてきているように感じます。

阿部 電話交換手についてのミシェル・マーティンの本[20] もそうですね。女性の労働とジェンダーと声と、新しい技術としての電話の本がありましたよね。

山内 このテーマについては、マイケル・ブルのサウンド・スタディーズ読本[21] のなかで、カラ・ワリスがマーティンの仕事にも触れつつ、「ジェンダード・ワーク」と「ジェンダー・ワーク」という、女性の仕事とみなされる仕事があることと、仕事を通じて女性的な主体になるという、二つの観点を絡めて話をしていたと思います[22]。

あとはタラ・ロジャースの『ピンク・ノイジーズ』[23]。エレクトロミュージックに関する古典でもある。女性の主体性と、女性とテクノロジーの関係性のありかたみたいなものをもう一度細かく、民族誌の方法を使いながら書いています。ロ

17) ファイト・アールマン「デカルトの共鳴する主体」金子智太郎訳『表象』第9号、2015年、105–125頁。

18) フェリシア・ミラー・フランク『機械仕掛けの歌姫——19世紀フランスにおける女性・声・人造性』大串尚代訳、東洋書林、2010年。

19) ヴィリエ・ド・リラダン『未來のイヴ』齋藤磯雄訳、創元社、1996年。

20) Michèle Martin, *Hello, Central?: Gender, Technology, and Culture in the Formation of Telephone Systems*, McGill-Queen's University Press 1991.

21) Michael Bull ed., *The Routledge Companion to Sound Studies*, Routledge, 2019.

22) Cara Wallis, "Gender and the Telephonic Voice," in *The Routledge Companion to Sound Studies*, 2018, pp. 329–337. Cara Wallis, *Technomobility in China: Young Migrant Women and Mobile Phones*, New York University Press, 2013.

23) Tara Rodgers, *Pink Noises: Women on Electronic Music and Sound*, Duke University Press, 2010.

ジャースは『キーワーズ・イン・サウンド』でも「シンセシス」の項目を担当していますね。シンセサイザーももちろん出てくるんですけど、思想史的にも面白い概念です。この項目は単著で扱ったインタビューや論点をうまく活用しています。

例えば、音の基本的なパラメータとして、ボリューム、ピッチ、ティンバー（音量、音高、音色）という要素がある。シンセサイザーという楽器自体がこの三つを操作できるように構想されている。これは音をめぐる思想でもあったし、実際に楽器として具現化して、操作できるようになった。これはヘルムホルツがまとめあげた考え方[24]ですが、ロジャースに言わせると男性的な発想にもとづく音の定義の仕方ではないかと。それで、『ピンク・ノイジーズ』のなかで実際にいろんな人にインタビューしていくなかで、シンセサイザーと関わっている女性たちは、そういったパラメータやそのコントロールとはぜんぜん違うかたちで音をあつかっていることがわかってくる。例えば、自分のシンセサイザーは小さな生き物のようなもので、時に予想もしないような音を発したり、好奇心をかきたてる存在であって、「機械」というわけでもなければ、それと「私」とも分離していない。自ら呼吸するように音を返してくるパートナーのようにシンセサイザーをあつかっていく、関係性が違うというようなことを言っています。

金子　興味深い話です。どれだけ一般的なのかな。前編に出てきた、音を使ってオルタナティヴな考察をしようという発想と、音のなかでのある種の植民地みたいなものを考えていく発想のずれとか重なり合いが、ジェンダーと音の研究にもあらわれるのではと思っているんです。女性電子音楽家や電話交換手の仕事を詳しくたどることで、音の世界の中心や周縁を見直すことができるかもしれない。

葛西　ずれで思い出したのですが、ジェンダーやクィア性との関連で、聞き手が目にする身体と、声から想起する身体とのギャップをめぐる交渉についての議論が見られますね。先に出たウェイドマンの「プレイバックシンガー」の話とも問題意識が交差するように思います。たとえばジョディ・テイラーは、ドラァグショーで定番のリップシンクについて、生物学的に固定された身体の境界を踏み越える手段として言及していました[25]。最近では石田美紀さんが『アニメと声優のメディア史』で、日本のアニメで女性声優が青少年を演じてきた歴史を踏まえて、声優と

24）ヘルマン・フォン・ヘルムホルツ『音感覚論──音楽理論の生理学的基礎』辻伸浩訳、銀河書籍、2014年。

25）Jodie Taylor, *Playing it Queer: Popular Music, Identity and Queer World-making*, Peter Lang, 2012.

キャラクターの一致・不一致と聞き手の欲望との関係や、声の演技によるジェンダー規範の撹乱を論じています[26]。

金子 なるほど。これらも音響技術をめぐる話と言えそうですね。さて、続けてになってしまいますが、葛西さん、次の本を紹介してください。

■耳鳴りのオノマトペ

葛西 学術書ではないのですが、いいでしょうか。

金子 それでぜひお願いします。

葛西 吉本浩二さんの『淋しいのはアンタだけじゃない』[27]という漫画です。タイトルから内容を想像しにくい作品ですが、今回の趣旨的にぜひ紹介したいと思いました。この本は聴覚障害をもつ人や、聴覚専門医、手話通訳、言語聴覚士などに取材をして描かれたノンフィクション漫画なんです。例のゴースト・ライター事件で世間を賑わせた佐村河内守[28]さん、あのときに彼に対して聴覚障害の偽装疑惑がもちあがりましたよね。ちょうどこの漫画が描かれていたのが、森達也さんが『FAKE』[29]を撮っていた時期と重なっていて、この作者もたびたび佐村河内家に行ってインタビューをしています。

この本が面白いと思ったのは、単に聴覚障害をあつかっているからではなくて、綿密な取材にもとづいて障害の実態が丁寧に描写されていて、しかも当事者の語りがかなり含まれているからです。例えば、聴覚障害といっても聞こえの程度はさまざまで、必ずしも何も聞こえないという意味ではないこととか。むしろ耳鳴りが「聞こえる」ことに悩まされている聴覚障害者もいるわけです。「デフ・ジョーク」と呼ばれる、聴覚障害者のコミュニティのなかでは笑えるけど、聴者が聞くと笑っていいかわからないようなジョークの話も出てきます。あとは聴力測定がどうやって行われるかとか、補聴器が日本でどういうふうに普及しているとか。そういう日本での聴覚障害の認識に関わるようなさまざまな課題も取りあげられているんです。特に興味深いのは、個々の人の耳鳴りの聞こえの違いを視覚化するところです。阿

26）石田美紀『アニメと声優のメディア史——なぜ女性が少年を演じるのか』青弓社、2020年。

27）吉本浩二『淋しいのはアンタだけじゃない』全3巻、小学館、2016-2017年。

28）佐村河内守（1963年 –）全ろうの作曲家として《交響曲第1番 HIROSHIMA》で時代の寵児となったが、2014年に作曲家の新垣隆が佐村河内のゴーストライターを18年間務めてきたと公表したことで波紋を呼んだ。

29）『FAKE』森達也監督、「Fake」製作委員会製作、2016年。

部さんのオノマトペの話とも関係しているんですけど。お見せしますね。

　金子　共有してもらう間に少し足すと、聴覚障害に限らず、さまざまな障害や、健常なものから少し外れるようなものに関する議論——医学書院の「ケアをひらく」シリーズとか、伊藤亜紗さんの本 [30) とか、近年ずっと注目を集めている印象があります。「コーダ（CODA, Children of Deaf Adult/s）」と呼ばれる、聴覚障害の親をもつ子どもが、どういう文化を経験するかとか [31)。

　葛西　主人公がコーダの小説がありますよね、『デフ・ヴォイス』[32)。

　金子　エッセイでは『しくじり家族』[33)とか。

『淋しいのはアンタだけじゃない』
（出典：第 2 巻、22 頁、小学館、2017 年）

　秋吉　あ、画像が見えました。この「ビィィィィ」というのとかは、音が聞こえないんじゃなくて、耳鳴りがずっと聞こえるという。

　葛西　そうです。作者によると、育った場所や教育環境の違いで、耳鳴りのオノマトペ表現が変わるんだそうです。耳科学の専門家への取材で、英語圏の方が耳鳴り表現の擬音のパターンが少ないという説も出てくるんですよ。日本の「ろう」や難聴の人に取材をすると、いろいろな擬音や喩えを使って耳鳴りの表現をされるそうです。虫の鳴き声に聞こえるとか、ジェット機が頭上を飛んでいる音や、鐘を撞いている音がするとか。さまざまなノイズの表現があるみたいなんですよね。

　金子　これも興味深いフォノグラフィの事例ですね。他に、漫画でなくてもいいんですけど、アカデミックではない本はありますか。

30)　伊藤亜紗『目の見えない人は世界をどう見ているのか』光文社、2015 年。

31)　澁谷智子『コーダの世界——手話の文化と声の文化』医学書院、2009 年。

32)　丸山正樹『デフ・ヴォイス』文藝春秋、2011 年（『デフ・ヴォイス——法廷の手話通訳士』文藝春秋、2015 年）。以後シリーズ化。

33)　五十嵐大『しくじり家族』CCC メディアハウス、2020 年。

■映像で聴こえをとらえる

阿部　別の媒体でいいですか。音を考えるために、音を介して、音だけで知識を共有できるのかっていう問題に興味があって。その問題提示をした本人である、フェルドのアルバム『ボイセズ・オブ・ザ・レインフォレスト』[34]。最近、彼はこれに映像をつけて、ルーカス・スタジオですごい編集をして、サラウンド・システムで映画としてまた出したんです。彼は本当に「リフト・アップ・オーバー・サウンディング（重ねあげた響き）」[35]っていうカルリの人たちの美意識というか聴き方を、どれだけ忠実に表現できるかを追求していて。ただフィールド・レコーディングをするのではなくて、カルリの人が聞いているような高さと幅と空間の感覚をとらえるためにマイクの置き方を工夫する。特殊なマイクの開発もする。それをスタジオで編集に編集を重ねて、「ダイアロジック・エディティング（対話を通じた編集）」を通してカルリの人たちに聞いてもらって、そのフィードバックを基にさらに編集を重ねてつくったアルバムです。カルリの一日の音風景と、彼らの出す音と、彼らの空間と時間の聴き方と、彼らのコズモロジーをぎゅっと詰めた作品として。

　でも、どこで一番売れているかというと、ニューエイジのリスナーとか、マッサージとかヨガのスタジオとかでよくかかっているらしくて。聴き方の文化の違い、耳の違いというものは編集に編集を重ねた音を使っても、やっぱり伝えにくいところがあるなあ、と。壮大なプロジェクトですけど、音によって音の知識を生産する可能性と限界、両方考えさせられる作品だなと思います。

金子　BGMとして消費されてもいると。映画は見れるんですか。

阿部　すごくこだわっていて、サラウンド・システムのあるところでしか見せたくないので、公開はしていないようです。どちらかというと、視覚的なものが加わって、聞こえてくるものが減った感じが私はしました。それから、環境破壊によるカルリの人の直面する問題など現時点のことも映画ではつけ足していました。

■造音

金子　次は山内さん、お願いします。

山内　僕が書評をした本でもいいですか。

金子　いいですよ。書評で取りあげたものをあえてここで話したいなら。

34) Various Artists, *Voices of the Rainforest*, Smithsonian Folkways, HRT15009, 1991.

35) スティーヴン・フェルド「重ねあげた響き——カルリ社会の音楽と自然」山田陽一訳『ポリフォーン』第5号、1989年、105-117頁。

山内　なんで話したいかというと、書評のほうでは字数の制限もあってうまく盛り込めなかったので。何東洪、鄭恵華、羅悦全編の『造音翻土』[36]という台湾の本です。この本っていわゆる学術書ではなく、展覧会のカタログが元々あって、それが書籍になっている。

金子　台湾で 2014 年に開かれた展覧会のカタログで、その展覧会自体が台湾における音の歴史を見渡そうとする、とても幅広い内容ですよね。

山内　そうですね。このなかで取りあげられているのは、音に関わるいろんな実践、プロテスト・ソングもあれば、サウンド・アートもあれば、ノイズ運動、レイヴ・カルチャーとか、いろんな文脈があります。そういったものを一挙にまとめて、台湾に固有な音あるいは声といったものを追求するなかで、ジレンマにぶつかりながらやってきた、さまざまな系譜をたどっていく。著者には現場に関わってきたアクティヴィストもいるし、ミュージシャンも研究者もいるし、一つひとつの文章はコンパクトながら、20 人以上が参加している。しかも、書評でも少しふれたんですけど、台湾からの概念化、理論化の試みっていうんですかね、そういった部分もあるように感じます。

　まずタイトルに使われている「造音」って言葉なんですけど、これはすごく翻訳しにくい。詳しくは書評に書いたので見ていただけたら。そこに書いていないことで、この場で言いたいのは、さっき話に出ていた「*hibiki*」とか、そういった特定の地域から出てきた言葉を、他の地域を語るときにどういうふうにあつかうのかという問題と関わることです。理論、概念を語るときに日本の音研究でも、いわゆる西洋でなく、例えば台湾や韓国でどういった議論があるのか留意して、さらに事例ではなくて理論として参照するのは一般的なことではないと思うんですよ。そういったことを念頭に、僕にとってこの本で語られているいくつかの概念は、漢字語でもあり日本語でもあつかいやすいところがあると思った。概念的な抽象性や普遍性という意味で、東アジアに共有される漢字という論点も重要です。この本の著者たちが提起しようとしている「造音」という概念にはいろんな含意があって、日本語でも使う可能性があるかもしれないなと。そういったことを考えながら、もう少し理論的な相互参照の仕方が出てくると面白いなと思いました。東アジアで音のリマッピングを考えるなら、それが理論的なレベルにおける一つのリマッピングの実践にもなるのかなと。

36）山内文登「何東洪、鄭恵華、羅悦全編『造音翻土——戦後台湾のサウンドカルチャーの探究』」☞本書 184–187 頁。

　金子　阿部さんの研究や、耳の造語とかもそうでしょうが、新しい概念とともに言葉を提起していくことはとても魅力的ですね。自分も頑張らないと、と思います。外国語との比較をヒントにするのは参考になります。他に展覧会カタログや、作品集などを紹介したい方は。

　秋吉　ポール・デマリニスの『ノイズに埋もれて』について金子さんが書評[37]を書かれていましたね。デマリニスは過去の音響技術のなかでも忘れ去られたものや軽視されてきたものをリサーチしながら、進歩史観的な技術史を相対化するようなサウンド・アート作品を発表しつづけている作家です。『ノイズに埋もれて』はデマリニスの作品を網羅的に紹介しているカタログで、作家本人の文章もいくつか載っています。また、寄稿者の論文もいくつか掲載されているんですが、サウンド・アートの専門家だけでなく、メディア論や哲学の研究者も文章を寄せています。それらを読むと、デマリニスの作品がいかに音響技術史の批判的な読解を通じて、音の歴史性や政治性にアプローチしてきたのかがよくわかります。そういう意味では、アートの研究に限らず、技術史研究の手本としても参考になる本ではないかと思います。

　葛西　図鑑だとテリー・バロウズの『アート・オブ・サウンド』[38]がありますね。日本語版も出ています。EMIのアーカイヴ・トラストの資料が掲載されていて、ハードもソフトも網羅されているので、フォノグラフ以降の、音に関するテクノロジーの世界最大規模のアーカイヴだと思います。原書の副題は「オーディオファンのための目で見る歴史」。フルカラーの図版や写真が満載で、開くのにも緊張するような凝った製本です。

　秋吉　こういう本が増えてくると、技術史の研究者としては嬉しいです。『アート・オブ・サウンド』には多数のテクノロジーの図版が載っていますが、眺めているだけでも楽しいですよね。もちろん外見がおもしろいというだけでなくて、音の文化史を考えるきっかけにもなると思います。テクノロジーの構造や仕組みのなかには、時代ごとや設計者ごとの音の思想が詰まっていると思うので。

　金子　そういうアプローチの研究ってあるんですか。

　秋吉　音響技術史に関しては、見当たらないですね。民族音楽学の分野で行われている楽器研究なら、そういうアプローチがありそうな気がしますけど。

37)　金子智太郎「ポール・デマリニス『ノイズに埋もれて』」☞本書196–199頁。

38)　テリー・バロウズ『アート・オブ・サウンド——図鑑 音響技術の歴史』坂本信訳、DU BOOKS、2017年。

　葛西　そうですね、岡田恵美さんの『インド鍵盤楽器考』[39] はまさに楽器に焦点を絞って、その製造や開発の背景にあるインド音楽の価値観を探り出した本です。たとえば、90 年代のインドで日系の楽器メーカーの電子キーボードが「カシオ」と総称されて普及し、さらにインド音楽のリズムやインド楽器の音色、ピッチベンド機能などを搭載したモデルがインド市場向けに開発され、「インディアン・キーボード」としてグローカル化されていくプロセスから、インド古典音楽で電子キーボードの採用を可能にしている規範のありようが読み解かれています。

■クワイエテュード

　金子　他にいかがでしょうか。

　阿部　これまでの話のなかで思いだしたので、まだ出版前の本でもいいですか。

　金子　ぜひお願いします。

　阿部　2 冊あって、一つはジョシュア・ピルザーというエスノミュージコロジストのこれから出版される本（［編註］2022 年 12 月に出版）[40]。彼の最初の著書は俗に言う従軍慰安婦のサバイバーたちについての研究[41] です。あえて概念的な話をせずにサバイバーたちを紹介していく内容なんですけど、彼の興味は声と歌の間にある。歌にもなっていないところに生まれる沈黙とか、声とか歌ともどっちにもとれないようなところを、きめ細やかに民族誌的に取りあげている。彼はここからさらに進んで、概念的な議論も含んだ新しい本を書き上げているところで、あと 1、2 年後には出版されると思うんですけど。この本は「クワイエテュード」という、静けさというか、沈黙ではないものをあつかっています。広島で被爆した韓国系の人々の研究で、面白いのは、音楽的なことを聞こえないものに見出していく研究方法です。

　金子　静けさの価値というか、美的な話になるんでしょうか。

　阿部　美しさとか美的なところではなくて、どっちかというと日常のなかの、歩きのリズムとか、陶器のつくり方とか、話すときの沈黙の感覚とか、そういう些細で繊細な日常の動作や、ジェスチャーを含めたものを読み取っていて。それをまと

39）岡田恵美『インド鍵盤楽器考——ハルモニウムと電子キーボードの普及にみる楽器のグローバル化とローカル文化の再編』渓水社、2016 年。

40）Joshua Pilzer, *Quietude: A Musical Anthropology of "Korea's Hiroshima,"* Oxford University Press, 2022.

41）Joshua Pilzer, *Hearts of Pine: Songs in the Lives of Three Korean Survivors of the Japanese "Comfort Women,"* Oxford University Press, 2012.

めて「クワイエテュード」と呼んでいるんです。これは一冊目の根底にあった考え方を広げていったもの。だから、前に聞こえない音という話をしていましたけど、音響的な音を超えたとらえ方、聞こえないものを音的な感覚で読みとっていくという作業が面白いと思います。

　もう一冊は、私が担当しているジェフ・ダイアーっていう大学院生の研究で、本の出版にはまだ時間がかかりそうなんですけど。カンボジアの、亡くなった人を想定して出す音とか、亡くなった人たちが聞いたり、聞きながら出す音とか、亡くなった人から聞こえてくるものについての本です。幽霊とはまた違う、まあそういうとらえ方もあるのですが、聞こえない音とか、音になっていない音についての研究はいろいろあるなと。

　金子　たしかに。幽霊の音はまた別に研究がありそうですね。すでに論文は出ているんですか。

　阿部　はい、出ています[42]。後で送ります。

　金子　ありがとうございます。静けさというテーマではアラン・コルバンの本[43]もありますね。

　山内　阿部さんの院生の研究の話を受けて思い出した論文があります。といっても拙稿[44]なんですが、ちょうど金子さんも寄稿されておられる編著なので、本の紹介を兼ねて最後に触れてもいいでしょうか（［編註］2023年に出版）。さきほど話した漢字語の問題とも関わってくるので。論文で取りあげたのは「肉声」という言説です。特にそれが「軍神」や現役の高位軍人、政治家などの録音の宣伝に用いられた経緯とかです。彼らの声は複製技術で媒介されているので、「肉声」とは矛盾した物言いで、そのあたりをちょっと掘り下げました。もう一つ、戦前の資料を見てい

42) Jeffrey Dyer, *Sounding the Dead in Cambodia: Cultivating Ethics, Generating Wellbeing, and Living with History through Music and Sound*, Doctoral Dissertation, Boston University, 2022.

43) アラン・コルバン『静寂と沈黙の歴史――ルネサンスから現代まで』小倉孝誠、中川真知子訳、藤原書店、2018年。

44) Fumitaka Yamauchi, "The Phonographic Politics of 'Corporeal Voice': Speech Recordings for Imperial Subjectification and Wartime Mobilisation in Colonial Taiwan and Korea," in *Asian Sound Cultures: Voice, Noise, Sound, Technology*, Iris Haukamp, Christin Hoene, & Martyn David Smith eds., Routledge, 2023, pp. 19–39.

45) Tomotaro Kaneko "Arranging Sounds from Daily Life: Amateur Sound-Recording Contests and Audio Culture in Japan in the 1960s and 1970s." in *ibid.*, pp. 240–256.

くと、この言葉は「肉弾」という物騒な言葉と結び付けられることが少なくないんですね。「肉声」という言葉は、すでに肉身を失った人たちとの関係で特別な意味をもちました。戦争の時代は、常に死者を追悼し、その声ならぬ声に深く耳を傾け、胸に刻む行為が重要になります。今生を超える聴力の錬成ですね。ちなみに、「肉声」とは和製の新造語で、韓国語でも同じような意味で使われますが、中国語ではあまり通じません。同じ漢字語圏でも意味にずれがいろいろあって。この論文では、天皇の「沈黙」や「玉音」といった話題にも触れました。金子さんは、同じ本のなかで「生録」の文化を取りあげてますね[45]。文字と録音の話に戻れば、座談会の書き起こしも、ある種の「肉声」とか「生録」みたいな言い方をされるのでしょうか。

　金子　座談会とは、という話になると長くなりそうなので、ここまでにしておきましょうか。今回は慣れない遠隔座談会だったので、みなさんやりとりが難しかったと思います。話しだすタイミングがつかみにくくて、司会がふってから話すかたちになりがちでした。このぎこちなさはコロナ禍における対話の記録として残しておきます。話した内容をふりかえると、関心が近いみなさんに集まってもらえたので、議論にありすぎなくらい統一感があった気がします。それでも、事前に話したいと思っていた論点はおおよそ出せました。最後に、他に話しておきたいことは何かありますでしょうか。

　阿部　金子さんが何回かおっしゃっていた、音を使ってと、音のなかっていう区別は、私のとらえ方としては同じように聞こえていました。これを文章に起こしたらどうなるか楽しみです。

　金子　そうですね。僕にとっても明確に区別できるのかはわかりません。互いを批判的に、いくつかの論点がぶつかり合うようにしたほうが、より批判的な議論になるのではないかと思っていました。あくまで提案です。

　葛西　全体的に、音とそれを聞く・発する存在や身体との関係性に関心が向きましたね。先ほど挙げた聴取のポジショナリティも、聞こえが関係性の中で形成される話でもありますし。場所が持つ機能やコンテクスト、建築的特性などが音と身体との関係性に与える影響についても、まだ議論の余地が大いにあると思います。

　金子　たしかに場についての話はあまり広がりませんでした。みなさんそれぞれの研究のなかにも個々の場所が出てくるでしょうが、話すと長くなりそうなのでここまでに。長時間にわたり、ありがとうございました。

223

結びに代えて──音によって歴史を書き直す

　この本の目的は、読む人に音と芸術をめぐる新鮮な考えかた、語りかた、聞きかたを見つけてもらうことだ。これはここまでに十分達成されていると思いたい。音と向きあう方法をめぐる座談会では、参加者にたくさんの本の紹介を通して自分の研究や関心を語ってもらった。そこで、本書の結びに代えて、座談会では話さなかった私自身の研究について書きながら、音を学術や芸術のテーマやジャンルにすることの意味をあらためて考えてみたい。まず音と芸術の関わりをめぐる 2010 年以降の研究動向を個人の視点からふりかえる。次にこの動向のなかで私が感じた問題意識を説明し、最後に自分の研究について書いておく。私は近年、日本の戦後美術と生録という二つの対象をめぐる研究を並行して続けているが、ここでは話を前者に絞りたい（生録については☞本書 68-71 頁）。大筋では芸術のジャンルについて何度も交わされてきた議論をくり返すことになるだろう。結論にしたいのは座談会にも出てきた「書き直し」である。

　「はじめに」にも書いたとおり、私は 2011 年からサウンド・スタディーズやサウンド・アート研究をめぐる書評を発表してきた。2010 年以降のこれらの研究は、これまでの総括のような出版や展覧会があり、学術制度が整えられていった。また並行して、研究の傾向に見られる問題点を指摘し、再検討をうながす動きもあらわれた。英語圏のサウンド・スタディーズの展開については、日本語ですでに阿部がまとめているので、ここでは詳述しない[1]。2012 年に『リーダー』（☞本書 72-75 頁）や『ハンドブック』が、2015 年に『キーワーズ』が出版された。さらに 2010 年代を通して次々と学術雑誌が創刊された[2]。阿部がこのような一連の動向に対する批判

1）阿部万理江「ちんどん屋の「響き」から考える──日本と英語圏の音研究／サウンド・スタディーズ」『音と耳から考える──歴史・身体・テクノロジー』細川周平編著、アルテスパブリッシング、2021 年、38-49 頁。本書に掲載した阿部による書評（☞本書 64-67 頁）や、金子による『サウンド・スタディーズ・リーダー』の書評（☞本書 72-75 頁）も参照。

2）阿部があげた「五つのメジャーな学術雑誌」（前掲書、39 頁）は以下のとおり。括弧内に出版社と国名を記した。*Sounding Out!*（Online, US）, *SoundEffects*（Online, Denmark）, *Journal of Sonic Studies*（Online, Netherlands）, *Sound Studies*（Routledge, UK）, *Resonance*（University of California Press, US）。

的再検討の一つとしてあげたのは、ギャヴィン・スタインゴとジム・サイクスの編集による『サウンド・スタディーズの地図を書き直す』である。この本は「学問の主題だけでなく学術活動のメカニズム自体を脱植民地化しようという試み」であり、その背景には人類学における「存在論的方向転換」があるとされる。阿部が述べたとおり、日本における音文化の研究はこうした英語圏の展開とは距離がありながら、一定の議論の積み重ねがあり、その一つの成果として『音と耳から考える』が書かれた。

サウンド・アートに目を向けると、先の『リーダー』と同年にカールスルーエ・アート・アンド・メディア・センターで開催された「サウンド・アート──芸術の媒体としての音」展が一つの総括だったと言えそうだ。このころ、東京都現代美術館で「アートと音楽──新たな共感覚をもとめて」展（2012年）、ニューヨーク近代美術館で「サウンディングス──現代の楽譜」展（2013年）が、「サウンド・アート」という言葉を展覧会名に入れずに開催された。この言葉は常に批判にさらされてきたが、遅くとも2010年代前半には、大規模な展覧会に用いられる機会が減っていった。2014年にプラダ財団美術館で開催された「アート・オア・サウンド」展の題名は「対立ではなく、二つの独立した領域の出会いを表現する」とされた。2019年にアーナウ・ホルタのキュレーションによってバルセロナのジョアン・ミロ美術館で開催された「サウンド・アート？」展は、疑問が展覧会のテーマになった[3]。ホルタも加わった同年の国際学術会議「RE:SOUND」の座談会でも、サウンド・アートに長年関わってきた参加者が問題意識を共有した。音をあつかう美術家や音楽と深く関わる美術家は活動を続けているし、研究も続いている。音への関心が失われたのではなく、サウンド・アートという言葉や、音というテーマを問い直そうとする気運が高まっていったのだろう。

■サウンド・アート史研究をめぐって

2010年以降の動向を追いながら、私も日本のサウンド・アート研究に取り組んだ。この研究にもさまざまなアプローチがあるが、ここでは歴史研究に絞って私が考えたことを書きたい。サウンド・アート史研究はしばしば、この言葉が普及する前の作品も対象とし、ジャンルのルーツを探り、年表や文脈をつくろうとする。2000年

3）この展覧会名は音楽家マックス・ニューハウスが2000年に発表した論考から取られた。Arnau Horta, "The sonorization of the art object: A tentative chronocartgrahy" in ¿ *Arte sonoro?*, Exhibition Catalogue, Fundació Joan Miró, 2019, p. 132.

に「サウンド・アート——音というメディア」展を開催した NTT インターコミュニケーションセンター（ICC）は、この展覧会の続編となった 2003 年の「サウンディング・スペース——9 つの音響空間」展に実験音楽家、アルヴィン・ルシエを招き、サウンド・アート史のパースペクティヴを示そうとした。これらの展覧会に携わった学芸員の畠中実は 2012 年に、サウンド・アートのルーツの一つとしてジョン・ケージを論じた[4]。

　日本のサウンド・アートをふりかえる考察においては、ケージに代表される実験音楽や、日本の実験工房、50 年代の具体美術協会、60 年代のグループ音楽、草月アートセンターの活動などがルーツとして挙げられがちである。しかし、畠中は先の論考で、少なくない作家がケージからの影響に言及しないとも指摘した。このことは、たんにさまざまなルーツがあるというだけでなく、サウンド・アート史という枠組み自体に対する警戒もあらわしているのではないか。こうした姿勢が各地域でますます強まってきたことが、この分野をめぐる 2010 年代以降の展開の背景にあるのかもしれない。

　サウンド・アート史をめぐる懸念の一つは、実際は複雑な相互関係をもつ多数の実践を一連の文脈、物語に閉じこめかねないというものだろう。作品の歴史的重要性がその物語によって決められ、分類やヒエラルキーがつくられる。研究が厚みを増すほど、歴史の枠組み自体を定める前提は問い直しにくくなる。東京都現代美術館の「アートと音楽」展のように、サウンド・アートを美術と音楽の交流と見ても事情はそう変わらないだろう。サウンド・アートを一つの芸術ジャンルとしても、既存の芸術ジャンルのあいだの交流としても、一定の実践をまとめ、枠組みをつくって固定し、枠のなかを充実させながら、枠を拡張していく手続きは共通するからだ。いずれも枠の内側が外側から次第に切り離され、自足してしまう恐れがある。

　このような手続きに危険を感じても、研究者がジャンルや文脈をめぐる議論をまったく止めてしまい、個々のものだけを見ようとするのは難しい。芸術家もこの枠組みに縛られると同時に支えられてもいる。私はサウンド・アートという言葉をすぐに放棄したり、言いかえたり、すでに過去のものと見なせばよいとは思わない。しかし、音というきわめて広い対象をかかえる言葉で括られて、歴史ある異質なジャンルのあいだに危うく位置するこのジャンルの歴史研究は、一続きの歴史を描くことの弊害をできるだけ意識する必要があるはずだ。

4) 畠中実「「ジョン・ケージ以後」としてのサウンド・アート（における「聴くこと」とテクノロジー）」『ユリイカ』第 44 巻 12 号、2012 年 10 月、224-229 頁。

この弊害についてもう少し考えよう。サウンド・アートを一つの芸術ジャンルと見ても美術と音楽の交流と見ても、伝統ある既存の芸術ジャンルから見ると芸術の拡張であり、既存のジャンルそのものには影響を及ぼさない実践とみなされがちである。その枠組みが既存のジャンルの内側に置かれても、ジャンルのあいだに置かれても同じことだ。数あるオルタナティブな実践の一つと見なされ、伝統あるジャンルとは別に扱われる。さらに、美術と音楽との関係ばかりに目を向けると、声と関わる文学や、音楽ではない音が豊富に使われる演劇や映画、またメディア・アートやパフォーマンス・アートとの関係は見逃されがちになる。クラシック音楽、現代音楽、ポピュラー音楽の違いはサウンド・アートにどう関わるのか。これらのさまざまな文脈を考慮すると歴史研究は複雑になるが、個々の作品はその複雑さを豊かさとして取りこんでいる。

　一つのジャンルや特定の交流をたどろうとする議論は、その枠組を維持しようとし、ジャンル内やジャンル間の断絶や分岐ではなく、ジャンルの拡張や他のジャンルとの結びつきに注目する傾向がありそうだ。その結果、サウンド・アートは次第に他のジャンルと結びつき、美術と音楽の交流はますます深まるとされる。そして、サウンドはジャンルではなく、数あるメディウムの一つに戻る。美術のポストメディウム理論にもとづけば、メディウムの一つに過ぎない音にこだわるのは時代錯誤だろう。長い目で見れば、このこだわりは一時的な逸脱や歴史の一段階でしかない。すでに多くの研究者が、サウンド・アート史の研究者さえも、このジャンルをそう理解しているかもしれない。しかし、メディウムの境界を軽視したり、メディウムをますます増やしたりすることで、個々のメディウムに次第に目が向かなくなったら、ロザリンド・クラウスが「差異を含んだ固有性（differential specificity）」[5] と呼ぶものは見落とされていくのではないか。

　大友良英が『音楽と美術のあいだ』を出版したきっかけの一つ、後々田寿徳の論考「美術（展示）と音楽（公演）のあいだ」（2013 年）は、実体験にもとづいて音楽と美術の制度的な非対称性という問題を論じた[6]。日本でサウンド・アートという言葉が使われて 20 年経ってもこの問題は無くならなかった。私にとっても制度の非対称性はサウンド・アートと呼ばれる作品に関心をもった理由の一つであり、この問題に対する姿勢が表現と深く関わると私は考える。ジャンルの歴史や交流史に

5）ロザリンド・クラウス『ポストメディウム時代の芸術——マルセル・ブロータース《北海航行》について』井上康彦訳、水声社、2023 年、109–111 頁。

6）大友良英『音楽と美術のあいだ』フィルムアート社、2017 年、430–432 頁。細田による書評も参照（☞本書 138–141 頁）。

は一定の意義があるが、サウンド・アートをめぐっては特に、そのなかで非対称性、断絶、分岐を強調する必要があるのではないか。2010年代後半にこうした思いこみをいだきながら、私は戦後日本美術史研究に取り組んだ。

■ 1970年代の日本美術における音

　サウンド・アート史研究において、私はさしあたり次のことに重きをおいていった。音と関わる作品が時代、地域、文化などによって限定された機会のなかでもつ意義を考えること。機会ごとの違いに目を向けること。そして、さまざまな意義のなかに、特定の機会を部分的に超えるものを、例えば、過去のある時代と現代に共通するものがないかを探すこと。時代や地域、制度やメディウムなどのあいだの断絶や分岐を背景にもつそれぞれの機会のありかたを、作品を通して理解すること。作品は断絶を内部に抱えることも、鑑賞者の注意を外部の断絶に向けることもある。以上を実践するためには、音と関わる作品だけでなく、背景となる芸術と社会の動向を、音という枠組みにできるだけとらわれずに見つめる必要がある。フィールドワークをする文化人類学者のように自分の偏見を常に問いながら。

　2010年代に私は、中川克志とともに日本のサウンド・アートの歴史研究に取りかかり、この言葉と深く関わる80年代のいくつかの文脈を調査した。この調査を通じて、私は美術の文脈をさらに深く理解する必要があると感じていった。70年代の日本美術と音の関わりを調査するきっかけをつくってくれたのは畠中実であり、堀浩哉ら当時から活躍する美術家を紹介してもらった。畠中は堀浩哉、堀えりぜと、パフォーマンス集団「ユニット00」として活動した経験があった。私はこの調査を作品の再展示や再上演、音源の制作などにもつなげたかったので、「日本美術サウンドアーカイヴ」というプロジェクトにした。作品を経験することや経験を共有することが何よりも重要である。畠中にはこのプロジェクトの立ち上げにも協力してもらった。

　70年代の調査から見えてきたのは、他の時代、特に60年代の美術との音の使われかたの違いであり、さらに少なからぬ美術家にとって音の使用がそれまでの活動を再考するきっかけになったことだった。60年代の後半は、絵画や彫刻といったジャンルを超えて、さまざまなテクノロジーを用いて環境をつくる「環境芸術」が流行し、多くの前衛芸術家が参加した。環境芸術にとって音は光や動きと組み合わせて環境をつくるための要素の一つであり、空間の広がりが感じられる音や、インタラクティブな音が用いられた。マルチスピーカーが駆使された70年の大阪万博は新しい音環境をつくるための格好の舞台だった。60年代後半に前衛的な試みに

関心をもった美術学生は、多かれ少なかれ環境芸術を意識していたと考えられる。しかし、万博後の彼らは、音環境をつくろうとせず、マイクで自己や環境を記録して、その録音を重ね合わせ、歪ませた[7]。そうした作品はインタラクティブな仕掛けもなく、観客はただ歪んだ音に聴き入った。

　例えば、今井祝雄、倉貫徹、村岡三郎による《この偶然の共同行為を一つの事件として》（1972年）は、自分たちの心臓音と大都市の交通音を重ね合わせた。彼らは大阪の御堂筋に面した建物の屋上に3つのスピーカーを置き、それぞれの心臓音の録音を再生した。その音量は周囲の騒音と同じになるよう調節された。心臓音を視覚化するオシログラフも展示された。残された5分ほどの録音は、現実音とミックスされたミニマルなノイズ・ミュージックのように聞こえる。おそらく信号機に左右される交通音の波のなかで、3名の心臓音のポリリズムがうねる。

　環境芸術以後の日本美術の展開は音だけに関わるのではない。版画、コピー、写真、映画、ヴィデオなど、美術家は身近な複製技術を駆使した。いずれを用いても、自己や環境を記録し、時間をかけて歪めるという方法がよく見られた。美術評論家の峯村敏明はこうした作品を80年代に、芸術以前、作品以前、表現以前の実践という意味をこめて「前芸術」と表現した。この言葉の意義や背景について再検討することが、私の現在の課題の一つである。前芸術は美術だけでなくヴィデオ・アートやパフォーマンス・アートの歴史研究においても、次の時代への足がかりとしか見なされず、そのためか作品の詳細や社会との関わりなどに光が当たらなかった。美術家自身が作品の記録に対して慎重な態度をとったことも、評価が進まなかった理由の一つだろう。

　個々の作品に目を向けると、前芸術の表現にはさまざまなずれに対する鋭い感性が見てとれる——現実と複製のずれ、複製とその複製のずれ、知覚される対象と知覚のずれ、次第に移り変わっていくイメージなど。美術家は芸術ジャンルの違いにも敏感だった。音楽、演劇、映画などから多くを学んだにもかかわらず、60年代のようなインターメディア的実践には進まず、ジャンルごとの制度の違いに目を向けた。こうした姿勢は彼らの一部が60年代末の学生運動に加わったときからあらわれていた。参加者は自分たちの運動が他ならぬ美術家の運動であると自覚し、美術制度に問いを投げかけた。日本でも美術家が制度を問うこと自体は長い歴史があ

7）個々の作品については、金子智太郎「1970年代の日本美術における音」（『あいだ』第261号、2022年、2-10頁）や、「日本美術サウンドアーカイヴ」ウェブサイト（https://japaneseartsoundarchive.com/）を参照。

り、60年代には美術評論家によって眼の制度が論じられた。そうした展開のなかで、70年代の作品に見られる姿勢の特色は、制度を超えて外部を目指すのではなく、制度の内部または境界に留まり、制度を反省し続けようとすることにきわめて自覚的なところだ。この時代の美術が美術制度批判という言葉で語られることはあったが、このような姿勢が個々の作品にいかに表現されているかをめぐってはさらなる検討が必要である[8]。

■音によって歴史を書き直す

　70年代の日本美術を調査しながら意識するようになっていったのは、音という視点から美術史を書き直すことだった。音という視点を通して、美術史がこれまであつかってこなかった作品や動向、姿勢や認識を考察し、音と直接は結びつかない事柄をめぐる理解を再検討する機会ができないか。サウンド・アートというカテゴリーを美術史とは別に確立するよりも、書き直しを通して音の意義を再認識するほうが、現在のサウンド・アートにとっても意味があるのではないか。パフォーマンスは前衛美術のルーツだと主張したローズリー・ゴールドバーグほど過激でなくても[9]、拡張だけではなく書き直しというかたちでサウンド・アート研究が美術史に貢献できないか。美術の音によって美術史を再検討しながら、同時にこの時代の音文化の地図を見直せないか。

　私は音と関わる1970年代の美術作品をサウンド・アートと呼びたいわけでも、呼びかたを変えて別のカテゴリーをつくりたいわけでもない。ジャンルやカテゴリーを無くそうとしたり際限なく増やそうとしたりする試みは、既存のカテゴリーに対する反省がなければ長続きしないだろう。こうした判断について私は70年代の美術から多くを学んだ。音と関わる作品の素晴らしさを語ることは重要だが、それだけではそうした作品は他の媒体の作品と比較されず、両者のあいだに結びつきが認められなくなる。音は音楽のメディウムという認識が根強いため、美術家にとって音は匂いや接触と比べても親しみがなく、あつかいにくいかもしれない。そんな極端なメディウムだからこそ、音のあつかいかたの変化に一時代、一地域の美術の変化の兆しがはっきりあらわれる機会があるのではないか。近代以降の美術史

8) Kenji Kajiya, "Introduction," in *From Postwar to Postmodern: Art in Japan 1945-1989*, Doryun Chong, Michio Hayashi, Kenji Kajiya, Fumihiko Sumitomo, eds., The Museum of Modern Art, 2012, pp.256-257.
9) ローズリー・ゴールドバーグ『パフォーマンス――未来派から現在まで』中原佑介訳、リブロポート、1982年、6-7頁。

のどこかで鳴り続けていた音の一展開が、美術全体の動向の輪郭を描きだすような機会があるのでは。

　私がサウンド・アート研究について考えたことが、サウンド・スタディーズにどれだけ当てはまるのかはわからない。しかし、この領域に関心をもつ人なら、例えばジョナサン・スターンによる視聴覚連禱論や圧縮やフォーマットをめぐる議論は、音や音響技術の歴史だけでなく、知覚や複製技術の歴史に書き直しを求める可能性をもっていると感じるだろう。阿部によれば、サウンド・スタディーズは「音楽の枠組みの歴史的・文化的特異性を問い直すという作業を可能にした」[10]。音に関わるあらゆる歴史でも同じことが言えるかもしれない。音という広大な領域を区画整理し、各研究の配置を考えるだけではこのテーマをめぐる研究は閉じていくばかりだろう。

　サウンド・スタディーズは既存の領域にリンクを張るかたちで広がった。この言葉の下にさまざまな領域から人が集まる意味はこれからも問いたい。それぞれの領域で歴史を書き直そうとする者が、他の領域の方法や概念を知り、応用できるのか。異なる領域の音のありかたを詳しく比較できれば、それぞれの領域の特色がさらに明らかになる。私はサウンド・スタディーズのなかで同じような理論が何度も参照され、この領域が閉じていくのを警戒している。視聴覚連禱論ですらサウンド・スタディーズのなかに留めるだけでは、その批判的意義が見失われていくだろう。サウンド・アート研究においても、スターンの言葉どおり、知が部分的でしかないと常に意識して再記述を試みたい。その過程でサウンド・アートという言葉が使われなくなるとしても、そう呼ばれた作品がもたらす意義は常に再検討する必要がある。新しく生まれた作品の新しさは歴史の書き直しを通じて理解される。私は自分が現在研究している1970年代日本美術の作品をサウンド・アートと呼んだことはないが、この研究がこれまでサウンド・アートと呼ばれてきた作品、またこれからそう呼ばれる作品を考えるときに役に立ってほしい。

10) 阿部、前掲書、59頁。

文献一覧

ファイト・アールマン「デカルトの共鳴する主体」金子智太郎訳『表象』第 9 号、2015 年、105-125 頁。

秋山邦晴『日本の作曲家たち——戦後から真の戦後的な未来へ（下）』音楽之友社、1979 年。

秋山邦晴『秋山邦晴の日本映画音楽史を形作る人々/アニメーション映画の系譜』高崎俊夫、朝倉史明編、DU BOOKS、2021 年。

秋吉康晴「電話は耳の代わりになるか?——身体の代替性をめぐる音響技術史」『音と耳から考える——歴史・身体・テクノロジー』細川周平編著、アルテスパブリッシング、2021 年、342-353 頁。

ジャック・アタリ『音楽/貨幣/雑音』金塚貞文訳、みすず書房、1985 年（『ノイズ——音楽/貨幣/雑音』みすず書房、1995、2012 年）。

テオドール・W・アドルノ『アドルノ 音楽・メディア論集』渡辺裕編、村田公一、吉田寛、舩木篤也訳、平凡社、2002 年。

阿部万里江「ちんどん屋の「響き」から考える——日本と英語圏の音研究/サウンド・スタディーズ」『音と耳から考える——歴史・身体・テクノロジー』細川周平編著、アルテスパブリッシング、2021 年、36-63 頁。

五十嵐大『しくじり家族』CCC メディアハウス、2020 年。

石田美紀『アニメと声優のメディア史——なぜ女性が少年を演じるのか』青弓社、2020 年。

伊藤亜紗『目の見えない人は世界をどう見ているのか』光文社新書、2015 年。

岩崎祐之助『ゲーム音楽史——スーパーマリオとドラクエを始点とするゲーム・ミュージックの歴史』リットー・ミュージック、2014 年。

ティム・インゴルド「ランドスケープの時間性」 Tim Ingold, "The Temporality of the Landscape" in *World Archaeology*, vol. 25, no. 2, 1993, pp. 152-174.

ティム・インゴルド『ラインズ——線の文化史』工藤晋訳、左右社、2014 年。

フランシスコ・ヴァレラ、エヴァン・トンプソン、エレノア・ロッシュ『身体化された心——仏教思想からのエナクティブ・アプローチ』田中靖夫訳、工作舎、2001 年。

エドゥアルド・ヴィヴェイロス・デ・カストロ『インディオの気まぐれな魂』近藤宏、里見龍樹訳、水声社、2015 年。

エドゥアルド・ヴィヴェイロス・デ・カストロ『食人の形而上学——ポスト構造主義的人類学への道』檜垣立哉、山崎吾郎訳、洛北出版、2015 年。

スティーヴン・ウィット『誰が音楽をタダにした?——巨大産業をぶっ潰した男たち』関美和訳、早川書房、2018 年。

ルートヴィヒ・ウィトゲンシュタイン『論理哲学論考』丘沢静也訳、光文社、2014 年。

サウル・ウィリアムズ『デッド・エムシー・スクロールズ——ヒップホップの失われた教え』 Saul Williams, *The Dead Emcee Scrolls: The Lost Teachings of Hip-Hop*, MTV Books, 2006.

ラルフ・エリソン『見えない人間』上下巻、白水社、2020 年。

大友良英『音楽と美術のあいだ』フィルムアート社、2017 年。

岡田恵美『インド鍵盤楽器考——ハルモニウムと電子キーボードの普及にみる楽器のグローカル化とローカル文化の再編』渓水社、2016。

小川博司、小田原敏、粟谷佳司、小泉恭子、葉口英子、増田聡『メディア時代の広告と音——変容するCM と音楽化社会』新曜社、2005 年。

奥野克巳、石倉敏明編『Lexicon 現代人類学』以文社、2018 年。

アナ・マリア・オチョア・ゴティエ『聴覚性——19 世紀コロンビアにおける聴取と知識』 Ana María Ochoa Gautier, *Aurality: Listening and Knowledge in Nineteenth-Century*, Duke University Press, 2014.

ブライアン・オドハティ『ホワイト・キューブの内側で——ギャラリー空間のイデオロギ

ー』　Brian O'Doherty, *Inside the White Cube: The Ideology of the Gallery Space*, University of California Press, 1986.

ウォルター・J・オング『声の文化と文字の文化』桜井直文、林正寛、糟谷啓介訳、藤原書店、1991 年。

マイケル・カーワン『ヴァルター・ルットマンと多様性の映画——前衛−広告−近代性』Michael Cowan, *Walter Ruttmann and the Cinema of Multiplicity: Avant-garde-Advertising-Modernity*, Amsterdam University Press, 2014.

ダグラス・カーン「ろうの世紀のオーディオ・アート」　Douglas Kahn, "Audio Art in the Deaf Century" in *Sound by Artists*, Dan Lander & Micah Lexier eds., Art Metropole and Walter Phillips Gallery, 1990, pp. 301–328.

ダグラス・カーン、グレゴリー・ホワイトヘッド編『無線想像力——音、ラジオ、前衛』Douglas Kahn & Gregory Whitehead eds., *Wireless Imagination:Sound, Radio, and the Avant-Garde*, MIT Press, 1992.

ダグラス・カーン『ノイズ、ウォーター、ミート——芸術における音の歴史』　Douglas Kahn, *Noise, Water, Meat: A History of Sound in the Arts*, MIT Press, 1999.

ロベルト・カザーティ、ジェローム・ドゥキッチ『音の哲学』　Roberto Casati & Jérôme Dokic, *Philosophy of sound*, Éditions Jacqueline Chambon, 1994.

金子智太郎「サウンド・パターンを聴く——トニー・シュヴァルツのドキュメンタリー録音」『美学』第 246 号、2015 年、185-196 頁。

金子智太郎「一九七〇年代の日本における生録文化——録音の技法と楽しみ」『カリスタ』第 23 号、2017 年、84-112 頁。

金子智太郎「「サウンド」の政治——サロメ・フォーゲリン『音の政治的可能性——聴取の断片』評」『エクリヲ』ウェブサイト「音楽批評のアルシーヴ海外編」2018 年。

金子智太郎「市民による音づくり——映画評論家、荻昌弘のオーディオ評論」『音と耳から考える——歴史・身体・テクノロジー』細川周平編著、アルテスパブリッシング、2021 年、413-427 頁。

金子智太郎「1970 年代の日本美術における音」『あいだ』第 261 号、2022 年、2-10 頁。

川崎弘二、岡本隆子、小杉武久編『小杉武久 音楽のピクニック』展覧会カタログ、芦屋市立美術博物館、2017 年。

クリフォード・ギアーツ『文化の解釈学〈1〉〈2〉』吉田禎吾、柳川啓一、中牧弘允、板橋作美訳、岩波書店、1987 年。

フリードリヒ・キットラー『グラモフォン・フィルム・タイプライター』石光泰夫、石光輝子訳、筑摩書房、1999 年。

パスカル・キニャール『音楽への憎しみ』高橋啓訳、青土社、1997 年。

セス・キム=コーエン『耳のまばたき——蝸牛殻のないソニック・アートに向けて』　Seth Kim-Cohen, *In the Blink of an Ear: Toward a Non-Cochlear Sonic Art*, Continuum, 2009.

ベス・キャロル『映画を感じる——空間的アプローチ』　Beth Carroll, *Feeling Film: A Spatial Approach*, Palgrave Macmillan UK, 2016.

クライヴ・ギャンブル『ヨーロッパの旧石器社会』田村隆訳、同成社、2001 年。

ポール・ギルロイ『ユニオンジャックに黒はない——人種と国民をめぐる文化政治』田中東子、山本敦久、井上弘貴訳、月曜社、2017 年。

G・W・クーパー、L・B・メイヤー『〈新訳〉音楽のリズム構造』徳丸吉彦、北川純子訳、音楽之友社、2009 年。

ニコラス・クック『音楽マルチメディアの分析』　Nicholas Cook, *Analysing Musical Multimedia*, Oxford University Press, 1998.

スティーヴ・グッドマン『音の戦争——サウンド、情動、そして恐怖のエコロジー』　Steve Goodman, *Sonic Warfare: Sound, Affect, and The Ecology of Fear*, MIT Press, 2010.

バーニー・クラウス『野生のオーケストラが聴こえる』伊達淳訳、みすず書房、2013 年。

ロザリンド・クラウス「ヴィデオ ナルシシズムの美学」石岡良治訳『ヴィデオを待ちながら』展覧会カタログ、東京国立近代美術館、2009 年。

ロザリンド・クラウス『ポストメディウム時代の芸術――マルセル・ブロータース《北海航行》について』井上康彦訳、水声社、2023 年。

ジークフリート・クラカウアー『大衆の装飾』船戸満之、野村美紀訳、法政大学出版局、1996 年。

エルネスト・グラッシ『形象の力――合理的言語の無力』原研二訳、白水社、2016 年。

デイヴィッド・グラブス『レコードは風景をだいなしにする――ジョン・ケージと録音物たち』若尾裕、柳沢英輔訳、フィルムアート社、2015 年。

ジャン・ピエール・クリキ編『オン・アンド・バイ・クリスチャン・マークレー』 Jean-Pierre Criqui ed., *On & By Christian Marclay*, MIT Press, 2014.

エドゥアール・グリッサン『〈関係〉の詩学』管啓次郎訳、インスクリプト、2000 年。

栗原詩子『物語らないアニメーション――ノーマン・マクラレンの不思議な世界』春風社、2016 年。

栗原裕一郎、大谷能生『ニッポンの音楽批評 150 年 100 冊』立東舎、2021 年。

ジェイス・クレイトン『アップルート――21 世紀の音楽とデジタル文化をめぐる旅』 Jace Clayton, *Uproot: Travels in 21st-Century Music and Digital Culture*, FSG Originals, 2016.

ジャネット・クレイナック『反復されたナウマン』 Janet Kraynak, *Nauman Reiterated*, University of Minnesota Press, 2014.

ジョナサン・クレーリー『観察者の系譜――視覚空間の変容とモダニティ』遠藤知巳訳、似文社、2005 年。

ジョナサン・クレーリー『知覚の宙吊り』岡田温司、大木美智子、石谷治寛、橋本梓訳、平凡社、2005 年。

キャレブ・ケリー編『音（ドキュメンツ・オブ・コンテンポラリー・アート）』 Caleb Kelly ed., *Sound* (*Documents of Contemporary Art*), Whitechapel Gallery, 2011.

マーク・ゴーベ『エモーショナルブランディング――こころに響くブランド戦略』福山健一監訳、宣伝会議、2002 年。

ケネス・ゴールドスミス『デュシャンは我が弁護士――ユビュウェブの論争、実践、詩学』 Kenneth Goldsmith, *Duchamp Is My Lawyer: The Polemics, Pragmatics, and Poetics of UbuWeb*, Columbia University Press, 2020.

ローズリー・ゴールドバーグ『パフォーマンス――未来派から現在まで』中原佑介訳、リブロポート、1982 年。

小杉武久『音楽のピクニック』新装版、engine books、2017 年。

クリストフ・コックス「形式への回帰」 Christoph Cox, "Return to Form" in *Artforum International*, vol. 42, no. 3, Nov. 2003, p. 67.

リズ・コッツ『見るための言葉――1960 年代の美術における言語』 Liz Kotz, *Words to Be Looked At: Language in 1960s Art*, MIT Press, 2007.

アラン・コルバン『音の風景』小倉孝誠訳、藤原書店、1997 年。

アラン・コルバン『静寂と沈黙の歴史――ルネサンスから現代まで』小倉孝誠、中川真知子訳、藤原書店、2018 年。

近藤譲『線の音楽』アルテスパブリッシング、2014 年。

ワイリー・サイファー『文学とテクノロジー』野島秀勝訳、白水社、2012 年。

佐々木敦『これは小説ではない』新潮社、2020 年。

椎名亮輔編『音楽を考える人のための基本文献 34』アルテスパブリッシング、2017 年。

R. マリー・シェーファー『世界の調律 サウンドスケープとはなにか』鳥越けい子、小川博司、庄野泰子、田中直子、若尾裕訳、平凡社、2006 年。

ミシェル・シオン『映画にとって音とはなにか』川竹英克、J・ピノン訳、勁草書房、1993 年。

柴那典『初音ミクはなぜ世界を変えたのか?』太田出版、2014 年。

柴那典『ヒットの崩壊』講談社、2016 年。

澁谷智子『コーダの世界——手話の文化と声の文化』医学書院、2009 年。

マイケル・シャナン『リピーテッド・テイクス——録音とその音楽に対する影響をめぐる小史』 Michael Chanan, *Repeated Takes: A Short History of Recording and its Effects on Music*, Verso, 1995.

アンドリュー・シャルトマン『「スーパーマリオブラザーズ」の音楽革命——近藤浩治の音楽的冒険の技法と背景』樋口武志訳、DU BOOKS、2023 年。 Andrew Schartmann, *Koji Kondo's Super Mario Bros. Soundtrack*, Bloomsbury Academic, 2015.

アンドリュー・シャルトマン『マエストロ・マリオ——任天堂はいかにヴィデオ・ゲーム音楽を芸術にしたのか』 Andrew Schartmann, *Maestro Mario: How Nintendo Transformed Videogame Music into an Art*, Thought Catalog, 2013.

トニー・シュヴァルツ『電子メディア戦略——社会を動かすメディアパワー』梶山晧訳、1983 年。

アンドレアス・シュテーン『娯楽と革命のあいだ——上海における蓄音機・レコードと音楽産業の黎明 1878-1937』 Andreas Steen, *Zwischen Unterhaltung und Revolution: Grammophone, Schallplatten und die Anfänge der Musikindustrie in Shanghai, 1878-1937*, Harrassowitz, 2006.

イヴォンヌ・シュピールマン『ヴィデオ——再帰的メディアの美学』海老根剛監訳、柳橋大輔、遠藤浩介訳、三元社、2011 年。

ジョゼフ・シュロス『メイキング・ビーツ——サンプルベース・ヒップホップの芸術』 Joseph G. Schloss, *Making Beats: The Art of Sample-Based Hip-Hop*, Wesleyan Univ Press, 2004.

デヴィッド・シュワルツ『聴く主体——音楽、精神分析、文化』 David Schwarz, *Listening Subjects: Music, Psychoanalysis, Culture*, Duke University Press, 1997.

庄野進『聴取の詩学——J・ケージからそしてJ・ケージへ』勁草書房、1991 年。

リロイ・ジョーンズ『ダッチマン——奴隷』邦高忠二訳、晶文社、1969 年。

ブランデン・ジョゼフ『ドリーム・シンジケートを越えて——トニー・コンラッドとケージ以後』 Branden W. Joseph, *Beyond the Dream Syndicate: Tony Conrad and the Arts after Cage*, Zone Books, 2008.

スティーヴン・ジョンソン『創発——蟻・脳・都市・ソフトウェアの自己組織化ネットワーク』山形浩生訳、ソフトバンクパブリッシング、2004 年。

ラニ・シン編『ハリー・スミスは語る——音楽／映画／人類学／魔術』湯田賢司訳、カンパニー社、2020 年。

ロバート・スコット『ムーンドッグ——6 番街のバイキング』 Robert Scotto, *Moondog: The Viking of 6th Avenue*, Process Media, 2013.

ジョナサン・スターン『MP3——フォーマットの意味』 Jonathan Sterne, *MP3: The Meaning of a Format*, Duke University Press, 2012.

ジョナサン・スターン編『サウンド・スタディーズ・リーダー』 Jonathan Sterne ed., *The Sound Studies Reader*, Routledge, 2012.

ジョナサン・スターン『聞こえくる過去——音響再生産の文化的起源』中川克志、金子智太郎、谷口文和訳、インスクリプト、2015 年。

ジョナサン・スターン『衰退した能力——障害の政治現象学』 Jonathan Sterne, *Diminished Faculties: A Political Phenomenology of Impairment*, Duke University Press, 2021.

トム・スタンデージ『謎のチェス指し人形「ターク」』服部桂訳、NTT 出版、2011 年。

ジョセフ・ストラウス『常ならぬ仕方——音楽における障碍』 Joseph N. Straus, *Extraordinary Measures: Disability in Music*, Oxford University Press Inc, 2011.

アンドレイ・スミルノフ『サウンド・イン・Z——20 世紀初頭のロシアにおける音の実験と電子音楽』 Andrey Smirnov, *Sound in Z: Experiments in Sound and Electronic Music in Early 20th Century Russia*, Walther König, 2013.

クリストファー・スモール『ミュージッキング――音楽は〈行為〉である』野澤豊一、西島千尋訳、水声社、2011 年。

生物音響学会編『生き物と音の事典』朝倉書店、2019 年。

シェリー・タークル『インティメイト・マシン――コンピュータに心はあるか』西和彦訳、講談社、1984 年。

フランシス・ダイソン『鳴り響くニュー・メディア――芸術、文化における没入と身体化』 Frances Dyson, *Sounding New Media: Immersion and Embodiment in the Arts and Culture*, University of California Press, 2009.

竹内正実『テルミン――エーテル音楽と 20 世紀ロシアを生きた男』岳陽社、2000 年。

立石弘道、谷口光子「ニコラ・ブリオー『関係性の美学』」『藝文攷』2016 年、80-93 頁。

田中雄二『電子音楽 in JAPAN』アスペクト、2001 年。

田中雄二『エレベーター・ミュージック・イン・ジャパン――日本のBGM の歴史』DU BOOKS、2018 年。

マイク・デイヴィス『スラムの惑星――都市貧困のグローバル化』酒井隆史監訳、篠原雅武、丸山里美訳、明石書店、2010 年。

ティモシー・D・テイラー『ストレンジ・サウンズ――音楽、テクノロジー、文化』 Timothy D Taylor, *Strange Sounds: Music, Technology and Culture*, Routledge, 2001.

ティモシー・D・テイラー『資本主義の音――広告、音楽、文化の征服』 Timothy D. Taylor, *The Sounds of Capitalism: Advertising, Music, and the Conquest of Culture*, Chicago University Press. 2012

ポール・デマリニス『ノイズに埋もれて』 Paul DeMarinis, *Buried in Noise*, Kehrer Verlag, 2010.

ジャック・デリダ『グラマトロジーについて（上）（下）』足立和浩訳、現代思潮新社、2012 年。

トマス・トゥリノ『ミュージック・アズ・ソーシャルライフ――歌い踊ることをめぐる政治』野澤豊一、西島千尋訳、水声社、2015 年。

ジル・ドゥルーズ、フェリックス・ガタリ『千のプラトー――資本主義と分裂症』宇野邦一、田中敏彦、小沢秋広、豊崎光一、宮林寛、守中高明訳、河出書房新社、1994 年。

ジム・ドゥロブニク編『聴覚文化』 Jim Drobnick ed., *Aural Cultures*, YYZ Books, 2004.

徳丸吉彦監修、増野亜子編『民族音楽学 12 の視点』音楽之友社、2016 年。

ゲイリー・トムリンソン『音楽の百万年――人類の現代性の創発』 Gary Tomlinson, *A Million Years of Music: The Emergence of Human Modernity*, Zone Books, 2015.

鳥越けい子『サウンドスケープ――その思想と実践』鹿島出版会、1997 年。

デヴィッド・E・ナイ『アメリカの技術的崇高』 David E. Nye, *American Technological Sublime*, MIT Press, 1994.

マイケル・ナイマン『実験音楽――ケージとその後』椎名亮輔訳、水声社、1992 年。

中川真『平安京 音の宇宙』平凡社、1992 年（『平安京 音の宇宙――サウンドスケープへの旅』平凡社、2004 年）。

中原昌也『人生は驚きに充ちている』新潮社、2020 年。

中村公輔『名盤レコーディングから読み解くロックのウラ教科書』リットーミュージック、2018 年。

長門洋平『映画音響論――溝口健二映画を聴く』みすず書房、2014 年。

長門洋平「いつもお天気がいいにもほどがある――小津安二郎映画の音楽について」松浦莞二、宮本明子編著『小津安二郎大全』朝日新聞出版、2019 年、382-392 頁。

ノーリー・ニューマーク『ボイストラックス――メディアと芸術における声への同調』 Norie Neumark, *Voicetracks: Attuning to Voice in Media ant the Arts*, MIT Press, 2017.

デヴィッド・ノヴァック『ジャパノイズ――サーキュレーション終端の音楽』若尾裕、落晃子訳、水声社、2020 年。

マシュー・ハーバート『音楽――音による小説』 Matthew Herbert, *The Music: A Novel Through Sound*, Unbound, 2018.

キャロリン・バーザル、アンソニー・エンズ編『ソニック・メディテーションズ——身体、音、テクノロジー』　Carolyn Birdsall & Anthony Enns eds., *Sonic Mediations: Body, Sound, Technology*, Cambridge Scholars Publishing, 2008.

ジョン・バージャー「食うものと食われるもの」　John Berger, "The Earters and the Eaten" in *Why Look at Animals?*, Penguin Books, 2009, pp. 61-68.

デヴィッド・バーン『音楽のはたらき』野中モモ訳、イースト・プレス、2023年。　David Byrne, How Music Works, McSweeney's Books, 2012.

マルティン・ハイデッガー『存在と時間 上』細谷貞雄訳、筑摩書房、1994年。

畠中実「「ジョン・ケージ以後」としてのサウンド・アート（における「聴くこと」とテクノロジー）」『ユリイカ』第44巻12号、2012年10月、224-229頁。

浜田淳編『音盤時代の音楽の本の本』株式会社カンゼン、2012年。

テリー・バロウズ『アート・オブ・サウンド——図鑑 音響技術の歴史』坂本信訳、DU BOOKS、2017年。

ピーター・ビアード『ダイアリー・幻の日記』リブロポート、1993年。

ジェームズ・ブラクストン・ピーターソン『ヒップホップ・アンダーグラウンドと黒人文化——地下世界への旅』　James Braxton Peterson, *The Hip-Hop Underground and African American Culture: Beneath the Surface*, Palgrave Macmillan, 2014.

ジョン・ピッカー『ヴィクトリア朝のサウンドスケープ』　John M. Picker, *Victorian Soundscapes*, Oxford University Press, 2003.

平倉圭『かたちは思考する——芸術制作の分析』東京大学出版会、2019年。

トレヴァー・ピンチ、カリン・ビスタヴェルド編『オックスフォード・ハンドブック・オブ・サウンド・スタディーズ』　Trevor Pinch & Karin Bijsterveld eds., *The Oxford Handbook of Sound Studies*, Oxford University Press, 2012.

ミシェル・フーコー『臨床医学の誕生』神谷美恵子訳、みすず書房、1969年（みすず書房、2020年）。

ミシェル・フーコー『言葉と物』渡辺一民、佐々木明訳、新潮社、1974年（新潮社、2020年）。

ミシェル・フーコー『監獄の誕生——監視と処罰』田村俶訳、新潮社、1977年（新潮社、2020年）。

スティーヴン・フェルド「重ねあげた響き——カルリ社会の音楽と自然」山田陽一訳『ポリフォーン』第5号、1989年、105-117頁。

スティーブン・フェルド『鳥になった少年——カルリ社会における音・神話・象徴』山口修、卜田隆嗣、山田陽一、藤田隆則訳、平凡社、1988年。

サロメ・フォーゲリン『ノイズと沈黙を聴く——サウンド・アートの哲学に向けて』　Salomé Voegelin, *Listening to Noise and Silence: Towards a Philosophy of Sound Art*, Continuum. 2010.

サロメ・フォーゲリン『音の政治的可能性——聴取の断片』　Salomé Voegelin, *The Political Possibility of Sound: Fragments of Listening*, Bloomsbury Publishing, 2018.

スタン・ブラッケージ『フィルム・アット・ウィッツ・エンド』　Stan Brakhage, *Film at Wit's End*, Documentext / McPherson & Co, 1991.

フェリシア・ミラー・フランク『機械仕掛けの歌姫——19世紀フランスにおける女性・声・人造性』大串尚代訳、東洋書林、2010年。

トマス・フランク『クールの征服——ビジネス文化、カウンターカルチャー、そしてヒップ消費主義の台頭』　Thomas Frank, *The Conquest of Cool: Business Culture, Counterculture, and the Rise of Hip Consumerism*, University of Chicago Press, 1997.

ミシェル・フリードナー、ステファン・ヘルムライク「サウンド・スタディーズとデフ・スタディーズの出会い」　Michele Friedner & Stefan Helmreich, "Sound Studies Meets Deaf Studies" in *Senses & Society* 7, issue. 1, 2012, pp. 72-86.

ピエール・ブルデュー『ディスタンクシオン——社会的判断力批判II 普及版』石井洋二郎訳、藤原書店、2020年。

フロイト『幻想の未来／文化への不満』中山元訳、光文社、2007 年。

アースラ・ブロック、ミハエル・グラスマイアー編『ブロークン・ミュージック（ファクシ
　　ミリ版）』 Urscula Block & Michael Glasmeier eds., *Broken Music. Facsimile Edition*,
　　Primary Information, 2018.

裵淵亨『韓国蓄音機レコード文化史』 배연형『한국유성기음반문화사』지성사, 2019.

カリン・ベイスターフェルト、アナリース・ヤコブス「音の追憶を保存する──多様な場面
　　にわたるテープ・レコーダーの家庭化」 Karin Bijsterveld & Annelies Jacobs,
　　"Storing Sound Souvenirs: The Multi-sited Domestication of the Tape Recorder" in
　　Sound Souvenirs: Audio Technologies, Memory and Cultural Practices, Karin
　　Bijsterveld & José van Dijck eds., Amsterdam University Press, 2009.

ダグラス・C・ベイントン『禁じられた言語──アメリカ文化と反手話運動』 Douglas C.
　　Baynton, *Forbidden Signs: American Culture and the Campaign against Sign Language*,
　　University of Chicago Press, 1996.

ヨハン・ゴットフリート・ヘルダー『言語起源論』宮谷尚美訳、講談社、2017 年。

ヘルマン・フォン・ヘルムホルツ『音感覚論──音楽理論の生理学的基礎』辻伸浩訳、銀河
　　書籍、2014 年。

何東洪、鄭恵華、羅悦全編『造音翻土──戦後台湾のサウンドカルチャーの探究』 何東洪,
　　鄭恵華, 羅悦全編『造音翻土──戦後台灣聲響文化的探索』遠足文化, 2015 年。

ジェームズ・ボールドウィン『アメリカの息子のノート』佐藤秀樹訳、せりか書房、1968 年。

細川周平『ウォークマンの修辞学』朝日出版社、1981 年。

細川周平『レコードの美学』勁草書房、1990 年。

細川周平編著『音と耳から考える──歴史・身体・テクノロジー』アルテスパブリッシング、
　　2021 年。

アーリー・ラッセル・ホックシールド『管理される心──感情が商品になるとき』石川准、
　　室伏亜希訳、世界思想社、2000 年。

フランソワ・ボネ『言葉と音──音響の群島』 François J. Bonnet, *The Order of Sounds:
　　A Sonorous Archipelago*, Robin Mackay trans., Urbanomic, 2016.

ウォルター・マーチ『映画の瞬き──映像編集という仕事』吉田俊太郎訳、フィルムアート
　　社、2008 年。

マーシャル・マクルーハン『メディア論──人間の拡張の諸相』栗原裕、河本仲聖訳、みす
　　ず書房、1987 年。

増野亜子『声の世界を旅する』音楽之友社、2014 年。

丸山正樹『デフ・ヴォイス』文藝春秋、2011 年（『デフ・ヴォイス──法廷の手話通訳士』
　　文藝春秋、2015 年）。

光平有希『「いやし」としての音楽──江戸期・明治期の日本音楽療法思想史』臨川書店、
　　2018 年。

クリス・メイ＝アンドリュース『ヴィデオ・アートの歴史──その形式と機能の変遷』伊奈
　　新祐訳、三元社、2013 年。

ドナルド・メルツァー『メタ心理学の拡大の研究』 Donald Meltzer, *Studies in Extended
　　Metapsychology: Clinical Applications of Bion's Ideas*, Clunie Press for the Roland
　　Harris Trust, 1986.

マーシリエナ・モーガン『ザ・リアル・ヒップホップ──LA アンダーグラウンドにおける
　　知、力、尊敬をめぐる闘争』 Marcyliena Morgan, *The Real Hiphop: Battling for
　　Knowledge, Power, and Respect in the LA Underground*, Duke University Press, 2009.

デヴィッド・モートン『録音──テクノロジーの伝記』 David Morton, *Sound Recording:
　　The Life Story Of A Technology*, Greenwood Press, 2004.

ウィル・モンゴメリー「サウンドスケープを超えて──現代のフォノグラフィにおける芸術
　　と自然」 Will Montgomery, "Beyond the Soundscape: Art and Nature in
　　Contemporary Phonography" in T*he Ashgate Research Companion to Experimental*

Music, James Saunders ed., Ashgate, 2009, pp. 145-161.

セス・ヤコボウィッツ『明治日本における書く技術——近代日本の文学と視覚文化のメディア史』 Seth Jacobowitz, *Writing Technology in Meiji Japan: A Media History of Modern Japanese Literature and Visual Culture*, Harvard University Asia Center, 2015.

ケリム・ヤサール『電気になった声——電話、蓄音機、ラジオがいかに近代日本をかたちづくったのか 1868 ～ 1945 年』 Kerim Yasar, *Electrified Voices: How the Telephone, Phonograph, and Radio Shaped Modern Japan, 1868-1945*, Columbia University Press, 2018.

山内文登「方法としての音——フィールド・スタジオ録音の「共創的近代」論序説」細川周平編著『音と耳から考える——歴史・身体・テクノロジー』アルテスパブリッシング、2021 年、172-185 頁。

山口勝弘『ロボット・アヴァンギャルド——20 世紀芸術と機械』PARCO 出版局、1985 年。

容世誠『粤韻留聲——レコード産業と広東の語り物（1903-1953）』 容世誠『粤韻留聲——唱片工業與廣東曲藝（1903-1953）』天地圖書有限公司, 2006 年。

吉本浩二『淋しいのはアンタだけじゃない』全 3 巻、小学館、2016-2017 年。

リチャード・ライト『アメリカの息子』橋本福夫訳、早川書房、1972 年。

パディ・ラッド『ろう文化の歴史と展望——ろうコミュニティの脱植民地化』森壮也監訳、明石書店、2007 年。

ブランドン・ラベル「フィールドレコーディング、或いは拡張された場において見出された音」ケイト・ストロネル、佐藤実、牧浦典子訳『偶然の振れ幅——その出来事の地平』展覧会カタログ、川崎市市民ミュージアム、2001 年、74-89 頁。

ブランドン・ラベル『バックグラウンド・ノイズ——サウンド・アートの展望』 Brandon LaBelle, *Background Noise: Perspectives on Sound Art*, Continuum Books, 2006.

ブランドン・ラベル『聴覚のテリトリー——音の文化と日常生活』 Brandon LaBelle, *Acoustic Territories: Sound Culture and Everyday Life*, Bloomsbury, 2010.

ブランドン・ラベル「生のオラリティー——音響詩と生きた身体」 Brandon LaBelle, "Raw Orality: Sound Poetry and Live Bodies" in *VØICE: Vocal Aesthetics in Digital Arts and Media*, Norie Neumark, Ross Gibson, Theo van Leeuwen eds., MIT Press, 2010, pp. 147-171.

ブランドン・ラベル『口の用語辞典——声と口唇幻想の詩学と政治学』 Brandon LaBelle, *Lexicon of the Mouth: Poetics and Politics of Voice and the Oral Imaginary*, Bloomsbury, 2014.

ウィリアム・ラボフ『ニューヨーク市における英語の社会的階層化』 William Labov, *The Social Stratification of English in New York City*, 2nd edition, Cambridge University Press, 2006.

アラン・リクト『サウンド・アート——音楽の向こう側、耳と目の間』木幡和枝監修、荏開津広、西原尚訳、フィルムアート社、2010 年。

ジェルジ・リゲティ「フォルム」足立美比古・加藤就之訳『エピステーメー』第 2 巻 8 号、1976 年、160 頁。

ヴィリエ・ド・リラダン『未来のイヴ』齋藤磯雄訳、創元社、1996 年。

アンリ・ルフェーヴル『空間の生産』斎藤日出治訳、青木書店、2000 年。

アンドレ・ルロワ＝グーラン『身ぶりと言葉』荒木亨訳、ちくま学芸文庫、2012 年。

G・レイコフ、M・ジョンソン『レトリックと人生』渡部昇一、楠瀬淳三、下谷和幸訳、大修館書店、1986 年。

ハーラン・レイン『手話の歴史——ろう者が手話を生み、奪われ、取り戻すまで（下）』前田浩監修、斉藤航訳、菊池書店、2018 年。

ジョン・レーヴァー「声質と指標的情報」 John Laver, "Voice Quality and Indexical Information" in *British Journal of Disorders of Communication*, vol.3, 1968, pp. 43-55.

キャシー・レーン、アンガス・カーライル『イン・ザ・フィールド——フィールド・レコー

ディングの芸術』　Cathy Lane & Angus Carlyle, *In the Field: The Art of Field Recording*, Uniformbooks, 2013.

レッシング『ラオコオン──絵画と文学の限界について』斎藤栄治訳、岩波書店、1970 年。

ホリー・ロジャース『ギャラリーを鳴り響かせる──ヴィデオとアート–ミュージックの誕生』　Holly Rogers, *Sounding the Gallery: Video and the Rise of Art-Music*, Oxford University Press, 2013.

アレックス・ロス『20 世紀を語る音楽 1』柿沼敏江訳、みすず書房、2010 年。

スティーヴ・ロデン『…私の痕跡をかき消す風を聴く──ヴァナキュラー・フォノグラフの音楽 1880 ～ 1955』　Steve Roden, ... *I Listen to the Wind That Obliterates My Traces: Music in Vernacular Photographs 1880-1955*, Dust to Digital, 2011.

若尾裕『サステナブル・ミュージック──これからの持続可能な音楽のあり方』アルテスパブリッシング、2017 年。

渡辺裕『聴衆の誕生──ポスト・モダン時代の音楽文化』春秋社、1989 年（中央公論新社、2012 年）。

渡辺裕『サウンドとメディアの文化資源学──境界線上の音楽』春秋社、2013 年。

渡辺裕『感性文化論──〈終わり〉と〈はじまり〉の戦後昭和史』春秋社、2017 年。

渡辺裕『まちあるき文化考──交叉する〈都市〉と〈物語〉』春秋社、2019 年。

黄裕元『流風餘韻──台湾レコード歌謡の黎明期』　黄裕元『流風餘韻──唱片流行歌曲開臺史』國立臺灣歷史博物館、2014 年。

『韓国留声機音盤 1907-1945』한길음・디, 1998.

『韓国留声機音盤総目録』민속원, 2011.

『現代思想 臨時増刊号 総特集＝スチュアート・ホール 増補新版』青土社、2014 年 4 月。

『ピピロッティ・リスト──Your Eye Is My Island─あなたの眼はわたしの島─』展覧会カタログ、京都国立近代美術館、2021 年。

『ボリューム──音のベッド』　*Volume: Bed of Sound*, Exhibition Catalogue, P.S.1, 2000.

Abe Marié, *Resonances of Chindon-ya; Sounding Space and Sociality in Contemporary Japan*, Wesleyan University Press, 2018.

Michael Bull ed., *The Routledge Companion to Sound Studies*, Routledge, 2018.

Michael Bull & Les Back eds., *The Auditory Culture Reader*, Berg, 2003（Bloomsbury Academic, 2016. Routledge, 2020）.

Dipesh Chakrabarty, *Provincializing Europe: Postcolonial Thought and Historical Difference*, Princeton University Press, 2000.

Christoph Cox & Daniel Warner eds., *Audio Culture: Readings in Modern Music*, Continuum, 2004 (Bloomsbury Academic, 2017).

Michael Denning, *Noise Uprising: The Audiopolitics of a World Musical Revolution*, Verso Books, 2015.

Jeffrey Dyer, *Sounding the Dead in Cambodia: Cultivating Ethics, Generating Wellbeing, and Living with History through Music and Sound*, Doctoral Dissertation, Boston University, 2022.

Nina Eidsheim & Katherine Meizel eds., *The Oxford Handbook of Voice Studies*, Oxford University Press, 2019.

Evan Eisenberg, *The Recording Angel: Music, Records and Culture from Aristotle to Zappa*, Yale University Press, 2005.

Veit Erlmann ed., *Hearing Cultures: Essays on Sound, Listening and Modernity*, Berg, 2004.

Veit Erlmann, *Reason and Resonance: A History of Modern Aurality*, Zone Books, 2014.

Steven Feld, "Waterfalls of Song: An Acoustemology of Place Resounding in Bosavi, Papua New Guinea," in *Senses of Place*, Steven Feld, & Keith H. Basso eds., N. M. School of American Research Press, 1996.

Steven Feld, "A Rainforest Acoustemology," in *Revista Colombiana de Antropologia*, vol. 49,

no. 1, 2013.

Michael Gallope, "Technicity, Consciousness, and Musical Objects" in Music and *Consciousness: Philosophical, Psychological, and Cultural Perspectives*, David Clarke & Eric Clarke eds., Oxford University Press, 2011.

T Storm Heter, *The Sonic Gaze: Jazz, Whiteness, and Racialized Listening*, Rowman & Littlefield, 2022.

Martin Holbraad, Morten Axel Pedersen, & Eduardo Viveiros de Castro, "The Politics of Ontology: Anthropological Positions," Theorizing the Contemporary, *Cultural Anthropology* website, January 13, 2014.

Arnau Horta, "The Sonorization of the Art Object: A Tentative Chronocartgrahy" in *¿ Arte sonoro?*, Exhibition Catalogue, Fundació Joan Miró, 2019, pp. 132–136.

Douglas Kahn, *Earth Sound Earth Signal: Energies and Earth Magnitude in the Arts*, University of California Press, 2013.

Kenji Kajiya, "Introduction," in Doryun Chong, Michio Hayashi, Kenji Kajiya, Fumihiko Sumitomo, eds., *From Postwar to Postmodern: Art in Japan 1945–1989*, The Museum of Modern Art, Newqq York, 2012, pp. 256–257.

Tomotaro Kaneko "Arranging Sounds from Daily Life: Amateur Sound-Recording Contests and Audio Culture in Japan in the 1960s and 1970s." in *Asian Sound Cultures: Voice, Noise, Sound*, Iris Haukamp, Christin Hoene, & Martyn David Smith eds., Technology, 2023, pp. 240–256.

Henri Lefebvre, *Rhythmanalysis: Space, Time and Everyday Life*, Continuum, 2004.

Michèle Martin, *Hello, Central?: Gender, Technology, and Culture in the Formation of Telephone Systems*, Carleton University Press, 1991.

David Novak & Matt Sakakeeny eds., *Keywords in Sound*, Duke University Press, 2015.

Joshu Pilzer, *Hearts of Pine: Songs in the Lives of Three Korean Survivors of the Japanese "Comfort Women,"* Oxford University Press, 2012.

Joshua Pilzer, *Quietude: A Musical Anthropology of 'Korea's Hiroshima,'* Oxford University Press, 2022.

Dylan Robinson, *Hungry Listening: Resonant Theory for Indigenous Sound Studies*, University of Minnesota Press, 2020.

Tara Rodgers, *Pink Noises: Women on Electronic Music and Sound*, Duke University Press, 2010.

Gavin Steingo & Jim Sykes eds., *Remapping Sound Studies*, Durham, Duke University Press, 2019.

Jennifer Lynn Stoever, *The Sonic Color Line: Race and the Cultural Politics of Listening*, NYU Press, 2016.

Jim Sykes, *The Musical Gift: Sonic Generosity in Post-War Sri Lanka*, Oxford University Press, 2018.

Jodie Taylor, *Playing it Queer: Popular Music, Identity and Queer World-making*, Peter Lang, 2012.

Eduardo Viveiros de Castro, "Exchanging Perspectives: The Transformation of Objects into Subjects in Amerindian Ontologies," in *Common Knowledge*, vol. 10, no. 3, 2004, pp. 463–484.

Cara Wallis, "Gender and the Telephonic Voice," in *The Routledge Companion to Sound Studies*, Michael Bull ed., 2018, pp. 329–337.

Cara Wallis, *Technomobility in China: Young Migrant Women and Mobile Phones*, New York University Press, 2013.

Amanda Weidman, *Singing the Classical, Voicing the Modern: The Postcolonial Politics of Music in South India*, Duke University Press, 2006.

Amanda Weidman, *Brought to Life by the Voice: Playback Singing and Cultural Politics in South India*, University of California Press, 2021.

Fumitaka Yamauchi, "The Phonographic Politics of 'Corporeal Voice': Speech Recordings for Imperial Subjectification and Wartime Mobilisation in Colonial Taiwan and Korea," in *Asian Sound Cultures: Voice, Noise, Sound*, Iris Haukamp, Christin Hoene, & Martyn David Smith eds., Technology, Routledge, 2023, pp. 19–39.

初出一覧

02 サロメ・フォーゲリン『ノイズと沈黙を聴く──サウンド・アートの哲学に向けて』
　『アルテス』創刊号、2011 年、203-207 頁。

04 ゲイリー・トムリンソン『音楽の百万年──人類の現代性の創発』
　『アルテス』2015 年 9 月号、165-169 頁。

07 ブランドン・ラベル『口の用語辞典──声と口唇幻想の詩学と政治学』
　『アルテス』2015 年 3 月号、80-84 頁。

08 ロバート・スコット『ムーンドッグ──6 番街のバイキング』
　『アルテス』2013 年 12 月号、114-118 頁。

11 キャシー・レーン、アンガス・カーライル『イン・ザ・フィールド──フィールド・レコーディングの芸術』
　『アルテス』2013 年 10 月号、79-82 頁。

12 ジョナサン・スターン編『サウンド・スタディーズ・リーダー』
　『アルテス』第 4 号、2013 年、221-223 頁。

15 アンドリュー・シャルトマン『「スーパーマリオブラザーズ」の音楽革命──近藤浩治の音楽的冒険の技法と
　背景』
　『アルテス』2015 年 7 月号、48-52 頁。

17 マシュー・ハーバート『音楽──音による小説』
　「音楽批評のアルシーヴ海外編」『エクリヲ』ウェブサイト、2019 年 5 月。
　▶ https://ecrito.fever.jp/20190525220647

18 ジェームズ・ブラクストン・ピーターソン『ヒップホップ・アンダーグラウンドとアフリカ系アメリカ文化
　──表層の下へ』
　「音楽批評のアルシーヴ海外編」『エクリヲ』ウェブサイト、2018 年 8 月。
　▶ https://ecrito.fever.jp/20180828223301

22 ジェイス・クレイトン『アップルート──21 世紀の音楽とデジタル文化をめぐる旅』
　「音楽批評のアルシーヴ海外編」『エクリヲ』ウェブサイト、2018 年 10 月。
　▶ https://ecrito.fever.jp/20181027220322

25 ホリー・ロジャース『ギャラリーを鳴り響かせる──ヴィデオとアート‒ミュージックの誕生』
　『アルテス』2014 年 2 月号、82-85 頁。

26 ジャネット・クレイナック『反復されたナウマン』
　『アルテス』2014 年 9 月号、127-131 頁。

29 ティモシー・D・テイラー『資本主義の音──広告、音楽、文化の征服』
　『アルテス』2015 年 5 月号、104-108 頁。

30 マイケル・カーワン『ヴァルター・ルットマンと多様性の映画──前衛‒広告‒近代性』
　『アルテス』2014 年 11 月号、124-128 頁。

31 スティーヴ・グッドマン『音の戦争──サウンド、情動、そして恐怖のエコロジー』
　「音楽批評のアルシーヴ海外編」『エクリヲ』ウェブサイト、2018 年 7 月。
　▶ https://ecrito.fever.jp/20180714220022

34 スティーヴ・ロデン『…私の痕跡をかき消す風を聴く──ヴァナキュラー・フォノグラフの音楽 1880-
　1955』
　『アルテス』第 3 号、2012 年、219-222 頁。

36 デヴィッド・バーン『音楽のはたらき』
　「音楽批評のアルシーヴ海外編」『エクリヲ』ウェブサイト、2018 年 7 月。
　▶ https://ecrito.fever.jp/20180721220125

38 アンドレイ・スミルノフ『サウンド・イン・Z──20 世紀初頭のロシアにおける音の実験と電子音楽』
　『アルテス』2014 年 4 月号、93-97 頁。

40 ポール・デマリニス『ノイズに埋もれて』
　『アルテス』第 2 号、2012 年、184-188 頁。

事項索引

人名索引

執筆者紹介

金子智太郎（かねこ ともたろう）
愛知県立芸術大学美術学部准教授。美学、聴覚文化論。
主著に「1970 年代の日本美術における音」『あいだ』（2022 年）、"Arrangements of sounds from daily life: Amateur sound-recording contests and audio culture in Japan in the 1960s and 1970s," in *Asian Sound Cultures: Voice, Noice, Sound, Technology*（Routledge, 2022）など。
担当：はじめに、座談会、各章解説、02、04、07、08、11、12、15、25、26、29、30、34、38、40 結びに代えて

秋吉康晴（あきよし やすはる）
京都精華大学・関西学院大学・関西大学等非常勤講師。メディア論、音響文化論。
主著に "Living instruments: Circuit-Bending toward a new materialism of technoculture", *Journal of Global Pop Cultures 1*（2022）、「電話は耳の代わりになるか──身体の代替性をめぐる音響技術史」『音と耳から考える──歴史・身体・テクノロジー』（アルテスパブリッシング、2021 年）。
担当：座談会、09

阿部万里江（あべ まりえ）
カリフォルニア大学バークレー校音楽科准教授。エスノミュージコロジー、文化人類学、人文地理学。
主著に *Resonances of Chindon-ya: Sounding Space and Sociality in Contemporary Japan*（Wesleyan University Press, 2018）, "Sonic Imaginaries of Okinawa: Daiku Tetsuhiro's Cosmopolitan 'Paradise'" in *Sound Alignments: Popular Music in Asia's Cold Wars*（Duke University Press, 2021）、『ちんどん屋の響き』（世界思想社、2023 年）など。
担当：座談会、10

imdkm（いみぢくも）
フリーライター。
ポップ・ミュージックを中心にレビューやインタビュー、ライナーノーツ等を執筆。著書に『リズムから考える J-POP 史』（blueprint、2019 年）。寄稿に細田成嗣編著『ＡＡ──五十年後のアルバート・アイラー』（カンパニー社、2021 年）等。
担当：17、22

大西穣（おおにし じょう）
翻訳家、音楽批評。
主な訳書にジョン・ケージ『作曲家の告白』（アルテスパブリッシング、2019 年）、ジェローム・スピケ『ナディア・ブーランジェ』（彩流社、2015 年）、主な著作に共著『ＡＡ──五十年後のアルバート・アイラー』（カンパニー社、2021 年）、「小澤征爾の世界と「ふれる」」『図書』（2022 年）、「レイ・ハラカミと「うた」」『ユリイカ』（2021 年）など。
担当：03

葛西周（かさい あまね）
京都芸術大学芸術学部専任講師。音楽学。
主な共著（分担執筆）に『クリティカル・ワード ポピュラー音楽──〈聴く〉を広げる・更新する』（フィルムアート社、2023 年）、『音と耳から考える──歴史・身体・テクノロジー』（アルテスパブリッシング、2021 年）、『移動するメディアとプロパガンダ──日中戦争期から戦後にかけての大衆芸術』（勉誠出版、2020 年）など。
担当：座談会、24

後藤護（ごとう まもる）
暗黒批評。
『黒人音楽史 奇想の宇宙』（中央公論新社、2022 年）で第一回音楽本大賞「個人賞」を受賞。その他の著書に『ゴシック・カルチャー入門』（P ヴァイン、2019 年）、近刊に『悪魔のいる漫画史（仮）』（blueprint、2023 年）。
担当：18、33

佐久間義貴（さくま よしたか）
編集者。音楽・音響論。
主な論考に「反響・パースペクティヴ・深さ──振動するジャームッシュの風景」『エクリヲ』（2017 年）、「亡霊たちの唱歌──神代映画の〈声〉を聴く」『エクリヲ』（2016 年）など。
担当：23

千葉乙彦（ちば おとひこ）
出版社勤務。映画／ポピュラー音楽批評。
主な執筆に「MV エフェクティズム」『エクリヲ』（2019 年）、「相米映画を聴く」『早稲田大学大学院 文学研究科紀要』（概要掲載、2017 年）。
担当：36

辻本香子（つじもと きょうこ）
国立民族学博物館外来研究員、大阪芸術大学・大阪公立大学等非常勤講師。民族音楽学、文化人類学、サウンドスケープ研究。
主な論文に「都市のサウンドスケープと芸能の音——香港・九龍半島における中国龍舞の習得と実践を事例として」河合洋尚編『景観人類学——身体・政治・マテリアリティ』（時潮社、2016 年）、「芸能になる・スポーツになる——中国龍舞の音をめぐる価値の変容について」『音と耳から考える——歴史・身体・テクノロジー』（アルテスパブリッシング、2021 年）など。
担当：20

dj sniff
ターンテーブリスト、キュレーター。
演奏家としてこれまでに REWIRE（2015 年、ハーグ）、「Sam Francis in Japan」展（2023 年、ロスアンゼルス）などへの招聘。主な録音作品は『EP』（PSI、2010 年）、『ダウトミュージックを斬る』（ダウトミュージック、2014 年）、『平行的玉音軌』（Discrepant、2022 年）など。インスタレーション作品を「液態之愛」展（台北當代藝術館 MOCA、2021 年）、「崩塌記憶之宮」展（臺灣當代文化實驗場 C-LAB、2023 年）、台北雙年展「小世界」（臺北市立美術館 TFAM、2023 年）で発表。主な音楽イベントのキュレーションはアジアン・ミーティング・フェスティバル（日本、シンガポール、台湾他、2015-19 年）、Beuys on/off Sounds of Eurasia（東京ドイツ文化会館 OAG ホール、2021 年）、ex-DJ（臺北市立美術館 TFAM、2023 年）など。
担当：39

長門洋平（ながと ようへい）
立教大学現代心理学部助教。映画研究、聴覚文化論。
主著に『映画音響論——溝口健二映画を聴く』（みすず書房、2014 年）、共著に『日活ロマンポルノ——性の美学と政治学』（水声社、2023 年）など。
担当：14

中村将武（なかむら しょうぶ）
東京大学大学院博士課程在籍。美学、聴覚文化論、ポピュラー音楽研究。
主な論文に「忠実性の美学に向けて——音楽の録音における高忠実性と低忠実性の多様性と共通性」『美学』（2023 年）、「hyperpop の音響とそのフォーマット」『ユリイカ』（2022 年）。
担当：21（訳）

西村紗知（にしむら さち）
批評家。
主著に『女は見えない』（筑摩書房、2023 年）、主な論考に「椎名林檎における母性の問題」『すばる』（2021 年）、「お笑いの批評的方法論あるいはニッポンの社長について」『文學界』（2022 年）など。
担当：01

原塁（はら るい）
京都芸術大学非常勤講師。専門は歴史的音楽学、表象文化論。
領域横断的実践に関心をもち批評活動を行う。主著に『武満徹のピアノ音楽』（アルテスパブリッシング、2022 年）、主な論文に「肉体とエレクトロニクスの邂逅——佐藤聰明《リタニア》における一九七〇年代初頭の実践との紐帯」『表象』（2022 年）など。
担当：31, 32

日高良祐（ひだか りょうすけ）
京都女子大学現代社会学部講師。専門はメディア研究、ポピュラー音楽研究。
編著に『シティ・ポップ文化論』（フィルムアート社、2024 年）、『クリティカル・ワード ポピュラー音楽——〈聴く〉を広げる・更新する』（フィルムアート社、2023 年）、分担執筆に『ポストメディア・セオリーズ——メディア研究の新展開』（ミネルヴァ書房、2021 年）、『技術と文化のメディア論』（ナカニシヤ出版、2021 年）など。
担当：19

檜山真有（ひやま まある）
キュレーター。
キュレーションした主な展覧会に田中藍衣個展「リバース ストリング」（越後妻有里山現代美術館 MonET、新潟、2024 年）、雨宮庸介個展「雨宮宮雨と以」（BUG、東京、2023 年）、「谷原菜摘子の北加賀屋奇譚」（クリエイティブセンター大阪、大阪、2023 年）など。
担当：16

北條知子（ほうじょう ともこ）
アーティスト。
主な活動に作曲家個展「Music From Japan Festival 2021」（スカンディナビア・ハウス、ニューヨーク、2021）、個展「声をひそめて」（TOKAS 本郷、東京、2019 年）、個展「Unfinished Descriptions」（Hundred Years Gallery、ロンドン、2018 年）、共著に『アフターミュージッキング──実践する音楽』（東京藝術大学出版会、2017 年）など。
担当：28

細田成嗣（ほそだ なるし）
ライター／音楽批評。
編著に『ＡＡ──五十年後のアルバート・アイラー』（カンパニー社、2021 年）、主な論考に「即興音楽の新しい波──触れてみるための、あるいは考えはじめるためのディスク・ガイド」『エレキング』（2017 年）、「来たるべき「非在の音」に向けて──特殊音楽考、アジアン・ミーティング・フェスティバルでの体験から」『アジアン・ミーティング・フェスティバル』（2018 年）など。
担当：13、27

マーティン・デヴィッド・スミス
（Martyn David Smith）
シェフィールド大学東アジア研究所准教授。
東アジア現代文化論。
著書に *Mass Media, Consumerism and National Identity in Postwar Japan*（Bloomsbury, 2018）。 論文に "The 'hedonistic revolution of everyday life': Men's magazines, consumerism and the Japanese salaryman in the 1960s" in *East Asian Journal of Popular Culture*（2022）. "The hell of modern sound: A history of urban noise in modern Japan" in *Asian Sound Cultures: Voice, Noise, Sound, Technology*（Routledge, 2022）など。
担当：21

松房子（まつ ふさこ）
TAKU FURUKAWA ARCHIVE 運営。
COLLABORATIVE CATALOGING JAPAN に「アニメーションのための音楽──クリヨウジと秋山邦晴」（2021 年）を寄稿。共著に『アニエス・ヴァルダ──愛と記憶のシネアスト』（neoneo 編集室、2021 年）。
担当：06

柳沢英輔（やなぎさわ えいすけ）
京都大学大学院アジア・アフリカ地域研究研究科特任助教。音文化研究、音響民族誌。
主著に『ベトナムの大地にゴングが響く』（灯光舎、2019 年）、『フィールド・レコーディング入門──響きのなかで世界と出会う』（フィルムアート社、2022 年）など。
担当：05

山内文登（やまうち ふみたか）
国立台湾大学音楽学研究所教授。東アジア近代音楽史、帝国・植民地研究（朝鮮・台湾）、聴覚文化論。
共編著に *Phonographic Modernity: The Gramophone Industry and Music Genres in East and Southeast Asia*（University of Illinois Press, 2024, forthcoming）、 論文に "Contemplating East Asian music history in regional and global contexts: On modernity, nationalism, and colonialism," in *Decentering Music Modernity: Perspectives on East Asian and European Music History*（Transcript, 2019）など。
担当：座談会、35、37

音の本を読もう
音と芸術をめぐるブックガイド

2024 年 3 月 31 日　　初版第 1 刷発行

編著者　金子 智太郎
発行者　中西 良
発行所　株式会社ナカニシヤ出版
〒606-8161　京都市左京区一乗寺木ノ本町 15 番地
Telephone　075-723-0111
Facsimile　075-723-0095
Website　https://www.nakanishiya.co.jp/
Email　iihon-ippai@nakanishiya.co.jp
郵便振替　01030-0-13128

印刷・製本＝ファインワークス／装幀＝加納大輔